MW00471342

LOOK
AWAY

LOOK AWAY

A True Story of Murders,
Bombings, and a Far-Right Campaign
to Rid Germany of Immigrants

JACOB KUSHNER

GRAND
CENTRAL

NEW YORK BOSTON

Grand Central Publishing
Hachette Book Group
1290 Avenue of the Americas, New York, NY 10104
grandcentralpublishing.com
twitter.com/grandcentralpub

First Edition: May 2024

Grand Central Publishing is a division of Hachette Book Group, Inc. The Grand Central Publishing name and logo is a registered trademark of Hachette Book Group, Inc.

The publisher is not responsible for websites (or their content) that are not owned by the publisher.

The Hachette Speakers Bureau provides a wide range of authors for speaking events. To find out more, go to hachettespeakersbureau.com or email HachetteSpeakers@hbgusa.com.

Grand Central Publishing books may be purchased in bulk for business, educational, or promotional use. For information, please contact your local bookseller or the Hachette Book Group Special Markets Department at special.markets@hbgusa.com.

Library of Congress Cataloging-in-Publication Data has been applied for.

ISBNs: 978-1-5387-0811-8 (hardcover), 978-1-5387-0813-2 (ebook)

Printed in Canada

Marquis Book Printing

Printing 1, 2024

Contents

Part III

To the victims of prejudice and the targets of terror

A Note on Sources

Due to the volume of sources consulted while researching this book, I have included only a selection of the nearly two thousand original citations, omitting ones for information that is widely available or can easily be verified. Sources I returned to repeatedly—federal and state parliamentary investigations, trial logs, my own interviews—I cited just once per chapter.

I attempted to reach all of the people who appear prominently in the book, including the families of the murdered men, to invite them to speak with me. I also attempted to reach frequently named individuals accused of serious criminality or of aiding the NSU, and officials accused of negligence, to offer the right of reply.

LOOK
AWAY

We started our new lives and tried to follow as closely as possible all the good advice our saviors passed on to us. We were told to forget; and we forgot quicker than anybody ever could imagine. After four weeks in France or six weeks in America, we pretended to be Frenchmen or Americans.

—Hannah Arendt, *We Refugees*

Always start off small. Many small victories are better than one huge blunder. If you never get caught, you are better than any army. Others will notice your activities, but never try to take any credit for them, your success should be all the recognition you need.

—Tom Metzger, Ku Klux Klan Grand Dragon, *Laws for the Lone Wolf*

Prologue

A Fiery End

One autumn afternoon in the German town of Zwickau, a woman splashed ten liters of gasoline around her apartment, then set it on fire.

She had been dreading this day for years, hoping it wouldn't come to this. But on November 4, 2011, it did, and she needed to act quickly to save her two cats from the flames. Their names were Lilly and Heidi. One was black with white spots on its paws, while the other had gray and black stripes. She scooped them up, put them in their carriers, and walked downstairs to the street.

A passing neighbor recognized the woman by her "strikingly long, dark hair." Everyone seemed to fixate on this feature, perhaps because nothing else about her seemed distinct. She was five foot five, the average height of women in Germany. She was neither heavyset nor slim. Her face was wide, flat, expressionless, with thin lips and hazel eyes. Later, when her face became famous across Germany, there was one trait that nobody seemed to use to describe her. Which was strange because it was the only one that mattered:

The woman was white.

Four years later, at the trial that would captivate the country, the white woman would claim that she waited to set the fire until the two men renovating the building's attic left for a break, so they wouldn't be hurt. That she had tried to warn the older lady who lived downstairs—who sometimes looked after the cats when she was away—buzzing and knocking hard on

her door, to tell her to run from the flames. Her lawyer would tell a court-
room packed with judges, prosecutors, lawyers, journalists, neo-Nazis, and
police that she'd taken great care to save lives the day she set the fire. The
lives of other white Germans, and her two precious cats.

She wouldn't have needed to set the fire if only the fifteenth bank rob-
bery had gone as well as the fourteen before it. For over a decade, her two
best friends, and sometimes lovers, had been robbing banks at gunpoint in
towns across Germany. On their previous heist, the two men—who shared
the same first name—had walked in carrying two pistols, a revolver, and a
hand grenade, one wearing a vampire mask and the other a ski mask. They
walked out with 15,000 euros in cash, making their getaway as they always
did—on bicycles. Over the years, they'd stolen hundreds of thousands of
deutsche marks and euros, worth nearly a million dollars today.

For their fifteenth heist they drove two hours from Zwickau to Eisen-
ach, the birthplace of composer Johann Sebastian Bach and where Martin
Luther translated the New Testament from Latin and Greek into German.
On November 4, 2011, at 9:15 a.m., they walked in wearing sweatpants
and sneakers, one in a gorilla mask, the other in a mask from the movie
Scream. They pistol-whipped the bank manager, leaving a wound on his
head. They pedaled away with 72,000 euros in a bag. At 9:30 a.m., police
issued an alert for officers to be on the lookout for two men on bicycles.
Twenty minutes later, a witness told officers he'd seen two men ride bikes
into a hardware store parking lot a half mile from the bank. They were in a
hurry. They loaded their bikes into a white camper van and drove off.

Hours passed without any sign of the culprits, and police theorized
they might attempt to drive deeper into Saxony, the eastern German state
where other recent bank robberies had taken place. Officers fanned out to
patrol the roads leading west toward the city of Chemnitz. But at four min-
utes past noon, police spotted a white camper van parked on the side of the
road a few miles north of the bank. Two officers got out of their vehicle and
approached it. Just then, they heard a gunshot, then another. The officers
took cover behind a nearby car and a dumpster. Another shot rang out.
Then the van went up in flames.

The cops radioed firefighters, who rushed to the scene and quickly
extinguished the blaze. Carefully, they opened the side door and looked

in. Lying on the floor were the bodies of the two bank robbers, each with a bullet through the head. After setting the van on fire, one of them had shot the other, then turned the gun on himself. Searching through the carnage, a police officer inspected the guns. On the vehicle's right-hand seat was a Pleter 91 submachine gun and a Czech-made semiautomatic pistol. A black handgun was lying on a small end table between the two seats. But what caught the officer's eye were the two shiny, brass-colored bullet cartridges. They looked just like the casings of his own, government-issued bullets.

Could the bank robbers be police?

Investigators had learned little from the series of bank heists across eastern Germany in the preceding years. Two months earlier, police in the town of Gotha described the suspects as "both about 20 years old, slender figures, approx. 180–185 cm, masked, dark brown hair, darker skin tone, German language without an accent." That last phrase—German-speaking, without an accent—seemed intended to distinguish the men from immigrants or foreigners. The robbers were *German*, or at least they sounded the part. But the second to last phrase—"darker skin tone"—seemed to differentiate them from the *typical* German, by implying they were not white. But the Gotha police got it wrong. That much was evident as officers looked inside the van at the bodies of two men, some of their white skin charred by the fire.

When news reports began circulating that two bank robbers had killed themselves in a blaze of fire and gunshots, only one person in all of Germany knew who they were: the white woman with the long dark hair and two cats. Knew that they weren't just two money-driven men with a death wish. Knew that while robbing banks had been a talent of theirs, it was only a means to a more sinister end: murdering immigrants, to keep Germany *white*. They weren't merely bank robbers, the woman knew—they were serial killers, terrorists.

She knew this because she was one, too.

* * *

The three friends were not predestined to become killers. It was the culmination of their decade-long indoctrination into Germany's far-right world.

They didn't radicalize alone, but as part of a white supremacist community. Its ringleader was a government informant who used taxpayer money to turn disillusioned young Germans into violent political operatives.

Some tried to warn the world about what they were up to. One leftist punk began photographing far-right rallies and documenting the white supremacists who attended, unaware that some of them would grow up to be terrorists or that she would one day be called upon to expose them. Before the murders began, a police officer had tried to arrest the trio for their other, foreboding crimes. But he was sidelined by a law enforcement system that cared less about protecting the public than protecting its own.

Growing up in eastern Germany after the fall of the Berlin Wall, far-right youth called themselves National Socialists—Nazis. Like the original Nazis half a century before them, they blamed minorities for their ills. They despised Jews and didn't consider them to be part of the white race.* They derided Blacks. But above all they fixated on immigrants: working-class men and women and their children, from Turkey, Vietnam, and Greece. Children like Gamze Kubaşık, whose family emigrated from Turkey to Dortmund, where they opened a corner store. Children like Semiya Simşek, whose parents came from Turkey and sold flowers at stands across Bavaria. But to the white woman with long dark hair, and to her two white friends, these immigrants posed an existential threat to the white nation they wanted Germany to be.

And so they killed them, or killed their next of kin. One year before the Islamist terror attacks of September 11, 2001, three German terrorists set out to rid their nation of immigrants. Over many years, and in many cities, they shot immigrants where they worked and bombed the neighborhoods where they lived. Shot them in their corner stores, kebab stands, a hardware store. Bombed them in a grocery store, a bar, a barbershop.

German authorities didn't catch on to what they were doing. Blinded by their own prejudice, they couldn't bring themselves to believe that sixty years after the Holocaust, some white Germans could still be radicalized to the point of carrying out racist mass murder. And so each time an

* Some white supremacists believe immigration is a tool used by Jews to dilute and destroy the "white race." Suggested reading: *Bring the War Home*, by Kathleen Belew.

immigrant was killed, officers would lie to the victim's family, fabricating evidence to feed officers' fantasies that immigrant crime syndicates were to blame. While police ignored evidence that the killings were being carried out by white Germans, men of Turkish and Greek background continued to be murdered one by one.

Thirteen years passed before the trio's crime spree finally ended. The country's reckoning would unfold in a Munich courtroom, the city's largest, renovated just in time to hold Germany's trial of the century. Each day, former far-right skinheads and former leftist punks filed into the courtroom as witnesses, defendants, lawyers, spectators. Each day, for five years. The truth trickled out slowly. The spy in the cybercafé. Taxpayer funds given to far-right extremists. The intelligence agents who shredded documents in a frenzy. The trial would force Germany to grapple with what drove an ordinary German woman and her ordinary German friends to carry out a serial assassination of innocent people—people selected for the country from which they came, the accent in their voice, the color of their skin.

A nation that liked to think it had atoned for its racist past would be forced to admit that violent prejudice was a thing of the present. That sixty years after Hitler's Nazis led Jews and other minorities to their deaths during the Holocaust, German police were so blinded by bias that they couldn't recognize the racist violence unfolding around them. The case would compel Germans to acknowledge that terrorism isn't always Islamist or foreign. More often, it's homegrown and white. And that in an age of unparalleled mass migration, the targets of white terrorism are increasingly immigrants.

This is true not just in Germany, but in Western democracies around the globe. Since 9/11, more people in the United States have been murdered by far-right extremists than by any other kind, including Islamist ones. And it's getting worse: The year President Donald Trump took office, American white supremacists murdered twice as many people as the year before. Trump's anti-immigrant, antidemocratic rhetoric inspired white terrorists across the globe. In Christchurch, New Zealand, in 2019, minutes before a white man shot up a mosque during Friday prayers, he circulated a manifesto that called for the "removal" of nonwhite immigrants from Europe and praised Trump as "a symbol of renewed white identity and common purpose."

He wasn't the first white man to find common purpose in terrorizing immigrants and racial minorities, Muslims, and Jews. And he wouldn't be the last. Another white terrorist found it in Chapel Hill, North Carolina, where he murdered three young Jordanian- and Syrian-Americans in their home in 2015. Four months later, another one found it at Emanuel AME Church in Charleston, South Carolina, slaughtering nine Black worshippers in 2015. Two years later, another found it in a mosque in Quebec City, Canada, where he opened fire just after an imam led the congregation in prayer, killing six people and injuring five. One month after that, another one found it in Olathe, Kansas, where he yelled at two Indian engineers, calling them "terrorists" and "illegal immigrants," and screamed at them to "get out of my country," before shooting and killing them. A few months after that, another found it on a train in Portland, Oregon, shouting racist and anti-Muslim slurs at two Black teenagers before stabbing three people, killing two.

Yet another white terrorist found it at the Tree of Life synagogue in Pittsburgh in 2018, killing eleven Jewish people and injuring six. Another found it as he hunted Mexicans in the aisles of a Walmart in El Paso, killing twenty-three. Another one found it in the Asian American spas and massage parlors of Atlanta, where he killed six Asian American women and injured two others. One month later, another found it at a FedEx in Indianapolis that employed Indian Americans, killing four Sikhs and four others. Another one found it in a Black neighborhood in Buffalo, New York, where he entered a grocery store and slaughtered eleven people, almost all of them Black. Another found it in a store in Jacksonville, Florida, where, on the sixtieth anniversary of Dr. Martin Luther King's "I Have a Dream" speech, in August 2023, he ordered white people to leave before killing three Black shoppers in a suicide attack.

To stop this carnage, we need to acknowledge who the terrorists really are. Just as in Germany, most terrorists who strike in the United States are homegrown and white.

Today, some Germans want to confront their domestic extremists. But many wish to look away. It's a sentiment shared around the world. No one wants to believe that their neighbors, friends, and fellow citizens may be radicalizing around them, or that white terror is on the rise. They'd like to think

it doesn't happen often, or that it couldn't happen *here*. Germany's failure to recognize its first white terrorist spree of the twenty-first century—much less stop it—is a chilling warning for other nations that are failing to fight extremists at home. Having briefly earned a reputation as a haven for the world's refugees, Germany is now struggling to protect them from violence by native-born whites.

"There are those in the east and the west who want to see Germany as an open society"—one that embraces immigrants, said Heike Kleffner, a German journalist who investigates the far right. But there are other Germans who would like to make Germany *white*. "This rift is played out in families, in small towns, big cities, villages. It's a battle about defining this country."

This upheaval is transforming Germany's politics and calling into question what being *German* even means. Similar debates are engulfing nations around the world. When three white Germans began their anti-immigrant spree, white terrorism was already a global phenomenon, though few yet knew it by that name.

To understand what white terror is, who is spreading it, and how to stop it, we must look to Germany's east, where three friends from a small town set off to murder immigrants—and the government that was supposed to stop them chose to look away.

PART I

Chapter 1

Rebirth of a Nation

It's a sunny day in Jena, a small city nestled between mountains and a forest halfway between Frankfurt and Berlin. A man with tattooed arms sets up a video camera and points it at a girl. She's sixteen years old. It's 1991—twenty years before she'll torch the apartment and carry her two cats to the street. Her shoulder-length hair is frizzy and brown. She's dressed in skinny jeans, earrings, and a loose-fitting top. She's sitting outside a youth club that's under construction. The man, Thomas Grund, is a social worker who will help run the club once it opens later that year. Two teenage boys sit on either side of the girl and light cigarettes as they posture for the camera. One of the boys asks how they should sit.

"Any way you'd like," Grund replies.

The girl accuses one of the boys, the one with shaggy dark blond hair hanging in front of his eyes, of hogging all the room and tells him to scoot over. Once they're settled, Grund begins the interview. He asks whether they all live in the housing project in Jena's Winzerla neighborhood, the one built in the 1980s for workers of the Carl Zeiss company that manufactures lenses for cameras, microscopes, and more. The teens say yes.

"I like living in the ghetto," the blond boy replies smugly.

"Do you all have your own rooms?"

The boys say yes. The girl says nothing.

"How long have you been here?"

"Two or three years," says the dark-haired boy, dressed in an army-green hoodie. Grund asks the girl whether she lives with her parents. "Yes,

with my parents," she replies, declining to elaborate that she's never known her birth father, and that her mother is rarely around.

"In your own room?" Grund asks. A pause.

"Yes, my own room," she finally answers.

Grund asks more questions, but she doesn't seem to listen. She's distracted by the blond boy with the bangs. The two flirt and lock eyes as she crosses her legs and rests her knee on top of his. She inches closer, unable to sit still, running her hand through her hair. At one point, they both lean in until their faces are a few inches apart. Then they freeze, remembering that the camera is still rolling, and pull away. But she can't take her eyes off him for more than a moment without sneaking a glance and flashing a smile.

"Are there ever conflicts between residents?" Grund continues.

"Yes," the girl replies, her attention drawn suddenly back.

"And not only with residents, but also with the police," the blond-haired boy adds. He tells Grund that there are conflicts over "everything"— "harassment," "robberies," even "assault."

"Where do you go to hang out?" Grund asks.

Discos and small corner-store casinos with slot machines and sports betting, they reply. Asked whether they earn enough money to support these habits, the girl says nothing. Only later, after the boys have said their piece, she adds that "there's nowhere else for us to go."

"What do you like to do in your free time?" Grund asks.

"Training with women," the dark-haired boy replies crudely, which causes the girl to laugh. Grund tries to get them to focus, asking whether they're afraid of being unemployed. The girl doesn't answer. The blond boy stops flirting just long enough to say, "No."

When Grund asks whether violence is a part of their lives, the two boys talk over each other in a race to reply. "From time to time," says the blond-haired one. The dark-haired boy looks skeptical. When things go down, "they *really* go down."

Asked about their hopes for the future, all three of them look around blankly, unable to reply.

<p style="text-align:center">* * *</p>

Sixteen years earlier, the girl, whose name is Beate, came into this world by surprise. On January 2, 1975, her mother, an East German named Annerose Apel, walked into a Jena hospital complaining of stomach pains. Doctors suspected kidney stones, but within hours, she gave birth to a baby girl. Just twenty-two, Annerose was enrolled in a dentistry program in Bucharest, Romania. She left her daughter in Germany with the child's grandmother and returned to Bucharest to complete her studies.

Annerose's transience was typical for the time. Although university in East Germany was free, admission was competitive and was often reserved for those who had demonstrated loyalty to the Communist Party. Thousands of young East Germans like Annerose with career ambitions found it easier to enroll in Eastern Bloc countries like Romania, then return to East Germany to begin their careers. This was Annerose's plan. But by the time she earned her degree and returned to Jena, she suffered from allergies so severe that they prevented her from working as a dentist. Annerose stumbled in and out of love. After her stint in Bucharest with a Romanian man who was almost certainly Beate's birth father, she returned to Jena briefly before marrying and moving in with a man in the town of Camburg, a half hour away.

The only steady force in Beate's life was her grandmother, with whom she developed a deep bond. Anneliese Apel raised Beate in her small apartment in Jena. On weekday afternoons she walked Beate home from kindergarten, and it was most likely Anneliese who, in early September 1981, saw her off for her first day of school.*

Beate was an enthusiastic playmate, but a mediocre student. "Beate tries hard to achieve good learning results," her second-grade report card

* In Germany on a child's first day of school, parents often gift them a *Schultüte*—a giant paper cone filled with sweets, school supplies, and toys. Cameras click as children pose for portraits under the weight. Today, the *Schultüte* is given to children across Austria, Poland, Belgium, and beyond, but the tradition began in Jena in 1817. At the time, Jena was becoming known as the philosophical center of Germany, home to Wilhelm von Humboldt, Friedrich Schiller, Friedrich Schlegel, and his novelist wife, Dorothea von Schlegel. Even the godfather of German philosophy himself, Johann Wolfgang von Goethe, visited Jena often to exchange ideas. A century and a half later, if Beate received a *Schultüte* on her first day of school, her grandmother probably prepared it, because her mother was rarely around.

read, "but she often lacks the necessary concentration and order. She does not reach her full potential." Nevertheless, "she participates actively and with much joy." In fourth grade she joined a medieval-style fencing club, at which she excelled. But when the club disbanded, she refused to join another, despite her mother's urging. By this time Annerose had divorced, returned to Jena, enrolled in an accounting program, and applied for a job as an accountant for Jena's famous Carl Zeiss factory. Founded in 1846 as a small mechanic's workshop, it thrived during Germany's two world wars, producing binoculars, rifle scopes, bombsights, and other optical instruments for the war machine.* After World War II, when Germany split into East and West, the company did, too: The West German enterprise operated out of the town of Oberkochen, while the East German operation continued in Jena. Thirty years later, Carl Zeiss was still one of Jena's foremost employers when it took in Annerose. In 1985, when Beate was ten, the company offered Annerose a subsidized apartment in a six-story building in Winzerla. This is where Beate was living when Grund directed his camera at her.

As mother and daughter grew apart, East Germany was trying to hold itself together. In the fifteen years that followed World War II, more than 2.7 million East Germans—one out of every five—had exited west to reunite with their families, to live in a democracy, for better-paying jobs. Desperate to halt the exodus, East German authorities had hastily erected a barrier made of barbed wire and concrete, which they later fortified into a nearly twelve-foot-high concrete wall. They added guardposts where armed soldiers were told to shoot anyone who dared try to cross. After nearly four decades of separation, when Beate was fourteen, it all ended suddenly, by mistake. On November 9, 1989, an East German official named Günter Schabowski went on the radio to announce some bureaucratic changes that would make it easier for some East Germans to travel to the West. When asked when the changes were to take place, he stammered, "It takes effect,

* During the war, German companies used millions of Jews as forced laborers. In October 1944, hundreds of women arrived at one of Carl Zeiss's satellite factories in Dresden, near the Polish border, on trains from the Auschwitz concentration camp. By the war's end, as many as one-third of all Carl Zeiss employees were forced laborers.

as far as I know...immediately." The announcement was poorly worded, and to East Germans itching for the freedom to emigrate or agitating for the end of the socialist system, it sounded like their dreams were about to come true. They flocked to the wall in the thousands. Across the Atlantic, Americans watched on their televisions as Germans breached the wall and began tearing it down. They watched as families that had long been separated hugged and kissed in the streets.

But the celebrations had barely ended when a new reality began to sink in for the sixteen million Germans still living in the former East: Capitalism meant competition. No longer reliant on a narrow selection of products, East German consumers could purchase an infinite array of things from all over the world. Sales of East German products plunged. The Treuhand agency was established to privatize businesses that had been owned by the socialist state. In reality, the agency helped West German companies buy out their East German competitors. Layoffs ensued, putting millions of people out of a job for the first time in their lives. East Germans had benefited from the socialist right—and duty—to work, even if all their job entailed was redundant tasks on an automobile assembly line or pushing papers for a bloated bureaucracy. Suddenly, there was no such guarantee. Thirty percent of the East German workforce found itself either working "short time" or without a job at all.

Many former East Germans would grow to resent this troubled transformation. Though millions would migrate west, many of those who stayed faced prolonged hardship, and economic disparities between the former East and West would endure for decades. Three decades after the wall fell, barely one in three eastern Germans would look back on reunification as a success.

One of the eastern German companies that struggled to survive reunification was the Zeiss factory in Jena. To compete against companies in China and elsewhere, the company had to tweak the sizes and shapes of its lenses to adhere to international standards—an expensive overhaul. In 1991, the Treuhand agency purchased the hemorrhaging Carl Zeiss company for 1 deutsche mark and laid off a third of its workforce. Almost overnight, 650 Zeiss employees lost their jobs. By the year's end, 17,000 of them were forced to go on "a journey into the unknown," in the euphemistic

words of a company historian. After fourteen years with the company, Annerose was laid off. She started drinking, and drifting. Soon her daughter began drifting, too.

* * *

Because money was hard to come by, or maybe just for the thrill, teenage Beate began shoplifting from department stores for clothes that fit her brooding mood: loose-fitting tank tops, aviator sunglasses, and bandanas to cover her long, darkening hair. In school, the once "joyful" student struggled to pass her classes, the one exception being physical education, where she excelled. In June 1992, after completing tenth grade, rather than continue on a path toward college, at age seventeen Beate applied for professional apprenticeships and began working as a painter's assistant. When she grew bored of literally watching paint dry, she switched to gardening and began growing vegetables. But Beate wasn't born with a green thumb, and although she completed the apprenticeship, it didn't lead to a job. She began spending more time at the youth club, the one where she sat for Grund's camera. Called Winzerclub, "Wine Grower's Club," it was one of 144 such clubs established by Germany's Ministry of Women and Youth to keep young people off the streets. The minister who oversaw them was a woman in her midthirties—an up-and-coming scientist turned politician for Germany's conservative Christian Democratic Union (CDU) party. Her name was Angela Merkel.

Merkel and her colleagues envisioned these clubs as places where teenagers—unsettled or disgruntled by the sweeping shifts taking place around them—could hang out under the watch of social workers who would keep them on track, introducing life and career skills that might feed them into the workforce. To lure teens away from trouble, they needed to welcome everyone—even those with radical, far-right ideas. Some clubs functioned as Merkel and her colleagues intended. But others, like Winzerclub, became hangouts for hoodlums, where eastern German teens could let loose as they rebelled against their new, capitalist world. The same year Grund interviewed Beate, she was charged with three separate counts of misdemeanor theft. Two were dropped, but for the third she was sentenced to community service. This slap on the wrist didn't stop her from

stealing. Soon thereafter, "Beate, her cousin and two others broke into the club and stole everything—really everything that wasn't nailed down," recalled Grund—money, games, cigarettes.

One of Beate's accomplices was a boy with blond hair—different from the one in the video. This boy had bright eyes and an easy smile. Uwe Mundlos was born to a father who taught computer science at the University of Applied Sciences Jena. His mother worked at a local supermarket. His younger brother had been born with spasticity, a physical disability that often demanded his older brother's attention. Mundlos treated his brother with kindness, pushing him around in his wheelchair.

Mundlos was a bright boy who got good grades in school. When he drew, he sometimes held the pencil in his left hand, other times in his right. Back then, left-handedness was widely considered a defect, so his teachers encouraged him to become right-handed—a detail that would one day interest police.

Like many young East Germans, Mundlos was enchanted by relics of the West that East Germans weren't allowed to have. Once, when his father, Siegfried, traveled to West Germany to celebrate his mother's ninetieth birthday, he returned to Jena with capitalist contraband: a wristwatch with a built-in calculator. He gave it to his son, warning him never to bring it to school where it might draw attention. Both father and son were skeptical of East German propaganda. Once, Siegfried gave his son a booklet about the Sachsenring automobile factory in Zwickau. It described how the Soviet Union had given East Germany fifty tractors manufactured at the plant in the wake of World War II. But young Mundlos, an astute observer, protested that this was impossible: Another part of the book said the factory had in fact been dismantled earlier the same year. The tractors were a lie—the government, a liar.

By seventh grade, Mundlos's skepticism led him to challenge his teachers, but he still excelled in class and earned admission to a reputable college prep high school, where he had a penchant for quoting lines from the animated cartoon series *The Pink Panther*. In grade school he had worn his hair long, like a hippie, but he now changed his appearance, favoring a buzz cut and showing up for class wearing black boots and a military jacket. He began spouting what Siegfried later called "amateurish ideas," like taking

pride in Germany's twentieth-century past. To many Germans, pride in
the past wasn't just taboo—it was unthinkable. Germany's history was
filled with genocide and two world wars. After World War II, legislators
passed laws making it a crime to incite hatred against protected groups.
To show patriotism or glorify German history was considered protected
speech, but to publicly display Nazi symbols, deny the Holocaust, or utter
insults toward vulnerable groups based on their religion, race, ethnicity,
or nationality were crimes punishable by fines or even prison. Eventually,
Germany earned a reputation as the epitome of a nation confronting the
darkness of its wartime past. It paid more than 50 billion euros—more than
$60 billion—in reparations to millions of people who were persecuted by
the Nazis, half of which went to Holocaust survivors in the United States
and Israel. Courts eventually convicted some twenty thousand Nazis for
war crimes—though fewer than six hundred received serious sentences—
and by some estimates as many as one million Germans may have played
some role in the genocide. Memorials were erected to commemorate the
victims. So great were Germans' attempts to atone for their nation's ter-
ror that they coined a word for it: *Vergangenheitsbewältigung*, meaning "to
struggle with or to overcome the past." Aging Holocaust survivors were
dispatched to schools to warn what antisemitism, racism, and prejudice can
create.

And yet despite all these efforts, fascism—the far-right militant,
authoritarian, ultranationalist politics popularized by the Nazis—never
died. Not everyone accepted the narrative that Germans should atone
for their past. Although the Nazi Party collapsed after Germany's defeat
in World War II, many who had served Hitler and oversaw the Holo-
caust were still alive. Some senior Nazis had fled abroad to escape justice,
helped along by Nazi sympathizers, including officials in the Catholic
Church. But other rank-and-file Nazis lived out the rest of their lives in
Germany. Some served as judges, others in posts near the top echelons
of government. Germany had no mechanism to force them, or anyone,
to conform. Of course, Germany could encourage its citizens to embrace
multiculturalism, and its authorities could try to prevent hateful ideas from
turning into violence. But the nature of democracy is that people have the
freedom to think what they wish. Germany has never banned Hitler's *Mein*

Kampf, as many—including the German news agency Deutsche Welle—incorrectly assume.*

For a German teenager with a penchant to provoke, nothing was more incendiary than becoming a Nazi, and Mundlos relished the role, embracing antisemitism and expressing it through dark jokes. He read books like Thies Christophersen's 1973 *Die Auschwitz-Lüge* (The Auschwitz Lie), in which the former SS officer stationed at the notorious concentration camp in Poland claimed the Holocaust was a myth manufactured by an international conspiracy of Jews.† Once, on an eighth-grade field trip to the Buchenwald concentration camp not far from Jena, Mundlos had "no room for sympathy for the victims," one of his classmates observed. Standing in front of the incinerators, he remarked that at least the Jews were "nice and warm."

Mundlos wasn't alone. All across Germany there were people who refused to participate in their nation's collective shame, guilt, and reckoning. Some right-wing Germans, one or two generations removed from the war, were fed up with being told to feel ashamed for crimes they hadn't committed or for a war they hadn't fought. But for *far*-right Germans like Mundlos, there was nothing to atone *for.* Collectively, these racists, xenophobes, and antisemites became known as *neo-Nazis.* To the new Nazis, the old Nazis were not murderers but war heroes, and the Holocaust was not a genocide but a legitimate battle against an existential threat. Young men like Mundlos became nostalgic for a time when white Germans had been on top of the world. They glorified their once-powerful nation and were determined to restore its reputation—to make the world respect Germany, even fear it, once again.

By the time Mundlos came of age, this Nazi nostalgia had gained a foothold in Jena—expressed through graffiti, public protests, the lyrics of far-right music, and often through violence. In Jena's Winzerla neighborhood, "there was no wall on the prefabricated buildings that did not have

* Hitler wrote it while in a Bavarian prison, and for decades the state government declined to reprint it. But after the seventy-year copyright on the book expired in 2015, sales surged.

† In the 1980s Christophersen fled Germany to Denmark to avoid prosecution for Holocaust denial and other charges.

a swastika emblazoned on it," Grund recalled. Beneath one train overpass someone sprayed the words "Auschwitz Express." If such obscenities bothered Winzerla's residents, they didn't show it. Two full years would pass before the words were finally painted over.

To Grund, Winzerla was a gray neighborhood "with more violence than opportunities." Some historians would claim that this absence of opportunity explained, if not excused, the antisocial behavior and extremist beliefs of disillusioned youth in the former East. But for Mundlos, this wasn't the case. Sharper and more driven than his peers, he never lacked for opportunities. Just like the Carl Zeiss factory had taken in Beate's mother, Annerose, when she needed a job, a generation later it took in Mundlos, too. After completing tenth grade in the spring of 1990, he began an apprenticeship as a Zeiss data processor. At night, he grew closer with Beate, hanging out at the Winzerclub, where they'd smoke and flirt to the backdrop of heavy rock music or play card games like skat and Doppelkopf. Once a week, the young couple dined at a restaurant on the edge of a nearby forest. In 1992, Mundlos moved in with Beate and Annerose. There, in Beate's bedroom, they could be alone. To Annerose, Mundlos was "communicative, friendly and courteous." For the next two years, Mundlos returned to his family only when it came time for laundry—Mundlos's mother, Ilona, would wash his clothes. "That's just how it is with young men," his father, Siegfried, would say.

Eventually, Mundlos began bringing Beate to his family gatherings. Siegfried was delighted. Beate seemed like an upstanding girl. He never heard her express any far-right or militaristic views. Siegfried hoped Beate might steer his son away from the far-right scene. But if Beate tried to subdue Mundlos's darker side, she didn't succeed. On weekends when they went clubbing, Mundlos would dress in black or green militant clothes. Beate would look him up and down and then ask him, *Don't you want to wear something else?* Beate didn't object to her boyfriend's politics—only when he literally wore them on his sleeve. Once, when Mundlos accompanied Beate to a nightclub with a leftist, punk-leaning clientele, nine people roughed him up. Presumably they'd been provoked by his "stupid clothes," as Siegfried called them.

It shocked Siegfried when Mundlos and his friends began printing posters and organizing small political rallies in which they'd wave flags

of the former German Empire. Siegfried would later say he tried to help his son escape his troublesome path. Once, he showed Uwe an abandoned quarry near the Carl Zeiss factory, hoping he might find solitude there and keep himself out of trouble, away from his far-right friends. Instead, Mundlos began taking those friends there to swim, camp, and let loose at night around a bonfire. In 1992, Siegfried took Mundlos and Beate—then seventeen—and a couple of their friends on a monthlong holiday to a lake where they swam, barbecued, and enjoyed "playing their little games." But when the four weeks were up, Mundlos got into an argument with Beate, who wanted to stay longer on her own. Mundlos was irate. There was a time for vacation, and a time to be *home.* His son, Siegfried noticed, had a sanctimonious side—a sharp "moral sense of responsibility" that he liked to impose upon his friends.

He did the same at Winzerclub. While "the older men in there [sat with] young girls on their laps and smoked and drank," as Grund recalled, Mundlos was didactic—an athletic guy who "didn't smoke or drink...a glass on New Year's Eve at most." For her part, "Beate was just a normal young girl from next door, a marginal figure with no political interest"— affable enough. But Mundlos was a contrarian who'd launch into a polemic with anyone bored enough to listen. At first, he was careful to feign toler- ance toward opinions contrary to his own, but he grew more obstinate with time. He began to berate his friends for what he called their "uncontrolled" lifestyle—for partying and drinking away their problems, and for their lack of ambition. Later he would describe his frustration in a 1998 essay for a neo-Nazi leaflet, *White Supremacy.** "Looking at our scene today," he wrote,

one quickly realizes that it is composed of very different people, with even more different views. The only thing that unites all of them is the love for their people and their country.

The views on how to fight are very different. While some com- rades contribute their share to the struggle by playing in bands, working in comradeships, in autonomous groups and clubs, a large

* Such far-right "fanzines" were not illegal unless they directly incited readers toward vio- lence or hatred toward a protected group.

part is content with just walking around in the typical look of the scene and going to concerts or drinking with comrades in the pub. Nobody will question that concerts are a very nice and entertaining thing. No one questions that they are necessary and important for the cohesion of the group and strengthening of the ideology, but everyone should be aware that with concerts alone, no battle can be won.

"Ask yourself the following questions," Mundlos urged his far-right readers. "How many comrades do you know who don't have the money for donations to *fight*, but do for concerts and booze? How many comrades do you know who prefer pleasure (parties, concerts) to fighting in the streets (e.g., demonstrations, rallies)?"

Mundlos's nagging earned him a reputation as a spoilsport, but he didn't seem to mind. He was no longer the same person he'd been when he and Beate stole from the Winzerclub, no longer interested in petty thefts or petty speech. His politics gave his provocations a purpose: He became a rebel with a cause.

Chapter 2

The New Nazis

On Beate's nineteenth birthday—January 2, 1994—she met a young man with piercing, deep-set eyes, a buzz cut, and a curled upper lip. He too was named Uwe—Uwe Böhnhardt. Soon he, Mundlos, and Beate would form a friendship that would last for the rest of the men's lives.

The youngest of three sons, to his brothers, baby Böhnhardt was "their favorite toy," their mother, Brigitte, would say. To Brigitte, her "dear Uwe" was a "bright little fellow" who was loved by everyone. But to everyone else, he was rough around the edges—and everywhere in between. Böhnhardt was only eleven when his older brother Peter, aged seventeen, fell—or was pushed—to his death from atop an old castle he had been climbing with some friends outside the city. His body was left outside the family's apartment door. The police concluded it was an accident. Peter's death left Böhnhardt shaken and enraged. Brigitte would say that it was around this time that her son began misbehaving in class. Unlike Mundlos, Böhnhardt struggled in school from an early age. He was forced to repeat sixth grade. Growing sick of school, Böhnhardt attended it more sparingly, for which he would be suspended, and therefore attend even less. When he was fourteen, Böhnhardt's parents sent him to a boarding school for troubled teens fifty kilometers from Jena. But distance and discipline didn't do the trick. The boy who was so adept at staying out of school was accused of breaking into it, and school administrators expelled him after just two weeks. When

he returned home, rather than punish him, his parents took him on a holiday, "to show that we still love you," Brigitte told him.

If Böhnhardt loved his family back, he didn't extend such compassion to anyone else. After dropping out of school for good, he started hanging out with boys several years his senior. They began stealing, and, in Brigitte's view, whenever they got caught, they'd blame it on her innocent Uwe, who was young enough not to be arrested or fined. What began as trivial transgressions—stealing chewing gum from a vending machine, breaking into corner stores—escalated quickly. Those who knew Böhnhardt tended to describe him in the most explosive of terms. "Böhnhardt was like a bomb," a "loose cannon" who "failed at school, stole gasoline and cracked cars," then took them on joyrides.

A police officer described him as tall, slim, and athletic—his body was a fighting machine, and that's how he used it. In July 1992, Böhnhardt, still just fourteen years old, began bullying and attacking a sixteen-year-old boy who he claimed owed him money. After a court hearing for the assault, a brazen Böhnhardt repeated the crime the very next day: He hunted the boy down, punched him in the stomach, and bashed his boot into the boy's eye socket. The victim spent five days in the hospital recovering from a concussion and a laceration to the head. But Böhnhardt wasn't finished. Just days after the boy was discharged, Böhnhardt confronted him yet again, threatening to send him back to the hospital if he didn't pay up, quick.

A headstrong teenager who fashioned himself a fighter, Böhnhardt attacked with his fists, with baseball bats, with his heavy leather boots. Once, while driving a stolen car, and without a license, he refused to stop when a police officer tried to pull him over. He sped through two intersections, ignoring the red lights. The chase ended when Böhnhardt rammed a police car. In 1993, Böhnhardt, age fifteen, was convicted for this and other offenses and sentenced to seven months in juvenile detention, where he would spend his sixteenth birthday.

Böhnhardt's brand of violence was sadistic, not political, but behind bars he did brush shoulders with neo-Nazis. He took a particular liking to a far-right cellmate named Sven Rosemann. The two men allegedly tortured a fellow prisoner by forcing him into a closet, dousing him with

cold water and a cleaning agent, and melting a plastic bag onto his back. But prison fighting often went unpunished, and prosecutors never charged them for the assault. Later, the cellmates wrenched metal poles from their beds and filled them with matches and paper to concoct homemade pipe bombs. After detonating one in March 1993, Böhnhardt was moved from the juvenile to the adult section of the prison.

After his release, Böhnhardt's mother, Brigitte, tried to set him on a better path. She helped him land an apprenticeship at a construction company specializing in masonry, hoping he might learn some practical skills that would someday land him a job. "*Somebody* has to build the homes of the rich and famous," she joked—why not Uwe? To everyone's surprise, Böhnhardt completed his apprenticeship. As a reward, his parents bought him a car and paid for him to get his driver's license. Still, his criminal rap sheet grew and grew: resisting law enforcement officers, incitement of the police, kicking and attempting to punch a police officer, illegal possession of firearms. He soon added extortion, assault, and the illegal use of Nazi symbols to the list. He'd get arrested, be released, then do it all again, turning Jena into the violent world he wanted it to be.

* * *

On a spring day in 1992, while Beate was watching paint dry by day and hanging out with Mundlos at Winzerclub by night—and just before Böhnhardt began bludgeoning the boy who owed him money—a fourteen-year-old girl named Katharina König was walking home from a soccer match when two young men and a heavyset woman grabbed her from the crowd. The two men held Katharina's arms from behind while the woman began to punch her in the gut.

Katharina was born in Erfurt, an hour west of Jena, three years after Beate. Her father was a Lutheran pastor with a penchant for stirring the pot. In the autumn of 1989, Lothar König helped organize the Monday Demonstrations, in which East Germans clamored for a "free society," raising public pressure that eventually helped topple the East German state. The next year Lothar learned of an opening for a youth pastor in a small Thuringian town. The family packed their bags and set off for Jena.

The move upended Katharina's world. In Jena, idle gangs of right-wing

skinheads like Beate and the Uwes waited at train stations late at night to exchange blows with leftist punks.* One way to escape the skinheads' violence was to join them, a beer in one hand, a baseball bat in the other.† The other option was to join the leftists—the punks—a beer in one hand, a can of spray paint in the other, which you'd use to tag antifascist graffiti on the streets. Whichever group you joined would help protect you from the other.

One of the few arenas where the two groups coexisted was the Ernst-Abbe sport field, named after the Carl Zeiss company's nineteenth-century founder. Old and young, skins and punks—everyone loved soccer. Later, Katharina couldn't recall whether the home team, Carl Zeiss FC, won or lost. But she remembered the two men who held her and the woman who threw the punches. They were not the Uwes and Beate. In Jena as in other small eastern German cities at the time, neo-Nazis numbered in the dozens—sometimes more. By the mid-1990s Thuringian intelligence agents would count 930 far-right extremists across the state. And it didn't take a sharp tongue or a condescending glance to provoke them. The way you dressed or the reputation of your father was reason enough.

The woman who punched Katharina that day was named Yvonne, but those outside her clique referred to her as Fat Elke, a nickname lifted from a popular song by the punk-rock band Die Ärzte (the Doctors). Several inches taller than Katharina, and many kilos heavier, Yvonne wore her blond hair buzzed off on the top, long on the sides, with bangs in the front and a patch of hair on her neck—a skinhead style known as a feather cut. When Yvonne punched Katharina in the stomach, Katharina fell to the ground, at which point Yvonne kicked her in the face. Yvonne and her two male companions sauntered off, leaving Katharina bleeding badly from a cut below her left eye, her cheek swollen with blood. Someone guided her

* Not all skinheads are neo-Nazis. The subculture originated with working-class London-ers in the 1960s and took off among punk rockers across Europe, including Germany. But by the 1990s, many leftists began embracing other styles, and today the English word "skinhead," or "skin," is usually synonymous with neo-Nazis.

† Germans sometimes refer to the 1990s as *die Baseballschlägerjahre*—the "baseball bat years"—in reference to neo-Nazis who roamed the streets carrying weapons to attack left-ists, immigrants, and other minorities.

back into the stadium to see a doctor, who called an ambulance to take her to a hospital. Doctors stitched up the wound underneath her eye, but the scar would never fully disappear. This sickly souvenir marked her indoctrination into Jena's bifurcated scene: The three people who had attacked her were fascists. Katharina joined the punks—the antifa.

Germany's antifascist movement dates back to the Weimar Republic and gained momentum during its underground opposition to the Nazis during World War II. Then, in the 1980s and '90s, as neo-Nazis and other fascists increasingly took their violent ideology to the streets, antifascists fought back, confronting far-right soccer hooligans in cities like Hamburg and ejecting far-right skinheads from punk music shows in cities like Berlin. By the time Katharina was a teen, antifascists in the former East were documenting fascist rallies, infiltrating far-right networks, and exposing far-right activities. In Jena, antifascists had begun attending meetings of the Junge Gemeinde, or JG, a youth club run by Katharina's father, Lothar, out of his church. Leftists like Katharina would hang out there listening to *Deutschpunk*. Born in the 1970s in the West German cities of Hamburg, Düsseldorf, and West Berlin, *Deutschpunk* remained largely underground in East Germany lest its overtly political lyrics, which criticized the state, attract the astute ears of the Stasi. The sound was fast-paced and aggressive, like British or American punk of the time. But the German genre became more radically antifascist, its lyrics taunting, teasing, and belittling neo-Nazis.

Sometimes, the Nazis retaliated with violence. In October 1987, when Katharina was nine, two of Germany's biggest antifascist bands—the East German band Die Firma and the West German Element of Crime—performed at a church in East Berlin. Forty neo-Nazis armed with bats stormed the concert screaming "Sieg Heil" and "Jews Out." Police, safely seated in their cars outside, decided to stand down and let them fight it out.

Left-wing Germans—and many who research Germany's police—have long accused German authorities of being "blind in the right eye," meaning they are lenient toward or overlook crimes committed by the right. When police fail to arrest fascists—be it for lack of resources, apathy, or because the fascists' actions didn't appear to break the law—leftists tend to see it as a sign that police are on the fascists' side. One of Katharina's

favorite bands, the Hamburg-based Slime, often derided police in its lyrics. Inspired by the radical 1988 hit "Fuck tha Police" by the legendary Los Angeles hip-hop crew N.W.A., Slime's lyrics compared cops to Hitler's SA and SS officers. Their album *Schweineherbst* (Pigs' Autumn) lambasted the police as scum for sympathizing with fascists. One song was so explicit in calling for violence against cops that authorities eventually added it to Germany's index of songs that may not be sold (or later, streamed) to minors or broadcast on the radio where minors might hear it.*

Just like the singers in her favorite bands, Katharina came to believe that the police couldn't be trusted to curtail Jena's neo-Nazis. Night after night, the fascists would beat somebody up, and the police wouldn't arrest them. What, after all, had the police done to punish Yvonne, the skinhead who assaulted Katharina after the soccer game? Nothing. Katharina decided to take matters into her own hands. At age fifteen she helped found an all-female antifa division that kept lists of Jena skinheads, sometimes following them and photographing them at demonstrations and rallies. The first time Katharina observed a far-right concert it was by accident. She and some antifa friends were driving down the main drag in Jena when they saw a large young man who—thanks to their antifa sleuthing—they recognized as André Kapke. Kapke was a Jena native the same age as Beate. He grew from a big-bellied kid into a full-bodied neo-Nazi who plastered posters around the city with the slogan *"Bratwurst statt Döner."*

Döner is to Germany what a hamburger and French fries is to the United States: a defining national dish. Around 1970, Turkish guest workers began wrapping grilled meat in flatbread, and soon döner kebabs made

* Some *Deutschpunk* incited violence: So-called *chaostage*, "chaos days," which began as anarchist music festivals in the 1980s, had by the mid-1990s grown into full-out riots where thousands of punks in cities like Hanover destroyed buildings and cars and looted liquor stores. In 1995, police arrested 450 of the more than 2,000 rioters, and a hundred police officers were reportedly injured. While most leftists did not use violence to advance or impose their ideology the way far-right skinheads routinely did, some embraced it: An unofficial schedule drafted in advance of the 1995 chaos days listed the weekend's activities as follows:
Friday 3 p.m.: Streetfights
Saturday 11 a.m.: Playing with Fire
Sunday: Glass-breaking demonstration.

of lamb, veal, beef, or chicken—the word in Turkish means "spinning grilled meat"—became classic street food in West Berlin. The meal underwent a uniquely German transformation: Cabbage and onions became a mainstay, and a mayonnaise-based sauce was squirted liberally on top. The sandwich grew in size and would sometimes be garnished with shavings of carrots and other vegetables and topped with *scharfe* sauce for those who like it hot. In the public imagination, döner replaced bratwurst as Germany's iconic fast food. Kapke's refrain, "bratwurst not döner," was a protest against immigrants changing Germany's ways. It conveyed a simple message: Germans *up*, foreigners *out*. Neo-Nazis regularly attacked döner restaurants to drive the point home.

Katharina and her friends watched as Kapke got into his car, following him north to a small village where they noticed dozens of vehicles parked along the side of the road. When they neared the town's central square, Katharina was shocked to see hundreds of neo-Nazis who had descended for a rally. Katharina felt the urge to confront them, but she and her two friends were outnumbered. Her second thought was to photograph them, but they didn't have a camera. They had no other choice but to turn around and drive home.

Sometimes Katharina went looking for trouble, but other times trouble found her. Late one night after a festival at the church, Katharina and her mother walked out through its massive wooden doors to the cobblestone street. As they bid each other good night, they overheard three men speaking crassly.

"We ought to take them to Auschwitz—to the gas chambers," one of the men said. Katharina realized he was speaking about *them*—Katharina and her mother. He said it like he wanted them to hear. Sensing trouble, Katharina's mother walked back into the church to warn her husband.

"We have a problem," she informed him. When Lothar came out to see what the matter was, the neo-Nazis grabbed him and began beating him in the street. When Katharina tried to intervene, they attacked *her*. Katharina suffered facial bruises, and her father had to be treated by a doctor the next day.

Fed up with the inaction of the police, Katharina and her fellow anti-fascists would sometimes fight violence with violence. After the city went

dark, "we'd go out and try to *get* a couple." A couple *Nazis*, that is. They'd
drive to nearby towns where neo-Nazis attended concerts, or wait outside
far-right house parties. They'd follow a straggler, surround him, and beat
him—just like the Nazis did to them.

"We call it an 'announcement,'" said Katharina. "A short and conse-
quential beating-up." Katharina didn't have any ethical or moral reser-
vations about hurting fascists. She saw it as self-defense. "Some people
understand the language of violence better than the language of words."

Still, such "announcements" were rare, and antifa life was usually more
mundane. Katharina and her comrades would sit for six or eight hours in
a car parked outside a house of neo-Nazis, hoping to photograph them as
they came and went. They'd write down their license plate numbers and
warn one another to avoid these vehicles at night, to not get beaten up
themselves. One of the cars they photographed, a red Ford, was registered
to Siegfried Mundlos, but they noticed that it was his son Uwe who drove
it. Another car they saw around town, a red Hyundai, license plate number
J-RE 76, belonged to Uwe Böhnhardt. A third, a white Ford, license plate
number J-AY 410, belonged to a woman with a wide, flat face, hazel eyes,
and long brown hair. The woman's name, Katharina came to learn, was
Beate Zschäpe. It wasn't long before their circles would collide.

<p align="center">* * *</p>

As the three friends spent more time together, Böhnhardt's bellicosity—
his indiscriminate violence and rage—began to take on a new direction:
Mundlos's politics began rubbing off. Four years his senior, Mundlos, with
his political dogma, gave Böhnhardt's brashness a purpose that vindicated
the younger Uwe's predilection for violence. To Mundlos, Böhnhardt had
every reason to be mad. Mad at Germany's government for leaving eastern-
ers in the lurch after reunification. Mad at immigrants, who they believed
were taking their jobs. And mad at their fellow Germans for their culture
of shame—for treating patriotism as pernicious, as if being German was
something bad.

Böhnhardt was drawn to Mundlos's radical ideas. Like Mundlos, he
developed a sick sense of humor, and would crack jokes in praise of Nazi
leaders like Rudolf Hess, Hitler's deputy whose 1987 suicide while in prison

for war crimes made him a hero among Germany's far right. At seventeen, Böhnhardt shaved his head completely. His older brother attempted to explain it as an early-onset receding hairline. But those who knew Böhnhardt knew better: Böhnhardt was now a bona fide skinhead. He and Mundlos dressed the part, buying bomber jackets at a skinhead store called Madley and wearing heavy black "jump boots" and black T-shirts that branded them as brothers of the right. The two Uwes dressed and looked so alike that even those who knew them found it hard to tell them apart from a distance. Rumor had it that police officers once roughed up Mundlos by mistake, confusing him for his younger, troublemaker friend.

Beate didn't brand herself with such skinhead chic. She sported a green bomber jacket only rarely, preferring sneakers to boots, jeans to cargo pants, tasteful tops to T-shirts. Beate didn't care much for music either, but she'd listen along as the Uwes played far-right cassettes at Winzerclub. This music formed a soundtrack to their politics. It was hate, on repeat, at the push of a button. Songs by the band Kraftschlag celebrated attacks against immigrants. Songs by Frank Rennicke, a xenophobe singer-songwriter and guitarist from Saxony, described Polish people as "contaminators of German soil." Lyrics by the Berlin neo-Nazi band Macht und Ehre (Power and Honor) proclaimed, "Jew, off to the oven!" and referred to immigrants as "grilled meat."

While most Germans would have found such lyrics abhorrent, their offensiveness was precisely the point. They lamented what their singers believed Germany was becoming: a liberal, multicultural mess. Among the Uwes' favorites were songs by the far-right rock band Noie Werte, whose lyrics were delivered fast and shouted. The band called on fellow fascists to "fight for their fatherland"—to mold Germany back into the white supremacist nation it had been. Although music that directly glorified the Nazis would have been illegal to perform in public, in Jena as throughout Germany, far-right fans tended to party in private, meaning there was little the authorities could do. It was to this musical backdrop that Böhnhardt's rage—normally indiscriminate—began to take on a particular direction. He began parroting ideas from these songs.

"Turks are shit, Africans are shit—everything is shit," Böhnhardt would bemoan. He started speaking of immigrants as if they were one

collective, parasitic group. "Foreigners are taking away our jobs," he once complained to his mother. Brigitte retorted that it was a good thing the Turks and Italians were there, working in a kebab stand or a pizza place all day long, so he didn't have to. "The Jews are to blame for everything," he'd provoke. Brigitte would later claim that she barred him from making such antisemitic remarks and forbade him from listening to neo-Nazi music in the house. But Brigitte didn't blame her son. She believed he was merely regurgitating the remarks of his friends. Brigitte also struggled to rationalize Böhnhardt's dress. To her, the bomber jacket, black pants, and combat boots didn't mark him as a neo-Nazi. It was merely the style of the times. She warned him not to bring any far-right paraphernalia into their home. One day when Böhnhardt brought home a gas pistol with pellets, she made him promise to give it away at once. Böhnhardt was a "gun fanatic," as Beate described him, who always carried a replica gun—a weapon that fires blanks, pepper spray, salt, air-powered BBs, or other nonlethal ammunition. In Germany you can buy such weapons legally at age eighteen. In Jena, they were not hard to find. Neo-Nazis bought them at a store called Peters Weapons. When Böhnhardt grew bored with one such gun, he'd leave it at a friend's house for safekeeping and begin carrying a newer one instead. He also owned a crossbow, which he hid against his mother's wishes in his childhood bedroom, where he would live until he was nineteen.

Brigitte couldn't have been oblivious to her son's slide into the skinhead scene. One day after police picked up Böhnhardt for one of his myriad crimes, when Brigitte went to retrieve him, officers warned her that her son was involved with the city's far-right youth. Siegfried Mundlos suspected the same, and blamed Böhnhardt for his own son's misdeeds.

"Uwe Böhnhardt was already a problem child," in Siegfried's view, long before he met Mundlos. Neighbors warned Siegfried that Böhnhardt was a pugilistic "psychopath," with whom his son ought to be careful. Siegfried felt like his Uwe was always stepping in to save Böhnhardt from the consequences of his criminal acts.

But Mundlos too was learning the language of violence. One day he chanced upon what he took to be a homeless woman sitting on the floor of a bakery in town. Mundlos pegged her as someone many Germans at the

time referred to derogatorily as *Zigeunerinnen*—Gypsies. Often described as wanderers or drifters for their migration across Europe and the world, Romani and Sinti have in fact lived in Germany for some six hundred years. In the 1920s, Germany's Weimar Republic government began referring to them as an "antisocial element"—outcasts who posed a danger to society. The Nazis slaughtered Roma and Sinti in what became known as the Romani Holocaust or *Porajmos*—the Romani word for "devouring." Half a century later, prejudice toward Romani people persisted, and they were a frequent target of neo-Nazis. That day in the bakery, Mundlos bought a slice of cake and hurled it at the woman, striking her in the head. He later joked about the assault with a friend—Beate's cousin—who didn't think much of it. It wasn't unusual for neo-Nazis to insult or even injure anyone who wasn't German enough for them. Not just in Jena, but across the nation, fascists, whose radical beliefs excluded them from mainstream politics, instead turned to violence to make their voices heard. Germany's constitution, its democratic principles, made all people—immigrants and native Germans—equal under the law. To "correct" this, fascists like Beate and the Uwes used words and threats, fists and boots, to make them unequal once again.

Fascists have always used violence as a tool to bend the rules and norms of their cities, their nations, to their own designs. But to Germany's neo-Nazis, violence wasn't just a *means* to an end. It *was* the end. Nazi ideology calls on the "Aryan" race to conquer and rule over "lesser" races. Antifascist activists like Katharina tried to warn their fellow Germans that fascists posed an existential threat to a nation founded upon equality and democracy. The German public and the press, the politicians and police, didn't often heed that warning. Even after the fascists did something so brazen it should have been impossible to ignore.

Chapter 3

Rostock Riots

A five-hour drive north of Jena just below the Baltic Sea lies the once-strategic port city of Rostock. During World War II, the Allies bombed the place to pieces—not only its ships and planes and factories, but its civilian centers, too. After the war ended, Europe needed to rebuild. But who would do the building? One out of every five Germans had died, fled, or was deported during the war. Within a decade, East and West Germany did what modern nations so often do: They relied on immigrants.

In 1955, the first "guest workers" arrived in West Germany from Italy, followed in the 1960s by workers from Spain and Greece. Others came from eastern Europe and as far away as Turkey. Meanwhile, East Germany recruited workers from behind the Iron Curtain—from Romania and socialist allies like Mozambique and Vietnam. But the state didn't think of them as immigrants the way we use the term today. They were never meant to be integrated into society or to one day become citizens. Rather they were *foreigners*—temporary laborers who would live segregated lives, ready to be sent back home at any time, as female workers who became pregnant often were. And though the East German state referred to these workers as "friends" and "brothers" and made racism a crime, prejudice and xenophobia were rife. Between the end of World War II and 1989, there were at least thirty-nine documented attacks against immigrants in the East. One of them occurred in August 1975, when a mob of some three hundred white Germans attacked over two dozen Algerian men with iron bars and

chased them through the streets of Erfurt, Katharina's hometown. This was six months after Beate was born.

If reunification rattled native-born East Germans, it hit the guest workers even harder. In Rostock, unemployment jumped from near zero in the socialist state to 17 percent in a few short years, and one in three workers had their hours reduced. But immigrants like the Vietnamese guest workers at the dockyards didn't just lose their jobs—they lost their residency permits, too. Those living in company dormitories lost their homes, and others were forced to return to China, Cuba, even Mozambique amid an ongoing civil war. Some guest workers, including many from Vietnam, moved to West Germany in search of work, but most had little choice but to return to their home countries.

While the immigrant underclass that remained was small, it suddenly became more visible to native-born Germans. Immigrants who had worked and lived in the shadows—at dockyards or factories—now opened clothing shops and corner stores, bakeries and döner kebab stands, grocery stores and restaurants. Many eastern German workers viewed these foreigners as competition. It wasn't long before some decided it was time to root them out. After the Berlin Wall fell, as East and West Berliners embraced and danced in the streets, what the TV cameras didn't show were the white Germans picking up stones and baseball bats, lighters and gasoline, and setting out to rid their new nation of immigrants.

The year East and West Germany officially reunited, white men in Magdeburg celebrated by attacking a dorm where Vietnamese guest workers lived. In the town of Frankfurt (Oder), young people attacked Polish workers with batons and stones, overturning cars and a minibus. A short drive from Jena in the town of Eisenach, white men besieged a house of Mozambican guest workers, throwing Molotov cocktails through the windows and shouting anti-immigrant slogans.

This was only the beginning. The following year, on Easter Sunday 1991, white Germans in Dresden threw a twenty-eight-year-old Mozambican immigrant named Jorge Gomondai from a moving tram. He died a week later from his injuries. That September in Dresden, white men wearing masks broke down the door to a pregnant Vietnamese woman's home.

"I tried to cry for help but one of them covered my mouth. They beat me on the head, the arms, and the stomach. They shot at me with a gas pistol.

They pulled out my hair. The neighbors looked on and listened. No one helped me."

As the violence proliferated, immigrants everywhere lost any semblance of security. Eight days after the attack on the Vietnamese woman, in the western town of Saarlouis, white men firebombed a refugee shelter, killing Samuel Yeboah, a twenty-seven-year-old man from Ghana, and severely burning two Nigerians. More than thirty years would pass before one of the men was charged and tried for murder.

The following month in the West German town of Hünxe, white Germans firebombed a bedroom where two Libyan children were sleeping, burning them severely. Six weeks later, a Vietnamese man living in Leipzig heard people congregating outside his door. He looked through the peephole and discovered a gang of some ten white men—neo-Nazis—wearing masks and brandishing knives and sticks.

"Foreigners out! You must die!" they screamed.

"Then they began kicking in the door," recalled Vu Xuan Ke. He tried to hide on the balcony, but the men found him there and stabbed him in the head. He threw himself from the balcony and plunged three stories to the concrete below. Bloodied, his leg broken, he crawled to a bush and prayed he wouldn't die. But when he called out for help, the only ones who came were the neo-Nazis, who proceeded to stab him in the leg with a serrated knife over and over, ripping out his flesh. Ke passed out. Somehow, he survived.

That same month, the largest attack yet took place in the town of Hoyerswerda. On September 17, 1991, a mob of white Germans surrounded a home for asylum seekers, pelting the building with Molotov cocktails and projectiles—for four straight days.

"They attacked our house with stones, flare guns, and tear gas and smashed several windows," one Vietnamese immigrant said. Police, overwhelmed, yielded to the white mob's demands, evacuating 230 foreigners—mostly Mozambicans and Vietnamese—to a military base. In the aftermath, Germany deported some 300 foreigners living in the area. A far-right magazine rejoiced that Hoyerswerda had become the "first city free of foreigners." A journalist asked a high school principal what he thought was the root of all the violence.

"I hear people say that this is all a result of social pressures, but those

arguments aren't enough to explain what we're seeing now," he replied. "Something else is at work. I can't put my finger on just what it is, or maybe I don't want to."

That unexplained force was white nationalism. It had never gone away. Similar events that precipitated the Holocaust—pogroms, attacks against Jewish-owned businesses, the expulsion of Jews from their homes—were now happening to immigrants. Beatings, arson, stabbings, murder: In 1992, Germany counted more than twenty-five hundred violent crimes and seventeen murders committed by far-right extremists. Human Rights Watch estimated that nearly a thousand violent attacks against immigrants had left at least seven hundred injured. "The refugees come here to escape the violence in their own countries," one refugee lamented, "and find similar violence here."

Most of the perpetrators were younger than twenty years old. One in four were just sixteen or seventeen. When interrogated, they often justified their attacks by blaming immigrants for taking their jobs and those of their parents—which simply wasn't true. Police statistics reveal that these white perpetrators were half as likely to be unemployed as the average East German, and they were far better off socioeconomically than the immigrants they attacked. In the words of a 1992 report by Human Rights Watch, "Xenophobia is not a problem that actually has to do with foreigners. It is an expression of the problems Germans are having with *themselves*. Those who claim that right-wing extremism is mainly a result of the dramatic increase in asylum seekers in Germany are ignoring the facts."

Young, impressionable, and looking to rebel, these Germans embraced an enticing and familiar narrative seen throughout history and around the world: that their whiteness or nationality afforded them the right to beat, maim, and kill.

"Forty-six years after Adolf Hitler, we are skating on very thin ice," declared Cornelia Schmalz-Jacobsen, a leader in Germany's neoliberal party, the Free Democratic Party (FDP).

In Rostock in the summer of 1992, the ice finally cracked.

* * *

On the afternoon of August 22, when a woman named Sylvia Modrow returned from her summer holiday, she was surprised to discover hundreds

of angry, stone-wielding people surrounding the apartment building where she lived.

Known locally as the "Sunflower House" due to a mosaic of three yellow sunflowers that stretch up its eastern façade, the eleven-story building housed white Germans like Sylvia as well as more than a hundred former guest workers from Vietnam. That summer, dozens of Romani people who had arrived from eastern Europe began sleeping outside the building while they waited for the city to find them shelter. They were highly visible, and locals called them an eyesore, nearby shopkeepers a nuisance—and some xenophobic Germans began calling for them to leave.

Rostock ought to have been an unlikely place for anti-immigrant violence to break out: There were hardly any immigrants around. At the time the Berlin Wall fell and Germany reunited, immigrants made up just 1.2 percent of the East German population. In the state of Mecklenburg-Vorpommern, of which Rostock is the capital, there were even fewer—just half of 1 percent. Immigrants were an almost invisible minority in a city of 240,000. But to Germany's xenophobes, they weren't quite invisible enough.

"Everything was in flux, everything was uncertain," the editor of Rostock's local newspaper recalled. "There was a change in people's fears—fears of immigrants taking away our jobs, and our living space."

Fearing that white residents might take matters into their own hands, the city's mayor pleaded for federal aid, warning that unless something was done quickly, "serious assaults and even killings can no longer be ruled out."

By the time Sylvia returned from vacation, the mayor's prediction had come true. She looked down from her balcony and watched in horror as angry white men stopped vehicles in the middle of the intersection.

"They were picking out everyone who looked like foreigners," Sylvia realized. She watched a Vietnamese driver accelerate across the front lawn, jump out of his car, and dash toward the building's entrance, lucky to escape. The mob proceeded to set his car on fire.

"Who knows what they would have done to this man," Sylvia thought. "It was obvious he was fleeing for his life."

The Rostock Riots had begun.

In the hours and days that followed, more and more rioters arrived, their numbers swelling into the thousands. Some gathered and gawked,

while others pelted the building's windows with rocks. Police made a few, feeble attempts to disperse the crowd and access the building but were thwarted every time. Firefighters tried hosing the protestors with water. Police reinforcements arrived from Hamburg and other cities. Some, wearing riot gear, tried ramming their way through the crowd, but to no avail.

On the third day, August 24, Rostock officials managed to bus away some two hundred people, mostly Romani, to a shelter. But the Vietnamese immigrants inside the building remained trapped. As night fell, police—exhausted, overpowered—stood down. Rioters siphoned gasoline from parked cars to make Molotov cocktails, which they lobbed through the windows. Smoke began billowing out. Frightened immigrants fled up a stairway to the roof, some carrying babies and children in their arms. Onlookers gawked as rioters breached the building and began chasing the immigrants up. As they retreated to higher and higher floors, the immigrants found themselves trapped between the rioters and the smoke.

With them was Rostock's commissioner for refugees, Wolfgang Richter, who phoned the fire department at 10:30 p.m. "Pay attention, I will explain it to you very calmly," Richter told the dispatcher:

> Mecklenburger Allee 19, the home of the Vietnamese. There are 150 people, 150 Vietnamese there. The police have withdrawn. The rioters have set the house on fire. The gases are already rising, and they are fighting up through the building floor by floor. I already informed Police Inspector Witten-Klein [forty-five minutes] ago. But nothing is happening. The Fire Department must come immediately, and very many police. The people are about to die.

The firefighters never arrived—rioters blocked their path. The immigrants might have burned alive had Richter, who was familiar with the building's corridors, not led them to the roof then down a back staircase to safety.

All told, the chaos lasted four days, and by its end, "at least 1,000 neo-Nazis had participated, many of whom had made their way to Rostock from as far away as Hamburg, Berlin and Dresden," wrote the migration historian Panikos Panayi, who estimated that "at its height perhaps 1,200

rioters fought with 1,600 police." It was a flash mob of xenophobes: One newspaper editor called it "riot tourism."

On the final day of the riots, eight hundred members of a Rostock trade union had marched through the city's streets demanding that the immigrants be protected. But most Rostock residents had ignored the riots: At 8 p.m. that evening, twenty-five hundred fans flocked to the local soccer stadium to cheer on the city's team.

One week after the riots began, thirteen thousand people marched to show their support for the immigrant victims and demand that their attackers face justice. To monitor the demonstration, police deployed a large contingent of some three thousand officers—twice as many as had confronted the violent, anti-immigrant mob itself. They deployed helicopters to monitor the peaceful protests, and officers arrested eighty people. The contrast between how police reacted to the anti-immigrant mob and the pro-immigrant demonstrators was striking—a textbook example of how authorities' bias made them "blind in the right eye." Prosecutors leveled charges against a mere forty of the thousands of rioters—and not for attacking the immigrants, but for disorderly conduct and violence against police. Twenty were convicted, and eleven briefly jailed. A decade would pass before prosecutors were finally pressured into charging just a few of the rioters for assaulting immigrants.

This Germany, with its white nationalist riots against immigrants, was not the multicultural utopia Europe's leaders had in mind when, just months earlier, they'd embarked on an unprecedented experiment in open borders. The year Germany reunified, the European Union extended its principles of free trade of products to people. Any EU citizen could now migrate to any other EU nation to live, work, and study. What's more, anyone in the world fleeing political prosecution in their home country could apply for asylum in the EU. In 1992, nearly half a million people sought asylum in Germany alone.

Even before Rostock, some German politicians thought migration had gotten out of hand. Germany's conservative, anti-immigration CDU party "began a campaign in the fall of 1991 to restrict the basic right to asylum" by amending a 1949 immigration law to exclude asylum seekers from "safe" countries from automatically receiving asylum hearings, writes the historian

Stefan Zeppenfeld. After the riots, legislators introduced the bill, calling it the "Asylum Compromise." At the time, newspapers such as *Bild* and *Welt* began running stories about immigrants being admitted without the proper paperwork or vetting, and "terms such as 'asylum fraud,' 'bogus asylum seekers'... found their way into the political discourse." The newsmagazine *Der Spiegel* ran a cover story with an illustration that depicted Germany as a massive, overladen ship teetering on a sea made of thousands of people. The headline: "Onslaught of the Poor: Refugees. Emigrants. Asylum Seekers."

"Responding to violent attacks on foreigners by restricting the right to asylum gives the appearance that the government is caving in to the demands of right-wing extremists," warned Human Rights Watch. But by the time the Rostock Riots erupted, two-thirds of Germans were in favor of restricting asylum. Nearly three million people took to the streets in cities across Germany to oppose the law and stand in solidarity with refugees, but lawmakers ignored them in deference to the greater number of Germans who wanted immigrants out.

"Politics sometimes listens to the loudest ones," said Katharina, who followed the protests in the news. "And the loudest ones in the 1990s were the neo-Nazis on the street."

The law passed by an overwhelming two-thirds majority, with votes in favor cast by members of nearly all of Germany's major parties, including Angela Merkel's CDU and the Social Democratic Party of Germany (SPD). Asylum applications plunged from 438,000 in 1992 to just 127,000 two years later. The white Germans who had terrorized immigrants in Rostock had won.

"The fascist movement understood—'if we just use more violence, the government will do what we want,'" recalled Katharina. The paltry prosecutions at Rostock were a signal to xenophobic Germans that "they could do whatever they wanted to," said the journalist Heike Kleffner. "They could commit physical attacks against migrants and leftists, they could attack the police, and they would never be brought to justice."

* * *

The new Nazis heard the signal loud and clear, and copycat attacks spread across the nation. Two months after Rostock, neo-Nazis firebombed the

home of a Turkish family in the town of Mölln, a few hours west. Two girls, aged fourteen and ten, were burned alive along with their fifty-one-year-old grandmother. Nine other people were injured, including a nine-month-old infant. Two white men, one twenty-five, the other just nineteen, were sentenced to life in prison and ten to twenty years, respectively, for murder.

Hundreds of thousands of Germans took to the streets to condemn the attack. In the months after Mölln, the percentage of Germans who self-identified as right-wing declined. But this slight shift in public opinion didn't deter extremists: Between 1991 and 1994 Germany counted some fifteen hundred far-right arson attacks, the majority of which took place in *western* Germany, not the former East. Six months after Mölln, four more white German terrorists—the youngest of whom was only sixteen—set fire to the home of another Turkish family in the town of Solingen, near Cologne. Four immigrant women and girls—the youngest of whom was only four years old—burned to death in the flames. Seventeen of their relatives were injured. Four years later, another white terrorist would set fire to a house of immigrants in Lübeck, an hour and a half southwest of Rostock, killing ten first- and second-generation immigrants from Africa and the Middle East. No one was ever convicted. To neo-Nazis across the nation, the impunity at Rostock and the attacks that followed showed that, when it came to terrorizing immigrants, they could get away with murder.

Chapter 4

Fiery Cross

Back in Jena, Beate, Mundlos, and Böhnhardt weren't yet plotting any murders, but in the years after Rostock they began harassing foreigners, too. The trio sometimes stole cigarettes from small kiosks owned by Vietnamese immigrants and derided them with racist slurs.

In the mid-1990s, the trio began taking their hate on the road. They drove across Germany and to the Czech Republic to attend far-right concerts and rallies. They vacationed on the Baltic island of Usedom, where Nazis had test-launched the first of the V-2 rockets that would wreak havoc on Allied cities during the war. The three camped there with other neo-Nazis at the beach. One of the trio's favorite getaways was none other than Rostock and the Baltic beaches to its north, where they befriended people who shared their white supremacist beliefs. One was Markus Horsch, a Rostock native. Police would later describe Horsch as a "violent skinhead." On New Year's Eve 1995, the trio traveled to Rostock to celebrate with Horsch in his quiet neighborhood of Toitenwinkel, where years later an immigrant would be murdered.

When they weren't on the road, Beate and the Uwes spent their evenings driving around Jena armed with a baseball bat. While the other two watched, Böhnhardt would jump out of the car, attack a left-looking passerby—a hippie or a punk—jump back in, and the three would race away. Sometimes Mundlos and Beate joined in the beating. Beate earned a reputation around town for running her mouth—not about politics, like

Mundlos, but to project a more Böhnhardt-style boldness. One night, Beate and the Uwes got into a fistfight with a bouncer at a local club called Modul. It's not clear how it started, but rumor has it that it ended after Beate broke a bottle over the bouncer's head.

It was around this time that Beate's world collided with Katharina's. Each year the city of Jena puts on an Autumn Market, a festival along the town's central thoroughfare. To Katharina it was a place to drink, eat sweets, and catch up with friends while soaking up the final rays of sunshine before the dark winter set in. One night, a dark-haired woman followed Katharina's friend Maria on a tram home from the festival. The woman sat opposite her and proceeded to stare Maria down. When the tram reached her stop, Maria left the safety of the well-lit carriage and stepped out into the night. That's when she heard footsteps behind her.

Maria, who was fifteen at the time, was what Katharina called a "normal" girl—she was neither a neo-Nazi nor a punk. She didn't wear punk clothes or sport a hairstyle that marked her as a leftist, and she didn't know the city's skinheads by sight. Maria was a bystander to Jena's turf wars. Had Katharina been on the tram, she'd have recognized the dark-haired woman as Beate Zschäpe. But Maria didn't know who Beate was or what she was capable of. When Maria heard the footsteps, she turned. What precisely the two women said to each other isn't clear. But in one telling, Beate accused Maria of making fun of her at the festival. Before Maria could object, Beate took a swing, and then another. Maria fell to the ground. Beate then sat on Maria and taunted her, before stealing her jacket and walking away into the night. Maria's left ankle was hurt so badly she couldn't stand. At the hospital, doctors informed her it was broken. Later, while she recovered, Maria told Katharina that she didn't understand what had happened.

"I was only walking by," Maria told her. She hadn't said a single word to Beate, hadn't even looked twice.

"What Maria didn't know is that every member of the far right at this time was violent," said Katharina, and they didn't discriminate when it came to their victims. "They didn't beat you up just because you looked *left*," recalled Katharina of those dark days and bloody nights. "They beat you up if you didn't look *right*. If you didn't look right-wing, for them, you were an enemy."

Beate and Uwe Böhnhardt weren't the only ones embracing violence. By the mid-1990s, police were investigating Uwe Mundlos for all manner of criminal activities—"incitement of hatred," for organizing unlawful assemblies. "Use of symbols of unconstitutional organizations, trespassing, and resistance against law enforcement officers." "Dissemination of propaganda materials of unconstitutional organizations." During interrogations by police, Mundlos "reacted aggressively," describing himself as a "German-national thinker" who was being persecuted by the state.

Although Mundlos hated the police and politicians, he'd always adored Germany's military. More so than his two companions, he tried to give purpose to his provocations. And so, in April 1994, at twenty years old, when he was called up to either enlist in the military or complete a year of social service work, as all German men were required to do at the time, he chose the Bundeswehr. The army was a natural fit for a young man who believed his country was under threat: It was inundated with racists, xenophobes, and neo-Nazis.

After defeating the Nazis in World War II, the Allies disbanded Germany's military. But in 1955 West Germany created a national defense force, the Bundeswehr, and the next year East Germany followed suit with a "National People's Army" of its own. Thousands of former Nazi officers rejoined, including some who'd been accused of committing war crimes. Both armies—in East and West—conscripted young Germans to fill their ranks, including some who held far-right extremist beliefs. By the mid-1990s—Mundlos's time—the Bundeswehr had documented hundreds of far-right incidents involving its soldiers. Some kept extremist music magazines in their barracks, and a few even hung military flags of the Third Reich. In February 1994, just two months before Mundlos enlisted, five soldiers stationed in Münster shouted xenophobic slogans at four foreigners, for which some of them were fined. That August, soldiers were arrested after attacking patrons of a Turkish tearoom while shouting "Sieg Heil!" At a base in Bavaria, the military's internal intelligence agency documented soldiers singing the Nazi anthem and celebrating Hitler's birthday.

Singing would land Mundlos in trouble, too. He'd been assigned to Tank Battalion 381 at the Kyffhäuser barracks in Bad Frankenhausen, an hour and a half north of Jena. Four months in, on August 23, 1994, the

military intelligence agency learned that Mundlos and five other soldiers had been singing Nazi songs in their barracks. Mundlos also wore his anti-immigrant opinions on his sleeve. On one occasion, he and some of his brigade mates were discussing the 1993 arson attack in which four white German terrorists burned five Turkish Germans alive, four of them children. Newspapers printed images of the severely burned victims, which disgusted much of the public. But not Mundlos, who "played down the arson attack and made fun of the victims," one soldier recalled.

The same month Mundlos was caught singing Nazi songs, he attended a far-right rally while on leave in Chemnitz, where police officers arrested him for carrying business cards in his wallet with pictures of Hitler and a photo of Rudolf Hess. The next day Siegfried Mundlos had to drive three-hours round-trip from Jena to bail him out. After Uwe failed to appear for duty because he'd spent the night in a jail cell, his supervising officer ordered him to seven days' disciplinary arrest. Meanwhile, police in Jena searched Mundlos's apartment, finding more than a dozen cassette tapes with right-wing extremist music and pamphlets for Germany's neo-Nazi political party, the National Democratic Party, or NPD.

Founded in 1964 in the former West, the NPD called on fellow Germans to reembrace the nationalist dreams of the Nazis—sometimes literally. The party advocated for Germany to retake territory it had conquered, then later lost, during World War II. NPD members even referred to the Allies' wartime bombing of cities like Dresden and Jena as a "holocaust" against *Germans*. The NPD believed that Germany needed to be preserved exclusively for those who were born into it—and those who looked the part. By the late 1960s, NPD members had been elected to seven seats on state parliaments across West Germany, and the party's anti-immigrant rhetoric caught on quickly in the East. While Mundlos was in the military, the head of the party, Günter Deckert, was sentenced to prison for "incitement to hatred" and denying the Holocaust, among other crimes.

There's no record that Mundlos was ever a dues-paying NPD member, but he befriended people who were, and now, police had found party leaflets in his home. Although political beliefs and speech are protected by Germany's constitution, soldiers aren't allowed to proselytize on the job. Mundlos might have been in real trouble, but because the NPD

materials were "in his exclusively private space"—his apartment, not the army barracks—a judge ruled they were protected from "any interference by the state." Later Mundlos was fined 600 deutsche marks—about $370—in a civil court for the unconstitutional music and other materials. Despite all the red flags that they had a far-right extremist within their ranks, rather than discharge Mundlos, his superiors promoted the young cadet twice while the civil case against him was still proceeding—a violation of military procedure. At best, the army didn't care about Mundlos's radical extremist views. At worst, the promotions were the military's way of rewarding them.

Once, while Mundlos was on leave, he, Beate, and Böhnhardt drove three and a half hours south to Bavaria to barbecue with far-right friends on the banks of the river Danube. A police officer spotted the unauthorized bonfire they'd lit. Officers crept through the bushes toward the glow of the flames, pausing thirty meters away to get a better look. There seemed to be some thirty people—mostly men, but at least one dark-haired woman—sitting on benches around a table full of food, a grill, and four kegs of beer. Music blared from a car cassette player, and the group was singing along to its violent lyrics:

"The blood must flow."

"The knife slips into the body of the Jew," they sang in unison, at which some of them made a stabbing motion with their hands. Believing the lyrics violated Germany's antisedition law, the officers made their move, springing from the bushes, surrounding the revelers and searching them. Questioned about the music, Mundlos slyly told the cops that he hadn't noticed anything seditious about the lyrics. Unable to prove which of them had been singing along, prosecutors eventually dropped the charges against the entire group, including Mundlos, Böhnhardt, and Beate.

Back at his barracks, Mundlos continued to cause trouble. Though he was by no means the only soldier to hold right-wing views, he pushed his relentlessly upon the rest. One fellow soldier would claim that he reported Mundlos to his superiors on eleven different occasions for a vast array of far-right infractions:

1. Uttering right-wing extremist slogans
2. Wearing anticonstitutional insignia

 3. Dressing in a Nazi-era military uniform
 4. Brawl in a discotheque
 5. Denial of the Holocaust
 6. Celebration of the birthdays of Hitler and Hess
 7. Inflammatory speeches and incitement of recruits
 8. Singing banned stanzas from an old, Nazi-era version of Germany's national anthem
 9. Brawl in the barracks
 10. Theft of ammunition
 11. Advertising an event for the NPD

When the military intelligence agency questioned Mundlos in the spring of 1995, he told them point-blank he was a "skinhead." And yet, after completing his service a year later, in March 1995, Mundlos left on good terms, receiving a certification of "satisfactory" leadership. Germany's military had knowingly trained a Nazi-worshipping far-right extremist how to shoot and how to kill.

<p style="text-align:center">* * *</p>

Before Mundlos had enlisted, rumor had it he proposed to Beate—and rumor had it she said yes. But by the time Mundlos returned to Jena, Beate had fallen for someone else: Böhnhardt. Böhnhardt too would soon be called for military service, but recruiters deemed him psychologically unfit for duty, so he stuck around. Böhnhardt had never appeared jealous of Mundlos when Beate was dating *him*, and now that the tables had turned, if Mundlos felt like a third wheel, he didn't show it. Reunited, the trio formed a threesome that would endure for more than two decades—until death tore them apart.

This new arrangement pleased Brigitte Böhnhardt immensely. The first time Uwe brought Beate to the family apartment, Brigitte was impressed. Beate was kind and polite, her demeanor "just how you imagine a young woman should be." When Beate told Brigitte she dreamed of becoming a kindergarten teacher, Brigitte—a schoolteacher herself—beamed. Beate's application for an apprenticeship was rejected—likely due to her criminal record, or perhaps her neo-Nazi reputation—but Brigitte didn't mind.

She'd see the couple flirt and cuddle and hoped that they would find jobs and move in together, maybe start a family, give her grandchildren.

Beate brought out Böhnhardt's courteous side. Sometimes he'd drive Beate's grandmother to the grocery store. At Beate's mother's home, he'd slip plastic bags over his black combat boots so as not to dirty the carpet. When Annerose stopped paying rent and lost her apartment, nineteen-year-old Beate moved in with the Böhnhardts and spent Christmas with them. Sometimes, Uwe Mundlos would swing by the house and disappear into Böhnhardt's bedroom for hours at a time. Brigitte hoped the older Uwe might be a positive influence on her son. Although *her* Uwe was physically stronger than Mundlos, Mundlos was clearly the smarter of the two. Once, when Brigitte asked him about his future, Mundlos replied that he was studying for his *Abitur*, the equivalent of a high school diploma, in the town of Ilmenau. While her Uwe had been expelled from school, Mundlos seemed bound for college.

Sometimes Mundlos and Brigitte would discuss politics, though they didn't often agree. Once, when newspapers printed the names of World War II–era Nazis who had been given jobs in the West German government, Mundlos said it was great that "they didn't let [the war] get them down." There was a "certain honor in the officer ranks," he said—no matter that these men were Nazis. Brigitte was shocked. Mundlos replied by asking Brigitte, decades his senior, whether she knew how bad war truly was—as if Mundlos somehow did. When it came to World War II, he told her ominously, there were only losers. It was as if Mundlos sympathized with the Nazis for *their* losses, too.

With time, Mundlos stopped visiting the Böhnhardts' apartment, preferring Winzerclub instead, where he, Böhnhardt, and Beate socialized with other young neo-Nazis. One of them, Ralf Wohlleben, organized political rallies for the NPD. At one such rally he wore a white T-shirt with the word "Skinheads." Wohlleben eventually left the NPD to cofound a small neo-Nazi political youth organization he called Comradeship Jena. His cofounder was André Kapke, the beefy boy turned ardent neo-Nazi whom Katharina and her friends had followed by car to a far-right festival—the one who used the phrase *"Bratwurst statt Döner"* to suggest that Germany was for ethnic Germans, not for Turks. Beate and the

two Uwes shared Kapke's disdain toward foreigners and Wohlleben's far-right politics. They joined the group, whose members met at Winzerclub. There, Mundlos would get into arguments with Thomas Grund, the social worker who ran the club and who had videotaped Beate. Mundlos would refer to the club's social workers as "leftists" and "red pigs"—sometimes to their faces. Mundlos "was radical, and politically totally convinced—a kind of picture-book fascist who didn't just parrot anything stupidly, but rather had a right-wing ideology and the clear goal of forming his right-wing base from our club," Grund recalled. Later, some would say Grund and the club's other social workers ought to have done more to confront them.

"Everybody ignored the racist nationalism that was brewing," Katharina would one day remark. Grund claimed he did all he could.

"We mixed groups—we tried to dismantle right-wing thinking," he later said. Grund claimed he would interrupt Mundlos and his comrades' conversations whenever they went too far—like when they shared conspiracies or lies about the Holocaust. But Mundlos was already too far gone. One time they showed up at the club dressed head to toe in the signature black uniform and boots of the SS. It was illegal to dress like that in public under Germany's law banning anticonstitutional symbols, and Grund ejected them from the club. It isn't clear whether this was when they left Winzerclub for good.* But at some point, one of the clubs that Angela Merkel had envisioned as places for integrating disgruntled youth *into* society, instead tossed them out.

* * *

The friends began loitering on the streets of Winzerla, smoking, drinking, joking, brooding. Other times, they piled into one of their cars and drove. One summer night in 1995, Böhnhardt, Wohlleben, Kapke, and another Comradeship Jena member named Holger Gerlach drove to a forest outside Jena where they and some twenty other white supremacists set fire to a giant wooden cross in the style popularized by America's most infamous

* Grund claimed only Mundlos was banned. It's possible that the ban was only temporary and the trio later left voluntarily after the club banned alcohol.

white supremacist group, the Ku Klux Klan. The KKK's ideas, symbols, and rituals captivated German white supremacists like Beate and the Uwes thanks to a neo-Nazi named Carsten Szczepanski.

Born five years before Beate, in 1970, he grew up in the Neukölln district of Berlin, which was becoming diverse with immigrants. When he was twenty he wrote a letter to Dennis Mahon, a prominent Klan leader from Oklahoma, urging him to form allegiances with Germans who shared the KKK's white supremacist views. On September 20, 1991, the same night neo-Nazis besieged the building of immigrants in Hoyerswerda, Mahon and Szczepanski had led fifty people in a KKK-style cross burning in Brandenburg. Though not illegal, it was a sensationalist, made-for-TV stunt, and journalists couldn't resist broadcasting it across the country.

"Sieg Heil, I come to you from America," Mahon addressed the German nation, calling the xenophobic riots in Hoyerswerda a "great victory for Germany."* Szczepanski was so infatuated with Mahon's ideas and the Klan's that, nine months earlier, he had founded an underground KKK-themed magazine he named *Feuerkreuz* (Fiery Cross). The magazine advertised KKK-themed T-shirts, stickers, cassette tapes with far-right music—even Confederate flags. *Feuerkreuz* called upon white supremacists across the globe to unite in a shared struggle against people of color and Jews. A photo of a smiling interracial couple—a Black man and a white woman—was printed with the caption "THE ULTIMATE ABOMINATION." One issue featured a full-page photo of a brown child holding a brown baby and the words "Germany's Future? FOREIGNERS OUT." Szczepanski republished a *New York Times* article about the proliferation of neo-Nazis in Germany's former East:

> Virtually every week has seen reports of rallies where Nazi slogans and salutes were manifest, of violent attacks on foreign workers, of swastikas and anti-Jewish epithets painted on walls and on

* In 2012 Mahon was sentenced to forty years in prison for a terrorist attack in which he mailed a bomb to the Scottsdale, Arizona, Office of Diversity and Dialogue, which seriously wounded two civil servants and injured a third.

tombstones. A common denominator in this scene is young men, identifiable as skinheads, whose hatred is directed against anyone they deem "un-German," including political leftists, blacks and other foreigners, Jews, and gays.

The article seemed intended to warn American readers of the frightening resurgence of Germany's violent far right, but Szczepanski reprinted it with pride. *Feuerkreuz* would surely have been illegal under Germany's sedition laws for inciting readers to hatred and violence against vulnerable groups, for publishing banned Nazi symbols, and for disrespecting the dignity of those persecuted by the Nazis. But authorities rarely enforced such laws, and Szczepanski managed to distribute copies across Berlin and Brandenburg. If such magazines were fringe, their radical messages were not. Weeks before the Mölln attack that would burn a Turkish woman and two girls alive, a poll found that a quarter of Germans agreed with the refrain "foreigners out!" More than one in three Germans agreed that "Germans must defend themselves against foreigners in their own country." More than half agreed with the maxim "Germany belongs to Germans." All Szczepanski needed to do was persuade his countrymen to act upon these jingoist impulses with violence.

"Will 1991 be the year of the downfall for the white race? In which foreigners take over our lives? A year of Turks and Niggers sitting in parliament?" Szczepanski asked his readers. "The survival of our WHITE RACE depends on the willingness of WHITE MEN and WOMEN to fight for it. CAN WE COUNT ON YOU?"

On several occasions, *Feuerkreuz* conjured *The Turner Diaries*—a 1978 novel by the American white supremacist William Luther Pierce, which he published under a pseudonym. In the novel, the protagonist takes part in a white supremacist insurgency against the U.S. government, beginning with an assault on the U.S. Capitol building. It escalates into a full-blown race war and genocide in which all of America's nonwhites, as well as Jews worldwide, are exterminated. By the 1990s, *The Turner Diaries* had become a quintessential manifesto for white supremacists around the world. Germany would eventually ban bookstores from selling it to minors under a 2006 law designed to protect young minds. But this did little to stop white

supremacists from circulating it. Beate and the Uwes kept a German translation on one of their computers.

The three friends took these American white supremacist ideas, rituals, and symbols, and mixed them with Germany's own. Szczepanski and Mahon's televised cross burning in Brandenburg seared itself into the minds of neo-Nazis across the nation, who began imitating the act. It's almost certainly what inspired Böhnhardt, Wohlleben, Kapke, Gerlach, and nearly twenty others to head into the forest outside Jena that summer night in 1995 to do the same. Somebody snapped photos of the men posing in front of the flaming cross, dressed in camouflage pants, standing with a Nazi-era flag and giving Sieg Heil salutes—both of which were illegal in public—and drinking cans of beer. Beate wasn't in any of the photos. Later, police would suspect she was the one behind the camera.

* * *

One day in September 1995, Beate, Böhnhardt, and Kapke drove south from Jena along Highway 88, which hugs the river Saale.* It was a Sunday, and as they wound through tiny towns, stopping to smoke cigarettes, they would have heard church bells ring. Their destination was Rudolstadt's Heinrich Heine Park, named after the renowned nineteenth-century Jewish poet whose writings the Nazis banned and burned.

"Wherever they burn books, they will also someday burn human beings," Heine wrote in 1823. Hitler's Nazis had proved him right. The trio passed by the park's memorial to the victims of fascism—a minimalist rectangular stone tower with the words *Den Opfern* (To the Victims). It was adorned with wreaths mourning the anniversary of Germany's invasion of Poland in September 1939. The night before, a neo-Nazi from the nearby town of Saalfeld had left a fake bomb there fashioned out of a fire extinguisher. Now the three friends pelted the memorial with eggs. They also dropped leaflets with an ominous message: "Germans learn to stand upright again!" It was the slogan used by the Nazis during the Third Reich.

* The highway was favored by neo-Nazis, to whom the number 8 conjures the eighth letter of the alphabet—H, for Hitler. Two eights conjure HH, the abbreviation for "Heil Hitler."

The friends used it as a call to arms. "Enough with the Holocaust," the leaf-let read. "Better to die standing than to live on your knees!!!"

Later that day, police found the perpetrators—records don't reveal how—and detained them. Böhnhardt was wearing a belt buckle adorned with the words "Blood & Honour" and a swastika, which was illegal. He and Kapke refused to reveal much, but when officers questioned Beate she told them that, yes, she and her friends had driven to Rudolstadt that morning. But she insisted that they hadn't thrown any leaflets or eggs. "We have nothing to do with the matter," she wrote in a statement.

Police pressed her to describe Böhnhardt's political beliefs. "Uwe Böhnhardt is right-wing. However, he cannot be called a right-wing *extremist*," she said of her boyfriend, as if to defend him. She also mentioned another neo-Nazi named Tino Brandt. Authorities suspected Brandt of orchestrating the crime using a newly available technology: a cell phone. While Beate was being interrogated, police in Jena rifled through her pos-sessions at her mother's apartment. There they found a dagger, a metal throwing star with a steel chain, and a gas cartridge for an air rifle. When officers asked Beate if she owned a gun, she told them yes, a 9mm revolver, but that the cartridges were only blanks—meaning it didn't require a per-mit unless she carried it in public.* She told them she didn't. Officers also found the photos taken in front of the burning cross in the forest. At their request, Beate identified the men with their arms outstretched giving Sieg Heil salutes: Uwe Böhnhardt, Ralf Wohlleben, Holger Gerlach, and André Kapke, who along with Beate and Mundlos formed the core of Comrade-ship Jena. Police also searched Böhnhardt's parents' house. In the bedroom where Brigitte supposedly forbade her Uwe from keeping weapons, officers found a 4.5mm pellet gun with a laser pointer.

Prosecutors charged both Beate and Böhnhardt with passing out leaf-lets denying the Holocaust. They charged Böhnhardt for the use of uncon-stitutional symbols—the belt buckle with the swastika. Police also fined Böhnhardt for possession of a weapon without a permit, but Böhnhardt never paid. Due to his prior convictions, he was sentenced to two years

* Germany has no constitutional right to bear arms like the United States does. To carry a handgun requires registration and a permit.

and three months in prison. He appealed, and a judge later dismissed nearly all the charges for reasons unknown. Prosecutors eventually charged Böhnhardt, Kapke, Wohlleben, and Holger Gerlach with the cross burning and with giving Sieg Heil salutes in public, which is punishable by fines or prison. But because it happened in the middle of a forest, a judge ruled it wasn't public, so the men went unpunished.

* * *

There was something else officers asked Beate. It pertained to an unusual incident—a homemade bomb that appeared a week earlier in front of a municipal office in the town of Saalfeld, a fifteen-minute drive south of Rudolstadt.

"I cannot give any further details," Beate told them, insisting she had no knowledge of the bomb. But had police bothered to surveil them, officers might have noticed the friends had an uncanny fascination with the tools of a bombmaker's trade. The year after police questioned Beate, she rented a small storage garage near Jena's sewage treatment plant along the river Saale. Had officers been watching, they might have seen Böhnhardt drop off metal pipes and insulation—leftovers from when he'd helped renovate his parents' kitchen. The Uwes would spend hours inside that garage, pouring explosive powder and tinkering with wires and pipes.

Later, those who knew Beate would be unable to put a finger on what sent her down her far-right path. While it's true that Beate had right-wing leanings, so did many Jena youth at the time.

"We hated the state, foreigners, the left—just about everything," her cousin Stefan would recall. The original Nazis had, too, but there was a difference: *They'd* chosen their far-right path at a time when most of the people around them were choosing the same. Millions of Germans were complicit in the Holocaust, even if not all of them participated directly. To do otherwise would have been to *resist*. But Beate embraced white supremacy at a time when her countrymen didn't and her nation condemned it. She befriended others who did the same, and together they tiptoed across the line between extremist speech and violence. Each time the trio crossed that line, they'd glance over their shoulder to see if they'd face any real repercussions. When they didn't, they'd cross the next line, and then the next.

If any nation in the world should have understood the danger of racist radicalization, it's Germany. After World War II, historians, psychologists, philosophers, and Holocaust survivors penned countless pages attempting to understand how Hitler and the Nazis had persuaded an entire nation to participate in or ignore a genocide. After all that Germany had done to learn from the mistakes of its past—to confront it, to teach the horror of it in schools, to criminalize speech that glorified Nazis or undermined the dignity of vulnerable groups—the country ought to have been the last place that white terror could rise again. But be it because they were incompetent, apathetic, ignorant, powerless before the sheer scale and impossibility of the task, or "blind in the right eye"—biased—more than half a century after the Holocaust, German authorities and policymakers were failing to stop racist Germans from radicalizing once again. And not only that—while police and prosecutors failed to punish or deter them, intelligence agencies were busy bankrolling them instead.

Chapter 5

Moles and Minders

The use and misuse of confidential informants dates back millennia, and may be as old as crime itself. During the Roman Empire, the Latin word *delator*, or "denouncer," was first used in reference to tax collectors who reported those who failed to pay their dues. But the early informant system was corrupt: Subjects would accuse one another of all manner of improper behavior, denouncing their enemies to benefit financially from their downfall by taking over their trades or homes. The most notorious informant in history is probably Judas Iscariot, who Christians believe exposed Jesus Christ's identity to Roman authorities by publicly kissing Christ and addressing him as "rabbi" in a crowd. For his service, the Romans were said to have paid Judas thirty pieces of silver. This is how the informant system still works today.

If Judas was the world's most infamous informant, Adolf Hitler was surely the second. In the summer of 1919, the thirty-year-old Austrian began working as an operative for the German military's political propaganda wing, tasked with indoctrinating soldiers into anticommunist ideology. Less than a year had passed since World War I ended and Germany's monarchy was abolished, and it wasn't yet clear whether the Weimar Republic—Germany's delicate experiment with democracy—would prevail. The republic's first popularly elected leaders had to be wary of army officers, who still wielded enormous power, with some hundred thousand soldiers under their official command. For their part, military leaders worried that socialists, communists, or even fascists might try to oust them completely,

as they'd done to people in power before. They decided to infiltrate nascent political parties and movements that they believed could pose a threat. On Friday, September 12, 1919, Hitler was dispatched to a Munich tavern to surveil a meeting of the fascist German Workers Party, whose numbers and influence were on the rise. Later, Hitler's commanding officer instructed him to infiltrate the party by becoming a member, and even funneled him money for that purpose. This turned out to be a mistake—a classic case of a minder putting too much trust in his mole. Hitler had his own ambitions, and went rogue. Within a few months, he got himself elected to lead the very party he was supposed to be monitoring. By then it had been renamed the National Socialist German Workers' Party—the Nazi Party. The rest is history.

Enamored with the power of intelligence gathering, in 1933 Hitler authorized his second in command, Hermann Göring, to create the Gestapo, the secret police.* During the Holocaust the Gestapo recruited, paid, or coerced white German and Polish citizens to inform on their Jewish neighbors and friends, who were not considered Aryan, or white. The Gestapo would then raid their shops and homes and loot the Jews' possessions, sometimes rewarding informants with some of the bounty. After they deported these Jews to the ghettos, Gestapo officers—or sometimes their informers—would move into their homes.

History tends to remember the Gestapo as an outsized presence—a vast network of intelligence agents, informers, and spies. In fact it was quite small, with just one officer for every ten thousand Germans at its height. But this proved to be plenty. The Gestapo didn't hunt down Jews and their defenders directly—they relied on everyday Aryan Germans to rat them out.† Some white German informers made false accusations against neighbors to settle old scores, just like in ancient Rome. Racism and antisemitism may be what drove Germans to genocide, but the informant system

* Hitler later handed the Gestapo off to Heinrich Himmler, a principal architect of the Holocaust.

† In the town of Wurzburg, of the ninety-one people charged by the Gestapo for "Friendship to Jews," more than half were denounced by civilians, as were nearly half of the eighty-four people charged with "Race Defilement"—sex between Jew and gentile. The result was that, as the historian Robert Gellately writes, "hardly anyone felt entirely safe, whether at work, play, during leisure activities, at school, or even in the privacy of the home."

was what allowed everyday people to lend a hand. During World War II, by one estimate, some twenty-seven thousand Europeans in Nazi-occupied Europe—at least 640 of them German—harbored Jews and other fugitives from the Nazis. But a far greater number expanded their personal wealth by helping send them to their deaths. This is the wager, and the danger, of any informant system: It strips informers of their morals, incentivizing them to condemn others regardless of whether it's the right thing to do or whether their information is false or true. For the right price, or to avoid the right punishment, there's nothing some informants won't say or do.

After Germany lost the war, West Germany created separate federal and state intelligence agencies with strict oversights and limits meant to avoid another all-powerful spy agency like the Gestapo. But East Germany soon set about constructing a secret police force with extraordinary powers: The Ministry of State Security, or Stasi. Like the Gestapo, the Stasi often compensated or coerced people into becoming informants, tasking them with ratting out everyone from common criminals to those who distributed contraband Western music or espoused democratic ideas.* Neighbors, family, friends, classmates—informants were indiscriminate and often framed the innocent and fabricated evidence to satisfy the Stasi's hunger for information. They even encouraged children to inform on their parents. One Leipzig pastor described the fear of surveillance and arbitrary arrest as "ever present...it permeated all walks of life, this haunting fear that you could be arrested anytime, right off the street. The Stasi heard everything, knew everything, were everywhere, and everybody knew it."

The Stasi grew into one of the largest informant networks the world had ever seen—an army of spies that at one point employed 90,000 agents and 189,000 informants—one for every 57 East Germans. The volume of information it collected was immense: Tens of millions of pages of records and tapes of secretly recorded conversations were stored at the Stasi headquarters in Berlin. Millions more piled up at other Stasi offices across East Germany. Then, after forty years living in a police state, on December 4,

* East Germany treated virtually all crimes as crimes against the *state*. The socialist government believed crime came from capitalism, from the West—came when people dared deviate from the socialist utopia they'd created.

1989, Erfurt residents awoke to see smoke billowing from the chimneys of the local Stasi headquarters. The Berlin Wall had fallen, the East German government was falling, and in an attempt to hide their own involvement, Stasi officers shredded files as fast as they could to conceal the extent of their spying and the identities of the spies. When residents saw the smoke, they stormed the building to stop the Stasi from destroying evidence of its insidious acts.*

After the fall of the Stasi, eastern Germany adopted the West German way. Each federal state would have its own intelligence agency, in addition to a federal one. They would be named Offices for the Protection of the Constitution, tasked with defending the German nation against plots to interfere with elections or against violent political extremism by its own citizens, as well as from foreign terrorist groups and espionage. Laws were passed to ensure that each of the seventeen agencies—the federal one, and those for each of Germany's sixteen federal states—would work independently to prevent them from becoming an all-powerful, Gestapo-like authority. Unlike America's FBI, Germany's intelligence agencies were forbidden from making arrests—that remained the purview of police, and German law mandated strict separations between officers and agents.

But old habits die hard, and these noble new agencies were staffed with nefarious men. In West Germany in the 1950s, as many as one in three intelligence officers were former Nazis. At least eighty were former Gestapo agents. From the start, these agencies operated "on the edge of legality," as two German historians describe in their book *Keine neue Gestapo* (No New Gestapo). And just like the Romans, the Gestapo, and the Stasi, these agencies depended on informants.

* * *

One of the intelligence agents tasked with overseeing these informants was a young man named Gordian Meyer-Plath. Meyer-Plath had studied

* In a matter of weeks, the Stasi managed to shred, burn, or otherwise destroy an estimated thirty-three million pages. Later, Germany would set out to piece back together the resulting six hundred million scraps of paper, in a document recovery project that continues to this day.

far-right extremism in universities from Bonn to Brighton by the time he applied for a job with the newly revamped Office for the Protection of the Constitution in Brandenburg. The state earned an early reputation as a far-right extremist stronghold. One year after the fall of the Berlin Wall, in November 1990, some fifty neo-Nazis attacked a twenty-eight-year-old Angolan guest worker named Amadeu Antonio in the town of Eberswalde. They beat one of his friends over the head with a baseball bat, stabbed another, and pummeled Antonio into a coma, while three armed police officers stood by and watched. Eleven days later, Antonio died from his injuries.*

By the time Meyer-Plath arrived in 1994, during the "baseball bat years" that followed the Rostock Riots, Brandenburg was swimming with skinheads. During his first weeks on the job, right-wing extremists beat up ten French tourists in Potsdam, attacked a home for asylum seekers, and set fire to the building of a gay and lesbian organization. Meyer-Plath soon discovered that his agency was woefully unprepared to prevent such attacks. Whereas neo-Nazis had begun using online chat rooms to coordinate their activities, Meyer-Plath's office didn't even have the internet. Then, a few months into his tenure, in the summer of 1994, just around the time that Beate and the Uwes were caught singing fascist songs at a bonfire in Bavaria, Meyer-Plath got his first big break: a handwritten letter from an infamous far-right extremist. The man wrote the letter from his prison cell. His name was Carsten Szczepanski—the neo-Nazi who burned a cross on live television and published the violently racist magazine *Feurkreuz*.

Brandenburg's intelligence agency had begun monitoring Szczepanski since the year he founded his KKK-themed magazine. They quickly learned he wasn't just inciting his readers to violence, but preparing to commit it himself. On December 8, 1991, Brandenburg police had searched Szczepanski's apartment and discovered a piece of wire with a small bulb soldered to it, and a piece of detonation cord with a fuse—both of which

* Prosecutors charged just five out of the fifty or so people who were present—and not with murder, but with inflicting bodily harm, as if they'd merely given Antonio a bloody nose. Noting the perpetrators' relative youth—all were between nineteen and twenty-one years old—a judge sentenced them to between two to four years in prison.

could have been used as ignition devices for a bomb. Officers also found chemicals and instructions for how to construct explosives. When police notified Brandenburg's intelligence agency, agents began to monitor Szczepanski, suspecting he might be plotting some sort of far-right terrorist attack. Szczepanski's bombmaking materials should have landed him in prison. Instead, just as in Rostock, prosecutors turned a blind eye, never charging him at all.

Then, on May 9, 1992, Szczepanski and sixteen other neo-Nazis attacked a Nigerian immigrant—a former schoolteacher named Steve Erenhi—outside a club and attempted to light him on fire. Szczepanski egged the mob on in chants of "Ku Klux Klan!" and "white power!" Unsuccessful at burning Erenhi to death, they threw his burned and broken body into a lake. Erenhi would almost certainly have drowned had passersby not managed to pull him out. This time, prosecutors reacted with unusual gravity, possibly due to the amount of attention the attack received in the press. They charged Szczepanski with attempted murder, and he was found guilty and sentenced to eight years in prison. On July 8, 1994, he wrote a letter from his cell to Brandenburg's intelligence agency saying he wanted to talk, offering to become what in Germany is known as a *Vertrauensmann*—a "trusted man," an informant—into the far-right scene.

* * *

From Meyer-Plath's point of view, it didn't get much better than this. Szczepanski's offer came at a time when Brandenburg desperately needed not just eyes on the neo-Nazi movement but ears within it. Spies they could trust, and whom the skinheads did, too. Within Brandenburg's far-right groups, Szczepanski "was regarded in the scene as a hero, a martyr," Meyer-Plath knew. Szczepanski was a man "who, in their eyes, had not just *talked*, but acted," like he had that night against the immigrant, Erenhi. Once he earned that reputation, "large sections of the right-wing extremist scene saw it as their duty to support him, to communicate with him, and to keep him informed."

Some of Meyer-Plath's colleagues weren't so convinced. They worried that recruiting Szczepanski crossed a moral line. Meyer-Plath knew

Szczepanski "was a decisive, dangerous right-wing extremist." *We can't work together with someone like that*, his colleagues warned. But given the wave of anti-immigrant violence proliferating across the state, working with him might be worth the risk, Meyer-Plath reasoned. And so he and his superiors approached the Ministry of Justice to ask permission to use Szczepanski as an undercover informant, and a judge agreed.

For Szczepanski to be useful, he'd have to keep in close contact with his friends in the far-right scene, "to make it seem credible that he still considered himself part of it." One opportunity for continuity came in the form of Szczepanski's magazines. Meyer-Plath's agency helped Szczepanski publish one he called *Der Weisse Wolf* (The White Wolf) from behind bars, delivering a computer to his prison cell and helping him disseminate copies. Just like that, Brandenburg's Office for the Protection of the Constitution became the financier and publisher of a white supremacist magazine. Meyer-Plath's agency also bestowed him with gifts like chocolate and meats. Once, Meyer-Plath gave Szczepanski a T-shirt from the militant neo-Nazi organization Combat 18. "Adolf Hitler fighting force," the T-shirt read. Despite being in prison for attempted murder, Szczepanski was living like a king.

And he was paid royally. For each piece of intelligence Szczepanski offered, Meyer-Plath's agency would pay him as much as 300 deutsche marks—about $185 at the time. Over the next four years, Meyer-Plath would meet Szczepanski on thirty-seven occasions, paying him between 50,000 and 80,000 in taxpayer deutsche marks, about $31,000 to $50,000. Years later, when the details of their arrangement surfaced, some in Germany would wonder who was using whom.

On at least one occasion, Szczepanski's intelligence did prove useful. He tipped Meyer-Plath off that the anticommunist band Proissenheads was selling CDs that contained lyrics violating Germany's law against inciting hatred. The irony that Brandenburg's intelligence agency was going after seditious music while actively helping publish and disseminate Szczepanski's seditious magazine seemed lost on the agency. In any case, the tip led to a nationwide investigation in which authorities seized thousands of the band's CDs later that year. It also fueled Meyer-Plath's confidence that Szczepanski was on his side. But because informants' activities are kept

secret from the public, it's impossible to discern Szczepanski's true value. There's no way to know whether Szczepanski was hiding the biggest clues of all, while feeding Meyer-Plath only crumbs about bad music.

Four years into Szczepanski's sentence, Meyer-Plath's agency received permission for Szczepanski to leave prison to take on undercover assignments. Every two weeks, a chauffeur would pick him up from prison and drive him to a tram or bus, which he'd ride to meet far-right friends and attend neo-Nazi meetings and concerts. In the morning they'd give Szczepanski a cell phone, then collect it again at night so agents could scour any text messages that came in. If his friends called, agents listened in. Meyer-Plath thought of Szczepanski's outings as "minor relaxations" in his sentence. But Szczepanski was barely serving his prison sentence at all: Soon he began working five days a week in a neo-Nazi shop in Saxony's Ore Mountains. The shop was owned by Jan Werner and Antje Probst, leading members of Saxony's chapter of the white supremacist music network Blood & Honour. Before long, Probst would offer her passport to a comrade in need—a young woman from Jena with long dark hair.

* * *

While Szczepanski liaised with neo-Nazis in Saxony, Beate and the Uwes befriended a young man in Thuringia with a remarkably similar trajectory: Tino Brandt. Brandt was one of the neo-Nazis Beate had identified in the photos of the cross burning that police found in her apartment in September 1995. By the mid-1990s, she and the Uwes were embracing the white supremacist community he helped create. It was Brandt who united Thuringia's neo-Nazis and helped them radicalize—taught them how to organize protests and gave them money with which to do it. Taxpayer money, in fact.

Brandt was born the same month as Beate in the small town of Saalfeld an hour southwest of Jena. By the time he was sixteen the chubby teenager with a boyish face thought Germany's culture was under attack. He believed mainstream news media censored right-wing ideas. After all, a man could be charged with sedition for publicly questioning how many Jews died in the Holocaust. As far as Brandt was concerned, free speech for right-leaning Germans didn't exist. At seventeen he joined Thuringia's

chapter of the NPD and later rose to become its vice president. Brandt began organizing party rallies across Thuringia and as far away as Munich. Still seventeen, he made his claim to far-right fame when, just days before the Rostock Riots began, he arranged for two thousand neo-Nazis to march through Rudolstadt in honor of Rudolf Hess, Hitler's deputy who was sentenced to life in prison at the Nuremberg trials. The date was August 17, 1992, the fifth anniversary of Hess's suicide by hanging, at age ninety-three, with an extension cable he found in a prison reading room. The marchers preferred to believe in a conspiracy that Hess was murdered. They chanted that Hess was a "Martyr for Germany." Seconds later, in a revealing twist, they shifted seamlessly to another chant: *"Deutschland den Deutschen. Ausländer raus!"*—"Germany for the Germans. Foreigners out!" To the white supremacists who marched that day, the connection between the two chants was clear: If Hess's life's work had been to rid Germany of Jews, theirs was to rid it of immigrants.

White supremacy has always taken aim at whichever outgroup is most expedient. Fifty years after the Holocaust, Jews in Germany were few and far between, but immigrants were easier to spot. As politicians scapegoated them or used them for political capital, as newspapers printed front-page stories about asylum seekers burdening Germany's immigration system, foreigners were at the forefront of these white men's minds.

On previous anniversaries of Hess's death, just a few hundred admirers had gathered to pay homage, usually in the small town of Wunsiedel, Bavaria, where Hess was buried. This time authorities were shocked that *thousands* of neo-Nazis had appeared, without them catching wind of it in advance. And not in some cemetery in the sticks, but in the town of Rudolstadt.

After the rally, antifa activists outed Brandt as the organizer and published his address. Brandt filed a defamation lawsuit against them and won.* He used some of the money he received in damages to establish a group that grew into a statewide network of neo-Nazis, the Thuringia

* In Germany, to publicly share someone's full name, address, or other information—what today we call "doxing" when it's done online—is illegal in most cases. Victims can seek damages, but awards are rare because those who do it are often anonymous.

Homeland Protection, or THS. Brandt began holding Wednesday night meetings at a small bar just two hundred meters from his home in Saal-feld. There, Thuringia's fascists would play cards, throw darts, shoot pool, debate politics. The hangouts grew from ten or twelve to as many as eighty. On Fridays, Brandt organized legal trainings in which he would coach THS members on how to evade the police. These seminars were part of Brandt's plans to prepare for what many white supremacists referred to as "Day X": the day when white people would reclaim global order, as they did in *The Turner Diaries*.

For his day job, Brandt worked at a publishing house called Nation Europa, disseminating far-right books. Each month or two, he would organize a "worldview" training where Nation Europa authors would lec-ture about right-wing political theory. As many as seventy people would attend. As the alcohol flowed, Brandt would walk from table to table to speak with his comrades and plan the "actions" they'd undertake on the weekends. Some of these were right-wing concerts or demonstrations. Other times they'd show up at leftist demos or music festivals to break bones. Later he would phone his henchmen and remind them to "clean up" their cars: to empty out all the baseball bats, knives, daggers, airsoft guns, neo-Nazi propaganda, and other incriminating materials in case they got stopped by police.

Two of Brandt's regulars were the Comradeship Jena cofounders Ralf Wohlleben and André Kapke. Sometimes their comrade Holger Gerlach would join—as would Beate and the Uwes. From his boots to his bomber jacket, Uwe Böhnhardt struck Brandt as a "funny guy" who was often silent, reserved. "He read *Mein Kampf*, like me," Brandt would recall. But Böhnhardt's library didn't go beyond Hitler. Though he "had a solid view of the world," he rarely partook in political discussions. Rather, he was "a militant person" who was fascinated by knives, crossbows, and guns. The two men would later be photographed shooting rifles together for target practice.

Unlike Böhnhardt, but much like Brandt himself, Uwe Mundlos was a voracious reader who bought books from the publishing house Brandt worked for, including biographies of Rudolf Hess. To honor Hess, Mundlos

would sometimes walk around with a swastika armband like Hess's SS men did during World War II. Brandt continued organizing rallies on the anniversary of Hess's suicide, and one year Mundlos and Beate brought along a bouquet of flowers with a dedication:

In memory of Rudolf Hess. Your Jena comrades.

Mundlos frequently disparaged immigrants, "as did all of us," Brandt would later recall. The two men discussed how immigration into Germany should be restricted, joking darkly that "family reunification"—the policy by which immigrants in Germany can apply for their relatives to come join them—ought to entail deporting those immigrants to go back to their home countries instead.

Brandt was never quite sure what to make of Beate or whatever love triangle she and the Uwes were involved in. She "always switched between the two Uwes," Brandt noticed, but they never held hands, linked arms, or kissed. Still, he could tell by the comfort and familiarity with which they spoke that the three friends were intimate. What *was* clear was that Beate wasn't like the other "skinhead girls" who parroted whatever fascist ideas the men would espouse. She was no "stupid housewife." Though she dressed "neatly" rather than in skinhead garb, she was well versed in National Socialist ideas. "She took part in actions and got involved in discussions." Beate wasn't a white supremacist merely by association—it was what she chose to be.

* * *

But there was one man at these meetings who wasn't entirely what he seemed. Brandt, the Thuringian Nazi mastermind, was by this time a government spy.

Two years after antifa activists exposed Brandt as one of the organizers of the Hess rally that took authorities by surprise, two strangers approached him and asked if he would be willing to fill out a questionnaire about the demonstration. Although the men were dressed in typical neo-Nazi garb, Brandt could tell they weren't part of the scene. Still, he obliged, writing

that the rally was to allow the "free-minded youth" of Thuringia to express their unpopular views. A few weeks later, Brandt was walking down the street when the two men reappeared.

"Tino, we'd like you to have a talk with us," one of them said. By this time Brandt suspected they were working for the Office for the Protection of the Constitution, and when he asked, they confirmed it. They wanted Brandt to become an undercover informant—to infiltrate the very far-right scene he had spent the last two years building. They handed Brandt 200 deutsche marks to help him think it over. He didn't think it over for very long.

Why did Brandt say yes? Like informants since the Romans, one incentive was surely the money. Another was probably power: He might use his position to inform on his rivals and protect himself from prosecution for his acts. It's also possible that Brandt fashioned himself a double agent from the start, planning to take the taxpayer money and use it to fund the very far-right activities the agents were tasked with monitoring—for this is what he would go on to do.

The first time Brandt met his handlers, they assured him he wouldn't have to rat out his far-right friends. Rather, they just wanted to know who was attending his rallies. An intelligence agent named Norbert Wiessner began meeting with Brandt for half an hour each Thursday at the "Greek in Coburg" restaurant not far from the publishing house where Brandt worked. Sometimes, Wiessner would ask Brandt to turn his cell phone volume up so that he could eavesdrop on Brandt's calls with comrades, just like Meyer-Plath did with Szczepanski. Brandt would talk, eat, sign some receipts using his code name, Otto, or sometimes Oskar—and Wiessner would hand Brandt the cash.

Brandt's pay was contingent upon the value his handlers assigned to the information he provided—usually between 250 and 300 deutsche marks each week, nearly $200 at the time. This pay scheme gave Brandt an obvious incentive to lie: The more things he told the agents, the more money he made. Brandt was a "junkie for whom money was a very good means of exerting pressure," one of his handlers would say. And yet agents never seemed to exert that pressure or get anything useful in return.

By taking their money but withholding information about criminal

activities, Brandt imagined *he* was the one in control. And maybe he was. Over the next seven years he amassed a small fortune, and he used his informant money to buy cars, which were always in need of costly repairs. His handlers would front the bills. Brandt also bought heaps of far-right books. But most of the money went straight into building an environment in which some of Thuringia's white supremacists could radicalize into violent extremists—the very thing the intelligence agency was supposed to stop. Putting on concerts wasn't cheap. Cars, gas, hotel rooms, telephone bills, flyers, and stickers to hand out at events—Brandt would present his handlers with fistfuls of receipts, which agents would reimburse. One of Wiessner's colleagues described Brandt as a "technology freak without end," always eager to acquire the latest cell phones, PCs, and cameras. His minders provided him with these, courtesy of the German taxpayer. One particular technology caught agents' eye: an early internet mailbox system that Thuringia's white supremacists used to communicate anonymously and undetected.

Prior to the internet, if a white supremacist wanted to know what others were up to, he might call the national neo-Nazi hotline. The same way that pre–cell phone Americans dialed the National Weather Service for the forecast, German far-right extremists could dial in and listen to a message about upcoming demonstrations.* Then, in the mid-1990s, some neo-Nazis in Thuringia began using a more secretive system, Thule-Netz. To keep its users anonymous and their messages secure, it employed an encryption technology called Pretty Good Privacy, or PGP.† Years before PGP became the world's go-to encryption for everything from cryptocurrencies like Bitcoin to emails to iPhones, it was being used by neo-Nazis.

At its height, no more than 150 neo-Nazis used Thule-Netz. But among the estimated sixty to eighty THS members who did was the "technology

* Authorities were likely aware of the line, but sharing such information wasn't generally illegal.

† Invented by the American computer scientist Phil Zimmerman in 1991 at the Symantec corporation in California, PGP uses public and private *keys*—unique, lengthy, auto-generated passcodes—that grant a user access only if they are correctly matched. Zimmerman famously tested the technology by encrypting the very first PGP message between a technology group and a leftist peacenik organization.

freak" Tino Brandt. Now that Brandt was a mole, he granted his handlers access. And yet they failed to gain any useful intelligence. It's possible that Thule-Netz's users weren't plotting anything illegal, or even that Brandt warned them not to. But it's also possible the encryption prevented agents or even Brandt himself from ascertaining their identities. Despite their absolute faith in Brandt, none of his handlers seemed to be able to pinpoint what exactly Brandt was contributing toward their constitutionally mandated mission of protecting Germany from extremist threats. If anything, he was *undermining* it: He even used taxpayer money to free neo-Nazis from punishment for their crimes, paying off their court-imposed or municipal fines. But to his minders, Brandt's subversions of justice were a small price to pay for having such a well-placed informant.

*　　*　　*

Mario Melzer, a local police detective, wasn't convinced. Short, stout, and speaking with swagger, Melzer was eighteen when he celebrated the fall of the Berlin Wall. He'd grown up in a family that agitated against the East German socialist state, which Melzer believed had, paradoxically, enlisted fascist skinheads to attack Christian youth groups and leftist punks.* Feeling a sense of duty to help usher eastern Germany into the new, democratic era, Melzer enrolled in a police academy in Bavaria, completed an apprenticeship as a cadet, and landed a job as a detective for the Thuringia State Criminal Police. In 1991, Melzer was assigned to a special commission on right-wing extremism called Soko Rex, which later morphed into an antiterrorism task force known as EG Tex. Their mission was to investigate potential criminal activity by far-right extremists in Thuringia. And nobody raised Melzer's eyebrows more than Tino Brandt.

Police suspected Brandt of participating in or orchestrating more than thirty different crimes ranging from the use of anticonstitutional symbols and disturbing the peace to premeditated assault and even attempted

* "The Stasi had a rich history of exploiting the far right for its own ends," wrote the journalists Sean Williams and Leigh Baldwin in their article "Follow the Leader" (*The Atavist*, June 2022). "When Adolf Eichmann stood trial in Jerusalem, the Stasi funneled cash to a campaign to defend the captured war criminal." Later, in the late 1950s and early 1960s, Stasi agents smeared swastikas on Jewish graves across the country.

murder. Some of the far-right rallies Brandt organized, Melzer believed, were illegal—they lacked permits and often ended in violence. Once, fifteen to twenty masked neo-Nazis boxed in a car and attacked its occupants with bats. "Tino Brandt was clearly identified as the perpetrator," Melzer concluded after investigating the incident. But for some reason, Brandt wasn't charged. Outside the village of Kahla, officers saw Brandt and other neo-Nazis conduct target practice and military-style drills while dressed in army uniforms—acts that likely violated laws against forming and training a militia.

Comradeship Jena, Melzer realized, was an organized crime group that acted like a regional chapter of Brandt's larger THS. And Melzer believed he could prove that Brandt was the ringleader, directing his subordinates like the Uwes and Beate to carry out the crimes. Melzer saw firsthand how Brandt had trained his henchmen to behave during interrogations by police: Whenever Melzer interrogated a THS comrade, they deflected questions in what Melzer perceived as a preorchestrated pattern. Brandt "was the brains and the planner behind it, and in my opinion, he is responsible for all these attacks," Melzer told his colleagues. In 1996, THS members in the small forest town of Graefenthal beat a punk teenager with baseball bats, leaving him in the snow with blood gushing from his head. Had the man's friend not found him and rushed him to a doctor, he might have died. Melzer believed Brandt had orchestrated the attack, calling on comrades to congregate there with weapons at a predetermined time. Prosecutors, Melzer believed, ought to have charged Brandt and his attackers for attempted murder. Instead, they watered down the charges against the attackers to disturbing the peace, and Brandt wasn't charged at all.

Time and again, prosecutors declined to charge Brandt for his acts. Melzer believed he knew why. Brandt, Melzer suspected, was a government mole—an informant for Melzer's counterparts, the Thuringian intelligence agency. Not only that, but Melzer believed Brandt was using the agency's—the taxpayers'—money to build up Thuringia's far-right scene. While he and his fellow officers worked to *stop* far-right crime, their colleagues in the intelligence agency were funding it—a thought that struck Melzer as "grotesque." But when he confronted intelligence agents at a meeting, Brandt's minders vehemently denied that Brandt was one of

their own. They even accused Melzer of waging a personal and unprofessional vendetta against Brandt, telling Melzer he was engaged in a "witch hunt." When Melzer asked his superiors for permission to seek a warrant for Brandt's arrest, they told him to drop it. It seemed that Brandt was untouchable—that his minders would do anything, even subvert justice, to protect their mole. His status as an informant seemed to grant him impunity—a silver shield.

Melzer believed that shield extended to Brandt's comrades as well. Brandt would give Beate and the Uwes money for gas to travel to and from demonstrations and meetings across Saxony, Bavaria, and beyond. Each year on April 20, the THS would celebrate Hitler's birthday. They'd put on concerts with music whose Nazi-worshipping lyrics surely violated the constitution. Brandt's handlers would ask him for the names of those who attended these functions. Beate, Mundlos, and Böhnhardt often appeared on the lists.

The three friends were no longer brooding in their small, skinhead bubble in Jena. When a damning display of photographs depicting atrocities by Nazi soldiers during World War II arrived in Erfurt, Mundlos and Böhnhardt traveled from Jena to see it. To see it being vandalized, that is. They watched as a neo-Nazi terrorist named Manfred Roeder—convicted for a string of arsons, bombings, and the murder of two Vietnamese immigrants in the 1980s—spray-painted the word *Lüge*, "lie," across one of the displays. When Roeder was charged with the destruction of private property, the Uwes and their Jena comrades showed up to support him at his trial.* A now-famous photograph shows the Uwes standing outside the courthouse next to Ralf Wohlleben and André Kapke. Böhnhardt's mouth is wide open, screaming in anger. Another image shows the Comradeship Jena contingent holding a banner in front of the courthouse with a message: "Our grandfathers were not criminals."

Their presence that day illustrated what Brandt liked best about the Uwes, Beate, and the rest of Comradeship Jena: They were "ideologically stable." Some neo-Nazis were posers—aimless in their actions or lacking historical grounding for their dogma. And while other far-right groups

* Roeder was ordered to pay a fine of 4,500 deutsche marks—just over $2,500 at the time.

fixated on growing their ranks, Brandt was pleased that the Jena contingent were "elitist"—they opted for quality over quantity. And now that Brandt had taken them under his wing, they were part of a *movement*—his movement—something larger than themselves.

Beate didn't like Brandt—a fact she emphasized to police during one of her interrogations, calling him "unlikable," and saying he suffered from an "inferiority complex." She claimed that many people did not take him seriously. "He had his fingers in the game everywhere," she would say—a puppeteer pulling the strings of Thuringia's far-right scene. She didn't mean it as a compliment. Still, she followed Brandt's lead. In February 1995, Beate had asked the city of Jena for permission for the THS to hold a demonstration "to preserve Thuringian identity against internationalization"—against ethnic diversity, against immigrants. This was an important moment in Beate's radicalization, the first time on record that she attempted to advance her extremist beliefs in a way that was democratic and legal. It may also have been the last. Three days before the event, the city refused to grant the permit. Beate didn't ask again.

At some point the three friends must have realized that words were not enough. They could stand and scream in front of a courthouse all they wanted, march with other Nazis, vandalize a memorial, hand out flyers. But these small, political polemics failed to persuade their countrymen to *act*. Speech, the trio realized, wouldn't be enough: They'd need to *scare* their country to its senses. It was time to make their explosive debut.

Chapter 6

Bombs over Jena

Four months after Beate tried to get a permit to organize a demonstration, one Monday evening in June 1995, employees at a Jena department store were moving mannequins and arranging displays after the store had closed. They noticed a strange package hidden behind a partition in the building's drywall. They phoned the police, who discovered a bomb containing more than 70 grams of TNT, enough to severely injure shoppers if the device had been rigged to explode. It was missing a detonator, leading police to surmise that it was intended as some sort of threat. Beate was well acquainted with the store: She'd shoplifted there as a teen. Whether she and the Uwes were behind the bomb, the world would never find out for sure.

Then, one night in November, at 11:30 p.m., Bosnian war refugees living in a kindergarten on the north side of Jena awoke to a bang. Someone had thrown an explosive through an open window. Luckily no one was injured. Whoever the attackers were, they'd deliberately targeted the immigrants. But four years after Rostock, such attacks against foreigners were frequent, and the perpetrators could have been anyone at all.

The following spring, someone wrote *"Jude"*—"Jew"—across a yellow Star of David and pinned it to the chest of a mannequin, imitating how Nazis demarcated Jews during the Holocaust. On the night of April 13, 1996, around 1 a.m., it was hung from a highway overpass south of Jena with a noose around its neck. A nametag identified the dummy as

Ignatz Bubis, one of the most prominent Jewish leaders in Germany at the time.* The next morning Bubis was scheduled to drive that stretch of highway past Jena to attend an event in Weimar. When someone spotted the mannequin and called the police, officers found two cardboard boxes with cables protruding from beneath the mannequin's clothes. Fearing it might explode, they let it hang for three and a half hours before finally cutting it down. Around the dummy's neck, the bombmakers hung a sign with a threat: "Careful—bomb!" There was no bomb—not this time. But the bombmakers of Jena had inadvertently blown their cover. They'd fashioned the dummy out of boxes that had held bottles of *Sekt*, sparkling wine—Beate's favorite drink. On one of the boxes officers discovered a fingerprint: the middle finger of someone's left hand. When they ran it through their database, it came back with a match. It belonged to Uwe Böhnhardt.

Böhnhardt was well known to police, his fingerprints readily available from his previous arrests and his stint in juvenile detention. Prosecutors eventually charged Böhnhardt with dangerously interfering with road traffic, disturbing the peace by threat of criminal acts, and incitement of the public to hate speech as well as with a few of his earlier crimes. Böhnhardt pleaded not guilty, but a judge found otherwise and sentenced him heavily to three and a half years in prison. He appealed, submitting statements by Beate, Mundlos, Ralf Wohlleben, and another far-right friend claiming Böhnhardt had been with them somewhere else the night the dummy was dropped. Incredibly, the judge dismissed the charge for the dummy bomb

* After the Holocaust, in 1948, the newly established World Jewish Congress resolved that Jews were "never again to settle on the bloodstained soil of Germany." But Bubis was one of thousands of Holocaust survivors who returned to Germany after the war, saying Germany was the closest thing to home he had. By 1950 there were fifteen thousand Jews in Germany, according to a Pew survey, down from about half a million before the Nazis took power. As chairman of Germany's Central Council of Jews in the 1990s, Bubis campaigned to make German companies compensate the Jews they used as forced laborers during the war—companies like Carl Zeiss. His outspoken warnings against antisemitism earned him enemies among Germany's far right. (Stephan Kramer, former personal assistant to Bubis, who later led Thuringia's intelligence agency, in discussion with the author, August 2021.)

entirely and reduced Böhnhardt's sentence for his other crimes to a little over two years. By the time the court issued an arrest warrant, Böhnhardt would be long gone.

Meanwhile, the bombs kept on coming. One Sunday in the autumn of 1996, an incident occurred at the Ernst-Abbe sport field, the same stadium where Katharina had been attacked four years before. The home team, Carl Zeiss FC, was playing a match when a group of children chanced upon a red wooden box in the bleachers, wedged between large foam mats that athletes used for high jumping. It had been sitting there for nearly a week. The previous Monday, just before 8 p.m., an unidentified man had phoned in a bomb threat to the Jena police. Officers had searched the stadium but couldn't find it. The children proved more perceptive, pointing officers to the box, which had black swastikas and the word "bomb" painted on it. Worried that the box could explode in the middle of a stadium full of families, officers cleared the stands. When they examined it, they discovered twenty liters of granite chippings—used in bombs as shrapnel—and a metal pipe.

Police initially suspected a neo-Nazi who had made some renovations to the stadium earlier that month, but when they searched his apartment they came up empty-handed. Only later would Mario Melzer suspect that Ralf Wohlleben and André Kapke had planted it—two of Beate and the Uwes' closest friends.

* * *

"On Day X, it's your turn, you shit cop!"

So screamed an angry man at a police officer one afternoon. The man was André Kapke, the immigrant-hating cofounder of Comradeship Jena. The cop was Mario Melzer.

By 1996, Melzer had begun surveilling Kapke, who he knew had close ties to Brandt and the Uwes. On this particular afternoon, Melzer was searching Kapke's apartment, where he discovered unconstitutional materials, for which Kapke was fined. He was also fined 2,000 deutsche marks for insulting Melzer.

One month after the stadium bomb, on November 1, 1996, Kapke and the Uwes visited the Buchenwald concentration camp, a forty-five-minute

drive northeast of Jena—the one Mundlos had visited on a school field trip and joked that the ovens were to keep the Jews warm. This time, they dressed in the signature brown uniforms of the SA, or Sturmabteilung, the Nazi paramilitary "storm troopers."* Melzer suspected Kapke was the leader of Comradeship Jena. Indeed, his friends called him the *Führer*, "leader," which is what Germans called Hitler. Whether this was in reference to Kapke's leadership or his gait wasn't clear. Kapke was a big man who drove around in a little car—the VW Golf that Katharina had once followed to a neo-Nazi rally. But Kapke's leadership skills were mitigated by the fact that he couldn't control his temper.

As the winter of 1996 set in, Melzer and his fellow detectives discerned nothing new about the city's recent bomb threats—the stadium bomb, the department store bomb, nor the bomb in the town of Saalfeld that police had questioned Beate about months earlier. As the year drew to a close, Jena residents began preparing for the most explosive night of the year, New Year's Eve, when Germans wish one another a *Guten Rutsch*—a "good slide"—into the new year, then try to dodge fireworks that they shoot into the air with abandon. Before the evening's festivities began, three partial mail bombs arrived at the Jena city newspaper, the police department, and city hall. They contained Styrofoam, a battery, a wooden screw, and a piece of wire—but no actual explosives. Each package carried a letter with tiny swastikas, death threats against a local politician, and death threats against a familiar target: Ignatz Bubis.

"We have had enough of lies and fraud," one of the letters read. "This will be the last joke. It's really going to go down in '97."

"With a bombing mood, [we go] into the fighting year of '97. An eye for an eye, a tooth for a tooth—this year is Bubis's turn," read another.

Officers tested the envelopes for DNA, to see if they could identify who had licked them shut. They were able to rule out Mundlos, and it didn't appear to match Böhnhardt either. (Nearly twenty years would pass before

* They might have faced as much as three years in prison: German law forbade wearing or using Nazi "flags, insignia, uniform items, slogans and greetings" in a public place. But although the custodians of the former concentration camp refused to let them enter, there's no record of whether they reported it to police.

Beate admitted it was her.) To Mario Melzer, all the evidence—the bombs, the letters, the threats against Bubis—"everything pointed to Comradeship Jena as the perpetrators. And the comradeship was part of the THS." Melzer knew that Böhnhardt, Mundlos, and Beate were members of both groups. He'd interrogated all three of them himself—Böhnhardt on multiple occasions. From these interactions, Melzer pegged Mundlos as an intelligent young man from an academic family—smart enough to evade Melzer's questions. Beate came off as self-confident and condescending, cunning and devious. Her boyfriend, Böhnhardt, in contrast, was "simple-minded." He was also a sadist with psychopathic tendencies. Melzer found it disturbing that a man who would beat someone's brains in at the slightest provocation could keep so cool under interrogation, refusing to utter a word.

Melzer was certain that Böhnhardt must be to blame for the bombs. Who could forget that Böhnhardt had literally left his fingerprint on the "Jewish" mannequin he hung from the bridge? Melzer had interrogated Böhnhardt about that incident himself. "It was just a coincidence," Böhnhardt told Melzer, absurdly.

If the comrades were worried that Melzer was on to them, they didn't show it. Just days after they'd mailed the threatening letters, on January 4, 1997, the Uwes visited Jena's police station and began photographing police cruisers. When officers confronted them, Mundlos punched one in the gut. After subduing the Uwes, the officers noticed a third man sitting in a vehicle nearby—their getaway driver. It was André Kapke. Officers searched the vehicle and discovered a paintball gun, for which Kapke lacked a license. Böhnhardt was charged with trespassing, Mundlos with resisting arrest, Kapke for the gun.

A few months later, in April 1997, police pulled over Böhnhardt, who was driving with Beate, Mundlos, Kapke, and Holger Gerlach. They refused to unlock the doors, so officers pried them open. The reason for their resistance became clear when officers discovered an arsenal of weapons hidden under the seats and in the trunk: three axes, several knives, a pellet gun with a rifle scope, a gas pistol, throwing stars, and more. But prosecutors would drop the weapons charges, claiming that they couldn't

definitively prove who was responsible for each individual weapon. Yet again, the friends walked free.

* * *

Authorities weren't the only ones keeping tabs on the trio and their network of far-right friends. One summer day, Katharina König examined some black-and-white images that an antifa friend had sent her. It was a neo-Nazi rally in the town of Worms. On August 17, 1996, some two hundred skinheads had gathered to honor the ninth anniversary of Rudolf Hess's death. The bright sun created stark whites and dark shadows, the contrast so intense the photos looked more like negatives that hadn't been developed. This made the faces of the white supremacists unmistakably clear. In one image, Brandt leans forward, listening intently. Another shows a handsome, well-built young man with short blond hair and a smile: Uwe Mundlos. Behind him sits a brown-haired teen with a mustache—Böhnhardt—gazing, or glaring, into the distance. One row in front of the Uwes, her mouth slightly ajar in an unclear expression, is Beate.

Katharina didn't think much of the images at the time. The photos were just a few of the many images of neo-Nazis that she and her fellow antifa members were collecting. They'd file them away in boxes along with news clippings about neo-Nazi events. They'd store them in the attics and closets of her father's church, unaware of how important they—or she—would one day become. Long before Katharina would earn a reputation for her work to stop the white supremacists of Germany's future, she was determined to learn about the victims of its fascist past. In the summer of 1997, as her classmates from the Adolf-Reichwein-Gymnasium set off on holiday with their families or to find jobs, or prepared to attend college in the fall, Katharina opted instead to take a *freiwilliges soziales Jahr*—a gap year to volunteer. She set off to the Beit Horim S. Moses home for Holocaust survivors, in Jerusalem.

Katharina's preoccupation with the Holocaust had begun with a field trip to a concentration camp, a voluntary pilgrimage that some but not all German schoolchildren make. It was wintertime when Katharina visited

Buchenwald, and despite her heavy jacket, she felt frozen as she imagined all the prisoners, working in their threadbare clothes. Katharina cried. She felt like throwing up. She could feel the prisoners' presence, imagine their faces. Each year her father, Lothar, organized a trip for Jena's youth to visit Auschwitz, and Katharina began going too. In tenth grade, her teacher led a unit on the Holocaust and encouraged students to engage in *Vergangenheitsbewältigung*—the reckoning with and overcoming of Germany's past. Young Germans like Katharina, she suggested, had a duty to ensure that mass racist violence would never happen again.

What Katharina's teacher espoused was by no means universal across Germany. Few schools incorporated antiracist civic education into their curricula to help students identify modern manifestations of hate. Many only required students to study the racial violence of the past. Katharina responded to her teacher's challenge by reading books about Nazi Germany and biographies of Hitler. On Christmas, when most teenagers unwrapped clothes or cassette tapes, Katharina would unwrap books about Nazis. When she turned eighteen, she read *Hitler's Willing Executioners*, by the American historian Daniel Goldhagen. She was alarmed to learn that much of the German public *knew* about the concentration camps and other Nazi atrocities at the time, yet chose to participate or remained silent nonetheless. She began thinking about her own family's role. Her grandfather, she knew, had been a Nazi soldier. He'd been drafted late in the war, in 1944—or so he claimed. After it ended, the Allies had imprisoned him in France. One hot summer day when Katharina was eight or nine years old, she watched her grandfather roll up his long-sleeved shirt, revealing a faded tattoo.

"What's that?" Katharina asked.

Her grandfather explained that when he joined the SS, they'd tattooed his unit number on his arm.

"It's not possible to read it," Katharina noticed.

"When I was a prisoner of war, in France, one night I took a pencil and I scraped it and put milk on it to remove it, so they wouldn't know I was a member of the SS," he replied. A few days after he'd obscured the tattoo, Allied soldiers went through the prisoner of war camp looking

at people's arms. Anyone found to have a tattoo was taken away. Likely they were simply moved to another prison, or at most, put on trial, but Katharina's grandfather was certain that the tattooed soldiers were taken to be killed. "Until the end, he was sure that *this* is the reason he was still alive."

Katharina peppered her grandfather with questions about the Holocaust.

"Did you ever kill anyone," Katharina asked, "during the war?"

"Sure. I was a soldier," he replied.

"Did you ever kill Jews?"

"I don't know."

"Were you ever in a concentration camp?"

"I don't know."

"Do you remember what cities you fought in?"

"I don't know."

It wasn't until years later when Katharina returned from Israel for a visit that the questions started moving in the other direction. Her grandfather's responses revealed a man who was still living in the past. Once, when Katharina told him about her life in Israel, he asked if she had made any friends there.

"Yes, of course," Katharina replied.

"Are they Jewish?"

"Yes."

"That's very good," he commended her.

"Why?" asked Katharina.

"Because if the Jews take over the world, our family will be saved through you."

Katharina cringed at the realization that, although no longer a Nazi soldier, her grandfather still disliked and distrusted Jews. As a child, Katharina didn't know the difference between the Wehrmacht—the army—and the SS. She'd always thought her grandfather was just a common soldier in the war. But through the history books she read, she learned that the SS were no ordinary soldiers: They were fiercely loyal men who directly carried out the genocide of the Jews. When her grandfather told her he'd been in the SS and in a French prisoner of war camp, she had assumed that this was

normal—that most other German men of fighting age had been, too. But as she grew up, "I realized that not everybody had that tattoo."

Shit, it's not just your grandfather—it's one of Hitler's willing executioners! thought Katharina—the ones she'd read about in the book.

I love him—I still love him, she tried to tell herself. *He's my grandfather, after all.* Back when he became a soldier, fascism was the only world he'd known. Then, after the war ended, that world changed completely. Socialism was like an alternate reality, one to which the East German state demanded strict adherence. For the next forty years, *this* was his world. Then in 1989 the Berlin Wall fell and that world crumbled, too. Suddenly he was thrust into a new, democratic and capitalist reality. For the third time in his life, what was right became wrong, and what was wrong became right.

"After that, my grandfather didn't believe in anything at all."

And yet prejudice, once rooted, cannot be so easily expunged. Despite the discomfort her grandfather's bigotry caused her, Katharina nevertheless felt encouraged by some of the last words he spoke to her before he died:

"It's good to act against fascists," he told her. "You should do everything you can to stop them."

She wouldn't let him down.

* * *

While Katharina was away in Israel, back in Thuringia, her hometown was still being bombed. A five-minute walk south of her father's church, past the café where young antifa punks met to drink coffee and smoke cigarettes, sat Jena's public theater. Much like Winzerclub, it was built after the fall of the Berlin Wall to create jobs and distractions during the reunification years. Children liked to play on the plaza outside when the weather was nice. On the afternoon of September 2, 1997, a girl named Heide noticed a bright red suitcase jammed between a trash can and the outside wall of the theater. It was emblazoned with a black swastika. Assuming it to be a prop for the theater that got left outside by mistake, she and another kid carried it to the theater's back entrance, where a receptionist brought it inside. It sat there until the next day when the theater's technical director found it.

Unnerved, he opened the suitcase and peeked inside. The bag turned out to be a bomb containing 10 grams of TNT.* The only thing missing was a detonator.

Unlike the department store bomb, the theater bomb made the news. When Brigitte Böhnhardt read about it in the newspaper, she was shocked: Her son's name was printed as a suspect. When she asked him if he had anything to do with it, he assured her he did not.

Mario Melzer knew better. His task force asked Thuringia's intelligence agency to conduct surveillance on Böhnhardt, but the agency was short-staffed. Agents trailed him only briefly and turned up nothing useful. One month after the theater bomb, the prosecutor with the authority to level charges against Comradeship Jena decided not to—for what reason isn't known. But to Melzer, the reason was clear: Brandt's handlers, he was certain, had once again intervened to protect their prized informant.

"Informants of the OPC were laying bombs that could have easily harmed children!" fumed Melzer, who believed Brandt was in on the bombs. "Some of these bombs could have exploded at any time. And they contained TNT!" And yet Brandt's handlers never reported any of his potentially criminal activities to police, much less decommissioned him or cut off his cash. And now that prosecutors had refused to charge Brandt, Melzer's "witch hunt" came to an end.

* * *

Though Melzer's police task force was now off the case, intelligence agents remained intrigued. On November 24, agents received a warrant to observe Beate and the Uwes for a week. They watched as the Uwes moved pipes and other suspicious materials into the storage garage that Beate had rented near Jena's sewage treatment plant. Agents tailed them to a Kaufland supermarket and watched them walk out carrying two liters of denatured alcohol, which can be used to make explosives such as Molotov cocktails. Back at the garage, the Uwes checked over their shoulders before carrying the materials

* State police theorized the TNT might have come from unexploded World War II–era devices, which were sometimes sold on the black market.

inside. They didn't notice the agents watching them. Later, on a path leading to the garage, agents spotted granite chippings, and scooped some of them up. Forensic work revealed that they matched the ones used in the stadium bomb. It was an incredible piece of evidence. But for some reason, agents would wait six weeks before passing it along to police. During that time, late on Christmas night, a suitcase surfaced in a cemetery on Jena's north side. It was fashioned to look like a bomb and had a red-and-white Nazi swastika flag emblazoned on it. A groundskeeper noticed it next to a monument to Magnus Poser, a communist who had fought against the Nazi regime and was murdered at Buchenwald. It was another dummy bomb—no ignition device or TNT.

When intelligence agents finally told police about the granite chippings at the garage, they classified the information as "top secret," preventing police from showing it to a judge who might issue a warrant. It took the police ten days to come up with a workaround: Because Böhnhardt's prior conviction for the dummy bomb made him a suspect, they sought a warrant against "Uwe Böhnhardt et al." Although they wouldn't be able to search Mundlos's and Beate's apartments, they could at least search the garage in the sewage district and two other garages near the Böhnhardt residence that seemed suspicious, too. The judge granted their request.

On the snowy Sunday of January 24, 1998, Beate and the Uwes drove Böhnhardt's red Hyundai to Dresden to protest the same traveling display of photographs about the crimes of Nazi soldiers that they'd visited in Erfurt a few years before—the one Roeder had desecrated. Photos show the trio holding a sign that read "Nationalism—an idea [that] seeks adherents." It seemed less like an attempt to recruit than to troll. In any case, it would be their last public appearance for some time. By the morning of Monday, January 26, the trio had driven back to Jena. That's when police finally made their move.

* * *

The sun hadn't yet risen when officers from Melzer's task force filed into room 202 of the Jena police district headquarters. The officer in charge that morning briefed them quickly. In just a few minutes, they would split into

two teams. One would drive to the Böhnhardt residence and search Uwe Böhnhardt's personal garage, while the others would search the garage Beate had rented in the sewage district. Conspicuously missing from the meeting was Detective Mario Melzer. He was attending an IT training course that week. No one bothered to alert him to the mission, which was a mistake, because Melzer probably knew more about the trio than anyone else.

The first set of detectives arrived at the Böhnhardts' apartment building at 7:30 a.m. and buzzed. Böhnhardt and his mom, Brigitte, answered the door. Brigitte excused herself to head to work. The officers then followed Böhnhardt across the narrow street in front of the building to his garage. He opened it, revealing his red Hyundai and a smattering of ordinary garage clutter. The officers began rifling through it. At some point, Böhnhardt asked to excuse himself while they continued their search. Incredibly, the officer in charge saw no reason to stop him. Böhnhardt had cooperated fully, and besides, they hadn't turned up anything incriminating yet. And so Böhnhardt placed a gym bag in his car—the officers didn't bother to check what was inside—and drove off. Where to, the officers didn't ask. The time was between 8:30 and 9:00 a.m.

Back near the sewage plant, officers had failed to crack a thick padlock on the door of the garage. It wasn't until 9 a.m. that firefighters arrived and broke it open. Inside, officers were shocked at what they saw: a metal pipe with two wires sticking out, a screwable tin can with a wick, a detonating device, Mundlos's passport—a piece of evidence that clearly tied all these things to the trio—and a total of 1,392 grams of TNT, enough to destroy a small vehicle and kill whoever was inside. Some of the TNT had been inserted into four partially constructed pipe bombs as well as into a fifth bomb that was dangerously complete.

Rather than immediately seek a warrant for the trio's arrest as they should have done, officers spent hours sifting through the explosives. It wasn't until they finished, at 2:50 p.m., that they sought a warrant, which they received, then spread out across the city to find the trio. By that time, Böhnhardt had driven off. Mundlos was also nowhere to be found. Officers entered his apartment and found it to be strangely tidy and organized—so

much so that they wondered whether he had anticipated it was going to be searched. There were documents, floppy disks, tape cassettes, textile paint, and a toolbox—but nothing immediately incriminating. Beate's apartment, on the top floor of a brown-gray building in Winzerla, was a different story. She wasn't at home, but officers found weapons and antisemitic paraphernalia. Over Beate's bed hung a version of the *Reichskriegsflagge* used by the German army during Nazi times, this one red and emblazoned with a swastika. For some reason, officers waited to search Böhnhardt's bedroom until his mother, Brigitte, returned from work, at 4:45 p.m. When Brigitte saw that the officers who had visited that morning were still there, she was distraught. "My Uwe!" she exclaimed, as the officers looked through her son's things. She was immediately suspicious of their intentions. She turned to her husband and told him to follow the officers closely.

"Go downstairs with [them] and look carefully. Don't let them find something that wasn't there!" one officer overheard her say, as if they might plant evidence in order to frame her son. They didn't need to. In Böhnhardt's bedroom, officers found capsules for guns that fired CO2 cartridges, plastic containers with an unknown liquid substance, pyrotechnic bang cartridges, real bullet cartridges, a 30-centimeter-long piece of pipe, and three daggers. Officers also discovered a crossbow, which Brigitte insisted did not belong to her son. *Where could he possibly have hidden a crossbow in a three-by-three-meter room?* Brigitte wondered. The answer was under his bed. It seemed there was a great deal Böhnhardt hadn't told his mother. About the only thing police didn't find in the apartment was *him*. After the officers had let him go, he, Mundlos, and Beate had climbed into Ralf Wohlleben's car, driven out of Jena, and disappeared.

In the days that followed, detectives sorted through the mounds of material they'd found in the garages and apartments. A floppy disk contained an ominous hint as to what the three fugitives were plotting next. It was a short poem addressed to Germany's growing population of second-generation Turks. Its title: "Dirty Pig Ali We Hate You."

> *A Turk who lives in Germany and says he too was born here, we see him as already lost.*

He can run or flee, he can even go to the cops.
But none of this will help him
Because we'll stomp upon his face.

A detective made a note about the crude poem in his report:

Relevance to the crime—none.

PART II

Chapter 7

Refugees Welcome

One day in primary school, Gamze Kubaşık was sitting next to a girl named Sandra when Sandra stuck chewing gum in another girl's hair.

The classroom was a thousand miles from Gamze's homeland, Turkey, which she'd left when she was just five years old. Gamze had dark hair, olive skin, and dark brown eyes. If these attributes made her stand out from her classmates, they didn't show it. But the same couldn't be said for the teacher. Upon discovering the sticky prank, the teacher overlooked Sandra, who was white, and immediately accused Gamze.

"It wasn't me!" she protested. But the other girl didn't confess, and the teacher had made up her mind. The school called Gamze's parents in for a talk.

To Gamze's relief, her father, Mehmet, not only believed his daughter, but defended her.

"You're just accusing her because our hair is black," Mehmet told the teacher, referring to their Kurdish heritage. Gamze soon forgot about the incident, and she never experienced anything like that again. She felt at home in Germany—far more so than in the country she'd fled.

* * *

Gamze's mother, Elif, was born into a family of cotton farmers in the village of Cöcelli, a half-hour drive northeast of Gaziantep, Turkey. When Elif turned seven, she began joining some of her siblings to trek to school

through the cotton fields, some of which belonged to the family of a soft-faced boy named Mehmet Kubaşık, who hailed from nearby Hanobası. The first time they met, "we didn't talk at all, we just looked at each other. It was clear we liked each other," Elif recalled. Mehmet was "the most beautiful man in the village." For two or three months, they didn't speak to one another—wordlessly, they fell in love.

When Elif worked the fields, Mehmet would visit her. Soon they began hiding away between bales of cotton. But outside the safety of that sanctuary, the two lovers didn't dare exchange so much as a glance. Mehmet's family, owners, considered Elif's family, workers, to be of a lower social class. They had no choice but to elope. They moved away from the village, with its strict traditions and disapproving eyes, to the nearby town of Pazarcık, where people might be more lenient toward a couple living outside of wedlock. In July 1985, they gave birth to a daughter they named Gamze—Turkish for "dimple," a sign of beauty.

Just a few months later, Mehmet was conscripted into the Turkish military, which was fighting a Kurdish separatist group called the PKK. But Mehmet and Elif too were Kurdish—Kurdish Alevis, a persecuted religious minority in Turkey that makes up about a quarter of Turkey's majority-Sunni population of eighty million people.* When Mehmet finished his service, the conflict followed him home: By the late 1980s Turkish soldiers were targeting Kurdish Alevis living in the Kubaşıks' village and began arresting some of their neighbors. The nearby cotton fields became a war zone.

"It was a year a lot of terrible things happened," remembers Gamze. "Some of our relatives were murdered. And that's when my parents decided to leave."

In March 1991, Elif, Mehmet, and Gamze left Turkey to stay with relatives in Switzerland before traveling onward to a nation with a nascent

* When Elif and Mehmet were children, a paramilitary fascist political party massacred more than a hundred Kurdish Alevis in the city of Kahramanmaraş, just a forty-five-minute drive northwest of their hometowns. After a 1980 coup, Turkey's military government banned the Kurdish language, arrested suspected Kurdish Alevi "terrorists," and raided and destroyed Kurdish villages, killing suspected PKK sympathizers. Turkish soldiers set up roadside checkpoints across eastern Turkey and blanketed mountains with land mines to disrupt PKK guerrillas, who responded by attacking military and police targets.

reputation of welcoming refugees—Germany. The Asylum Compromise hadn't yet passed, and Germany was admitting more immigrants than ever before—a record 1.5 million in 1992. While the Kubaşıks applied for asylum, they were shuffled between different housing accommodations, at one point sharing a single room the size of a small dentist's office. But Gamze didn't mind: "There were so many other children around—I had a lot of friends." When the family moved to a tall apartment building, Gamze spent hours gazing out the window. "It was so dreamy to look from that height. It felt like we were living under the sky."

When Germany granted them asylum, the Kubaşıks relocated to the diverse city of Dortmund, in Germany's northwest. Their landlord was a friendly old German man Gamze called *Opa*—Grandpa. Their neighborhood, Nordstadt, was full of immigrants. "There was a Greek family in the neighborhood with five daughters of similar age to me at that time," Gamze remembers. "There were four or five Turkish families and, to my luck, they all had children." During the summer, Gamze and the other neighborhood kids flocked to the city's parks, where the Kubaşıks would barbecue with friends, neighbors, relatives. Several of the girls would play volleyball together. They'd ride bikes and rollerblade up and down the street, "a community of immigrants."

The Kubaşıks' story was typical of the times. Two hours east in the city of Kassel, a Turkish immigrant and his son, Halit Yozgat, opened a small cybercafé. To the north, another young Turkish immigrant named Süleyman Taşköprü took charge of his family's grocery store in the port city of Hamburg off the North Sea. In Munich, a Greek immigrant named Theodoros Boulgarides opened a hardware shop. And just southwest of the Kubaşıks in Cologne, a narrow street named Keupstrasse became an artery for working-class immigrants from Turkey, lined with barbershops, kebab stands, jewelers, and cafés. Across town, an Iranian family opened a grocery store on Probsteigasse. Both streets would one day catch the eye of two white men from Jena and a white woman with long dark hair.

* * *

Two thousand miles southeast of Dortmund, around the time Beate and the Uwes traveled to Dresden to protest the photography exhibit,

Katharina König was on her gap year in Israel, a nation established for the explicit purpose of welcoming refugees—victims of Germany's dark past. As part of her volunteer work at the Beit Horim S. Moses home for Holocaust survivors in Jerusalem, each morning Katharina visited the residents' rooms. Most had been children or teenagers when Germans had nearly ended their lives. Now that they were old, Katharina helped them bathe and dress, and rolled them in their wheelchairs to the garden. They liked listening to music from before the war, like the Comedian Harmonists, a German male a cappella group—half of its members Jewish—whose songs were lighthearted and fun. Whenever "My Little Green Cactus" came on, one resident, Ms. Löwenthal, would ask Katharina to turn up the volume, then sing along.

On one of Katharina's first days on the job, something happened that would scar her for life. Mrs. Rosenthal, a resident born in Poland, spoke six languages—Polish, German, French, Yiddish, Hebrew, and English. And she tended to speak them all at once, confounding her caretakers. One day, Katharina walked in and addressed Mrs. Rosenthal warmly in German.

"*Wir gehen jetzt duschen!*"—Let's go shower!

Mrs. Rosenthal started to scream.

"No, don't! My family!" That's when Katharina remembered: Mrs. Rosenthal had been imprisoned at Auschwitz, where hundreds of thousands of men, women, and children were led into gas chambers and showered with Zyklon B. To Mrs. Rosenthal, to *go shower* meant to be led to your death. Katharina nearly burst into tears, horrified at what she'd done. She tried to calm Mrs. Rosenthal down.

"You're in Israel, you're safe! Your son will come on Shabbat to visit you. Everything is okay. We'll not go to the shower, we'll just go straight to breakfast."

Later, she helped Mrs. Rosenthal take a bath, but she never showered again. When Mrs. Rosenthal's daughter came for a visit, she noticed Katharina glancing at the faded black number that had been tattooed on her mother's forearm at Auschwitz. She told Katharina that her mom had lost her entire family to the showers.

"She's the only one who survived."

Katharina had set off to Israel "to figure out more about history." But

the history she encountered wasn't Israel's. It was Germany's. This was where Germany's past collided with its present. Her days at the old people's home were a rude awakening to the scars her nation had left on the world.

"What do you learn in school about the Third Reich?" the survivors would ask her. "What about Jewish people? Do you know any Jewish people in Germany?"

"No," Katharina would reply. "I don't even know a single one." Now she was surrounded by Jews—as well as their trauma. One had been forced to become a prostitute for the SS—the paramilitary division that played a central role in carrying out the Holocaust, the one Katharina's grandfather had joined. Ms. Löwenthal had gone blind, and once when Katharina went to wake her from a nap, she was startled to discover her underneath her bed, searching for something on the floor.

"Ms. Löwenthal...what are you doing?"

"I'm looking for matches. It's so dark in this bunker," she replied.

She thinks she's back in a bomb shelter, like during the war, Katharina realized. Quietly, patiently, Katharina sat by her side and waited for her to return from where her trauma had taken her. But others, like Ms. Löpert, never fully did. The first day Katharina attended to her, Ms. Löpert took one look at Katharina and balked:

"I don't want a *German* to look after me."

Ms. Löpert had come to detest the German language and swore never to speak a word of it again. She made good on that promise, forcing Katharina to communicate with her in English as best she could. When Ms. Löpert's grandson came to visit, she scolded him:

"*Sprich kein Deutsch!*"—Don't speak German!

"I did it to understand you," he replied.

"Don't speak German at all!" she told him. "*Deutsche sind unsere Feinde*"—Germans are our enemies. One day, Ms. Löpert asked Katharina whether she knew what her family *did*. As in, what they did during the Holocaust. Katharina told her the truth.

"My grandpa was in the SS. My family was part of the Third Reich."*

* Katharina would later learn that *both* her grandfathers were Nazi soldiers—the other one was in the SA.

The Holocaust wasn't just history, Katharina realized—it was *her* history. In Germany, "everyone has at least someone in his or her family who got killed by Germans in the Third Reich"—or who was doing the killing. "Everybody."

In Israel, Katharina couldn't keep her mind from wandering to dark places. *What if one of my grandparents killed these people's families?* Sometimes the survivors asked why she came to Israel.

Are you trying to make right what your grandparents did wrong?

"No," Katharina told them. She just wanted to get to know these people who had lived through Germany's genocidal past. As Katharina told the survivors about her antifascist activism, the past began to feel like the present.

"We are demonstrating against fascists—against neo-Nazis, against antisemitism," she told them. The survivors were shocked.

"They said, *Woah! You still have fascists? You still have Nazis?* I told them, 'Yeah, in Jena, we have a lot.'"

What do they do?

"They beat me up—on more than one occasion. They beat my friends up," she said, as Beate had done to Maria that night outside the tram. "They beat my father up. It's dangerous. And Germany doesn't do what it *could* do to stop them."

The Holocaust survivors couldn't believe it.

It's good that we have Israel, that we have our own state, they said. *Because if it's still possible to be a fascist in Germany, what has changed? What has your government learned?*

What *had* Germany learned? The question haunted Katharina. She'd studied the Holocaust in school, as all German children do. She'd even learned something about what her own grandparents had done. With Katharina, Germany's attempt at *Vergangenheitsbewältigung*, the struggle to overcome the past, had worked wonderfully. There she was, a German volunteering in Israel, taking interest in Jewish culture, befriending Jews. But just like her teacher had told her, the real problem, she now realized, was Germany's future. Though most Germans learn about the fascism of the past, "we don't learn how to stop it *today*."

"We as Germans are responsible for what happened. It doesn't mean we are guilty—but we are responsible to make sure that it will never happen again."

Every couple of weeks, Katharina received letters from family and friends back in Jena. They'd tell her about the latest punk concerts and the neo-Nazi rallies. In February 1998, she received a series of letters stuffed with newspaper clippings about a startling event: Police officers had raided a garage near Jena's sewage treatment plant. Inside they discovered bombs and TNT. The bombmakers who'd been threatening her hometown, Katharina learned, were three neo-Nazis whose names and faces she knew. And they'd managed to escape. She tucked away the letters and news clips.

Maybe they'll catch them, she thought.

* * *

One February day in 1998, the same month Katharina received the news clippings about the three friends on the run, a fascist in the Saxon town of Chemnitz rang Mandy Struck's doorbell. A few fellow "comrades" had "screwed up," he told her, and needed somewhere to sleep.

Struck was active in Chemnitz's far-right scene—her nickname was "White Power Mandy." Part of a prisoner support group for incarcerated neo-Nazis, she jumped at the chance to prevent white supremacists from winding up behind bars. Still, she didn't savor the thought of sheltering three strangers in her home, so she asked her neo-Nazi boyfriend, Max-Florian Burkhardt, to put them up. Burkhardt agreed, and the fugitives moved in with him at Limbacherstrasse 96 on Chemnitz's north side.

The apartment was near the salon where Struck worked as a hairdresser, and she soon stopped by to size them up. Both men were tall. One was friendly and had a "squeaky" voice—Mundlos. He looked familiar and she wondered if she might have met him at a party or a concert. The other man appeared acrimonious—Böhnhardt. Not that he said anything off-putting. "It was just a feeling. He didn't talk, he just looked, observed." The woman was "a bit pudgy," had dark hair, and wore sporty clothes. She seemed supine—friendly, easygoing, open-minded. Soon Struck was stopping by regularly to share cigarettes with the trio.

Life for the fugitives, Struck noticed, wasn't particularly difficult or dreary. Sometimes it was literally fun and games. Mandy once watched the three of them play a board game that they'd crafted by hand. The squeaky one—Mundlos—designed a T-shirt featuring the TV character Bart

Simpson with the word "Skinsons." Although the friends were hiding from the law, they didn't seem overly concerned: They'd leave the apartment to go grocery shopping or to make phone calls from nearby pay phones. One day Struck found the dark-haired woman on the couch, crying in pain, complaining of stomach cramps. She didn't want to see a doctor—at least not under her real name. Struck offered Beate her insurance card, which Beate used to see a gynecologist.

With time, Struck began to hear rumors about the trio's life back in Jena—that they'd once hung a mannequin with a Jewish star off a bridge. That they had blown up a garage to hide evidence, or something to that effect. But years later, when a judge probed her for details, somehow she claimed not to even remember their names. She said when it came to helping comrades, "you didn't ask" too many questions.

* * *

Meanwhile, in Thuringia, the news that three of Tino Brandt's comrades had fled as fugitives hit him like an "earthquake," threatening to fracture his carefully constructed world. Brandt had helped indoctrinate them into Thuringia's white supremacist scene. Now he'd have to help them hide. As usual, Brandt's thoughts turned to the subject of money. Naturally, the trio would need cash to support their life on the run—for rent, transport, food. Brandt gave Kapke some of his own money to pass along to them and began fundraising for more, organizing neo-Nazi concerts in the trio's honor and sending along the proceeds. Sometimes the musicians even donated their own earnings to the cause.

One stream of revenue that must have felt particularly satisfying was the money Brandt and Kapke earned selling copies of the game that Struck had seen the three comrades playing. Back in Jena, they'd reimagined the world's most popular board game—Monopoly—with a sinister, neo-Nazi theme. They named it "Pogromly," an apparent reference to Nazi-era attacks and evictions against Jews.* The game used fake reichsmarks, the

* Derived from the Russian word for "devastation" or "violent destruction," the original term probably referred to riots that expelled or massacred Jews during the nineteenth- and twentieth-century Russian Empire. The "November Pogrom" of 1938 in which Nazis

Nazi-era currency, and instead of properties, players acquired German cities, purging them of Jews. The four railroads were named after Nazi concentration camps—Auschwitz, Buchenwald, Dachau, Ravensbrück. The trio replaced "Chance" and "Community Chest" with "SA" and "SS" cards with instructions like "The Führer thanks you for your loyalty to the fatherland: collect 3,000 RM" and "Reparation payment: Jews must pay for crimes committed against the German people. You will receive 400 RM."

They'd made at least twenty-five copies of the game, which they'd sold for 100 deutsche marks—about $60—each. Police found one copy in Beate's apartment, but Kapke managed to funnel others to Brandt, who sold them and sent the proceeds to the trio. One happy customer was Thuringia's intelligence agency, which dutifully bought a copy from their informant on the taxpayers' dime—for ten or twenty times the going rate, Brandt would later boast. But Brandt's handlers didn't ask many questions, so they were unaware that German taxpayers were funding three bombmaker-fugitives—and terrorists-to-be.

In their attempt to find the trio, agents did offer Brandt a reward of 5,000 to 10,000 deutsche marks—$2,500 to $5,000—for information that would lead to his former protégés. To the money-minded Brandt, this must have been a tantalizing offer. But if Brandt knew how to find them, it was one thing he wasn't willing to sell. Still, Brandt did give his handlers *something*: He told them the trio had used Ralf Wohlleben's car to escape Jena the day of the raid, and that he suspected they were hiding in Chemnitz, which turned out to be true. But as usual, intelligence agents didn't pass this information along to police.

Brandt even told his handlers he'd heard rumors that the trio was planning to flee the country—which was true. Mundlos had become obsessed with news of interracial conflict in southern Africa—what he called "ethnic cleansing" against whites.* He longed for the three of them to travel

and sympathizers destroyed Jewish businesses, synagogues, and homes, and deported some thirty thousand Jewish men to concentration camps, was dubbed Kristallnacht—the Night of Broken Glass—by the Nazi government, in reference to the shattered glass that littered German and Polish streets in the aftermath.

* The far-right magazine *White Supremacy* published this in an article titled "The Color of Racism," which lambasted Zimbabwean dictator Robert Mugabe's campaign to repossess

there in solidarity—maybe even join the fight. Brandt shared Mundlos's interest in the region. In 1999, he and seventeen fellow THS members traveled to South Africa to undergo firearms training with a known far-right extremist. When Brandt told his handlers the fugitives might try to flee, the intelligence agents decided to lay a trap. They gave Brandt 2,000 deutsche marks to send to the trio so they could obtain false passports. Brandt would then tell his handlers the dates they were to travel, so authorities could intercept them. But when Brandt passed the money to Kapke to give to the trio, Kapke pocketed it for himself. The passports never materialized.

At some point, Beate began to have second thoughts about fleeing to South Africa. They considered splitting up—the Uwes would leave the country and Beate would turn herself in. But be it for lack of passports or lack of nerve, these plans fizzled, too. They may have decided they had more to accomplish at home.

They might also have wondered what they were fleeing *from*. The authorities didn't appear to be on their trail. Intelligence agents squandered their best chance to track the trio when Brandt informed them that one of the fugitives planned to call him from a pay phone. On March 8, 1999, at approximately 7 p.m., the call came from Chemnitz. Brandt recognized the voice immediately as Böhnhardt's. Böhnhardt told him they were hurting for cash. He double-checked the amount of money Brandt had sent and the names of the comrades who'd passed it along. He seemed concerned that some of the funds were disappearing along the way. He'd heard that one far-right concert had raised more than 1,000 deutsche marks, half of which was supposed to go to the trio. But they hadn't received the money. Brandt told Böhnhardt he'd already spent as many as 1,000 or 2,000 deutsche marks to pay for the trio's fake IDs. Böhnhardt was furious. They'd paid for the IDs, too. The fugitives were being swindled by their far-right friends.

The call didn't last long. It was the last time Brandt would speak to

land from white farmers. It was published under the pseudonym Uwe UmerZOGen—almost certainly Mundlos, who contributed to the magazine. *Umerzogen* is German for "reeducated." ZOG is the abbreviation for Zionist Occupied Government, an antisemitic conspiracy that Jews control Western states.

the trio, or so he claimed. What was odd was who *wasn't* on the call: Thuringia's intelligence agency. Brandt had told his handlers in advance, but agents hadn't bothered to listen in.

One Sunday shortly after, Brandt drove to bring Wohlleben some neo-Nazi CDs. Fearing intelligence agents might have bugged Wohlleben's house, he invited Wohlleben out for ice cream. Wohlleben was cautious, too. He left his cell phone in the car, in case authorities were trying to listen in. While the two men licked their desserts, Wohlleben said he was keeping in touch with Böhnhardt's family and had visited them on three occasions, presumably to let them know their little Uwe was all right. Brandt told Wohlleben about his call with Böhnhardt. The men finished their ice creams and headed home.

Given how concerned Böhnhardt had been about money, Brandt was surprised when, some months later, he offered Wohlleben his tax refund in "support" for the trio—and Wohlleben declined. Donations were no longer necessary, he told Brandt: The trio had money aplenty. Their fortunes had suddenly changed.

* * *

Six p.m. was closing time at the Edeka supermarket at Irkutskerstrasse 1 in Chemnitz. It was Friday, December 18, 1998, and cashiers were preparing to empty the registers for the night when two men walked in. One wore a black coat, the other a checkered flannel shirt. Both had black bandanas over their faces. One pointed a pistol at the chest of a female cashier and ordered her to fill a bag with the cash. As they fled the store, one employee yelled "*Überfall!*"—Robbery!—through the store's loudspeaker. A sixteen-year-old boy followed the gunmen out as if to chase them. Three bullets came flying toward him. Luckily for the boy, this was the Uwes' first time shooting at people, and they were amateur marksmen. The bullets hit a wall. Their timing had been perfect. Because it was the end of the day, the cash registers had been full of money. They made off with around 30,000 deutsche marks, about $15,000 at the time. Investigators concluded that the 6.35mm bullets could have been fired from any number of types of guns. Without any leads, the robbery went unsolved.

Several months later, in October 1999, the Uwes entered a post office

less than a ten-minute walk from Max Florian Burkhardt's apartment. At around 4:45 p.m., just as the final customers had left, the Uwes marched in wearing matching black motorcycle helmets, green jackets, and jeans. One of them approached a terrified clerk named Katrin, aimed his gun at her through the glass divider, and fired. Luckily for Katrin, the shot turned out to be a blank. The other Uwe sprang over the counter. Hearing a commotion, Katrin's colleague Gisela emerged from a back room only to have a pistol pressed to her head. When Gisela reacted slowly, the man threw a white bag with a red drawstring to Katrin, which she stuffed with cash. The Uwes walked out of the post office and sped off on a small motorcycle with only 5,700 deutsche marks—about $2,300.

Three weeks later, the Uwes robbed another post office—on the same street as Burkhardt's apartment, just a five-minute walk away. They burst in at 11:07 a.m., forced their way over the counter, and emptied the cash registers. In Germany, post offices offer banking services and keep cash in vaults, and the Uwes managed to raid the safe. They left with 62,800 deutsche marks, more than $30,000, and fled on a motorbike. The robbers had wedged a piece of wood into the post office door to keep it closed while they were inside. On it, detectives found a three-inch strand of hair. But at the time, they didn't bother to analyze the hair for traces of DNA. Later, when they finally did, they lost the results.

The Uwes were skinheads—their hair was buzzed short. But next door to the first post office they'd robbed was a salon with a hairdresser who, unbeknownst to police, had helped harbor the fugitives. Her name was Mandy Struck.

Chapter 8

"The Bangs"

Back in Jena, after the trio's escape, police questioned Beate's mother and grandmother, who said they hadn't seen her. Mundlos's and Böhnhardt's parents said they hadn't heard from the Uwes, either. The officers weren't convinced. They began tapping Brigitte's and her husband Jürgen's phones in one of thirty-seven intelligence-gathering attempts to discover the fugitives' whereabouts. Jürgen's birthday—February 14—was just around the corner, and Brigitte's was three days after that. The officers suspected that Böhnhardt might try to call. But he didn't, nor did he ever use his cell phone again, which was smart of him—it too was tapped. Noting that Ilona Mundlos's birthday, May 18, was also on the horizon, officers even tapped the phone at the Rewe grocery store where she worked. But Ilona's birthday came and went. No call from Uwe Mundlos. When Böhnhardt's grandfather passed away soon thereafter, officers attended the funeral. Böhnhardt didn't.

Officers decided to follow the money. They checked the trio's bank accounts:

Beate Zschäpe: 2,997.61 deutsche marks, about $1,703.
Uwe Böhnhardt: 1,101.39 deutsche marks, about $625.
Uwe Mundlos, 91.45 deutsche marks—about $52.

But their instincts came too late: Nine days earlier, on February 11, security footage showed an unidentifiable individual withdrawing 1,800

deutsche marks from Böhnhardt's account at an ATM in Winzerla, just a short walk from Winzerclub. Had officers acted sooner, they could have asked the banks to freeze their accounts and alert them of any activity. Instead, they were at a loss.

Police waited a month before making their manhunt public, posting descriptions of the fugitives on their rudimentary website:

> Uwe Böhnhardt. 22 years old. 186 cm tall, slim, gaunt, dark blond, short hair, ears sticking out.
> Uwe Mundlos. 26 years old. 180 cm tall, slim, athletic figure, dark brown hair, cropped short.
> Beate Zschäpe, (birth name) Apel. 25 years old. 160 cm tall, slim, inconspicuous appearance. Dark blond, shoulder-length hair, slightly wavy.

Two days later, a German TV station broadcast the descriptions, and tips began flooding in by the dozens:

> Tip number 14: Beate Zschäpe had a relationship with a man named David Feiler.
> Tip number 25: The trio had visited a restaurant in the town of Gera.
> Tip number 32: The trio had been driving Ralf Wohlleben's car.

This last one was true—Tino Brandt had told his handlers the same. But the vehicle was nowhere to be found. One of the most promising leads turned out to be the first. The very afternoon the trio escaped, Ralf Wohlleben's girlfriend, Juliane Walther, had surprised officers by showing up at Mundlos's apartment—with a key. When they asked how she'd gotten it, she replied that Mundlos had lent it to her the day before so she could let herself in to watch TV.

If that alibi seemed suspect, it became considerably more so when officers discovered Mundlos's apartment didn't *have* a TV. They also found it suspicious that Mundlos's computer had vanished. Their suspicions grew two days later when Walther walked into the Jena police station holding a power of attorney ostensibly signed by Beate, authorizing police to give

her the key to Beate's apartment as well. Officers didn't hand it over. But they didn't manage to get anything out of Walther, either. When police questioned her and her boyfriend, Ralf Wohlleben, both flatly refused to speak about the trio. If the two of them were in touch with the fugitives, the officers couldn't figure out how.

A couple months after the trio's escape, in March 1998, Walther approached Ilona Mundlos to say she was setting up a bank account on Uwe's behalf. Walther asked Ilona to give her a credit card for her to pass along to Mundlos. Ilona declined and told police about Walther's offer. Officers sensed an opportunity: They tried to persuade Siegfried Mundlos to go along with Walther's scheme. If Siegfried gave a credit card to Walther, who in turn gave it to Mundlos, police could track him to wherever he shopped. Siegfried was suspicious. Such tricks smelled of the Stasi. For all Siegfried knew, the police were trying to trick him into financing the fugitives—which would make him a criminal, too.

What police didn't know was that Walther had been talking to Thuringia's intelligence agency. Agents would say Walther had "direct access to the three wanted persons. She acted as a contact person as well as a support person for the continuation of their escape."* Agents surveilled her, watching as she liaised with other far-right friends, including known members of Brandt's THS. But just as with Brandt, intelligence agents never shared any information with police.

On April 11, nearly three months after the trio escaped, police were monitoring Ralf Wohlleben's phone and the phone of another THS member named Jörg Helbig when Helbig received a call from an unknown number.

"Hello Jörg, I have a message for Ralf," the caller began. "Please tell him to be at the same meeting place on Monday at 2 p.m. as he was two weeks ago, but please go to Böni's parents first and bring some clothes. It is very important." The call confirmed officers' suspicions that Wohlleben

* Walther and the agents would later disagree about how often they met and the value of the information she passed along. Walther claimed she spoke with agents only twice, but agents claimed they met her on at least ten occasions and paid her as much as 200 deutsche marks, about $100, each time.

was in touch with the trio. Monday came and went, and as far as the police knew, the meeting never took place. Five days later the man phoned again, this time from a phone booth in Chemnitz.

"Hello Jörg, this message is once again for Ralf. It is now *Sunday*, 2 p.m., same place, and now he absolutely has to come. This is very important. He should go to Uwe's mother and get some money. We need a lot of money and he's supposed to get, uh, a video recorder and clothes and whatnot—a bunch of stuff."

A video recorder? Why that? the officers might have wondered. Thirteen years would pass before they'd find out. For now, officers could safely assume that Wohlleben was assisting the trio. And yet they only surveilled him on one occasion, and not on the Sunday mentioned in the phone call, but on the following Wednesday—three days too late.

Still, the messages police had intercepted did suggest something: that Brigitte Böhnhardt might be helping her fugitive son.

* * *

Siegfried Mundlos suspected Brigitte knew something about the trio that everyone else did not. When he confronted her, in Siegfried's recollection Brigitte replied that the friends were staying with the Böhnhardts' relatives in Mecklenburg-Vorpommern, the state where Rostock is located. Brigitte seemed at ease about the situation and told Siegfried not to worry.

"They won't starve," she said.

The last time Siegfried had spoken with his son was the day he fled. While officers raided the garage, Uwe Mundlos had passed by the Rewe grocery store where his mother, Ilona, worked, just a short walk from his apartment. He bid her goodbye, saying he would call his father to do the same. Ilona phoned Siegfried first:

"Siggi, there will be a call from Uwe this afternoon. Don't argue with him."

The call came, and Siegfried didn't argue. "Goodbye, I love you," Uwe told his father, before hanging up. Siegfried would never speak to his son again.

But Brigitte would speak to *hers*. She had learned early on that the trio was being helped by their far-right friends. A few days after their escape,

her son's car keys and registration papers had mysteriously appeared in the Böhnhardt family's mailbox. Later, she received a handwritten letter directing her to a nearby pay phone at a specified time. When Brigitte showed up, it rang, and she heard her son's voice. Brigitte was relieved to know he was alive—that he hadn't been killed by police, who Brigitte always believed had it in for him. Böhnhardt told her the three of them were safe—though he couldn't say where. Brigitte asked whether it was true what the newspapers said—that they'd been building bombs. Uwe replied that she shouldn't believe everything she read in the papers. Brigitte begged him to turn himself in.

"No, *Mutti*—not now," Böhnhardt replied.

Whereas Mundlos and Beate had no serious prior convictions that might cause a judge to give them lengthy prison sentences for the bombmaking, Böhnhardt did, and he was afraid he'd be put away for a long time. Brigitte said she and Jürgen would pay for a lawyer, who might persuade prosecutors to offer a plea deal. But when Brigitte enlisted the lawyer who had represented Uwe during some of his many previous run-ins, he informed Brigitte that the local prosecutor was threatening him with a ten-year sentence.

"Not even a child molester who has already killed five children would get that," she thought, in reference to Germany's lenient—though not *that* lenient—sentencing. Later, the attorney persuaded the prosecutor to consider just five years in prison, which could be suspended for good behavior after two and a half. But Brigitte's fugitive, bombmaking son had no intention of going back to prison at all. Brigitte would claim that over two or three subsequent, clandestine phone calls, she tried to persuade him to give himself up. But when given the chance to end this saga—to take responsibility for his actions, face the consequences, then move on with his life—Böhnhardt preferred to remain on the run.

Siegfried was right to be suspicious of Brigitte. If the fugitives had friends in far-right places, they also had an ally in Brigitte Böhnhardt. When Böhnhardt asked his mother for money, back before the fugitives had begun robbing banks, she and Jürgen obliged. They began secretly—and almost certainly illegally—sending 500 or 800 deutsche marks at a time, by way of an intermediary. To ensure she gave the money to the right person, Uwe instructed his mother to ask the intermediary for a code word

Rippchen, meaning "spareribs." It was a double entendre: In his youth Uwe had broken two ribs, but the code might also have referred to somebody else's ribs that the violent teen had once cracked. Brigitte hoped the money would prevent her son from deciding to steal. She was right to worry. Within two years of the trio's escape, they'd already robbed the Edeka grocery store and two post offices, netting over 50,000 deutsche marks— about $30,000.

Each time Brigitte heard her son's voice, she felt a little relief. He'd ask how the family was faring. She could tell he was homesick. To Brigitte, the calls were always too short—ten, perhaps fifteen minutes at most, she complained. And so, before long, Böhnhardt began hatching a plan to meet his parents in person.

<p style="text-align:center">* * *</p>

Three hours northeast, in Brandenburg, intelligence agent Gordian Meyer-Plath learned about the fugitives from his snitch. Meyer-Plath had been digging for intel about illegal far-right music. In late January, he detailed his mole Carsten Szczepanski's upcoming moves in a memo: "On February 8, 1998, the source will meet with the top brass of the Chemnitz skinhead scene, responsible for organizing supraregional skin concerts and producing high-quality skin music records." Six months later, Szczepanski told Meyer-Plath something astonishing: Three fugitives in Saxony were preparing to flee not only the state, but the country. And not only *that*—they were illegally attempting to acquire guns. Acquire guns from *him*—Szczepanski. Meyer-Plath's mole.

On August 25 at 7:21 p.m., Szczepanski's boss at the Saxon skinhead shop, Jan Werner, sent Szczepanski a text message that read, "what about the bangs?"

"The bangs," Szczepanski explained to Meyer-Plath, was slang for weapons. The money to buy them was to come from Blood & Honour, a notorious neo-Nazi network in Europe.* Werner and his girlfriend, Antje Probst,

* Founded in 1987 in Britain and named after the motto of the Hitler Youth, the group was eventually banned in Germany, but it would remain active in other European countries and in Germany underground.

headed the network's Saxony chapter. Szczepanski told Meyer-Plath about the three fugitives—that they'd planned to flee to South Africa and that Antje Probst intended to give the woman her passport for that purpose.

This was explosive news: fugitives, on the run, illegally arming themselves and plotting to flee the country. Years later, many would wonder why the news never reached intelligence agencies in Thuringia or Saxony, or the police.* Meyer-Plath would claim he passed this information along to his superior and insist that his mole had no idea the trio was plotting to do far worse than obtain guns and flee.

But in another telling, just like his counterparts in Thuringia, Meyer-Plath and his agency had become too entranced with their mole. If they passed this intelligence along to police, Szczepanski's far-right friends might learn he was a snitch. In this telling, Meyer-Plath and his colleagues preferred to keep their secrets to themselves. This is the story that more closely fits the facts: The same day Szczepanski received that text, agents replaced Szczepanski's SIM card with a new one. The incriminating text about the "bangs" disappeared. Later, Meyer-Plath would claim not to remember if he or his colleague had given Szczepanski a new SIM card, in order to avoid police surveillance. Barely had the three friends from Jena gone underground when authorities began covering their tracks.

On October 8, Meyer-Plath instructed Szczepanski to gather further intel on the trio, but eleven days later, the two men met for the final time. Meyer-Plath was leaving Brandenburg's intelligence agency for a new job in the Bundestag. One year later, a judge would rule that Szczepanski was eligible for early release, despite having served less than half of his sentence. The would-be murderer turned well-paid informant was free. Later, *Der Spiegel* discovered that Szczepanski hadn't even paid the 50,000 deutsche marks in damages he owed to Erenhi, the Nigerian man he nearly killed. Instead, Brandenburg's intelligence agency had fronted the bill, using taxpayer money to pay Szczepanski's tab for attempted murder. It wasn't until

* Szczepanski also revealed to Meyer-Plath that the fugitives were hiding in Chemnitz. But neither Meyer-Plath nor his colleagues typed this key piece of intelligence up in their official reports. It appeared only in a handwritten note in the margins of a single memo. And somebody would *erase* the note before turning it over to investigators.

two years after Szczepanski got out of prison—when intelligence agents discovered he was planning to bomb a group of antifascists—that they finally decommissioned their mole.

* * *

But what about the bangs? After Szczepanski neglected to acquire them, the trio turned to another man with the same first name.

Born in New Delhi to a German foreign trade representative father, Carsten Schultze was bullied from a young age for his attraction to boys. After his family moved to Jena, he joined Comradeship Jena and later became vice president of the Thuringia youth contingent of the NPD. After the trio's escape he decided to help, breaking into Beate's apartment to retrieve some of her things and passing them along to her in Chemnitz. At times he also gave the trio money—donations he'd collected from far-right friends.

Then, in March 2000, his fellow Jena comrade Wohlleben asked Schultze for a favor: The fugitives needed a weapon. Wohlleben asked him to procure a semiautomatic pistol with a silencer. When Schultze asked where to get one, Wohlleben told him to talk to the co-owner of Madley, the local skinhead shop. He even gave Schultze the money. A little over a week later, Schultze followed his instructions, buying a gun for between 500 and 1,000 deutsche marks—about $250 to $500. He hid it in his apartment, then boarded a train to Chemnitz to deliver it to the terrorists-to-be.

By this time the trio had worn out their welcome at Burkhardt's place and were living in an apartment rented for them by André Kapke. But they didn't invite Schultze to their hideout. Instead, the Uwes met him at the train station, where they barked at him to take off his conspicuous "ACAB" ("all cops are bastards") hoodie, to avoid drawing attention. The three then walked to a nearby café to meet Beate. Afterward, the Uwes led Schultze to an abandoned building. Schultze handed them the gun and the silencer, but before the Uwes could inspect it, someone passed by and the three of them split. The fugitives were now in possession of a rare, collector's handgun: a Czech-made 7.65mm Česká Zbrojovka 83 pistol, serial number 034678.

* * *

The trio's far-right friends weren't the only ones who knew they were hiding in Chemnitz. Brigitte Böhnhardt knew it, too. Now in their second year on the run, her little Uwe and his two fugitive friends came up with a plan to meet her and her husband, Jürgen, in person.

The fugitives chose the first exit off the highway into Chemnitz, so they could speed away if something went wrong, Brigitte figured. As Brigitte and Jürgen left Jena one spring morning, they tried to ensure it wouldn't come to that. They drove a rental car to keep police off their trail. As they neared Chemnitz, they exited the highway as Böhnhardt had instructed, pulling into a parking lot next to a café and a park. The three friends had already arrived.

They were dressed differently than the way they used to back in Jena. Gone were the heavy black jump boots and bomber jackets. Instead, they wore casual streetwear, intended to help them blend in. Böhnhardt was wearing a beanie that covered his jutting ears. Brigitte and Jürgen greeted Mundlos and Beate, then spoke with their son alone. Brigitte asked Uwe where they'd been living and how they were making ends meet—questions he declined to answer. She asked if their apartment was decent and if they had enough food to eat. Uwe assured her he was healthy—he'd even been to see a dentist. Later, Brigitte and Jürgen showed the three friends photos of Jena, of the new buildings going up in the city, and how their hometown had changed in the year since they left. The meeting lasted a couple of hours. The Böhnhardts handed their son some money and drove home.

One year later they met again, at the same exit off the highway. This time the trio didn't need any money. Though Brigitte claimed she and Jürgen didn't know it, by this time they'd begun robbing banks. Two more years would pass before Brigitte would see her son again. For the very last time. Once again, she and Jürgen drove toward Chemnitz and exited the highway. They spoke of mundane things—about what the three friends were cooking, what new recipes they had tried. Uwe asked about his niece, who Brigitte replied was growing up quickly and had begun attending school.

Why don't you just turn yourself in? Brigitte pressed him.

"We don't want to," came his reply.

Brigitte didn't know that by this time, her son had done things that no lawyer could fix. Her Uwe was a murderer.

Chapter 9

Flowers for the Dead

O n September 10, 2000, Semiya Şimşek heard a voice and awoke in bed with a start. It was 4 a.m., still dark outside in Aschaffenburg.

The fourteen-year-old was in the dorm room of her boarding school in Bavaria, having just returned from her summer holidays in Turkey. She'd traveled to her father's hometown, the small village of Salur in the province of Isparta, whose capital city of the same name is known as the "City of Roses" due to the fields of flowers that surround it. Semiya and her father, Enver, spent long hours sitting together on the balcony of their family's home, listening to the sounds of bells tied around the necks of sheep grazing in the surrounding Taurus Mountains. Sitting there with her father, "I felt how happy he was at that moment," Semiya would recall.

Semiya's mind was still flush with these memories when a school supervisor shook her awake. "Semiya, you have to get up."

Semiya was groggy and confused. The supervisor told her to pack some clothes. When they got outside, she was surprised to see her father's cousin and a family friend waiting for her.

Your father is sick, they told her. Semiya got in the car.

* * *

Unlike the Kubaşıks, who came from the Kurdish Alevi minority, the Şimşeks hailed from Turkey's Sunni Muslim majority. Rather than fleeing persecution in search of safety, like the Kurds, they immigrated to

Germany in search of opportunities. Semiya's grandfather did so in the 1960s, and eventually Semiya's mother, Adile, followed. It was during one of Adile's return visits to Turkey, in 1978, that she married Enver, who had thick black hair and a matching mustache. But they were forced apart when Enver was drafted for a mandatory two-year stint in the Turkish military, from 1980 to 1982. The couple wrote letters but saw each other only fleetingly. A few years after his military service ended, Adile brought Enver back to Germany with her. It was 1985, and Enver was twenty-four years old. One year later, when Adile went into labor with Semiya, Enver fainted with shock and doctors had to attend to *him*.

In Germany as in Turkey, the Şimşeks opted for village life. An hour northeast of Frankfurt, the town of Flieden was home to just a few thousand people. And yet their street, Katharinenstrasse, was a microcosm of the diversity that Germany's immigration policies had created. By 1990, six million of the sixty-three million people living in Germany had immigrated from somewhere else. Flieden was home to guest workers from Turkey, as well as families from Italy. A Pakistani family owned a farm nearby and let Semiya ride the horses they raised. Semiya became friendly with an Italian widow in her building who she referred to as *Oma*—Grandma. The Şimşeks' apartment shared a garden where children of all different backgrounds would come to play, frolicking between lines of clothes hung out to dry. "As children, we didn't think about whether another child was German, Italian, or Turkish," Semiya would remember. That garden, "it was our world together."

Enver worked on an assembly line in a factory during the week, and as a cleaner on the weekends. In 1992, he started a business of his own—a flower stand in the town of Schluechtern. The man who'd grown up near Turkey's City of Roses began pollinating his new homeland, employing nearly a dozen people to sell orchids, roses, chrysanthemums, and other flowers at different stalls, stands, and vans across Bavaria. Enver began his days before sunrise and often ended after the sun had set. On Monday nights he'd drive his truck seven hours to Amsterdam for the world-famous flower auction, the Royal FloraHolland, where he'd bargain for flowers, then haul them the seven hours back. By the summer of 2000 he needed a vacation, so he traveled back to Turkey with his wife, Adile, daughter,

Semiya, and son, Abdulkerim. It was there, in Isparta, that he and Semiya sat on the veranda and listened to the sheep bells ring.

In August, after Semiya and her brother returned to boarding school, one of Enver's flower sellers asked for time off to take a late-summer holiday of his own. Enver covered the man's shifts selling flowers from a Mercedes van on Liegnitzer Strasse, on the southern side of Nuremberg. The road was heavily forested, beautiful, and busy with cars. On the afternoon of Saturday, September 9, a customer pulled up to the white van emblazoned with the words "*Şimşek Blumen.*" There were some twenty bouquets laid out on a table, with buckets of stems on the ground. But Enver was nowhere to be found. The customer wasn't the only one confused. A couple had arrived a few minutes earlier and had been waiting in their car. After ten minutes passed without any sign of the seller, the couple drove off. The man waited five minutes longer, wondering whether something was amiss. The van was unlocked, and the flowers were sitting out in the open, for anyone to take. The customer decided to call the police.

When officers arrived, one tried to open the side door to the van, but it jammed. She gave it a firm tug, and it jerked open. Inside, amid a battery of bouquets—roses and daisies and baby's breath—she saw Enver lying on his back, soaked in blood. He appeared to have been shot in the head and in the right shoulder. In fact, he'd been shot eight times. By chance, the customer who had called the police was a paramedic. He felt for Enver's pulse and discovered it to be strong. Enver was still alive, but unresponsive, and wheezing for breath. The customer retrieved a sling from his car and helped the officers hoist Enver out. They inserted a suction hose down his throat, to keep his airway open. Minutes later, emergency responders arrived and rushed him to a hospital a couple kilometers away.

* * *

The sun rose as Semiya, her uncle, and the family friend raced from Semiya's boarding school toward Nuremberg. The two men told her little about her father's condition. He wasn't sick, exactly, but injured. As soon as Semiya walked into the hospital, a police officer stopped her.

"Are you Semiya Şimşek?" he asked. "Is Enver Şimşek your father?"

He proceeded to ask Semiya a series of unsettling questions. Incriminating

ones, like whether her father carried a gun and, even more worrisome, whether he had any enemies.

Enemies? What enemies? Semiya replied that her father owned an air pistol—a nonlethal weapon used for self-defense—and a pocketknife for cutting flowers. "I didn't understand anything at all," she would say of the officer's insinuating questions. "I just wanted to see my father." When the officer finally let her proceed to the hospital room, Semiya was shocked at what she saw. Enver was lying unconscious. "The pillow was covered in blood. I still had no idea what had happened, but I knew something really bad had happened. Something terrible."

Enver was surrounded by relatives and friends, but not one of them could offer Semiya an explanation. All they knew was that Enver had been shot. Semiya glanced around the hospital room for her mother, but Adile wasn't there. The day of the shooting, Adile had been selling flowers at a stand an hour and a half east of Enver. Around 9 p.m. she was home preparing dinner when two police officers rang her doorbell. Adile's German was limited, and the officers didn't speak Turkish, so Adile didn't understand. It seemed that something bad had happened to someone, but she didn't know to *whom*. Adile's brother arrived to translate: Enver was in the hospital with gunshot wounds. The two of them raced off to the hospital, a two-and-a-half-hour drive away.

By the time Semiya arrived, police had escorted Adile to a station across town. There, officers asked Adile whether her husband frequented bars of dubious reputation. Whether he drank, whether the couple had problems in their marriage. All while her husband was lying unconscious in a hospital bed, fighting for his life. When officers finally let Adile return, she, Semiya, and their relatives spent two days by Enver's side, praying he'd come back to life.

Semiya's younger brother, Abdulkerim, had been at a boarding school of his own.

"Something's happened to your father," a teacher told him, and handed him a train ticket to Nuremberg. At the hospital, Abdulkerim saw that his father's face had been totally destroyed by bullets. He would never forget when doctors told them that Enver "would probably not survive."

On September 11, 2000, thirty-eight-year-old Enver Şimşek took

his last breath. In the days that followed, family and friends flooded into the Şimşeks' home to mourn. Women read passages from the Koran, but Adile, widowed at thirty-six, cried and said little. Though he was only thirteen, Abdulkerim tried to comfort her. "Allah brings those he loves to him early, Mama."

Enver died on a Monday, but it wasn't until Friday that police released his body to the family, after the autopsy was complete. One week later, Semiya flew Enver's body back to Turkey, along with nearly twenty relatives and friends. They landed in the city of Antalya at night, then drove his coffin three hours along the dark country roads to Salur, Enver's hometown. Inside the Şimşek family home, they wrapped his body in linens and brought him upstairs to a bedroom, where relatives took turns spending a quiet moment with him to pray. When the time came for the burial, according to tradition, Semiya and her mother stayed back. From the house, Semiya could see her father's resting place from the same balcony where just weeks earlier she'd sat by his side. Abdulkerim and the men carried Enver's coffin to the cemetery and took turns shoveling dirt into the grave. A breeze carried the mourners' cries to the balcony, to Semiya's ears. It was the same breeze that had carried the sound of sheep bells. In Turkey, cemeteries are not planted with grass like in Germany, Semiya learned. Instead, the soil is left to do what it will, attracting stray seeds from the wind.

"Over the years, herbs and flowers grow on it and can flourish freely and wildly there," Semiya would later write. "When they move in the wind, it is said that sins fall away from the dead."

*　*　*

Back in Germany, when police examined the bullets and casings, they realized it hadn't been one shooter, but two. There were two different types of bullets—6.35mm and 7.65mm—shot by two different guns. The first came from a Browning pistol, though officers couldn't be sure which model. The latter had been shot from a distinctive, self-loading Česká 83 pistol. The gun featured a "blowback" action with a barrel that remained firmly fixed to the frame to minimize movement and increase accuracy. The safety and the magazine release are ambidextrous, meaning either a left-handed or a right-handed shooter could operate it with ease. One witness told officers

he'd seen two men on bicycles not far from Enver's van. "One man was wearing short cycling shorts and the other man was wearing a baseball cap," the witness said. Police didn't fixate on the lead.

When the Şimşeks returned from burying Enver in Turkey, police officers began visiting Adile. They asked her where she was on the day of the attack. Could she corroborate her whereabouts? Had anyone seen her there? Officers banged on the table, shouting at Adile to admit *she* was somehow involved. Adile would find some excuse to retreat to the kitchen to prepare the officers some tea, to cook—anything to get away. The stress of these interrogations took a physical toll. Sometimes she stayed in bed all day, exhausted. She suffered skin rashes and dizzy spells, and began to see a therapist. At one point she asked an elderly neighbor to keep an eye on her—"in case I was next."

When Abdulkerim pleaded with officers, saying their questions were disturbing his mother, police directed their suspicions at *him*, a fourteen-year-old boy who had been away at boarding school. When officers learned he'd called his father's phone on the day of the murder, he told them he'd called to see if his father was all right. But officers speculated that the real reason was to make sure Enver was dead—that the "hit" had been successful.

Officers quizzed Adile about a four-week pilgrimage to Mecca she and Enver had taken a couple years before. Afterward, Enver had begun using a prayer mat that he would place in the back of his van or under the large umbrella that shielded his flowers from the sun. Officers grilled Semiya, too. *How and when do Muslims pray each day?*

"Five times," she replied, and according to the position of the sun. *I have no idea what this has to do with the shooting of my father.*

Neither did the police. Rather, it was classic racial profiling: making insinuations or assumptions about people based on their race and, in this case, their religion, too. Because some drug traffickers in Germany were Turkish, all Turkish-looking people became suspect. Semiya wondered why police didn't consider xenophobia or racism as a motive. The idea that the shooters might be German did occur to the officers. But in the words of one investigator, "the focus was definitely on organized crime."

In reality, the killing looked more like *disorganized* crime—the work of

an amateur. The killers had shot at Enver nine times at close range—missing once—and still hadn't managed to kill him on the spot. What's more, the shooters had left behind "very large sums of money" in the van—cash in the front seats, a money pouch in back, bills in Enver's wallet. Nearly 7,000 deutsche marks in all, about $3,600. Neither opportunistic criminals nor organized ones tended to leave such sums behind.

When Semiya returned to boarding school, police found her there and questioned her about Enver's frequent trips to Amsterdam. Only later did it occur to Semiya that the nearby port city of Rotterdam was a global narcotics conduit. Enver's weekly travel to the Netherlands seemed to fuel officers' suspicions that he was trafficking drugs. Semiya knew the officers' theories—she'd read about them in the press. After Bavarian media broadcasted investigators' suspicions, some of Semiya's classmates began making light of her father's death, joking that Semiya's dad had been in the mafia. The Turkish press was no more scrupulous. Semiya was infuriated by a headline in the Turkish *Daily Sabah* newspaper that speculated: *Was the Turkish mafia behind the murder?*

Meanwhile, officers ransacked the Şimşek family home. "The police took pretty much everything that wasn't nailed down," Semiya recalled—documents, passports, briefcases, jewelry, medical documents, notebooks, shoelaces, cell phones. "What was particularly painful was that they took at least half a dozen photo albums. It felt like they were dragging away our memories of a happy life—everything that had once made up our family." Many of the photos were never returned.

Officers took DNA samples from Adile and the children. They enlisted drug-sniffing dogs to search Enver's flower vans for false floors or hidden cavities that might carry cocaine or cash. As weeks turned into months and as their searches turned up nothing, rather than discard their theories about organized crime for lack of evidence, officers doubled down. They asked Adile whether she'd had sex with her husband often, then lied to her and Semiya, saying that Enver had had a second family—a years-long secret relationship with a woman who gave birth to two of Enver's children. Officers showed Adile photos of a blond woman who they said was his mistress. Adile called their bluff, replying that the police should invite the woman and her children to move in with them—they would become

her children, too. But the officers' antics only grew. They showed photos of Enver to a woman who didn't even know the Şimşeks, attempting to get her to confess to having had an affair with him. The agony of losing Enver was compounded by the officers' lies.

At some point Semiya couldn't help wondering whether the officers might be right. These were the police, after all—this was their job. What if someone in the family *had* played a part in the murder? To Semiya, such suspicions never lingered long. But when she visited Turkey, she noticed that Enver's mother seemed to suffer the most. Enver "had led a life of which she knew little, in an unknown country, and one day he was murdered there. I can't remember a single day when she didn't cry."

For his part, Abdulkerim felt like he "grew up from one day to the next." He stopped playing soccer, and at school he tried to shrink away. He didn't tell anyone his father was murdered, and he hoped they wouldn't find out. Before his father died, Abdulkerim had never noticed xenophobia. Now he saw it everywhere—in the police officers' lies, in the way investigators and the media incorrectly referred to him and his sister as "foreigners." Born and raised in Germany, now he felt like he didn't belong.

Meanwhile, the family's flower business faltered. When a Turkish bank wrote to Adile informing her she could cash out her husband's stocks—money that could help the family—Semiya's uncle warned Adile that doing so might feed police officers' speculations that Adile had murdered Enver to get his money. And so Adile let the money be. The following year, the market crashed and the stocks became nearly worthless.

All the while, the interrogations continued. It seemed as if investigators, failing to crack the case, hoped the Şimşeks might do it for them. At one point they asked Adile, "Do you have any idea who could have killed your husband?" As if she'd known all along but it had simply slipped her mind. Police officers placed a bug in the glovebox of the van in which Enver was killed, to hear whatever the Şimşeks or their employees discussed. Officers wiretapped the family's phone and listened in. For *ten months*. They asked the Şimşeks' neighbors how long Adile had cried over her husband, as if to ascertain whether her sorrow was real. But Adile's tears didn't stop. "The pressure did not let up," Semiya would recall.

"Then came the second murder."

Chapter 10

Dead of Summer

Afew days before Christmas 2000, around 5:30 p.m., one of the Uwes—Beate would later claim it was Böhnhardt—entered an Iranian-owned grocery store on Probsteigasse, a short one-way street in an historic district of Cologne. He paced about, placing groceries in a wicker shopping basket that he'd brought with him. It contained a bag of peanut snacks, a bottle of whiskey, and a festive red tin decorated with golden stars and a blue ribbon that normally would contain stollen—a German sweetbread baked with dried fruits, nuts, and spices and dusted with powdered sugar. When Uwe reached the checkout counter, he told the cashier he'd forgotten his wallet at home. He set his basket down and told the cashier he'd be right back. Minutes went by, then hours. One of the shop's owners placed the basket in a back room. Days passed. Christmas came and went. Then New Year's Eve.

The family that owned the store had fled political persecution in Iran, and Germany gave them asylum, and eventually made them citizens. On the morning of Friday, January 19, Masha, the oldest of her four siblings, was looking forward to going out dancing with her friends that night. She'd even selected her outfit. She was nineteen, just a few months away from her high school graduation. Early each morning her parents brought her and her siblings to the store before sending them off to school. It was still dark outside when they reached the shop at 7 a.m. Masha wandered into the back room of the store and saw the red box of stollen, which ought to have been eaten weeks earlier during a Christmas dinner. Masha had noticed

the box earlier, but her parents had told her not to open it, in case the man returned. More than a month had passed, so Masha decided to open it at last. She lifted the lid and peeked inside. Instead of stollen, she saw what appeared to be some sort of gas canister connected to wires. She quickly shut the lid, but it was too late. By opening it, she'd triggered the bomb.

* * *

Several months earlier, in the summer, the three fugitives decided to leave Chemnitz behind and resettled to Zwickau, forty-five minutes to the west. Much smaller than Chemnitz, the town suited them well—so well that the two Uwes would live out the rest of their lives there. All eleven years they had left.

The friends eventually settled in the Marienthal district. Rumor had it that nearby lived a tattoo artist who was willing to ink illustrations that could land you in jail—swastikas and other Nazi symbols. The four-bedroom flat at Polenzstrasse 2 was one block south of a main street, a short walk north of the train yards. Beate would cook meals and wash the boys' laundry. She often chatted and smoked with neighbors while the Uwes were away. They knew her by the alias Susann, or sometimes Liese. An Afghan family lived in their building, but if the terrorist trio resented them, the family didn't notice. Once, when two children overheard the Uwes in the stairwell talking about guns, Beate lied to the kids that "Gerry" and "Max"—the Uwes' aliases—belonged to a rifle club.

Just as in Chemnitz, in Zwickau the trio received help from their far-right friends, including a man named André Eminger. Born in 1979 an hour southeast of Zwickau in the Ore Mountains that separate Germany from the Czech Republic, by his early twenties Eminger had shaved his head and was listening to right-wing music. As if to ensure that nobody would misconstrue his politics, he had the words "Die Jew Die" tattooed on his chest. Eminger had met the trio through Max-Florian Burkhardt and quickly came to admire them: three fascists who didn't merely *talk* of their hatred for foreigners but did something about it. Eminger decided to help. He had signed the lease on the trio's first Chemnitz apartment, and now he and his wife, Susann, signed the lease in Zwickau as well. Eminger also bought the trio train passes and rented camper vans that the Uwes used for their robberies.

By this time, the trio had perfected their tactics. They'd enlist a co-conspirator like Eminger to rent a van, then park it some distance from the location they intended to hit. They'd take a pair of bicycles out of the van, cycle to the bank or the post office, and rob it at gunpoint. Mundlos usually kept watch over the customers while Böhnhardt jumped over the counter to grab the cash. They'd cycle back to the van and hide inside it for hours until the coast cleared, then drive off. They robbed a Chemnitz post office this way on November 30, 2000. The following month, Eminger rented them a Fiat Caravan, this time for an even more sinister purpose. The trio had been building a bomb—a real one, not a dummy bomb or a bomb that was missing a detonator. And unlike the bombs they'd left across Jena, this one would explode.

To build it they'd emptied a gas cartridge and refilled it with over a kilogram of gunpowder. They inserted six 1.5-volt batteries, which they connected to the gas cartridge using a copper wire. At the end of the wire was an ignition device. They placed insulation on the lid of the red stollen box to interrupt the flow of electricity. When someone opened the lid, the insulation would slide out and the current would flow, causing the bomb to explode. In December, the two Uwes hopped in the van Eminger rented and set off to find that someone.

They drove west past the southern outskirts of their hometown. Their destination was the wealthy city of Cologne, Germany's fourth largest. Cologne was known for attracting tourists from all over the world to its magnificent cathedrals, sprawling parks, and legendary Carnival parade.

It was also known for being a city of immigrants.

* * *

When Masha opened the red box of stollen, the force of the explosion shattered the pressurized gas can, shredding the metal tin into sharp pieces. The shrapnel ripped through Masha's face. She was raced to a hospital. Five percent of her body was burned—her face, her right hand, both her arms and legs. The bomb also fractured the orbital bone in one of her eye sockets.

Police asked Masha's father to describe the man who'd walked into the store nearly a month earlier. He looked to be "25–26 years old, approximately 175 to 180 cm tall, slim." He was clean-shaven, with protruding

cheekbones. He wore a white T-shirt and light-colored jeans. He spoke *Hochdeutsch*—formal German, without a distinct regional accent that might identify where he was from. And he was white. He "had medium blonde hair, somewhat longer at the nape, curled at the sides." The man's hair receded slightly at the front. An artist created a rendering of the suspect. But the long wavy hair he sketched had probably been a wig.

Masha spent weeks in a coma. Doctors operated several times to treat the severe burns and cuts across her face and body. Later, they performed plastic surgery. Eventually Masha's parents renovated and reopened the grocery store. Masha graduated high school and received her *Abitur*. Her life, which had so nearly been robbed from her, went on. But it was a life under scrutiny. Officers investigated the family's finances, presumably to look for suspicious sums of money that might lead to a clue. They tapped the family's phones, even Masha's, to listen in for incriminating details. Officers asked whether anyone had ever threatened Masha's father. They asked whether the family engaged in political activities, either in Germany or back in Iran. At one point, investigators even speculated as to whether the Iranian secret service might have been behind the attack.

Just as with Enver's murder in Nuremberg, police in Cologne never connected the dots—never so much as suspected that whoever planted the bomb might be one of the same people who had planted bombs all over Jena. They speculated instead that the bomb was the work of a mentally ill, lone perpetrator. A year and a half after the bombing, prosecutors closed the case, unsolved. By that time, the perpetrators had become serial killers.

* * *

Abdurrahim Özüdoğru was twenty years old when he emigrated from Turkey to Germany in 1972 on a scholarship to study mechanical engineering. Abdurrahim quickly learned German, earned his degree, and found a job at a company in Nuremberg, where he would spend the last twenty-six years of his life.

In 1980, Abdurrahim married, and he and his wife opened a tailor shop on Gyulaerstrasse, though it didn't earn them much money. It was more like a hobby than a job. They soon had a daughter named Tülin, which in Turkish means "halo around the moon." To Tülin, her father was "a very

cheerful, hardworking, open person." As a toddler, whenever Abdurrahim would come home from work, Tülin would stamp her feet angrily to protest that he'd left. "I could not bear to be away from him for even a few hours," she recalled.

Abdurrahim and his family celebrated Christmas with their German friends, and invited them over to celebrate the Muslim holiday Eid al-Adha.

"I breathed the same air as everyone around me, visited the same Christmas markets," Tülin recalled. "I was born in Germany and as a German citizen, Germany is my home."

When Tülin learned about the Holocaust in school, "it affected me strongly... The fact that people were murdered because a right-wing ideology declared them to be different, inferior—that shook me deeply."

Echoes of Germany's racist past would reverberate into her life one summer night in June 2001. That evening, a passerby glanced in the window of her father's tailor shop and noticed a man lying on his back, his clothes stained with blood. He phoned the police. It was 9:30 p.m. when officers arrived. There was a bullet hole through Abdurrahim's right temple and a trail of blood that left a pool on the floor. His body was already cold. When paramedics arrived, they pronounced him dead. He'd been shot twice in the head. He was forty-nine years old.

Forensic specialists determined that the 7.65mm bullets that killed him had been fired from the same Česká 83 pistol used to kill Enver Şimşek less than one year before, just a twenty-minute drive across town. Police immediately speculated that the murderer might be an immigrant drug trafficker. Officers searched Abdurrahim's apartment with drug-sniffing dogs, to no avail. They wondered whether his murder might be the work of the Grey Wolves, a fascist Turkish paramilitary gang that they believed—incorrectly—Abdurrahim may have been affiliated with. Just as with Enver's murder and the bombing in the Iranian supermarket, officers didn't think of immigrants as victims, but as criminals.

Tülin never doubted her father was innocent: "He had no enemies. He had no quarrels with anyone. In fact, you could always see him smiling... Even in the last days of his life, there was nothing that worried him or that he was afraid of."

Tülin suspected that her father's killer might have harbored some sort of hatred of immigrants, or Turks. She didn't *want* to believe it—didn't want to think her dad was murdered because of where he came from or the color of his skin. But no other explanation seemed to make sense. Like Masha and like Semiya Şimşek, Tülin had been nearing her high school graduation. After the murder, she dropped out of school. A full year passed before someone persuaded her to go back and finish her studies.

"Tülin, you used to shine, you gave people hope, you were the *sun*," the friend said. And just like the sun: "You must not go down" for good. Tülin pulled herself together, returned to school, and graduated. But life would never be the same. Before her father's death she'd had hobbies, written poetry, and listened to music. Afterward, she didn't turn on the radio for years. Tülin wasn't the only one who changed. The people around her did, too. Tülin could see it in how they treated her. Friends she'd known for years suddenly no longer greeted her. Perhaps they were afraid of associating with someone whose family was nefarious enough to have warranted a murder.

* * *

Two weeks after Abdurrahim's killing, a seven-hour drive north from Nuremberg, a man named Süleyman Taşköprü was about to be next.

Born in Istanbul in March 1970, Süleyman was two when his father moved to Germany to weld ships in the port of Bremerhaven on the North Sea.* His father later relocated to Hamburg and his mother, Hatice, little brother, Osman, and little sister, Ayşen, followed. But Süleyman had such excellent grades that his teacher begged his parents to let him stay behind with his grandmother to finish school. Still, Süleyman missed his parents, and at eleven he moved to Germany to live with them. They settled in Hamburg's Altona district, where Süleyman began playing soccer and backgammon. His friends called him Sülo for short. He became a fan of the American actor Sylvester Stallone, and when he visited Hollywood

* After World War II the U.S. military maintained a large presence at Bremerhaven. Soldiers stationed there could import American-made cars, or ship German ones—Audis, BMWs, Mercedes—back to the States.

to see Stallone's star on the Walk of Fame, he declared that he wanted to be commemorated with such a star one day. His wish would come true far too soon.

In the early 1990s, Süleyman found a job working for a Japanese camera company and moved into a place of his own. Though he was five years older than Ayşen, she acted like a big sister to him. Whenever Süleyman had problems, he'd call her to talk it out. To Ayşen, her brother was stubborn and determined, but he had a generous heart. Süleyman would send his little sister giant boxes of candy and marshmallow cakes, and bouquets of flowers to his mom. He was twenty-eight years old when, in 1998, a German woman he had been living with gave birth to their first child, a daughter they named Aylin. Süleyman's father, Ali, admired how tenderly his son cared for Aylin, gushing over her as she spent hour after hour in his lap.

His daughter's birth changed something in Süleyman. After some years living away from his family, he moved back to Altona to be closer to them. In the early winter months of 2001, he took over management of his family's vegetable store on Schützenstrasse, which also sold some canned goods and beverages. A sign out front read "Taşköprü Market." It had a single room of about twenty-five square meters. But to Süleyman, those twenty-five square meters housed a hectare of pride. His sister, Ayşen, was impressed to see him put his energy into rearranging the store's items to make them more intuitive to customers and conjuring up new products to sell. Most of their customers were white Germans, but some were of Turkish heritage. Students who lived in the area also frequently came in.

Süleyman was working the counter June 27, 2001, when, around 10:45 a.m., he sent his father, Ali, out to buy some olives. Ali returned thirty minutes later, and as he parked his car on the street, he noticed two men leaving the store. One of them was tall—around five feet ten inches. He didn't see whether they were Turkish or white. When he walked into the store, he saw dark splotches behind the counter.

"Son, did you spill something here?" he called out. Süleyman didn't reply. When Ali walked farther into the store and looked down, he found his son on the floor, blood pooling on the white tile beneath him. Ali pulled Süleyman into his arms. He tried to say something to his son but

couldn't find the words. He could feel his son was still alive. But the feeling didn't last more than an instant. Ali raced out of the store to a nearby butcher shop, where he told the woman behind the register to phone an ambulance and the police. Medics performed CPR and tried to suction the blood out of Süleyman's nose and mouth. They were too late. Süleyman's body was wrapped in a wool blanket and left for the police. He was thirty-one years old.

It took the police half an hour to arrive. The press got there first, as did Süleyman's brother, who collapsed on the ground in grief. The cashier from the butcher shop watched as one reporter nearly accosted the grieving man—to interview him or to photograph him, it wasn't clear. The sight of it made the butcher so angry that she began pelting the reporter with eggs. Officers discovered one 7.65mm bullet casing shot from the same Česká 83 pistol, as well as two 6.35mm bullets shot from a different type of gun. The bullets had ripped through Süleyman's head. A coroner found no indications that Süleyman had put up a fight. He hadn't had the chance.

Süleyman was the second Turkish immigrant to be murdered in just fourteen summer days. He left behind his three-year-old daughter. To memorialize their slain son, brother, father, the Taşköprü family embedded a memorial into the sidewalk in front of the family's store: a red, five-pointed star, with a photo of Süleyman's face in the middle. It was a replica of Sylvester Stallone's star on the Hollywood Walk of Fame. The one Süleyman had always wanted.

In the days that followed, the Hamburg police employed the same tactics as their colleagues had in Nuremberg and Cologne. Officers interrogated Ayşen about her brother and father's relationship. *Did you have a fight? Did you have arguments? Is it your code of honor?* By which they meant: *Was it an honor killing? Is there a Turkish code of silence that keeps you from admitting it to police? Isn't it customary for Turks to kill each other?*

"No, it isn't customary!" Ayşen shouted back.

Then came questions about debts, drugs, the mafia. Officers wondered whether Süleyman had been a drug dealer or a pimp. They asked about Ayşen's bank accounts, and about her ex-husband.

"What does this have to do with the death of my brother?" Ayşen asked.

As the officers questioned others in the neighborhood, their wild theories began rubbing off. People began speculating to Ayşen's parents that Süleyman had been involved in the mafia or drugs. With time, Ayşen began to wonder if the officers were right.

What have you done, for this to have happened to you? Ayşen wondered. To her, that was the worst thing of all—that she began to have suspicions about her own brother. She implored the police to check into other leads. She told officers that in the days prior to the murder, two white men in suits drove by the family's vegetable store repeatedly. At the time, she'd asked Süleyman, "Have you done anything? Are those plainclothes policemen? Why do they keep driving past?"

"Why are you talking bullshit?" her brother had quipped back, and Ayşen decided to drop it. Rather than pursue the lead, officers began showing Ayşen photos of people she knew—not white people, just those with Turkish or Middle Eastern features—to see how she'd react. But if when police looked at these faces they saw *suspects*, when Ayşen looked, all she saw were *people*.

When officers interrogated Süleyman's father, Ali, they used Ayşen as an interpreter—the police department hadn't bothered to retain Turkish-speaking officers. Their racism seeped into their official reports. One officer from the Hamburg state criminal police would say that Süleyman Taşköprü was "what we state detectives call a normal Turkish man—passionate, very energetic, and dominant in nature." Police even posed as journalists to interview relatives to try and eke out information they might be withholding. One witness told officers that she saw two men flee the scene on bicycles. The officers didn't follow up.

* * *

Two weeks, two different murders. Two months would pass before the next.

Pinar Kılıç was born in Ankara, but when she turned ten, she moved with her mother to Bavaria, Germany, where her mom landed a job as a chemist for the German industrial conglomerate Siemens. One summer while on holiday back in Turkey, Pinar met a man.

"He was charming and handsome, and I liked his friendliness," Pinar

remembered. In 1985, she married him. Habil Kılıç was twenty-two at the time. Born and raised in Turkey, he decided to follow his wife to Germany, but the immigration process was slow. It took years for his visa to get approved. At last, in 1988, Habil followed in his wife's footsteps, to Munich, and eventually landed a job as a forklift driver in a food market hall. He began work at 3:30 a.m., moving products into place before the first customers arrived. But Habil felt unsettled in Germany. He struggled with the language, struggled to find consistent work, and on numerous occasions told Pinar that they should leave.

"We have to go back to Turkey. I'm a zero here. Nothing," he said.

But Pinar liked Germany. She had her mother, a job, German colleagues, German friends. She was working in retail and had become an expert in selling traditional Bavarian clothing. "I was probably the only Turkish woman in Germany selling *Dirndl* and *Seppelhosen*." She wasn't about to give it all away. In March 2000 they applied for a permit to open a produce market in a storefront beneath their apartment. The store was on a bustling road in Munich's Ramersdorf district, with a police station just a hundred meters away. The couple settled into a busy routine. In the afternoons, Pinar would pick up their daughter from school and prepare dinner while Habil worked in the store. On Saturdays he ran the store alone so that his wife could sleep in. He even worked there after his grueling 3:30-a.m.-to-noon shift at the market hall. During the summer months, Habil kept the store's front door open, allowing customers to flow in and out with the afternoon breeze.

In late August 2001, a year after they opened the shop, Pinar and their ten-year-old daughter went on holiday to Turkey while Habil stayed back to work. On Wednesday, August 29, shortly after 10:30 a.m., the store was empty of customers and Habil was standing behind the counter when somebody came in, pointed a gun at his head, and fired two shots. The first entered his left cheek. The second entered the back of his head. He fell to the ground and died nearly immediately. He was thirty-eight years old.

Hours passed before Pinar received the news. They were on their way to the beach when Habil's brother received a phone call and turned to Pinar:

"Your husband is very ill."

Pinar phoned a friend of hers in Munich to find out more.

"You have to come to Germany immediately," she told Pinar. But she didn't say why. When Pinar landed in Munich, her mother and a friend picked her up at the airport.

"You have to remain very quiet now," one of them said, trying to calm her, before telling her that her husband had been shot. Pinar raced straight to the police station, where officers offered her coffee. Then, rather than tell Pinar what happened, they proceeded to interrogate her.

"My daughter and I were in Turkey," she told the officers. What could she possibly tell them? The days that followed were full of questions, but not answers. Police turned the family's apartment upside down, smeared the walls and the furniture with black powder—dust to search for fingerprints. When they gave Pinar back her keys to the store, she was horrified to discover "they'd broken everything—everything." They'd even left her husband's blood on the floor. Pinar had to clean it up herself.

Police detective Josef Wilfling hypothesized that the killer—or killers— might be professional hit men. The location was brazen—just a hundred meters from a police station. And because Habil had left the door open to let in the breeze, the assassin hadn't even needed to place his hands on the glass. The shooter had even managed to collect the bullet casings, presumably to prevent police from identifying the murder weapon. Officers found a small piece of plastic and theorized that the assassin had fired the gun from inside a plastic bag in order to catch the casings. Whoever the shooters were, they seemed to know exactly what they were doing—as if they'd killed before.

When coroners inspected Habil's body they found the two 7.65mm bullets that had ripped through his skull. They'd been fired by a Česká 83 pistol, the same model used in the three earlier murders. Detectives interviewed nearby residents—mostly immigrants from Turkey and their children. Some suggested the murder could be the work of the Kurdish military group the PKK, or the Grey Wolves, the same Turkish paramilitary gang that officers in Nuremberg had incorrectly suspected Abdurrahim of having ties to.

Two witnesses told officers that they'd seen two men, twenty to thirty years old, flee the scene on bicycles. They were clean-shaven, with short hair. They wore black cycling clothes and cyclists' gloves. The bikes were

black with thin tires. One of the men carried a backpack. One witness said the men looked like bicycle couriers. It seemed to one witness, who herself was of Turkish heritage, that the men had a slightly darker skin tone—that they were perhaps eastern European, not German. "Our kind," she said. Only later did she acknowledge she probably hadn't seen their skin tone at all—they were too heavily clothed. But police treated the phantom cyclists not as suspects, but as potential witnesses, and didn't manage to track them down.

Unlike with the other three murders, this time officers in Munich did consider the possibility that the killers might be white Germans with a far-right, xenophobic motive. But the shooting didn't *feel* like the handiwork of neo-Nazis, whose killings tended to be "brutal, loud attacks, and whose perpetrators made no effort to conceal it," Detective Wilfling would later tell a court. In contrast, Habil's killers left no trace and made no statement, no proclamation of any political cause. "And let's not pretend there *isn't* a Turkish drug mafia," Wilfling would add, in defense of officers' ethnic profiling. With no real leads to work from, at the end of 2002, police closed the case, unsolved.

But Pinar had no closure, no answers. Without the income from the produce store, she ran out of money and was forced to sell it. Her meager government pension of 177 euros per month wasn't enough to pay rent, so she moved to a cheaper part of town, a move that uprooted her daughter, who had to change schools. At work, Pinar's colleagues began showing her newspaper clippings with police officers' suspicions that drugs or gangs were to blame. The thought that white Germans might have murdered her husband never occurred to her. Pinar had always felt at home in Germany. Suddenly she felt harassed and unwelcome instead. One day somebody slashed the tire of her car.

Pinar felt guilty, as if she were somehow to blame for her husband's death. When Habil had pleaded to return to Turkey, it was Pinar who had insisted they stay. And now, on account of the officers' suspicions, Pinar felt like she was a suspect in her own husband's murder. Still, she trusted what the officers told her.

If the police think it was someone from the family, then there must be something to it, she thought.

Chapter 11

Twenty-First-Century Terror

One day in Dortmund, Mehmet Kubaşık was walking down the street when a stranger insulted him, calling him a "stupid immigrant," or something to that effect. His wife, Elif, bristled, but when it came to confrontations, Mehmet was more like his daughter, Gamze. Just as she hadn't held a grudge when a teacher accused *her*, instead of a white girl, of putting gum in a classmate's hair, Mehmet brushed it off.

All through the 1990s, as German white supremacists radicalized and directed more anger at immigrants, the Kubaşıks went about their lives without a second thought. In school, Gamze quickly learned to speak German, and by second grade she had become her parents' personal interpreter, translating notes her school sent home, doctor's appointments, bills. In 1994, when Gamze was nine years old, Elif gave birth to a baby brother, Ergün. At first, Gamze competed for her father's attention, and Mehmet responded by taking care not to cradle Ergün while she was in the room. But when another younger brother, Mert, was born in 2000, Gamze learned to care for them both. She would hold Mert and walk him to kindergarten and back.

Despite Mehmet's affection for his sons, "he had a very close relationship with his daughter," Elif remembers. On hot summer days, Gamze would ask her father, "Can we get ice cream today?" Later, she'd implore him, "Can we get ice cream *again*?"

"He couldn't say no," Gamze recalled.

"My parents would often have disagreements about me because I would always get what I wanted. My mother would sometimes get angry at my

dad because he would buy me everything." Years later, when Gamze was in high school, "I was the first one to have a cell phone in my grade."

To Gamze, her father was "a cheerful man" whose sense of humor put others at ease. Whenever they had friends or neighbors over, she'd hear them laughing loudly at Mehmet's jokes. "We laughed a lot, and I loved the stories that he told." Her friends envied her. "Your father is so great," they would tell her. "All my friends usually had closer relationships with their mothers. But I was always more of a daddy's girl. I would always come to *him*, to ask for things, or ask questions."

Mehmet was also a friendly face to Dortmund's growing Kurdish community: "Everyone, whether small or big, young or old, liked him," Elif recalled. Neighbors would flock to the family's living room, where Mehmet would entertain them. He'd cook for the family when Elif needed a break. Sometimes, Mehmet's generosity was too much for his wife. Whenever someone from the neighborhood asked for a favor, Mehmet would stop what he was doing and rush out of the house to help. He loved to drive around in his red BMW, and sometimes the family would pile in together and hit the road to places like Paris.

Since receiving his work permit in 1993, Mehmet had worked various jobs, from construction to selling fruits and vegetables wholesale. Later he became a döner deliveryman, but he suffered a stroke and a doctor told him to stop lifting heavy things. Mehmet was out of a job. With too much time on his hands, his mind began drifting toward his homeland and his family back in Turkey.

"Will I ever see my parents again?" he once wondered aloud. If the Kubaşıks went back to Turkey, they'd have little protection from the Turkish government, whose anti-Kurdish actions had chased them away. But after Germany's SPD trounced the conservative CDU in the 1998 elections, lawmakers passed a landmark dual citizenship law. The Kubaşıks applied, and in 2003, twelve years after they'd fled to Germany, they received German citizenship and passports, and Gamze's parents earned the right to vote. Gamze, who was seventeen at the time, hadn't noticed she was different to begin with. Her Turkish passport had been red, like the German ones. "But for my parents it was very important," she knew. At last, they were every bit as German as their neighbors and friends.

But not everyone saw it that way. A decade after the 1993 Asylum Compromise, two-thirds of Germans favored immigration quotas, and in 2004, 61 percent believed there were too many immigrants living in Germany. But if some Germans felt the country was inundated with immigrants, economists worried there were too *few*. By the turn of the millennium, Germany boasted Europe's largest economy. But its native-born population—its workforce—was declining faster than nearly any other nation on earth. At just 1.4 children per woman, Germany's birthrate was even lower than in China under the "one-child policy," where the birthrate was 1.6. Germany desperately needed immigrants to fill jobs, pay taxes, and to finance the nation's robust social security programs. Fortunately, due to the EU's principle of freedom of movement and Germany's reputation as a great place to find work and to live, by the early 2000s some 7.5 million foreigners—9 percent of the population—called Germany home.

Germany had become a nation of immigrants. But across the Atlantic, a country that had long claimed that moniker was about to undergo a drastic change. Four planes were barreling toward New York and Washington, D.C. The way the West viewed immigrants—and terrorists—would never be the same.

* * *

Katharina König was at home in Jena when she got a call telling her that planes had crashed in New York City. It was a Tuesday afternoon, and the JG youth club was about to start its weekly meeting at her father's church. When she arrived, people were watching on TV, horror-stricken, as airplanes crashed into the World Trade Center in New York City, the Pentagon near Washington, D.C., and into a field in Pennsylvania.

"It *looked* like an Islamist terrorist attack," Katharina thought. Among the forty or so people at the church that night were five Muslims—immigrants from Algeria, Morocco, Palestine.

"This will be trouble," one of them said.

"He didn't mean for *all* of us," Katharina recalled. "He meant, for *us Muslims*."

He was right. Anti-Muslim sentiment exploded. Semiya Şimşek overheard people bad-mouthing Muslims, saying things like the Koran

instructs Muslims to kill Christians in order to go to heaven. Sometimes, Semiya snapped back that this was nonsense. Although the Şimşeks were Muslim, Semiya knew the Bible—her mother, Adile, had read passages to her as a child. *Why don't Christian Germans read the Koran and learn for themselves?*

For their part, German lawmakers began paying more attention to Islamist terror. In 2000, Angela Merkel was elected to lead Germany's CDU party.* Merkel urged voters that "an aging society naturally needs immigration, orderly immigration." The CDU branded itself as ideologically conservative and economically liberal. But when it came to immigration, ideology trumped economics. After 9/11, CDU legislators passed a comprehensive new immigration law that made it easier to deport foreigners under the auspices of national security. Though not nearly as sweeping as the Patriot Act, which drastically—and in some cases unconstitutionally—expanded intelligence gathering in the United States, including spying on American citizens, Germany's new terrorism law also fixated on Islamist groups. Another provision made it easier for authorities to declare religious extremist groups illegal. Border agents were told to collect biometric data—fingerprints and iris scans. Germany's Federal Office for Migration and Refugees could begin transmitting foreigners' data to the police.

Katharina König thought Germany was tracking the wrong terrorists. More than three years had passed since she set off to Israel on what was supposed to be a six-month stint volunteering at the home for Holocaust survivors. When it ended, she couldn't bring herself to leave. Six months turned into nine, then twelve, then fourteen. Finally, when her grandparents asked the family to celebrate their fiftieth wedding anniversary, in March 1999, Katharina bought a ticket home. Back in Thuringia, she recounted to her family and friends how shocked the Holocaust survivors were to learn that Nazis still existed in Germany—and that authorities did little to stop them.

* On the campaign trail, Merkel found herself surrounded by xenophobes. While she was campaigning in the state of North Rhine-Westphalia, the state's CDU party leader demanded "*Kinder statt Inder*"—"Children not Indians"—in opposition to Southeast Asian computer scientists who he claimed were being given work permits and jobs in Germany's burgeoning IT sector at the expense of native Germans.

What has your government learned?

Their question reverberated inside her head. Far-right extremists believed Germany's attempt to atone for the past had gone too far. "Our grandfathers were not criminals," read the banner her hometown skinheads had held outside an Erfurt courthouse. Germany's white supremacists didn't want to *forget* the past—they wanted to rewrite it. But it wasn't just the neo-Nazis. In a 2002 survey, just 3 percent of Germans said they believed their relatives who had lived through the Holocaust had been "anti-Jewish." Only 1 percent thought it was possible those relatives "were directly involved in crimes" against Jews. If Germans couldn't admit what their forefathers had done, how would they learn from history and stop white supremacist terror from happening again?

Back in Jena, Katharina discovered that attacks against immigrants hadn't ceased in her absence. Among the victims was one of her friends. On three different occasions, Kalemba Mukomadi, an asylum seeker from the Democratic Republic of Congo, was attacked by neo-Nazis. The first time, he was hanging out on his doorstep in Jena's Lobeda neighborhood when men approached him with knives. The second time he was beaten badly enough to leave bruises on his head and ribs. The third time, he was with Katharina and Lothar on Father's Day when neo-Nazis stormed the church courtyard, dragged out a Palestinian man, and tried to hit him over the head with a bottle. They slammed Katharina's arm into the heavy wooden church door and dragged Lothar out front, beating him and Kalemba in the street.

Thuringia's far-right extremists were armed and ready for a fight. In January 2001, three years after the trio fled, legislators asked Thuringia's interior minister, Christian Köckert, how many guns and bombs police had confiscated from far-right individuals in recent years.

"In the past five years," Köckert replied, "a total of seven such finds were made in the right-wing extremist area in the cities of Ilmenau, Gotha, Jena, Lobenstein, Eisenach and Arnstadt. A total of three alarm pistols"— a self-defense weapon that fires nonlethal bullets or blanks—"one [real] pistol, five 'pipe bombs,' one gas cartridge filled with a black powder–like mixture and 3,900 grams of commercial explosives were found." Some far-right extremists were employing these weapons to attack immigrants.

Months earlier, on August 10, 2000, in the town of Eisenach, the door to a Turkish snack shop had gone up in flames. Police determined that someone had rigged a homemade bomb to the door—a commercial-grade CO_2 gas cartridge filled with black explosive powder. And yet Köckert somehow concluded that while "serious acts of violence by violent lone perpetrators cannot be ruled out in the future," currently "there are no indications of a concrete threat."

"The state government has no knowledge that Thuringian right-wing extremists are involved in right-wing terrorist activities," he claimed. In response to a question about the three fugitives from Jena, Köckert replied, "The manhunt continues. The suspects Mundlos, Zschäpe, and Böhnhardt are still on the run."

Three months later, a magazine that monitors far-right extremists published a paragraph about the "bomb tinkerers" of Jena, who'd fled three years before.

"The THS members Uwe Böhnhardt, Uwe Mundlos and Beate Zschäpe were able to escape; they have not been apprehended to this day," the magazine wrote. But with time, the media forgot about the fugitives. And so did Katharina.

* * *

For Gordian Meyer-Plath and Germany's intelligence community, the fallout from 9/11 was enormous. America had failed to prevent the attacks in part because the FBI and the CIA had refused to share intelligence. Instead of collaborating, they competed. The consequence was 2,977 dead civilians—the deadliest terrorist attack in U.S. history.

Meyer-Plath wondered whether Germany's own intelligence community might do any better if terrorists tried something similar there. "In the late '90s, there was not a lot of trust between the intelligence agencies and the police" in Germany. But 9/11 was a wake-up call about the grave consequences of failing to collaborate to the extent the law allowed—"the biggest watershed in how security agencies and how police work together," Meyer-Plath saw.

"Unfortunately, this watershed came too late" to stop the terrorists from Jena.

After 9/11, Meyer-Plath returned from Bonn to Brandenburg to head its political extremism unit. Over the next two decades, Germany's intelligence workforce would nearly double. Their use of informants grew, too, but based upon a problematic premise: that snitches were the only way to stop terror. "You won't get really good information without having someone within that group," Meyer-Plath believed. "Or two. One might be a crook and not tell you everything."

But Germany's proliferation of far-right informants was about to backfire spectacularly. Months before 9/11, in January 2001, German legislators and cabinet members under then chancellor Gerhard Schröder had petitioned Germany's highest court to ban the NPD, the far-right party that Brandt and Wohlleben had joined, on grounds that it sought to overthrow Germany's democratic order.* But in March 2003, the court rejected the ban for a revealing reason. Germany's intelligence agencies had recruited and funded so many informants within the party's ranks—some thirty of the NPD's two hundred leaders, one out of every seven—that the court couldn't discern which of the party's anticonstitutional ideas belonged to its genuine members, and which were planted there by government spies. This should have been a stark and humiliating lesson about the overuse of informants, but Meyer-Plath's faith in the system wasn't shaken. Germany *needed* these informants to protect the public from extremist threats.†

But this was only true if Germany's intelligence agencies could be trusted to act on the intelligence they received. When it came to the trio from Jena, time and again, agents did nothing at all.

"The secret service believed they had those informants under their full control and that they were playing a game with them, like playing chess," one observer of Germany's intelligence apparatus would say. "Believing those informants were pieces with whom they could play, they didn't take

* Between 2002 and 2012, 110 elected NPD officials would be charged with 120 crimes while in office—mostly physical assaults and illegal possession of weapons and explosives, as well as robbery and blackmail. Daniel Koehler, "Right-Wing Extremism in Germany," chapter 2 in Arie W. Kruglanski, David Webber, and Daniel Koehler, *The Radical's Journey* (Oxford: Oxford University Press, 2019).

† Later, in 2017, a second attempt to ban the NPD would fail when judges ruled that the party had become too uninfluential, too insignificant to pose a serious risk to democracy.

into account that it could be just the other way around"—that the informants were toying with *them*.

* * *

After each murder and bombing, Beate would sit at home and record the TV news footage that followed, which the trio would splice into a video compilation. By 2002, they'd produced two versions of a video manifesto with footage from their four murders. The manifesto claimed they were part of a larger movement: the National Socialist Underground, or NSU. It was Mundlos who came up with the name. They spelled out the NSU's aims in a letter: "The National Socialist Underground embodies the new political force in the struggle for the freedom of the German nation." Its mission entailed "vigorously combating the enemies of the German people." Its motto was "victory or death." In 2002, the trio sent a version of the letter to several neo-Nazi publications, introducing themselves to Germany's far-right scene.

"The NSU will never be contacted through an address...this does not mean, however, that it is unapproachable." Enclosed with the letter was money—likely loot from the robberies. One of the neo-Nazi magazines that received a copy publicly thanked the NSU in its pages.

How could such an extensive network of neo-Nazis, which announced itself so brazenly, go unnoticed by the intelligence agencies? The language of the letters—"Network of comrades," "national organization"—ought to have indicated that the NSU was much larger than just three neo-Nazis on the run. But years would pass before investigators concluded that the NSU operated with the help of at least three dozen male and female neo-Nazi supporters, using assumed identities, passports, driver's licenses, and health insurance cards of their friends—people like Wohlleben, Schultze, the Emingers, and Mandy Struck.

The trio turned to these collaborators whenever times got tough. As the year 2001 drew to a close, so too had the German deutsche mark, which on January 1, 2002, was replaced by the euro. This posed a challenge for the NSU. All the money they'd stolen was in deutsche marks. They needed to convert it all to euros—quickly, and without getting caught. For wanted robbers to carry hundreds of thousands in stolen bills into a bank would be

ludicrous. Banks were required to report any currency conversions of 5,000 deutsche marks or more to Germany's anti-money-laundering authorities. The trio would have had to make more than twenty trips to exchange all the money they'd stolen by that time. Instead they enlisted allies to do it for them. They gave 10,000 deutsche marks to Holger Gerlach, for instance, asking him to exchange it in small batches into euros, which he did. All told, authorities didn't recover a single stolen deutsche mark as the terrorists washed them clean.

By this time, Gerlach was one of the trio's most loyal supporters. Shortly after their escape from Jena, when money was tight, he had given the fugitives 3,000 deutsche marks. More important, he gave them a gun. In 2001, Ralf Wohlleben, the trio's accomplice in Jena, handed Gerlach a heavy object in a bag and told him to deliver it to the trio in Zwickau. Beate picked Gerlach up at the train station and drove him to their apartment. Gerlach would later claim he had no idea what that heavy object was until one of the Uwes reached in and pulled out a gun, loading it in Gerlach's presence. He would also claim he didn't know that his three friends had become killers.

Throughout this time, the fugitives were hiding in plain sight. Most summers they would take beach vacations to their old stomping grounds north of Rostock on the Baltic Sea. They lived normal lives there, attended far-right concerts, and hosted friends. On September 25, 2002, more than a year after their last heist, they decided to rob a bank on the outskirts of Zwickau, a fifteen-minute drive from where they lived. The two Uwes ran in and let loose with pepper spray. One pointed a short-barreled revolver at a bank teller's head. They made off with their first bounty in euros—48,571 of them.

Another year passed before they robbed again, during which time something happened that ought to have offered them some relief: The five-year statute of limitations to prosecute the trio for their crimes in Jena ran out. In Germany, the only crime without a statute of limitations is murder. Even terrorists, as long as they don't actually kill anyone, are allowed to get away with their crimes if authorities can't catch them in time. And so although police in Saxony were now hunting for bank robbers, nobody—not Melzer or his colleagues, not Thuringia's intelligence agency—was still hunting for the bombmakers of Jena.

In September 2003, the trio called upon their old comrade André Eminger to rent another van, which the Uwes drove to Chemnitz to rob another bank. They used their standard methods—masks and bicycles, guns, and a bag for the cash. But they didn't pedal away with their usual bounty. When they entered the bank at 10:30 a.m., one of the Uwes jumped up on the counter, pointed his gun at a bank teller's head, and demanded the cash from the drawer. The other Uwe jumped behind the counter, pointed his gun at a different employee, and demanded she open the safe. The employee pointed out that the safe was equipped with a time lock. By the time they waited for it to open, they might be surrounded by police. They had no choice but to make off with what little cash was in the registers—a paltry 435 euros.

Frustrated, the next target they hit wouldn't be a bank.

Chapter 12

The Bomb on the Bike

O n February 24, two and a half years after the NSU killed Habil
Kılıç in his grocery store in Munich, the Uwes jumped into a
camper van rented under Holger Gerlach's name and set off for
Rostock to continue their spree.

As with their earlier attacks, Beate stayed at home in Zwickau. This
allowed her to record TV news footage to use in the manifesto the trio
planned to one day release. It also gave her an alibi. And if the Uwes got
caught, at a moment's notice she could destroy evidence at the apartment
that might incriminate her or the NSU's many helpers.

Thirteen years after the anti-immigrant riots at the Sunflower House,
the Uwes drove across the wide waters of the Unterwarnow estuary that
connects Rostock to the Baltic Sea. They arrived in Rostock's quiet Toiten-
winkel district, where their neo-Nazi friend Markus Horsch had lived.
There they set their sights on a döner stand: Mr. Kebab Grill. Its owner was
a Turkish immigrant named Haydar.

Haydar and his grill had been confronted by xenophobic white Ger-
mans before. "You're not even German," a white man told him in 1998.
Three months later, his stand was set ablaze. The perpetrators were never
caught. Haydar restored it in a quiet cul-de-sac, but he wasn't at the stand
the day the Uwes arrived. It was manned by Mehmet Turgut, a young
Kurdish immigrant. Mehmet was born in the small village of Kayalık in
east-central Turkey, one of four brothers, who called him by his nickname,

Memo. Like the Kubaşıks, the Turguts had fled political and military persecution to Germany. After three short-lived and unsuccessful attempts to earn asylum, Mehmet remained in Hamburg illegally, along with his brother Yunus, whose asylum had also been denied. Twice Mehmet was deported to Turkey. Each time, his father tried to persuade him not to return to Germany: A girl in the village had caught Mehmet's eye. Perhaps he could marry her and settle down. But Mehmet knew that his father couldn't support him and his siblings forever. In Germany, he could earn a decent living. He persuaded his father to lend him money to apply for a new passport. Unable to find formal employment in Hamburg, Mehmet picked up whatever under-the-table work he could find, including shifts at Haydar's döner stand in Rostock.

That morning, Haydar was stuck in traffic, so Mehmet began prepping the food alone. At 10:15 a.m., Uwe Mundlos walked up, entered the unlocked side door, raised the Česká pistol, its silencer screwed on, and ordered Mehmet to lie on the ground. Mundlos fired four shots. Three of the bullets ripped through Mehmet's neck, throat, and head. The fourth narrowly missed. Mundlos returned to the camper van, parked nearby.

Five minutes later, Haydar arrived, calling out for Mehmet to help unload groceries. Hearing no response, Haydar figured he must be sipping coffee or reading the newspaper and simply hadn't heard him. But when Haydar walked into the snack bar he found Mehmet bleeding out on the floor, alive but unresponsive. Haydar dragged Mehmet out of the stand. A passerby called an ambulance and the police. When paramedics arrived, they thought it had been a stabbing, because the wounds on Mehmet's neck and head let loose such a torrent of blood. They tried to resuscitate him, but at 11:10 a.m., they pronounced him dead. He was twenty-five years old.

Police discovered three 7.65mm bullets embedded in the floor. Another was still lodged in Mehmet's skull. Forensics confirmed what officers suspected: Mehmet was the fifth victim of what by this time officers had begun referring to as the Česká murder series.

Just as with the earlier murders, police suspected Mehmet might have been involved in the drug trade, despite that he had no criminal record aside from his immigration violations. German police traveled to the

Turguts' village in Turkey to ask questions. *Do the Turguts have enemies? Is it some sort of blood revenge?* The officers' suspicions cast a dark shadow over the entire family. Friends and neighbors began speculating. *Your son must have sold drugs in Germany. This has something to do with women*, they insisted. It got so bad that Mehmet's father eventually bought land in a different village, to escape the hurtful gossip. He suspected his son's murder might be the work of far-right Germans. He had worked in Germany, too. He knew xenophobia existed there.

"It was the neo-Nazis," Mehmet's younger brother, Mustafa, remembered his father saying at the time. "And one day the truth will come out."

Haydar flew Mehmet's body from Germany to Turkey to be buried. Mustafa watched their father kiss Mehmet on the forehead and bid farewell for the final time. It was during his brother's funeral that he received a text from an unknown number.

"I killed a Turk," the text read. "And [now] it's your turn."

* * *

One day when Gamze Kubaşık returned home from school, her father surprised her: "We're flying on vacation to Turkey."

Two years had passed since the Kubaşıks finally received their German citizenship. With it came German passports, and with those came the freedom to travel back to Turkey without fear of persecution. Still, the night before their flight left Dortmund, her father, Mehmet, was anxious and excited, and struggled to sleep. On the plane to Gaziantep he began sweating. Gamze had never seen her father so nervous. But when they landed, the sounds and smells of his homeland seemed to put him at ease. To Gamze, her father's tiny home village of Hannobası couldn't have been more different from Dortmund. She guessed it housed just thirty-five people—every last one of whom seemed to have gathered in front of the house to great them.

For the first time, Gamze realized she had *family*—a big one. "There were so many relatives I didn't know which ones were my grandparents—who was who," Gamze said. Her mother, Elif, rejoiced as she reunited with her sisters after many years apart. Gamze listened as they shared stories,

ate, and laughed, making up for lost time. The family house was a traditional rural Turkish home with long wooden roof beams. Mehmet had carved Gamze's name into one of them when she was born. Gamze had never seen her parents so happy. Still, when the six weeks had passed and the Kubaşıks flew back to Germany, Gamze noticed that her parents were relieved to be home.

Still without a job, one day Mehmet was walking down Mallinckrodtstrasse, a busy street that slices through the northern side of Dortmund from east to west, when he spotted a storefront for rent not far from home. His business instincts kicked in. Why not open a *Trinkhalle*—a kiosk or corner store? He could hire someone to lift the heavy stuff. All he'd have to do was stand behind the counter and chat with customers. Elif tried to dissuade him. To help him run it, she'd have to quit her part-time job at a shopping mall food court. Besides, owning a business was hard work. They knew people who ran similar stores. They always seemed busy and tired.

"But I can't just sit around," Mehmet implored. Elif relented. In June 2004, the Kubaşıks received their business license to open the shop. The kiosk was small—just 430 square feet. It had a large glass window facing the street, with posters that advertised ice cream and M&M's. Through the window, passersby could see newspapers and magazines, cigarettes and drinks. Inside were fridges full of soda, water, and beer, and shelves lined with snacks. A sign above the shop's window advertised the *Ruhr Nachrichten*, the Dortmund city paper, with its tagline: "*Das Beste am Guten Morgen*"—"The Best Part of a Good Morning."

That is what the kiosk became to Gamze's parents. Elif would open the shop each morning at six. Mehmet would arrive between nine and ten and they would eat breakfast together. In the afternoons, Elif would sell snacks to the crowds of kids after school before heading home to prepare dinner. Mehmet closed the shop around nine or ten at night, coming home exhausted, though never quite ready to sleep. The shop soon roped in Gamze, too. After school, she walked the five minutes to the U-Bahn—the subway—riding it seven stops to Schützenstrasse station. She'd walk up the station's eastern stairway to the street, where she could see the kiosk straight in front of her. Gamze would work the counter while her father

went out to buy groceries or visit friends, or went home to spend time with Elif and Gamze's brothers.

But the shop's demanding hours—open before dawn, closed long after dark—made life grueling. With time, Elif and Mehmet's social life began to wither. They thought about selling the shop and using some of the money to take the whole family on an extended vacation to Turkey, perhaps for an entire summer. In a few months' time they would indeed all make the journey—but for reasons none of them had planned.

* * *

Despite their successes, the NSU wasn't satisfied killing immigrants one at a time. For their next act, they'd try to maim as many as they could all at once. A few months after Mehmet Turgut's murder, on June 9, 2004, the two Uwes traveled to Cologne's Mülheim district, a twenty-minute drive northeast from the Iranian-owned grocery store where they'd left the cake box bomb years earlier. This time, they scouted out a barbershop on Keupstrasse, a short walk from the Rhine. Keupstrasse was a quiet one-way street lined with Turkish and Kurdish storefronts—cafés, tearooms, shops, kebab shops, jewelers—above which were apartments populated largely by immigrants and their descendants, many of whom were naturalized German citizens. The Uwes rented a black VW minivan in Zwickau, into which they loaded not two bicycles, but three: two mountain bikes and a Cyco brand women's bicycle they had purchased earlier that day at an Aldi store for 249 euros. They attached a hard protective case onto the back of the bike, into which they placed a bomb.

They'd built the bomb over many weeks in their apartment in Zwickau. They took a blue gas cylinder—the type used for camping—and dumped in more than seven hundred carpenter's nails, 10 centimeters long and 5 millimeters thick. They packed in 5.5 kilos of gunpowder, which they wired to a pack of 9-volt batteries. Unlike the cake box bomb, which sat in the storage room for weeks before Masha triggered it, they'd fitted this bomb with a detonator that they could activate by remote control.

At 2:30 p.m. the Uwes parked the minivan near the train depot just south of Keupstrasse. They offloaded the two mountain bikes and Böhnhardt pushed them both past VIVA FM, a Cologne radio and TV

station. Its security camera caught a glimpse of Böhnhardt at 2:34 p.m. He left the two mountain bikes around the corner from the hair salon—they'd use them for their escape. Twelve minutes later, he walked past VIVA FM in the opposite direction, on his way back to the van. He and Mundlos unloaded the Cyco bike with the bomb. Mundlos pushed it toward Keupstrasse, trailing some distance behind Böhnhardt, who was carrying two white bags. One seemed to contain a typical Turkish flatbread, the other an angular object—a remote control for a model airplane, repurposed as a detonator. The security camera captured both men again, forty-two seconds apart. Mundlos, who wore a baseball cap, pushed the bike to the front of the barbershop and left it leaning against the storefront window. He looked up and saw customers—victims—inside. He locked eyes with a barber named Hasan Yıldırım, who figured the man was a customer about to walk in for a cut. But Mundlos walked away.

The bomb was heavy—about 20 kilograms. Had anyone tried to move the bike, they'd have known something wasn't right. At 3:56 p.m., from a vantage point within sight of the barbershop, Böhnhardt used remote control to trigger the detonator.

* * *

Why did I want a shave on this day of all days? Kemal Gündogan would later wonder. It had been "a perfectly normal day" for him. He'd been working a temporary job as a forklift operator for a Ford Motor Company factory in town. When he finished his shift, he decided to pass by his barber, Özcan Yıldırım. Özcan immigrated to Germany in the early 1990s. He had the day off, and his brother Hasan was running the shop. It was Hasan who locked eyes with the man with the bicycle and baseball cap.

Kemal took a seat inside the barbershop, right beneath the window. He heard a deafening bang as the glass façade crashed in on him. The force of the explosion threw him and the other customers across the room.

Outside the shop, the bomb sent the bike flying into the air and shattered around thirty windows, damaged fifteen cars, some as far as 250 meters away. The seven hundred nails ripped through storefronts and through the bodies of people on the street.

When he came to, Kemal saw fire all around him. He staggered to his

feet and out the back door of the shop. He felt something warm running from his head and down his face: blood. He wondered if he was going to die. Just like a montage in the movies, his life flashed before his eyes: his childhood in Turkey, his parents who still lived there. He saw the face of his wife, Resan. He thought of his future, of the children he hoped to one day have with her.

He was still sitting on the sidewalk, head dripping, when somebody brought him a towel, which he pressed against his face. He took out his phone, dialed Resan and told her he was hurt. Resan raced to Keupstrasse, not far from their home. She found the area cordoned off by police, but she pushed past and found her husband bleeding on the ground, shards of glass embedded in his head. An ambulance rushed Kemal to the hospital, where doctors removed the splinters and stitched his wounds shut.

Kemal wasn't the only one injured. Sandro D'Alauro, thirty-four, born to an Italian father and a mother from Cologne, was walking with his friend Melih to a kebab shop on Keupstrasse when he felt like his legs had been shot off from behind. As he looked up from the pavement, all he saw was smoke. He didn't hear a sound. Melih was on the ground. D'Alauro wondered if he was dead. Then D'Alauro noticed that his own shirt was on fire. He scrambled out of it. An ambulance came. At the hospital, doctors discovered nails in his legs and shoulder and burns across his body. Two of his fingers had nearly been ripped off.

Another victim felt a jet of flame incinerate his ear. Over a hundred splinters pierced his face. Doctors had to remove them with a needle, one by one. His thighs were so badly burned that doctors had to transplant large grafts of skin to repair them. Twenty-two people were injured, some severely maimed. One was as young as seventeen, another sixty-eight. Most were immigrants or first- or second-generation Germans. The blast was so intense that the nails had splintered into pieces, flying at speeds as fast as 480 miles per hour. Detectives found scraps of cloth, battery parts, wires, and switches from the bomb. The bicycle was missing its front wheel and the back one was deformed. One of its brakes had flown through a car window sixty meters down the street.

Just after 5 p.m., police sent a fax out to colleagues across the country announcing that a "violent terrorist crime" had happened on "Kolbstrasse"— they got the street name wrong. To many Germans, the bombing *felt* like

a terrorist attack. It brought to mind the 1980 Oktoberfest bombing in Munich by the white German terrorist Gundolf Köhler, which injured more than two hundred people and killed twelve, including the bomber. At the time, authorities concluded that the twenty-one-year-old geology student turned suicide bomber had merely been lonely, heartbroken, depressed. It was only four decades later that German authorities admitted that Köhler had been a far-right extremist who kept a portrait of Adolf Hitler over his bed. His terrorism was designed to influence an upcoming election, which he hoped would usher in a National Socialist state.

Forty minutes after police in Cologne announced that a terrorist attack had taken place, officers issued a correction—but not about the street name. Rather, they removed the reference to terrorism altogether, saying instead that an "unconventional explosive device" had been used and that updates would follow. It was as if officers suddenly remembered who the victims were—immigrants—and decided that the bombing might not be terrorism after all. Within hours, police began interviewing the victims, including the barbershop brothers. Officers questioned them about their customers and asked whether they had ever been threatened or extorted by Turkish gangs.

"We have only friends and good neighborly relations," Hasan told the detectives.

Judging from their questions and notes, officers seemed to have already made up their minds that the bombing was connected to organized crime. Özcan Yıldırım explicitly suggested to the detectives that the attacker might be someone who hated foreigners. The detectives weren't convinced. When witnesses were unable to corroborate the officers' unfounded theories, investigators wrote that "apparently no one is willing to make concrete statements to police."

"In certain circles it is customary to take things into your own hands and not involve the police," detectives wrote. These immigrants, these organized criminals, the detectives assumed, must have decided to administer their own justice.

* * *

After Kemal was discharged from the hospital, he didn't have much time to rest. He was on a temporary contract and feared that if he didn't show up

for work the next day, he'd be fired. Donning a hat to obscure his wounds, he arrived at the factory as if nothing had happened. Once there he realized he was unable to do anything at all. For a week, his colleagues performed his work for him so his bosses wouldn't catch on.

"The serious wounds eventually healed," Kemal later said, though he'd feel the physical scars every time he took a shower or stroked his head. "But then came the nightmares," from which he'd startle awake—if he managed to fall asleep at all.

At first, Kemal thought he'd been the victim of some sort of private dispute between the barbershop owners and a disgruntled customer—not unlike what the police suspected. With time he became convinced that the bomber was someone who hated foreigners. When his wife, Resan, traveled to Turkey for three weeks, Kemal left the lights on in their apartment all night. He began hallucinating, having panic attacks. When Resan returned, he didn't tell her what he'd been going through. Instead, he withdrew. Out in the world, the sound of a car backfiring could send him into a panic. He stopped going out and stopped seeing his friends. He even lost the job that he had tried so hard to keep. Eventually he opened a kiosk, like the Kubaşıks'. The long hours kept him away from Resan and tested their marriage. But in the end, the perpetrators couldn't prevent their dreams from coming true: Resan would eventually give birth to two children and became a social worker like she'd always wanted.

Meanwhile, the barbershop brothers struggled. Even after the shop reopened, customers stayed away. Hurting for money, they considered selling the shop. Detectives, still suspicious of the Yıldırıms, sensed an opportunity. They deployed an undercover police officer, who introduced himself to Özcan as a businessman interested in buying their salon. They began to negotiate a sale, but the ruse didn't lead to any actionable intelligence. The detectives weren't deterred. They decided to send in a *second* stooge, who pretended to operate a nearby food truck to gather intelligence. Nothing ever came of their schemes.

Desperate for clues, the police hung posters in German and Turkish with photos of the bicycle used in the bombing. They offered a 20,000-euro reward to anyone who provided information leading to an arrest. One week after the attack, investigators acquired the surveillance camera footage

from VIVA FM. They watched as a man in his late twenties—Mundlos—wearing "a pair of knee-length dark Bermuda shorts, a dark short-sleeved T-shirt, closed-toed shoes, dark socks, and a baseball cap and a bag around his waist," pushed a silver Cyco bike toward Keupstrasse, forty minutes before the bombing. The bomb went off at 3:56 p.m., and one minute later the camera caught a glimpse of a man—Böhnhardt—cycling away from the scene. He wore "long sport trousers with white stripes on the side, a short-sleeved light-colored T-shirt, a baseball cap, sports shoes, and gloves." His baseball cap had a distinctive bright stripe along the visor. But investigators couldn't work out who the men were.

As if to celebrate their bombing, the Uwes and Beate set off for another extended summer vacation, this time to the town of Lübeck, near Germany's Baltic coast. It was an hour's drive east of where they had murdered Mehmet Turgut in Rostock several months before. Rightly unconcerned that authorities were on their trail, they spent their summer relaxing at the beach.

Chapter 13

"Turkish Mafia Strikes Again"

On the eve of the anniversary of the Keupstrasse bombing, June 8, 2005, a Cologne newspaper interviewed the barbershop owner, Hasan Yıldırım.

"The question of who did it and why will always torment me," he said. "Tomorrow, when it's all been exactly a year, I don't want to be in my shop."

"Who was the mad assassin who calmly pushed a bicycle with a nail bomb in front of a hair salon on June 9th and then ignited it by remote control?" the newspaper asked. "Why did he do it? And will he cowardly strike again?"

The next morning, 250 miles to the southeast, at around 9:40 a.m.—almost one year to the hour after the Cologne bomb went off—two cyclists dressed in black set off through Nuremberg's St. Peter district. Their destination was a kebab stand run by Ismail Yaşar.

The third of eleven children, Ismail was born in 1955 to a Kurdish family along Turkey's southern border with Syria. After completing his mandatory military service, he immigrated to West Berlin in 1978 and eventually settled in Nuremberg. A welder by trade, he sometimes struggled to find work. In 2003, Ismail began to run a kebab stand in the parking lot of an Edeka supermarket. Down the street from the stand was a school, and Ismail would often give the children free ice cream and sell them döner kebabs. Ismail's son Kerem Yaşar recalled how, in late May 2005, a German newspaper ran a profile of his father, writing that Yaşar cooked excellent döner. But Kerem knew that his father longed to leave the

stand behind, at least for a while, and return to Turkey. The last time Ismail spoke with his mother over the phone, he told her he had plans to visit her in Turkey: "I've made enough money now…I'm coming home."

Ismail never got the chance. His flight to Turkey was just six days away when the cyclists pedaled in his direction. A music teacher who was leaving her nearby apartment saw them pause to look at a map. She almost offered to help, but she was running late and hurried off. The two Uwes oriented themselves and continued cycling south toward the kebab stand. Ismail was grilling meat and toasting bread when the Uwes dismounted from their bikes. They entered Ismail's stand. One raised a pistol hidden inside a yellow plastic bag, pointed it at Ismail's head, and fired. The first shot grazed the right side of his face and lodged in the door. The second shot didn't miss. It entered below Ismail's right ear and exited below his left. Ismail fell backwards. The gunman fired twice more at his chest.

As the Uwes prepared to make their escape, a customer walked up. The Uwes ducked behind the counter, where they waited for him to leave. Instead, the customer came even closer. If he had glanced down, he would have seen two assassins crouching next to the man they'd just killed. Instead, assuming the stand simply wasn't yet open, the customer sauntered off. As soon as the coast was clear, the Uwes slipped away.

The music teacher who had seen the two cyclists half an hour earlier happened to return and pass them once again. Around 10:15 a.m., one of Ismail's regulars exited the Edeka supermarket with some groceries and walked across the parking lot to the stand. He leaned over the counter— and glanced down. There lay Ismail in a pool of blood. Fifteen minutes had passed since the shooting. The man called the police, and paramedics arrived five to ten minutes later. Ismail Yaşar, age fifty, was already dead.

* * *

Ismail left behind two children and a stepdaughter. His son Kerem, who was fifteen, attended school kitty-corner from the kebab stand—the same school whose pupils flocked to Ismail's stand for ice cream. Kerem often visited his father during lunch breaks, chatting while he ate. The school was so close to the kebab stand that, had the gun not had a silencer, Kerem might have heard the gunshots from his classroom. He might even have

seen the Uwes cycle by. But on this particular day, Kerem wasn't at school. Enrolled in a vocational training program, he was out working at a prestigious car dealership as an auto mechanic's apprentice. On his breakfast break he'd gone into a nearby grocery store to grab a bite to eat. When he came out, a police car was waiting for him.

"Are you Kerem Yaşar?" the officer asked.

"Yes."

"Your father is dead."

Those words rang inside Kerem's ears as the officers escorted him to a police station where his mother, Ismail's third wife, was already waiting. The two of them sat together and cried. Officers began interrogating them straight away, asking if Kerem knew the clients who had been coming to his father's kebab stand in recent days. They took his fingerprints and swabbed his mouth for DNA.

When officers searched the crime scene they found no bullet casings—no shells. Only two bullets, three more of which were lodged inside Ismail's body. Whoever the killer was, his motive clearly wasn't money. The cash register was unlocked and still had cash inside, and Ismail had 265 euros in his pockets. Rather, officers instinctually suspected that narcotics were to blame. Medical examiners tested Ismail's body for drugs. Officers searched his kebab stand with drug-sniffing dogs. They even checked inside some of the kebab meat for traces of narcotics. They asked neighbors and relatives whether he sold drugs or had connections to the PKK, the Kurdish militant group. Their search and questions turned up nothing.

But German police didn't let facts get in the way of fantasies. Officers pressed Kerem's classmates to admit that Ismail had sold them drugs. But Ismail hadn't, and the kids didn't believe the officers' lies. The police were not deterred. They decided to lay a trap, opening up a snack bar of their own where Yaşar's had been in the hopes of luring his theoretical drug dealers back. For an entire year, undercover cops sold kebabs and sodas at a cost of 30,000 euros to taxpayers, hoping someone would approach them to buy or sell drugs. But nobody did, because Yaşar wasn't a drug dealer. At long last, police shut down the stand.

All the while, Kerem lived in the fog of his dad's unsolved murder. Each morning on his way to school, and each afternoon on his way home,

he passed the place where his father had been killed. For months, the snack bar stood there, cordoned off and boarded up, then open again and staffed by undercover cops, then closed once more. Kerem couldn't help feeling that if his father had been a native-born German, his murder would have quickly been solved. His suspicion that police officers were biased against people of Kurdish or Turkish heritage was confirmed one day when an officer pulled him over for speeding. The officer pulled out his gun—as if Kerem posed some sort of threat—and ordered him to put his hands on the steering wheel. It was broad daylight, in the middle of a busy street. The officer frisked him for drugs. *It's because of your dark hair*, Kerem realized, his Kurdish features. *They never would have done this to anyone else.* He never trusted the police again.

Kerem did consider the possibility that far-right extremists had murdered his dad. Everyone knew neo-Nazis existed, but one investigator dismissed the notion that white people might be to blame.

"Given that killing human beings is considered highly taboo within our cultural space"—by which he meant white, native-born Germans—"we can safely assume that the perpetrator is, in terms of his behavioral system, located far outside our local system of values and norms." Only an immigrant, the investigator implied, could become such a cold-blooded killer.

The police weren't the only ones who thought this way. After officers lied to Kerem's mother, telling her that Ismail had been selling drugs to the kids who frequented his snack bar, local news media republished these fabrications. Mere weeks had passed since Kerem recalled reading a glowing profile about his dad in the local newspaper. Now journalists changed their tune, running unfounded stories that theorized Ismail had been involved in drug dealing or organized crime. The editors of the *Nürnberger Nachrichten* ran a headline referring to Yaşar's and the other recent murders as "*Döner-Morde*"—"Kebab Killings." The headline struck a perverse chord.

"It was inhuman, my father was a person, not a döner," Semiya Şimşek's brother Abdulkerim said about the headline.

"It was careless, cynical and racist" the way the German press sensationalized the killings, said Semiya. But the headline made sense to a German public that had long associated Turkish immigrants and their German-born descendants with criminality. A 1996 poll found that 50 percent of

eastern Germans and 38 percent of western ones believed that foreigners committed more crimes than native Germans. In reality, according to federal police, that year just 22 percent of crime suspects were foreigners.

In any case, one week after that headline ran, Germany's prejudicial press would get another chance to pounce.

* * *

Born in Greece in 1966, Theodoros Boulgarides immigrated to Germany at age eight with his parents and brother. They settled in Munich's Westende-Friedenheim neighborhood, which was becoming home to a vibrant Greek immigrant community. Theodoros worked for Siemens and, later, as a ticket inspector for the Deutsche Bahn, Germany's railway, where he spent his days going back and forth on public transit ticketing passengers who hadn't purchased their fare. But Theo, as his friends called him, had a soft heart, and he'd often let offending passengers go without issuing them a fine.

In 2005, Theodoros decided to start a business of his own: a locksmith shop, which he named Schlüsselwerk—Keywork. It was the perfect location: Though his father had long since passed away, his mother lived just around the corner. And his and his wife Yvonne's apartment led directly to the shop's back door. Theodoros and his business partner, a man named Wolfgang, spent three months readying the shop for its grand opening at the beginning of June 2005. They took turns running the register, opening around eight or nine in the morning and closing at six. Just two weeks after it opened, on June 15, Wolfgang called Theodoros at 6:24 p.m. When Theodoros didn't answer, Wolfgang headed to the shop himself.

Early that morning, the Uwes had driven to Munich in a camper van rented by their accomplice Holger Gerlach. They'd entered the Boulgarides family apartment, then walked through the hardware store's back door. Theodoros had been standing behind the register. One of the Uwes fired at him. When he fell to the ground, the shooter sent two more bullets through his head.

When Wolfgang saw Theodoros's body, he called the police. Paramedics arrived six minutes later, but Theodoros Boulgarides was already dead. He left behind two daughters. He was forty-one years old.

Within minutes, police began interrogating his horror-stricken widow and her teenage daughter. Police tried every trick in the book to persuade Yvonne to admit that her husband had been a drug dealer. The officers lied repeatedly, telling Yvonne they had evidence that Theodoros habitually drove several hours to Frankfurt to sleep with prostitutes. The officers fantasized about Theodoros's sex life, asking whether he had been a sex addict. They asked whether Yvonne took birth control or used other contraceptives and whether her previous marriage had been officially terminated. Once, officers showed Yvonne a photo of a blond woman they claimed was Theodoros's secret lover, a photo they pretended to have found in his car. It was precisely what officers had done to Adile Şimşek, the widow of the flower seller Enver, five years before.* Once, officers even accused Yvonne herself of committing the murder.

"Just admit you killed him," an officer said. They asked Yvonne's daughter whether Theodoros was a human trafficker, smuggling people from Greece into Germany. They asked whether he'd sexually abused her— without a shred of evidence to suggest he had. In their attempt to get the Greek immigrant community in Munich to incriminate him, investigators behaved like they were in a TV cop drama, donning disguises and posing as journalists.

"They wanted to drag us through the mud," said Wolfgang. "And they succeeded." Nobody wanted to have contact with the Boulgarides family anymore.

Yvonne and her daughters repeatedly suggested to police that the killer might have had a xenophobic motive. For all of the officers' wild fantasies, this was not one they were willing to seriously entertain.

Bavarian state police assigned twenty officers to task force "Theo" and later increased it to thirty-nine, drawing officers from across Bavaria. In

* It isn't clear how common it is for German police to ethnically profile victims in this way. But a 2022 study by the researcher Hannes Püschel published in the book *Rassismus in der Polizei* (Racism in the Police) found that officers in Bavaria showed less empathy and demonstrated less emotional care to immigrant crime victims than to German ones. An earlier, 1999 study by Matthias Mletzko and Cornelia Weins, *Polizei und Fremdenfeindlichkeit* (Police and Xenophobia) found that 15 percent of officers at a western German police department held strongly xenophobic attitudes.

October 2005, the Bavarian Ministry of the Interior set up a special task force based in Nuremberg, where three immigrant men—two Turks and a Greek—had been killed. The task force would investigate what authorities had begun calling the "Česká murder series." Authorities understood that the killings were connected, but they still believed the common link was immigrant crime. They called it task force Bosporus, after the famous body of water that runs through the center of Istanbul, Turkey's largest city. The name belied officers' false presumption that the killings had more to do with Turkey than with Germany.

Theodoros was buried in Greece, alongside his father and grandfather, who had been killed by Germans, too. During World War II, Bulgarians collaborating with the Nazis massacred 130 Greeks in a forest, among them Theodoros's grandfather. German nationalist terror had claimed two generations of the Boulgarides family. It left the generations between and after them with gaping holes in their hearts.

* * *

After Theodoros's murder, the press gave a platform to the officers' conspiracies that immigrants were to blame. "Turkish Mafia Strikes Again," read one headline in Munich, despite that Theodoros was Greek. Such headlines pleased the terrorists immensely. Lumping immigrants together with their German descendants and describing them as one big nefarious criminal class—this was precisely what the NSU wanted. They saved the newspaper clippings and edited fresh TV news footage into their DVD manifesto.

Terrorism, the trio learned, wasn't hard—so long as nobody was watching. It *was* expensive. Nails for nail bombs don't cost much, but the explosive powder does. The mundane things cost them the most. Living on the lam they racked up 102,000 euros in rent. With apartments come taxes and utility bills, like the one they got each year from Germany's public broadcasting company. The bill was 215 euros and 76 cents, and they always paid it on time. They spent 1,200 euros on public transit—trains, buses, and trams. They spent another 29,000 euros to rent the campers and vans they used to get to and from each hit. They didn't waste money on ostentatious things, just modest summer vacations in camper vans parked at Baltic

beaches. In the summer of 2005, the three friends had forayed even farther north, across the Baltic Sea to Denmark and Sweden. There they attended white supremacist concerts with members of the European neo-Nazi networks Blood & Honour and Combat 18.

When they weren't on vacation, they spent time playing board games like *Risk* and *The Settlers of Catan*. Beate read books: translations of *The Lord of the Rings*, *Harry Potter*, novels by Stephen King and John Grisham. On TV she watched *Malcolm in the Middle*, *Monk*, and *Desperate Housewives*. In 2006, Beate befriended a neighbor named Heike. They'd sit in the building's courtyard, where Heike would confide details of her love life, gossip about the neighbors, and recount the challenges of raising kids. One day they were watching television with Heike's son when a right-wing demonstration came on the news.

"I'd love to be there myself," said the boy.

"Keep your hands out of it," warned the far-right terrorist. "That can only bring bad luck."

He wasn't the only child to spend time around terrorists. André and Susann Eminger had two sons, and each week Susann would drive them to the trio's apartment where they'd play Legos and ride a small bike that Beate kept for them there. Beate would scour the apartment beforehand to make sure no guns were lying around. By 2007, Susann knew about the robberies, though they'd both claim Beate never told her about the murders.

Beate made little effort to keep herself out of the public eye. In the summer months she'd ride her bike to the Emingers' house, and in the winter she and Susann would go to dinner, to see a movie, or to the theater. They once saw the comedian Ilka Bessin perform her famous routine as the character "Cindy aus Marzahn"—a frumpy, overweight East German, or *Ossi*. After the show, Beate asked Ilka for an autograph. "For Liese," the comedian wrote, addressed to one of Beate's eleven aliases.

Beate became a sort of amateur performer herself. One December morning in 2006, a police officer showed up at the terrorists' door. Beate answered. The officer asked if she'd be willing to make a witness statement about a burglary that had taken place in the apartment upstairs. Beate stammered that she didn't have the time. Later, officers returned with a

summons, legally obligating her to testify. Susann Eminger lent Beate her ID, and Beate pretended to be her. André accompanied Beate to the police station to complete the charade that Beate was in fact Susann, his wife. For eight years, police across Germany had failed to find the fugitive murderers. Now Beate was sitting in front of them, lying to their faces. After questioning her and André for forty-five minutes, the officers let them go.

The Emingers were two of many trusted supporters who enabled the NSU. The Emingers were such close friends that when André fell off a roof in Leipzig while installing some solar panels, Böhnhardt and Beate traveled to the hospital to visit.

In March 2003, intelligence agents in Saxony had approached André to recruit him as an informant, unaware that he was friends with terrorists. André declined, lying that he'd left the far-right scene. Another friend named Ralf Marschner hired Mundlos to work in his Zwickau store Heaven and Hell, which, like Madley in Jena, sold clothing and trinkets to far-right skinheads. Marschner also employed Mundlos at a construction-demolition company he owned. It's possible he employed Beate and Böhnhardt, too. What the trio probably didn't know was that Marschner, unlike André Eminger, *was* an undercover informant. Code-named Primus, he was being paid by Germany's federal intelligence agency to provide insights into the far-right scene in Zwickau. But just as with Tino Brandt and Carsten Szczepanski, Marschner took taxpayers' money without revealing the NSU.

Chapter 14

A Death in Dortmund, a Killing in Kassel

B y the spring of 2006, six months into its existence, police task force Bosporus was getting nowhere. Officers were in the midst of interviewing 120 potential witnesses to the Česká series killings and would go on to garner more than a hundred leads. But time and again, their prejudice blinded them to the clues that really mattered.

"Have you ever seen a Nazi on a bike?" joked one investigator, brushing off the witnesses who'd seen two white men cycling away from the scenes of the crimes. There were other patterns officers should have noticed, too. Just like in the United States and other Western nations, in Germany, those who most vehemently oppose immigrants tend to live in places barely touched by them. Except for Mehmet Turgut's slaying in Rostock, all of the murders and bombings took place not in eastern Germany, where immigrants and their descendants were few and far between—just one for every twenty people—but in the multicultural west, where one out of every five people was an immigrant or the child or grandchild of one. Perhaps the terrorists intended this as a provocation, attacking immigrants in western cities that viewed foreigners more favorably.

One diverse city that caught the terrorists' attention was Gamze's hometown of Dortmund, whose large far-right milieu earned it the moniker the "Nazi capital" of Germany's west. Dortmund's Nazis converged around the city's Nordstadt district, where the Kubaşıks lived. Nordstadt

was a somewhat downtrodden area just north of the city center, next to the inland industrial port. In 2000, Dortmund's unemployment rate had reached an incredible 26 percent—twice the national average—and in Nordstadt it was even worse. By 2005, one out of every three working-age adults was jobless. The neighborhood's low cost of living attracted working-class immigrants. But Nordstadt also attracted neo-Nazis, who treated it like a "National Liberated Zone"—an area where far-right-extremists "shape everyday life and the streetscape," as the German government defines them. "Those who think differently or are defined as 'foreign' are declared enemies who should not be tolerated in these 'zones.'" Nordstadt would soon attract the attention of the Uwes, too.

* * *

On the morning of April 4, 2006, Gamze awoke at 7 a.m. as she did almost every weekday. It was a typical cloudy spring day in Dortmund. Her father, Mehmet, was still asleep. Normally, he'd have been up early to open the family kiosk, or to walk Gamze's younger brother Mert to kindergarten. But her aunt was visiting from England, and the previous night she, Elif, and Mehmet had gone out for dinner and stayed up late while Gamze worked. Now Gamze gently woke her father and whispered that she would walk Mert to kindergarten, so he could rest. It was the last time she'd see him alive.

At twenty years old, Gamze was attending a vocational training program, studying economics and administration. When her last class let out, she and a friend rode the metro to the kiosk. As they arrived, her friend said, "Look—there's police and an ambulance outside!"

No, that can't be, Gamze thought. Nearby there was a Moroccan mosque and cultural center, where police would show up from time to time. She supposed something had happened there. She didn't know that between 12:10 and 12:55 p.m., her father was standing behind the register when two men walked into the kiosk. One took out a Česká pistol with a silencer. Mehmet put up his hands. The first bullet missed Mehmet, striking the wall behind him. But the second bullet went through Mehmet's right eye and lodged in his skull. The force propelled his body backwards against a shelf. Mehmet fell to his knees. Another bullet pierced his right temple. A

final bullet struck the counter next to him. Any passing pedestrian could have seen the shooting through the large glass storefront window. Mehmet died on the spot. He was thirty-nine, the NSU's eighth victim. His death left three children without a father. One of them was making her way through the crowd that had formed on the street. Gamze's feet carried her quickly, as if moving of their own accord.

"Oh, no—now his daughter's got wind of it," she overhead someone say as she approached. A young officer blocked her path and grabbed her by the shoulder.

"You can't come in here," he told Gamze.

"I'm the daughter of the people who run the kiosk," she told him, "and I want to get past." The officer asked her for identification. She showed him her school ID. He looked at it, then looked at her.

"Ms. Kubaşık, please come with me to the police car over there and I'll tell you what is going on."

As Gamze sat in the back of the squad car, a female officer got in the front passenger seat and turned to face her. "Your father is injured, but he will make it," she said, untruthfully, urging Gamze to stay calm. When Gamze got back out of the car, she thought about her father's stroke a few years earlier. She wondered if perhaps he'd become dizzy and fainted. But then she saw police officers in white, full-body forensic suits entering the kiosk, the sort of outfits you see on TV crime shows. Something very bad had happened. A policeman who must have been in his midsixties caught her eye. Gamze could tell he had something to tell her but didn't know how.

"What's wrong?" she asked.

"Your father is dead," he replied.

* * *

The next morning, three police officers arrived at Gamze's house. Her mother answered the door.

"The police want to show us your father," she called to Gamze.

But when she and Elif walked outside, the officers directed them to two different vehicles. When Elif asked why, the officers assured them both that they would be reunited at the police station. This was the second of many lies that officers would tell the two women in the days to come.

The first was that they were being taken to see Mehmet's body. Instead, upon arrival at the station, Gamze was led up some stairs to a room where they asked her to make a detailed statement. The brutal first question that officers asked her was: "Ms. Kubaşık, can you tell us why your father was murdered?"

When Gamze replied that she had no idea, they asked whether her father had had any enemies—the same question that a different set of officers had asked Semiya Şimşek six years earlier. They asked whether Mehmet had been in any fights or skirmishes. She told them he hadn't as she struggled to remain calm. One officer showed her a series of photographs—headshots, possibly passport photos—of five different men in their thirties and forties, asking if Gamze knew them. When she replied that she didn't, the officer told Gamze that her father had been doing business with one.

"That can't be," said Gamze, who knew all of the kiosk's suppliers well. Then the officer came out with another lie: that *she* had been seen with one of these men. At one point the officer pointed at two photos he'd been showing her of different men he claimed she knew. One depicted a man with a full beard, the other clean-shaven.

"Haven't you noticed that these two are the same person?"

It's as if he's making fun of me, Gamze thought. The officer's questions continued.

Did your father take drugs? Did he sell them?

Gamze was so disoriented by the officer's insinuations that on several occasions she asked, "Are you sure that it is *my father* who was killed?" Whatever man the police officers imagined Mehmet to be, it sounded like someone else. Officers asked Gamze whether Mehmet was involved with the mafia, or with the PKK. A decade after the Kubaşıks received German citizenship, it was as if police were implying Mehmet wasn't German after all.

"My father lived as a German, but with his black hair and dark eyes," to the police "he would forever stay a Turk or Kurd," Gamze realized.

When the officers finally let Gamze go, she found out her mother had just gone through the same ordeal.

"Why are they asking us such questions?" Elif asked her daughter.

But Gamze didn't know. Three days after Mehmet's death, police brought Gamze and Elif to the station once again, this time with Gamze's younger brothers. Mert was only six. *What do they want to do with a six-year-old?* Gamze wondered. Officers separated Elif from her children and led them to a room where cotton swabs were lying out on a table. A woman swabbed Gamze's mouth and nose, then proceeded to do the same to her brothers. When it was his turn, Mert began to cry. Gamze tried to calm him down. An officer gave him a teddy bear, but it did nothing to put him at ease. It wasn't until the woman approached Gamze with scissors, saying she needed to cut off some of her hair, that Gamze realized what was happening. She had seen DNA testing on TV. She hesitated, asking the woman what it was for.

"We need to make sure that you are the children of the deceased," the woman replied. Gamze looked at her siblings, and they looked at her. An officer walked in with two more teddy bears, handing one to Ergun, who was twelve, and offering the other to Gamze.

"I don't need a teddy bear," the twenty-year-old Gamze replied.

"Okay," said the officer, with a shrug. While Ergun and Mert held their teddy bears, the woman snipped off pieces of their hair.

* * *

As they flew to Turkey for the funeral, Gamze sat silently while her mother softly cried. Gamze asked a relative seated nearby how her father's body would arrive. She had figured he'd be driven there by road. Her relative replied that Mehmet was beneath them, on the same flight.

He's been with us the entire time, Gamze realized. The thought gave her a sliver of solace. But her heart dropped when, at the funeral, she saw Turkish police writing down the license plates of the vehicles that came and went. Afterward, friends, neighbors, and family flocked to her father's family home in Hannobası to keep company during the traditional Turkish period of mourning—forty days and forty nights. The relatives Gamze had reunited with three years earlier, laughing and telling stories, were weeping. They asked Gamze the same question, again and again:

Why did your father die?

When Elif, Gamze, and her two brothers returned to Dortmund, a

relative picked them up at the airport and told them ominously that "people are talking." While they were in Turkey, police had gone around the neighborhood spouting speculations that Mehmet had been a mafioso. One officer asked a neighbor if Mehmet had used or sold heroin or had affairs with other women. The neighbor replied that Mehmet would never do something like that. As usual, the officer lied, saying that he had—the neighbor simply wasn't aware of Mehmet's double life. Officers showed neighborhood teenagers photos of Mehmet, asking, "Do you know this man? He sold drugs to kids like you."

When Elif learned a neighbor had told police he once saw a baggie— possibly drugs—drop out of Mehmet's pants pocket while walking down the street, Elif confronted the man, who recanted.

"I can't understand why anyone would *do* that!" said Elif. Gamze thought the man may have just wanted attention. But with time she came to see it as a by-product of the officers' lies, which spread like wildfire. Once, while Gamze was out walking with a friend, a woman recognized her: "Isn't that the daughter of the man who sold drugs to children? Let her die the same way!"

To avoid the accusations, the icy stares, and the suspicions the police had planted, Elif bought her groceries at six or seven in the morning before the store was crowded with people who might recognize her from the news.

For her part, Gamze watched as officers led a drug-sniffing dog around her father's prized BMW, the one he'd driven Gamze around in as a kid. Twice they searched the kiosk for drugs, to no avail. Officers continued to interrogate Gamze and Elif. They asked if the family's honor had been disgraced or if they'd had marriage problems. The weight of it all affected Gamze immensely.

"I couldn't listen to it anymore. We felt like criminals."

At one point, Elif asked police if the perpetrators might be right-wing extremists. Despite witnesses reporting yet again that two people had biked away from the scene, the police said there was no evidence to suspect they'd been involved. One day, two policemen came by with a bag that contained two rings and a watch Mehmet had been wearing on the last day of his life. The police hadn't bothered to clean off the blood. Elif struggled

to sleep—she'd wake at the slightest sound. Gamze's brothers were traumatized, too. When a classmate taunted Ergun that his father had been a drug dealer, Ergun fought the boy and was nearly kicked out of school.

In almost every respect, what Gamze and her brothers went through mirrored what had happened to Semiya Şimşek six years earlier. Gamze hadn't yet heard of Semiya. But while Gamze had been in Turkey mourning her father, she did hear of a family with a strikingly similar story. During the traditional forty days of grieving, they weren't supposed to watch TV. Such entertainment would be disrespectful to the deceased. Which is why Gamze was surprised when her uncle broke the rule and told them to turn on the news. Turkish media were reporting that a Turk had been murdered in the German city of Kassel, two days after Mehmet. On Thursday, April 6, shortly after 5 p.m., a young man named Halit Yozgat was shot to death while working at his family's cybercafé. Kassel was just a two-hour drive east of Dortmund. Gamze's hands shook and her mind raced as she scoured her memory: *Do I know any Halits?* After assuring herself that she didn't, she began to make some sense of what the newscaster said next: The weapon that killed this man Halit was the same one that killed her father.

* * *

Halit Yozgat was born on January 2, 1985, a beautiful baby—so much so that the nurses at the hospital in Kassel had shown him off to one another. He was "so tiny and small," his parents remarked, "but he had full hair, long eyelashes, strong eyebrows and nice round cheeks." His parents, Ismail and Ayşe, had immigrated to Germany from Turkey in the mid-1970s. At the time Halit was born, Germany did not grant citizenship by birth. Born to two Turkish parents, Halit would remain Turkish until he turned eighteen. Growing up near Kassel's city center. Halit excelled in school. His favorite subject was math. He memorized parts of the Koran and dreamed of one day becoming an imam. When the family traveled to Turkey to visit their relatives, the kids would pester their parents about when it was time to go "home"—back to Germany.

When Halit was twelve, his parents bought a computer for him and his sisters to use for schoolwork. Curious how it worked, Halit disassembled

it in a day. When his father found out, Halit happily assured him that he knew how to put it back together. By late afternoon, the computer was working again. After completing tenth grade, Halit left school so that he could put his interest in technology to use. In 2004, at age nineteen, he and his father opened an internet café on the ground floor of the four-story apartment building where Halit was born. It had eight telephone booths where first- and second-generation immigrants would make calls to their families back home. A door led to a room with six computers. Most days, at around 4 p.m., Halit left the café to attend night class in pursuit of his *Abitur*. By the spring of 2006, he was twenty-one and nearing graduation.

On the afternoon of April 6, Halit was sitting at his desk at the front of the café, doing his homework, when his father left to run an errand. When Ismail returned a few minutes before 5 p.m., Halit wasn't waiting by the door to greet him as usual.

"Halit, where are you? Are you at a computer?" his father called out, but Halit didn't reply.

Ismail noticed two dark red splotches on the counter.

"Halit, what are you doing here with the red paint?"

That's when he looked behind the desk and saw Halit on the floor, blood pouring out of his head. Ismail screamed.

A woman who had been in a phone booth speaking with relatives back in Turkey dropped the phone and ran to the front of the store. Two teenagers had been on a computer playing *Call of Duty*. One, a seventeen-year-old immigrant from Jordan, rushed over to try to stop the bleeding while Ismail tried to call an ambulance. When he couldn't get through, he rushed to a tearoom next door to use the phone there. Upon returning, he took his son into his arms and called out his name over and over. By the time the paramedics arrived, Halit was dead.

Another man who'd been in a phone booth told police he thought he caught a fleeting glimpse of the killer. But he hadn't gotten a good look because a sticker on the glass door of the booth obscured his view. Weeks would pass before investigators realized there was a fifth witness in the café—a man who didn't want his presence to be known.

* * *

Two cities, two back-to-back killings, two days apart. Police officers raced to connect the dots. The day after Halit's murder, they established a homicide squad consisting of thirty-five officers. Witnesses said they'd seen two men carrying a heavy-looking plastic bag—officers presumed it contained the gun. Forensic analysis confirmed that the bullets used to kill Halit were fired from the same Česká 83 pistol, making it the ninth murder in the series that had now lasted nearly six years. Officers collected data from cell towers to trace the calls that had been made in the vicinity, obtained surveillance footage from nearby cafés and shops. At last, it seemed as if officers were doing things right.

But it didn't take long before they regressed into the same prejudicial policing as their colleagues across the nation. Assuming the killer wasn't German, officers checked the vehicles that passed by the café, looking for foreign license plates. They took Ismail to the police station and proceeded to question him for four and a half hours. They swabbed him and his wife, Ayşe, for DNA. They asked the couple for the names and phone numbers of all their relatives back in Turkey, then proceeded to interrogate them one by one.

Just like with the so-called döner murders of Mehmet Turgut at his Rostock kebab stand and Ismail Yaşar at his stand in Munich, the press got to work spouting fantasies of their own. Newspapers in both Germany and Turkey speculated that Halit Yozgat had been selling heroin and was killed over a drug or money dispute. After that, "everyone looked at us hostile, both the Germans and the Turks," Ismail recalled.

At some point the idea that their son's killers might be anti-immigrant *Germans* did occur to the Yozgats, just as it had to the Kubaşıks, the Şimşeks, and other families before. But when the Yozgats suggested this to the police, officers denied the possibility outright.

"We had an eye on the right-wing scene in Kassel at the time of the crime, and the series, including the crime in Kassel, was not an issue connected to the right-wing scene," declared the lead investigator. He pointed out that no one in far-right networks had boasted about the murder, as neo-Nazis tended to do. When police rejected this theory, Ismail did, too.

"We're just imagining things," he thought. "We're in Germany after all. We are citizens of this country. We have always been decent, we have

always worked—all in the belief that here in Germany, everything is fair, just, structured," Ismail believed. "We are *Germans*, after all."

The notion that their fellow Germans had set out to kill his son because he wasn't German enough "was unthinkable."

"That would have turned our whole image of Germany upside down."

* * *

Less than a month after Mehmet's murder, Gamze and Elif were at home when the telephone rang. The man on the line introduced himself as Ismail Yozgat. Gamze put the phone on speaker. The bereaved father had barely introduced himself when Elif started to cry and had to hang up. Ismail's wife, Ayşe, called back, and she and Elif began to speak. They talked about how they'd been treated—interrogated, suspected—by police. The Yozgats told Elif that they were organizing a rally in Kassel to draw attention to the murders. They hoped the other families who had lost loved ones to the Česká 83 might attend. The Şimşeks promised to be there, Ayşe told Elif. Would the Kubaşıks come, too? Gamze and Elif were nervous, but they hoped the demonstrations might generate public attention and lead people to come forward with clues.

"We wanted Germany to *listen*," said Gamze.

On Thursday, May 6, 2006, exactly one month after Halit's murder, Gamze and Elif drove the two hours from Dortmund to Kassel. Elif noticed a police station a stone's throw from the cybercafé. "How can it be that they kill people *here*?" she wondered. The street looked so much like Mallinck-rodtstrasse, where Mehmet had been killed. Gamze was anxious. She'd heard that Halit had left behind four sisters, some of whom were around her own age. She wasn't sure what to say to them. But she was relieved to see the sheer number of people—some eighteen hundred—who had turned up to march with them. They carried signs: *"Keine 10"*—"No 10th Victim." Hugs and tears quickly gave way to a feeling of strength and of unity—the feeling that Gamze, her mother, and brother were not alone. Among the marchers was Semiya Şimşek, who spotted a distressed young Gamze in the crowd.

"She was twenty, the same age as me, and I recognized myself in her from the first moment. It was like looking into a mirror," Semiya recalled. There was no mistaking the familiar expression of pain on Gamze's face:

"I saw the sadness in her eyes, and probably nobody could understand her better than me. I knew what she was going through." In the years since Enver's murder, whenever she walked at night, Semiya would look over her shoulder. If someone was behind her she'd wait until the person passed before continuing on her way. Now, as the crowd of protestors convened outside the cybercafé where Halit Yozgat had been murdered, Semiya approached Gamze.

"Is it *your* father who was also killed?"

Gamze was taken aback. She didn't know who Semiya was. That a complete stranger had somehow intuited correctly that Gamze too had lost a father made her wonder: *How many fathers have been killed?* Semiya tried to hug Gamze, but Gamze felt distant and barely returned the embrace.

"Your father shouldn't have died," Semiya told her.

Gamze didn't know what Semiya meant. *Of course* Mehmet shouldn't have died. It was only later, after the two began talking, that she began to understand. Semiya's father, Enver, was the first man to be slain. After his death, the Şimşeks had agonized as police interrogated their family, attempting to trick them into pointing a finger at one of their own. Now the same thing was happening all over Germany, over and over again: An innocent man would be killed, police would retraumatize the family, and no one would be any closer to the truth. In the six years after Enver's murder, police ought to have done something to stop it. Instead, those six years brought eight more murders. Had the police reacted differently, *rightly*, Semiya told Gamze, "your father could still be alive."

Some German legal scholars reject the notion that police officers' racism led them astray. They say that those who criticize the police for their response to the NSU's terror suffer from "hindsight bias." At the time, the murders didn't look like the sort of terrorism Germans knew. Many associated terrorism not with the far right, but with the left, thanks in large part to the Red Army Faction, or RAF, also known as the Baader-Meinhof Group. Throughout the 1970s and 1980s, the socialist terror group attacked American military bases that continued operating in Germany following World War II. Its members believed violent action was necessary to oppose what it viewed as Western imperialism. The RAF would go on to commit nearly three hundred bombings and arsons as well as assassinations, kidnappings, and a plane

hijacking.* Some of the group's leaders were imprisoned, and it eventually fizzled out, but Germans' notion that *this* was what terrorism looked like, didn't. Terrorists had a clear, political motive, and they took credit for their acts.

When it came to the NSU, police failed to find a political motive, so they presumed it wasn't terror. What authorities didn't understand was that killing immigrants *was* that motive. What to the police and to the press seemed like criminal acts linked to drugs, prostitution, or personal feuds were in fact *terrorist* acts against nonwhite Germans.

To excuse authorities for their failure would be to excuse their racial and xenophobic prejudice. *Real* policing isn't just about instincts, but *evidence*. If police wanted to solve the murders, rather than double down on their biased assumptions, they needed to follow the facts. Facts like the many witnesses who saw white men cycling away from the crime scenes. Facts like all the victims fit the profile of what far-right extremist Germans decried in their magazines and songs. Clues like the crude poem police found in the garage in Jena in which the bombmakers threatened immigrants. Facts like there being no evidence whatsoever that the families were involved in drugs or organized crime.

But these facts contradicted what officers knew in their hearts to be true: that somehow, immigrants must be to blame. Even if police acted earnestly upon their assumptions, their assumptions were wrong—and they were wrong because they were biased against immigrants.

Their prejudice proved fatal.

Your father could still be alive. Semiya's words rang inside Gamze's ears

* The RAF's terror included the 1972 bombing of the Hamburg headquarters of the Springer company, which publishes the popular daily newspaper *Bild*; the 1974 assassination of Germany's federal public prosecutor; the 1989 murder of Deutsche Bank CEO Alfred Herrhausen; the bombing of various U.S. military installations; and the 1991 assassination of Detlev Karsten Rohwedder, the head of the Treuhand agency that had overseen the sale of East German companies like Carl Zeiss Jena to buyers in the West. In one of their most infamous acts, in 1977 the RAF kidnapped a former Nazi SS officer who had become a prominent businessman and a voice against communism, Hanns Martin Schleyer, then murdered him. The group even hijacked a Lufthansa flight en route to the popular German holiday getaway of Mallorca, Spain, rerouting it to Mogadishu, Somalia, in a failed attempt to extort $15 million in U.S. currency from the West German government. Uwe Mundlos had once been infatuated with the RAF's tactics, if not its politics—their ability to remain underground for so long.

as the two young women watched demonstrators lay wreaths outside the internet café. Together they walked in silence toward Kassel's city hall. Gamze walked near the front, and when she looked back, there were marchers as far as the eye could see. They carried placards with photos of the nine murdered men. Gamze noticed the clicks of the journalists' cameras, the sound of police helicopters flying overhead. She walked alongside Semiya and the Yozgat sisters—six women among the hundreds of friends, relatives, and supporters who marched to demand justice for their loved ones and to make the murders stop. When they reached city hall, relatives of the victims made rousing speeches.

"My twenty-one-year-old son was murdered with three shots to the head," Halit's father, Ismail, told the crowd. "I would have liked to see you all, such a crowd, at my son's wedding. Instead, it's this sad occasion." After the march ended, the Yozgats invited the Kubaşıks and Şimşeks to their family home. Gamze and Semiya bonded over their grief and anger at the prejudiced police and the careless news media.

The day after the march, Gamze and Semiya were relieved to discover that for the first time, the press wasn't insinuating that their fathers were drug dealers who had gotten what they deserved. Instead, news focused on the families' hunt for answers as to why these men were slain. Gamze and Semiya decided to do everything they could to keep it that way. In the months and years that followed, they spoke to the press and demanded answers. Why didn't investigators suspect native-born Germans might be to blame? Why did they insist there was some nefarious connection between the different families, despite that none of them had ever met? Why could they not see the obvious—that these families were being targeted by someone who hated them for who they were?

In the days after the march in Kassel, a Turkish German community organization that helped organize the event set up a phone line that people could call with tips. It never received a single call.

* * *

After the demonstration, Gamze's mother, Elif, came up with an idea. The rally in Kassel had garnered so much attention in the press. Why not hold a second one, this time in Dortmund, where Mehmet was killed?

If we stay quiet, the media are just going to publish false things about us—they're going to tell lies, Gamze learned, tarnishing Mehmet's image and ruining the family name. *But if we raise our voices at least they will say the families want answers and they want the murders to stop.*

Elif was active in a local Kurdish Alevi cultural center, which agreed to help. To get the necessary permit for the rally, they approached a detective named Gülay Köppen—the only officer who had treated them with respect in the difficult days after Mehmet's murder. Köppen was of Turkish heritage, and she often translated between the other officers and Elif. She had even attended the rally in Kassel, albeit in her official capacity as a detective.

"She was the only one from the police who ever called us and asked how we were doing," Gamze said of Köppen.

With Köppen's help they secured the permit, and Elif made posters and printed flyers with the slogan of the rally—"No 10th Victim"—to hand out to strangers on the street and to stuff into mailboxes. Like the Yozgats had done, they reached out to all the families. To their disappointment, the Şimşeks couldn't come. One widow told Elif, "I'm scared," and hung up the phone. Others said they wanted nothing to do with it. Some worried that the attention might draw more ire from the police.

Gamze and her mother pushed ahead. Their plan was to march from the kiosk to Dortmund's central train station, a kilometer south. That way thousands of people would see them. But to their disappointment, when the day came, police routed the demonstration through quieter side streets instead, to avoid crowds from a nearby football match. Still, the rally drew at least two hundred people and garnered headlines such as "Silent Vigil, Loud Reminder." In the months that followed, other families organized rallies in Nuremberg where Enver Şimşek, Abdurrahim Özüdoğru, and Ismail Yaşar had been murdered, and in Munich, where Habil Kılıç and Theodoros Boulgarides were killed. Across Germany, immigrant-rich communities took to the streets to demand that police protect them.

Chapter 15

Dead Men and Homeless Cats

One spring day, Mundlos and Beate were out riding their bikes when Mundlos asked her what she would do if they ever got caught. Would she shoot herself before the cops could arrest her, like he and Böhnhardt planned to do? When Beate replied that she wouldn't, he suggested that there were other ways to die—like poisoning oneself with carbon monoxide. Beate recoiled at the thought.

"He couldn't understand why I would rather go to jail than kill myself if I was caught," Beate would later recall.

In the autumn of 2006, the trio decided it was once again time to fundraise for the cause. Over the previous seven years they'd stolen hundreds of thousands of deutsche marks and tens of thousands of euros with hardly a hitch. But on their ninth attempt, something went wrong. When they entered a local credit union in Zwickau not far from where they were living, they behaved more aggressively than in previous robberies. When Böhnhardt threw a vase and bashed a female bank clerk in the head with a desk fan, a nineteen-year-old bank trainee named Nico R. decided to take action. He lunged to grab Böhnhardt's gun.

"*Bist du verrückt?*"—"Are you crazy?"—Böhnhardt yelled and swung the gun out of Nico's reach, then fired. The bullet struck Nico in the stomach. Nico survived, and the Uwes fled without any cash. The incident revealed that the Uwes had grown reckless: They'd shot a man in a bank lined with security cameras, just a few miles from their home. One month later, in what may have been an attempt to vary their routine, Böhnhardt

robbed another bank, alone. But they needn't have worried. Although local police realized some of the bank robberies were connected, they had no idea who the two masked burglars were—much less suspected that they happened to be serial killers.

For their part, the investigators tasked with finding the Česká killers had no idea that they were also robbing banks. While task force Bosporus was hitting dead ends in their hunt for imagined immigrant mafiosos, authorities an ocean away actually managed to make some headway. In 2007, Munich police asked the FBI to conduct an analysis of the evidence in the case. In a classified memo titled "Serial Murder," the FBI concluded that "the offender is specifically targeting Turkish appearing individuals," and "identifies 'targets' by frequenting areas of Germany that have Turkish populations and looking for people…who resemble ethnic Turks." The FBI pointed out that nothing had been stolen from any of the crime scenes, which cast doubt on German authorities' theories that drug money was to blame.

"The offender is a disciplined, mature individual who is shooting the victims because they are of Turkish ethnic origin or appear to be Turkish," the FBI wrote. "The motivation is a combination of personal cause and thrill. The offender has a personal, deep rooted animosity towards people of Turkish origin…This allows the offender to feel justification for shooting relative strangers. There is also a component of thrill involved, as the crimes are high risk to the offender, who is entering businesses during the day and using a handgun."

The United States, with its own history of white supremacist terrorism, from the KKK to modern white militias, from *The Turner Diaries* to preppers for a real-life Day X, was able to see what *Germany*—despite its supposed reckoning with the gravest white supremacist violence in history—could not: that a white supremacist, anti-immigrant terror spree was underway. The FBI noted that in each case, bullets had been fired from the same two handguns—a rare 7.65mm Browning pistol (the Česká) and an unidentified 6.35mm gun.

"The choice of the 6.35mm weapon is unusual in that it is an old weapon that is no longer common. The offender is very proud of this weapon," the FBI warned, advising their German counterparts to issue a press release describing this weapon to elicit the public's help in identifying where it

came from. "Another media release," the FBI suggested, "should be generated to highlight the facts of the case, to seek to identify anyone who has a grudge against ethnic Turks and who would have been in the various localities at the time of the shootings."

German authorities did no such thing. They simply couldn't fathom that white, native-born Germans could become anti-immigrant terrorists. As police failed to find the fugitives, they were about to get a rude awakening: The terrorists were coming for *them*.

* * *

April 25, 2007, was an unseasonably hot day in Heilbronn, in southwest Germany. A twenty-two-year-old police sergeant named Michèle Kiesewetter and her colleague Martin Arnold sat in their squad car, a BMW 5 Series station wagon, in the shade of a parking garage to escape the midday sun. The river Neckar flowed a stone's throw to the west. They took off their seat belts and opened the car's windows and doors. They ate some sandwiches, smoked some cigarettes. They didn't notice as two men approached their vehicle from behind.

Kiesewetter had grown up in Thuringia in the small town of Oberweissbach, nestled in the Thuringian Forest, an hour-and-a-half drive southeast of Jena. At eleven she decided she wanted to become a police officer. Her uncle was a cop, and she was enthralled by his stories. Kiesewetter was an energetic child, always on the move—running, cycling, jumping wherever she went, scraping her knees and elbows. Her family would remember how, at just seven years old, she jumped off the seven-meter high dive into the pool. When she was older, she competed in biathlon, skiing and shooting. In 2002, a year after she graduated high school, at age seventeen she enrolled in the state of Baden-Württemberg's police academy, and in 2005 was hired as a riot police officer in the quiet town of Böblingen.

That hot day in April, Kiesewetter agreed to pick up a last-minute shift in nearby Heilbronn. It was early afternoon when the two men approached the squad car from behind and opened fire. Rounds of 7.62mm Tokarev and 9mm Luger bullets—different from the ammunition the Uwes had used to attack immigrants, and discharged by different guns—ripped through both officers' heads. The Uwes grabbed the officers' service weapons—two

Heckler & Koch pistols—as well as thirty-nine 9mm bullets, a set of hand-cuffs, a type of pepper spray, a flashlight, and a multitool. Then they ran away.

Just after 2 p.m., a witness noticed a police officer with a bloodied shirt crawling from the open squad car door. The witness rode his bike as quickly as he could to a nearby train station, where he informed a cabdriver, who called the police. It was 2:12 p.m. when police learned that one of their own had been shot. For Kiesewetter, it was too late: She'd been killed at the scene. Her colleague Arnold was raced to a hospital and survived.

Authorities' response to the attack differed immensely from the way their counterparts had responded to the murders of immigrant men. This time, police sent helicopters to surveil the city and dispatched dozens of squad cars to create a perimeter five kilometers from the crime scene, to block the perpetrators' escape. Later, a police checkpoint thirty kilometers from the crime scene captured an RV with license plate C-PW-87 traveling away from Heilbronn between 2:30 and 2:37 p.m. Though officers didn't yet realize it, Uwe Böhnhardt had rented it two weeks earlier in Saxony using Holger Gerlach's ID. It was one of thirty-three thousand vehicles police documented moving about the city in the hours after the attack. In the days and weeks that followed, police investigated a thousand tips and considered an incredible five thousand leads in their relentless attempt to identify the attackers. Their swift and comprehensive actions revealed what officers *could* have done—but chose not to—when immigrants were the ones being killed.

Even more revealing is what authorities *didn't* do. They didn't lie to Kiesewetter's relatives, saying she sold drugs or visited prostitutes. They didn't spread false rumors among her neighbors or inquire about her sex life. They didn't shout at her relatives to admit that they'd ordered the hit. The officers didn't dare use such insensitive tactics: Kiesewetter and her colleague Arnold were white.

Incredibly, investigators nevertheless speculated that immigrants or minorities were to blame. A June 29, 2007, report into "the Hunt for the Phantom" killer revealed that "the investigators are also researching the members of 'mobile social groups' such as Sinti and Roma—but they are hard to catch."

"We are also checking intensively in the Gypsy milieu," said one investigator. Rumors spread that Roma or Sinti families had been spotted earlier that day within a hundred meters of the scene. It isn't clear if those rumors were true. Officers eventually interrogated several Sinti or Romani people—officers didn't distinguish—but were unable to conclude whether they'd been there at all. Police cited a psychologist's description of one Roma suspect as a "typical member of his ethnos," noting that "the lie is a central part of his socialization." Armed with prejudice, but not evidence, they eventually had to let him go.

If German police were quick to vilify immigrants, their bias reflected Germans' attitudes at large. In a poll the year before Kiesewetter's killing, 59 percent of Germans agreed with the statement that "too many foreigners are living in Germany." The next year, one in four Germans surveyed expressed xenophobic beliefs. And while officers directed enormous resources toward investigating the shooting of their two white, native-born colleagues, Germany's immigrants were still under attack. Four months after Kiesewetter's killing, in August 2007, a mob of fifty people in the town of Muegeln, Saxony, shouted "Foreigners out" as they chased eight Indian immigrants away from a weekend festival, then beat them, giving them black eyes and leaving deep gashes in their faces that required stitches. Dozens of people looked on, but no one intervened. The following month in the Baltic port city of Wismar, when a group of students from the Czech Republic and Hungary asked for directions, a mob of Germans chanted "Foreigners out" and attacked them with pepper spray. The next month, a young mob in a Berlin suburb punched three Greek men and shoved a Greek woman to the ground, bombarding them with insults. That December in the eastern German town of Magdeburg, three drunk Germans attacked four immigrants from Niger. Days later, a German man on a bus punched a pregnant Iraqi woman in the face.

When it came to despising and committing violence against immigrants, the three friends from Jena were not alone.

* * *

Back in Zwickau, the trio went about their normal lives. Mundlos loved the outdoors and spent hours walking or going on bike rides. "If he couldn't go

outside for three days due to the weather in winter, he became unbearable," Beate would later say.

One year after murdering the policewoman, in April 2008, they decided to move from the working-class neighborhood of Polenzstrasse 2 to a more middle-class one at Frühlingsstrasse 26. Their second-floor unit had four rooms, a kitchen, and two bathrooms, and came with storage space in the building's basement. They fortified their hideout with four surveillance cameras—one of them hidden in a flowerpot in the kitchen window—to record anyone who came and went. Footage showed a middle-aged Beate walking up the stairs, her black hair in a ponytail, a watch on her right arm. Upon arriving, she would take off her shoes in the hallway and leave them outside the door. Sometimes Mundlos would walk in wearing a T-shirt and carrying a box of pizza. As a precaution, whenever the doorbell rang, the Uwes would hide while Beate answered. In the event that the visitors were police, the Uwes planned to shoot themselves on the spot.

The Uwes introduced themselves to one of their neighbors over liters of beer and a pizza. Rightly unconcerned that the authorities might be on to them, they used their real first names. One said he was Beate's brother, the other her "man." But the Uwes quickly confused their stories and reverted back to their old aliases, "Gerry" and "Max." The two men would retrieve their bicycles from the basement and walk them to the street, saying hello to whoever they'd meet. Sometimes a camper van would appear outside the house, and the two men would get inside, drive away, and disappear for a day or two.

Be it from stress or for leisure, Beate began to drink more heavily— or so she would later claim. Instead of a bottle of sparkling wine—*Sekt*— every couple of days, she started drinking a bottle a day, sometimes two, even three. Beate would claim that by this time, *both* Uwes, not just Mundlos, had become stringently opposed to alcohol, viewing it as a vice that distracted them from the greater purpose at hand. Beate claimed she felt judged by them and that she often retreated to her room to drink alone.

On the ground floor of their building lived an elderly neighbor, Ms. Erber, who befriended Lilly and Heide, the trio's cats. When the friends went on vacation Ms. Erber would care for them. By this time, their favorite spot was Fehmarn, an island in the Baltic Sea. All summer Germans flock

to its wide, sandy beaches and squeeze into *Strandkorbs*—beach baskets—to sit in the shade as they watch the gentle waves. Beate and the Uwes would take up residence at one of the island's many RV parks. They would vacation there for five straight summers, from 2007 to 2011, cycling or surfing or chatting with other beachgoers by day, and listening to the waves at night. They were there the summer of 2011 when, on another island six hundred miles due north, a man who they did not know would launch the deadliest white terrorist attack Europe had seen in thirty years.

Anders Breivik had been plotting and preparing, collecting guns and bullets, industrial fertilizer and other chemicals in his mother's house, where he still lived at age thirty. He too was convinced that immigrants were destroying all that white Europeans held dear. After 9/11, America's War on Terror displaced millions of people from Afghanistan and Iraq, and thousands of them settled in Norway. The nation was already home to immigrants from Vietnam, Hungary, and Pakistan, from Pinochet's Chile and Ruhollah Khomeini's Iran. On the morning of July 22, 2011, Breivik detonated the homemade bomb he'd been building in Oslo's government quarter, then boarded a ferry to the island of Utøya where six hundred teenagers—youth members of Norway's relatively pro-immigrant Labour Party—were spending their days at a summer camp in the woods. Breivik sprayed them with bullets, chased them off cliffs, shot them in the back. By the time authorities realized what was happening, he had slaughtered seventy-seven people, most of them children. He did so in the name of anti-Islamization, of protecting European identity, of preventing a "civil war due to Muslim immigration," and defending his nation from those who did not belong.

Breivik was just the beginning. Across the globe, white men looked to him with admiration and resolve. Before an Oslo judge could even hand down Breivik's sentence, a white man in Wisconsin entered a Sikh temple with a semiautomatic pistol. Mistaking the worshippers for Muslims, he sprayed them with bullets, killing seven and injuring three.

A new wave of global white terror had begun.

* * *

The summer of 2011 was not particularly warm on the island of Fehmarn. The three friends would have had more sun had they stayed home in

Zwickau. But they made their usual pilgrimage nonetheless, renting a dark blue VW Touran van and setting up for the summer at the "Wulfener Hals" campsite on a bay called the Sund. They introduced themselves to their neighbors as "Max," "Gerry," and "Liese."* "Max" was a "computer freak" who loved to play computer games, their neighbors that summer would say. He also liked to play cards—Doppelkopf—and made friends that way with the neighbors. "Gerry" had tattoos on his leg and upper arm—flower tendrils and a skull. He kept to himself, except on rare occasions when he'd play *The Settlers of Catan* with the neighborhood kids, and in the evenings when he'd fire up the grill and throw sausages on. On outings, "Gerry" did the driving—cautiously, always obeying the speed limit. It was a far cry from Böhnhardt's days driving stolen cars recklessly and leading cops on chases back in Jena.

At the beach, both Uwes were in their element. Later, Beate would claim she felt restless, helpless, trapped. But if so, she didn't show it. By day, "Liese" would sunbathe with the neighbors. She befriended a thirteen-year-old girl whose family vacationed next door. Beate took the girl and her sister to the movies. She even helped wash the family's laundry, and often planned and cooked the meals for the entire group. Later, when one of the families returned home, they received a package of sausages in the mail. The package listed no return address, no sender. But it did have a phone number: "Liese's." Beate had decided to send them a farewell gift.

"Liese," her neighbors noticed, was in charge of the trio's money. Whenever it came time to pay for anything, Beate would reach into her purse. Later, investigators would point to this as evidence that Beate was in no way trapped or tethered to the Uwes. If she'd opposed the murders, the bombings, the bank robberies, she had the means to run off on her own. Aside from Mundlos's expensive taste for windsurfing, Beate was prudent with their funds. She paid for everything in cash, which couldn't be traced as easily as credit cards.

Sometimes the three friends chatted with their neighbors about their

* Throughout their years on the run, some witnesses recalled them using the English names "Gerry" and "Lisa," while others knew them by the German versions, "Gerri" and "Liese."

cats—but never politics. Their neighbors at the campsite would say that the subject of immigrants never came up. On at least one occasion, "Gerry" let something slip, boasting to a neighbor that he knew how to build a bomb. "He bragged a bit, that he knew how to do it. He joked about it," the neighbor recalled. But at the time, the man shrugged it off—"sins of youth"—and never reported it to the police. In Fehmarn, the trio was so unconcerned about being discovered that when a film crew arrived to film a workout video near the beach, Beate volunteered to be in it. Wearing black-and-pink spandex leggings, a black tank top, white tennis shoes, and sunglasses, she appeared in the exercise video doing calisthenics.

The trio's only close call with the law in Fehmarn had occurred the previous summer and had nothing to do with their crimes. After a group of teenagers went out scuba diving, news spread around the campsite that something was awry. Rescuers spanned out over the water, plucked girls from the sea, and administered CPR to several boys. Two children, a boy of about eleven, and a girl of sixteen, had gone out diving and never came back. The boy's mother was in shock, and it was Beate who walked her to her trailer to comfort her. When journalists arrived to report on the tragedy, Beate and the two Uwes disappeared into their van.

On several occasions, Holger Gerlach, who for years had been renting the vans that the Uwes used to rob banks and to murder, showed up on the island for what they called "system checks." Since Gerlach provided the trio with insurance cards, IDs, passports, and other documents in his name, the trio would ask him about any life changes or updates, so that their alibis matched. On one occasion Gerlach delivered 10,000 euros to the trio at the beach, to spend on their holiday needs.

The Uwes were still far-right music fans, and had they been listening to the latest neo-Nazi bangers at the beach that summer, they would surely have been pleased by a song by Gigi & the Brown Town Musicians, whose 2010 album *Adolf Hitler Lives* contained a song about *them*. Titled "Döner-Killer," the fourth track was an ode to NSU.

He has already done it nine times. He comes, he kills, and he disappears.
More exciting than any thriller, they chase the kebab killer.

The lyrics reveal that the band understood what the families and the FBI did too, but what German police did not: that these killings were part of an anti-immigrant serial murder. "Profilers expect the next murder. The only question is when and where," the lyrics teased. The band also correctly identified the killers' broader, terrorist motives: to instill fear among all immigrant Germans. "There is fear and terror at the kebab stand. If he comes by, they'll die," the lyrics went.

The song ended by cheering on the killers:

> *When will they go hunting again? No investigator can tell . . .*
> *Because nine are not enough. Nine are not enough.*

* * *

By the time they left the island and returned to Zwickau in the autumn of 2011, the three friends had made quite a run of it. They'd killed nine men from immigrant families, earning themselves white supremacist fans across the nation. They'd murdered one German police officer to get her gun, and nearly killed another. They'd maimed two dozen people, most of immigrant heritage, with nails and other shrapnel. And although four years had passed since their last known criminal act, they decided they weren't quite ready to quit.

Two of their most lucrative heists had been in Stralsund, on a sound off the Baltic Sea coast where they spent their summers. In November 2006 they'd netted 84,000 euros, and in January 2007 they'd made away with 200,000, by far their biggest take. But rather than drive east along the coast, the Uwes returned to their old stomping grounds: Thuringia, where it all began. Traveling west from Zwickau on September 7, 2011, they would have driven through the southern tip of Jena, less than a kilometer from where Böhnhardt's parents still lived. When they parked their RV in the town of Arnstadt, the weather was cool but not cold. The duo would have felt the wind, which blew a steady southwest at nearly twenty miles per hour, as they cycled toward a Sparkasse bank. They entered wearing a vampire mask and a ski mask and carrying two pistols, a revolver, and a hand grenade.

"*Überfall!*"—"Robbery!"—one of them yelled. They cycled away with 15,000 euros in cash.

Six weeks later, in October 2011, a white Fiat Capron camper van appeared in front of their apartment in Zwickau. The next day, the trio loaded it with weapons and other items. This time they chose the automotive town of Eisenach, the city where white men celebrated German reunification by besieging a house of Mozambican guest workers. At the time the Uwes arrived, a mere 2.3 percent of the city's inhabitants were immigrants, and just 5 percent claimed immigrant background—most from Vietnam, Russia, and Ukraine. But the Uwes weren't after immigrants—just cash.

November 4, 2011, was a windless day in Eisenach—sunny and clear. The Uwes put on sweatpants, sneakers, a gorilla mask, and a mask from the movie *Scream*. They rested their bikes against the window of a café and walked into the Sparkasse bank next door. One of the Uwes grabbed an older woman by the arm and forced her to the floor. As they stole the cash from the registers, several five-euro notes fell to the ground, and they ordered two employees to collect them. They demanded that the bank manager open the safe, but he told them it had a time lock. One of the Uwes pistol-whipped him, causing his knees to buckle and leaving a gash across his head that began to drip blood. They turned to an employee named Antja and demanded that *she* open the safe, which she did. The Uwes set to work grabbing the money and stuffing the bundles into a grocery store bag. They left with 72,000 euros, got on their bikes, and cycled a kilometer north to where they'd parked their camper van.

That's when it all fell apart. A man saw them load their bikes into the van and drive off with a screech. He had heard about the robbery on the radio and called the police, who found the van parked a short drive away. A squad car pulled up. As the first officers approached, one of the Uwes fired a shot—but the gun jammed. The officers took cover by their vehicle. The Uwes were listening to police chatter on their radio, and they would have heard that more cops were on the way. They must have known there was no escape. They'd always boasted to Beate that they'd never be taken alive. And so they started a fire inside the van. Mundlos pointed a shotgun at his friend Böhnhardt and shot him in the head. Then he turned the gun on himself.

The cops watched the van go up in flames. Firefighters put out the blaze and a police officer peeked in. He saw a Pleter 91 submachine gun, a

Czech-made semiautomatic pistol, and a black handgun between the seats. He was surprised to see two shiny, brass-colored bullet cartridges—casings for the same bullets he used in his own government-issued gun. That's when he wondered:

Could the bank robbers be police?

* * *

Back in Zwickau, Beate was buzzed on a bottle of champagne she'd begun chugging since morning. She was at her computer, listening to internet radio streams for news from Eisenach.

They should have been back long ago, thought Beate. She was anxious, scared that something had happened. It was early afternoon when the news that she dreaded came through: reports of a bank robbery and a camper van on fire, the bodies of two bank robbers inside.

And there she was, home alone in a terrorists' hideout, surrounded by incriminating evidence. Neo-Nazi paraphernalia. Bombmaking materials. Hit lists with the names of prominent Jews. DVDs with the TV news segments they'd recorded and a manifesto to broadcast their rampage to the world. The Czech-made Česká 83 pistol, the one the Uwes used to kill the nine immigrant men. Ten liters of gasoline. And two cats.

It wouldn't be long before police figured out the dead bank robbers' identities, and when they did, they'd discover that thirteen years earlier, they'd fled Jena along with a third. Soon, the police would be coming for *her.* If Beate was to have any chance at saving herself from prison, all of these things, save for the cats, needed to be destroyed. Later, her lawyers would say she hesitated—agonized—over whether to start the fire. But she couldn't have agonized for long. At 1:52 p.m., Beate began searching the internet for animal shelters in Zwickau. "Where can I donate safely," she typed into her web browser. Her last internet search was at 2:28 p.m., and two minutes later she closed her computer and turned off the news. At 3:07 p.m., after splashing gasoline across the apartment, Beate set it ablaze.

Later she would claim that she never expected the fire to cause an explosion—much less three. She would say that she couldn't have known the ceiling would collapse onto the apartment below. That she'd taken care

to ensure nobody else was in the building. She knew that the people who lived on the second floor were usually out during the day. She rang their bell, just to be sure. She recalled that the two handymen renovating the attic had been listening to music while they worked. She could tell they'd gone out for a break because the music had stopped. On the ground floor of the building there was a Greek restaurant, the smell of which Beate had always found repulsive—and whose immigrant owners she may have, too. Once, on their birthday, she'd gifted them a pair of fat, caricatured Roman figurines from the popular animated cartoon *Asterix*, likely as a xenophobic joke. But on this day the restaurant was empty and closed.

The only person in the building Beate had to worry about was Ms. Charlotte Erber, the eighty-nine-year-old woman who lived behind the restaurant, on the building's ground floor. Ms. Erber was the kind woman who cared for Lilly and Heidi, the cats, when the trio was away. Beate went down and buzzed her door. Ms. Erber was in her kitchen when she heard the intercom. She picked up her cane and made her way slowly to the door. But by the time she looked through the peephole, no one was there. She retired to her living room, unaware that above her the building was going up in flames.

Beate didn't call the fire department or phone the police. In her haste to leave the burning apartment, she didn't pack a change of clothes. She even left behind several thousand euros in cash. But she didn't forget the DVDs, fifteen of them, already packaged and labeled, ready to reveal their white terrorist manifesto to the world. Beate put on a jacket, put the DVDs in her purse, placed Lilly and Heidi into their carriers, and set off down the street. For all she knew, Ms. Erber might burn to death in the flames.

Witnesses would say Beate looked normal, composed, even calm. As a cloud of black smoke billowed from the building, she approached a neighbor who was driving up the street. The neighbor asked Beate what on earth had happened, but Beate didn't reply. She set down Lilly and Heidi and asked the neighbor to look after them.

"Grandma is still in there," she said, referring to Ms. Erber. Inside the burning house, Ms. Erber still hadn't noticed the flames. It was only by chance that she returned to the kitchen and saw smoke. She opened the

kitchen window to let it out, then made her way to the living room to do the same. Upon opening the living room window, she noticed that her niece was standing on the street, yelling that the apartment was on fire and she should get out right away.

By that time, Beate had walked east, in the direction of the railway tracks, and disappeared.

PART III

Chapter 16

The Confetti Cover-up

Early on the morning of November 5, 2011, a telephone interrupted Brigitte Böhnhardt's sleep. Groggy, she picked it up and heard a woman's voice on the line.

"This is Beate."

Brigitte said nothing. The name didn't ring a bell.

"This is *Uwe's* Beate," the caller said. *Beate*, her son's girlfriend, the son Brigitte hadn't spoken with in nearly a decade.

Are the three friends finally ready to turn themselves in? Brigitte asked.

"Uwe isn't coming home again," Beate said.

At first, Brigitte didn't understand. Beate repeated herself. Brigitte paused, working up the courage to ask if Uwe was dead.

"Yes, Uwe's dead," Beate replied, then asked if she'd seen the news about "the two boys" in Eisenach, whom police had yet to identify. It was them, Beate told her.

Brigitte sat with the phone in her hand. A thousand questions raced through her mind, but she didn't get the chance to ask even one. Beate told Brigitte that she had to go—she still had another phone call ahead of her, to the parents of a different dead Uwe.

The following day, two police officers arrived at the Böhnhardt residence to take DNA samples from Brigitte and her husband, Jürgen, to identify the bank robbers' remains.

* * *

Back in Saxony, police had been searching for the wrong suspect.

Because Beate had used the alias "Susann Dienelt" with her neighbors, police attached that name to their composite sketch. When officers found the *real* Susann Dienelt, she told them she'd lost her ID at a nightclub years ago. To be sure, officers ushered her into a lineup to see if the neighbors recognized her. When Saxon state police realized their mistake, federal investigators issued a nationwide alert for Beate Zschäpe, pulling her description from her 1990s police files:

Height: 1.66 meters
Weight: 63 kilograms
Shoe size: 38
Head shape: round / wide
Hair color: dark brown
Eye color: blue-gray
Voice: fast, loud
Language: German, Thuringian dialect.

Suddenly, Beate became Germany's Most Wanted, her name and likeness splashed across televisions and newspapers across the country.

Meanwhile, officers in Eisenach towed the burned-out camper van to a garage with the Uwes' bodies still inside. The van was soaked from the fire brigade's hoses and blackened by the ash from the men's bodies and the melted refuse: train tickets, passport photos, children's toys. A teddy bear and a pair of pink Crocs shoes. One hundred and twelve thousand euros. Two backpacks, two flash drives, and six DVDs labeled "National Socialist Underground" that police presumed contained far-right music. They packed all of it into forty boxes to sift through later.

In Zwickau, the trio's apartment was also soaking wet and covered in ash. There too, police found DVDs—thirty-five of them. In the apartment's basement storage area was a TV with a photo of Adolf Hitler clipped to it, one of some eighteen hundred pieces of evidence the officers saved. They found what appeared to be hit lists of prominent leftists and Jews. There were vaccination records for the cats, Lilly and Heidi. They were registered to Mandy Struck, the neo-Nazi hairdresser in Chemnitz who helped hide

the trio during their first days on the run. Another piece of paper had the abbreviation "Hollä. Str. 82," the address of the cybercafé in Kassel where Halit Yozgat was killed. The note contained rows of numbers—radio frequencies for local police and emergency rescue services. It appeared the Uwes had been eavesdropping on the police, plotting to strike when officers were preoccupied somewhere else, or maybe just tuning in to laugh as the officers failed to find them. On one of the trio's hard drives investigators found a copy of *The Turner Diaries*.

Then there were the guns. In the camper van, officers found the two Heckler & Koch P2000 pistols stolen from the police officers they had attacked in Heilbronn. There was the Pleter 91 submachine gun that had jammed when one of the Uwes began shooting at the cops in Eisenach. Officers examined a Winchester pump-action shotgun and surmised it was the one that had ended it all—the gun Mundlos used to shoot Böhnhardt through his left temple before he set the van on fire, sat down, placed the barrel to his own mouth, and fired. The officers recovered twenty firearms in all, along with copious amounts of ammunition. The gun that would command the most attention was the 7.65mm Česká 83 pistol used exclusively for the immigrant murders. The gun's serial number was illegible—scratched out or burned beyond recognition by the fire. Its surface was rusted from the fire department's water, the grip partially melted from the heat of the blaze. The barrel's muzzle was threaded with a silencer that nearly doubled the gun's length. It was covered in melted plastic from the bag the Uwes presumably tied around it to collect the bullet casings and keep them out of the hands of police. The Česká's magazine still had eleven cartridges inside. A twelfth was loaded into the chamber, ready to fire. Despite all its deformities, when ballistics experts tested the gun, "the weapon functioned perfectly."

Finally, amid the rubble, investigators found a note—a friendly bet Beate had made with Böhnhardt: "I am sure that my great figure will be absolutely fit for summer and the beach on May 1," it read. If not, Beate would have to clean the apartment—and cut two hundred video clips. *Video clips? Why video clips?* the officers must have wondered.

They wouldn't have to wonder for long. A few days after the fire, DVDs began arriving in the mailboxes of news outlets and Muslim community

centers across Germany. They contained a short film with edited clips from *The Pink Panther*, the cartoon Mundlos liked to quote in his youth. Set to a soundtrack of jazz, it depicted a sinister cartoon protagonist as he discovers an advertisement for a group fighting for the "protection of the fatherland": the National Socialist Underground. Dutifully joining the cause, the panther trails caricatures of foreign-looking men, plotting to blow them up. When the explosions occur, the film cuts to grizzly real-life images of the bodies of the nine murdered men, some of which had appeared in the news. Another photo shows thirty-one-year-old Süleyman Taşköprü lying bloodied on the floor of his produce shop. The Uwes had snapped it themselves, a trophy of their kill. The panther points to a map of Germany marked with nine white Xs—one for each man killed. At one point, he shoots a police officer in the head—a nod to the assassination of Officer Michèle Kiesewetter in Heilbronn. The video ends as the panther receives accolades for protecting his homeland from immigrants. The film's narrator promises that the panther will return one day—presumably to continue his spree. TV stations broadcasted clips of the video, revealing to Germany what nearly thirteen years of policing had not: The bombmakers from Jena weren't merely fugitives. They were *terrorists*, and this was their manifesto.

* * *

Now two of the terrorists were dead, but the third was nowhere to be found. After walking away from the burning building, Beate phoned André Eminger, who picked her up, drove her to his home, gave her a set of Susann's clothes—hers smelled strongly of gasoline—then left her at Zwickau's central station, where she boarded a train. She rode around Saxony, then north to Bremen, where she paused in a cybercafé to read the news. For three days, she rode the rails nervously and sleeplessly, hoping no one would recognize her, unsure of where to get off. By the fourth day, Beate was weary. "Those four days, she thought about killing herself," just like the Uwes had done, one of her lawyers would later lament. Instead, she went to Winzerla—to Jena, her childhood home. If she tried to visit her mother's apartment, she would have noticed police officers milling about outside. At 8:59 a.m., at a tram stop just a few hundred meters away, she borrowed a cell phone from a student and called the police.

"Good day. This is Beate Zschäpe," she said.

But the operator was oblivious to the nationwide manhunt. Beate tried to explain that *she* was the one everyone was looking for. A large swath of Zwickau was cordoned off, she told the operator—because of *her*. But the operator knew nothing of it. Beate hung up the phone.

A few hours later, she tried again to turn herself in, this time in person. On her way to a police station she passed the law office of Gerald Liebtrau, wandered in, and handed hundreds of euros in cash to an attorney whom she asked to accompany her to a nearby police station. There, Beate surrendered, in the city where it all began. When police searched her, she had just 12 euros and 23 cents. But it was neither money nor murder that seemed to concern her. She asked the officers about the fate of her two cats, Lilly and Heidi. The officers replied that they'd been taken to an animal shelter and were in good hands.

* * *

When Katharina König heard about Beate and the Uwes, she was shocked, but not surprised. *This is what we always expected*, she thought. *This is what we always warned.* For years the neo-Nazis she grew up with in Jena had tagged death threats as graffiti, sung along to the violent lyrics of far-right songs, joked about killing foreigners. Now they finally had.

Nearly fourteen years had passed since the night Beate beat up Katharina's friend Maria outside the tram stop—and a decade since Katharina's friends and family sent newspaper clippings to her in Israel about the trio's bombmaking and narrow escape. After she returned to Jena, Katharina had enrolled in a university program and began studying Judaism, Islam, political science, and Arabic. In January 2004, as the NSU prepared to murder Mehmet Turgut in Rostock, she'd been back in Israel for a visit when she received a call from a friend:

"Katharina, we need women!"

"For what?"

"For the local elections in Jena. Do you want to join?"

A coalition of leftists were trying to land a seat on Jena's city council. Angela Merkel's CDU party had dominated Thuringian politics—as well as Germany's—for Katharina's entire adult life. To Katharina, the

CDU seemed uninterested in curtailing neo-Nazis. Its competitor, the SPD, focused mostly on Germany's workers and unions. And although she empathized with the Green Party's concern for climate, her firm stance against fascism fit with a predecessor to the modern party Die Linke—The Left.*

"Sure," Katharina told her friend, treating her candidacy as a joke. She figured she didn't stand a chance. But to her surprise, she won a seat. Once she was a city council member, journalists began quoting her and her warnings about fascists. On three occasions, neo-Nazis reached out asking her to help them exit the far-right scene. After garnering what information she could about their networks, Katharina helped them find jobs, flats, and nonfascist friends. After serving five years on Jena's city council, in 2009 she ran for even higher office—a seat in Thuringia's state parliament—and won.

As an activist, Katharina had been an outsider, photographing fascists in their cars and fighting them in the streets. Now she fought them with the *law*. She demanded answers from prosecutors, police, and fellow politicians as to why they weren't doing more to stop far-right extremists.

When news broke about the three far-right fugitives from Jena, Germany's press knew exactly who to call. The day after Beate turned herself in, dozens of journalists descended upon Lothar's church, still home to the left-wing youth group. They all wanted to learn about the three friends from Jena.

"This is our chance," Katharina told her father. For two decades, she'd tried to warn her countrymen about far-right extremist threats. Now everyone was coming to *them*, to hear the sensational story of the bombmakers who became bank robbers who became xenophobic serial killers. Katharina seized the moment to show that the two dead Uwes and Beate were just three among many violent far-right extremists in the state, some of whom still posed a threat. Since the 1990s, Katharina and other Junge Gemeinde members had been collecting documents, photographs, and notes on Thuringia's far right, filing them away in the attic of the church. Now they dusted them off and sifted through them for information to feed the press.

* At the time, it was the Party of Democratic Socialism, or PDS.

They tracked down Mundlos's former schoolmates for clues to how he had radicalized. They asked Maria to recount how Beate had beaten her up, then shared her story with the press. A friend of the JG, a Jena journalist who had photographed the far-right scene in the 1990s, sifted through old negatives and unearthed images of teenage white boys in Thuringia giving Heil Hitler salutes, storming left-wing punk shows, getting arrested by police, and of a Jewish memorial desecrated with swastika graffiti.

"Have you heard about Juliane Walther?" Katharina asked the reporters, of Wohlleben's onetime girlfriend who had shown up at Beate's vacant apartment with a key. "What about Tino Brandt?" She began telling journalists about Brandt's THS. "It's not just three," Katharina told them, "it's a movement."

Working day and night, Katharina and her fellow activists compiled a list of "top fascists" in Thuringia—Wohlleben, Kapke, Eminger, Brandt—explaining to the press how they all were connected. One journalist called Katharina a "walking antifa Wikipedia."

As the full gravity of the NSU's terror began to sink in, Thuringia's lawmakers formed a committee to investigate the trio and their network. Katharina maneuvered to secure herself a seat.

* * *

One week after the fire, on November 11, news media began reporting on the Pink Panther video manifesto. The NSU was a "network of comrades," or so the video claimed. But how far did that network reach?

While Katharina searched for an answer, German intelligence officials set out to ensure no one would ever know. The day the manifesto went public, a clerk at Germany's federal intelligence agency in Cologne began feeding documents into a shredder. At first, she'd refused to do it. But when she was told the order came from the top—a department chief who went by the code name Lothar Lingen—she obliged. German media revealed that the documents were part of an operation to recruit far-right informants, including from within Tino Brandt's THS. The operation lasted from 1996 to 2003—well into the NSU's terrorist spree.

The revelation caused a national scandal, and because the shredding occurred in Cologne during the city's famous Carnival, in which confetti is

thrown into the air in celebration, the media began referring to it as "Operation Confetti." Three days after the shredding, German intelligence agencies destroyed even more potential evidence—six transcripts of telephone calls they'd recorded between members of the far right. This time the order came from even higher: Germany's Ministry of the Interior. Some newspapers reported that the files pertained to an operation to recruit right-wing informants in Zwickau, where the NSU had been hiding. Had intelligence agents known about the NSU all along?

Officials swore the files were destroyed as part of a routine procedure because they were more than ten years old, insisting they had nothing to do with the NSU. But to the families of the murdered men, the timing suggested authorities weren't merely negligent for having failed to stop the killings, but complicit in covering them up. These suspicions gained further credence when the intelligence agency in the state of Hesse, where Halit Yozgat was killed, conducted an internal investigation into what its agents might have known about the NSU. When members of Katharina's political party demanded to see it, the agency claimed that releasing the report could put their informants in danger and ordered the trove of documents to remain hidden from the public for 120 years.*

While agents were concealing and destroying potential evidence, police began questioning and arresting suspects, including some of the far-right extremists that Katharina and her antifa friends had exposed. When police questioned Holger Gerlach, he admitted he'd been in touch with the trio as recently as a few months before their demise. Officers arrested Gerlach one week later. Be it in pursuit of a lighter sentence, or in the hope that they might not charge him at all, Gerlach began cooperating with prosecutors. He admitted that he gave the Uwes the pistol at Ralf Wohlleben's request, then watched one of the Uwes load it in their Chemnitz apartment. Still, prosecutors charged him with three counts of aiding a terrorist

* After a public outcry, officials reduced the period to thirty years. Then, in October 2022, a German comedian obtained the report through a public records request and announced them on his late-night comedy show. Although they revealed how disorganized the agency had been, they shed little light on the NSU.

organization for renting the camper vans and for lending the trio his driver's license. He faced up to ten years in prison.

Journalists showered Katharina with questions. She revealed that Gerlach had been friends with the neo-Nazi hairdresser Mandy Struck. Police then questioned her, too. When police interrogated André Eminger, he lied, claiming he'd left the neo-Nazi scene more than a decade earlier. A few days later, at 6:28 a.m. on November 24, 2011, Eminger was asleep on his couch when twenty police officers stormed in to arrest him. Prosecutors charged him with two counts of being accessory to a robbery, supporting a terrorist organization, and aiding and abetting the Keupstrasse bombing in Cologne—Eminger had rented the van and loaned Böhnhardt his ID. Prosecutors also suspected that Eminger, who worked for a video production company, had helped with the Pink Panther video. If convicted, he could face up to fifteen years in prison. Later, when police searched the Emingers' residence in Zwickau, they found a drawing of the dead Uwes with a death rune and the words "Never forgotten" in Fraktur, the old German typeface used during the Nazi era and still favored by neo-Nazis to commemorate fallen comrades. This shrine to the Uwes was framed above the TV alongside photos of the Emingers' children.

None of the trio's accomplices drew more suspicion than Ralf Wohlleben, the Comradeship Jena cofounder who gave Carsten Schultze money to buy the Česká and who communicated with the trio during their first years on the run. On November 22, 2011, intelligence agents who were monitoring Wohlleben's phone calls overheard him chatting with a friend.

"Well, you terrorist," the friend on the line teased Wohlleben. "Even if they had found *me* in that apartment, it doesn't necessarily mean that I am guilty," the friend said, reassuring Wohlleben that he had nothing to worry about. "Anyway, keeping my fingers crossed that nothing else will happen."

But Wohlleben *was* worried: "I can already see myself on the inside," he replied. Seven days later, Jena police arrested Wohlleben and prosecutors charged him as a co-conspirator in nine murders for having furnished the Česká. He faced twelve years in prison. A judge deemed him a flight risk and ordered him jailed.

Carsten Schultze faced the same charges as Wohlleben, for passing the Česká and the silencer to the trio in the abandoned building in Chemnitz.

But unlike the others, Schultze really *had* left the far-right scene. He now worked for an HIV/AIDS awareness organization handing out flyers in gay bars in Düsseldorf.

One year to the day after Beate surrendered, prosecutors announced their charges against her. Ten counts of murder. Thirty-two counts of attempted murder, including twenty-two counts of serious bodily harm to the victims of the Keupstrasse bombing. Membership in a terrorist organization. Complicity in the bank robberies. And one arson that could have resulted in death, for burning down the apartment in Zwickau. If convicted she could face what Germans refer to as a "life sentence," though most prisoners sentenced to life can appeal to be released on parole after just fifteen years.*

Prosecutors investigated nine others they suspected of helping the trio. Max-Florian Burkhardt, who gave the fugitives their first home in Chemnitz and continued renting apartments for them for years. His girlfriend Mandy Struck, who helped harbor them and lent Beate her ID. Jan Werner, who had sent Carsten Szczepanski the text about "the bangs." Susann Eminger, who also lent Beate her ID. André Kapke, the trio's chubby friend who loved the phrase *"Bratwurst statt Döner"* and who helped Brigitte Böhnhardt funnel money to her fugitive son.

But in the end, the ten murders, two bombings, and fifteen bank robberies would be pinned on just five living people.† They'd be tried all

* Prosecutors hoped Beate would be sentenced with a "particular gravity of guilt," which would make it highly unlikely for a parole board to release her after fifteen years. Rather, she would continue serving indefinitely until the board approved her parole.

† When asked why they didn't charge more of the dozens of people who the victims' families allege aided the NSU, the office of the federal prosecutor replied that they'd led a "comprehensive, utmost time-consuming" investigation into all of the potential suspects, consulting more than four hundred police officers who investigated the attacks, and that they had "heard thousands [about two thousand] of witnesses, examined thousands of clues and analyzed thousands upon thousands [seven thousand] of physical pieces of evidence together with about 4TB of data," and that they were "aiming at convicting possibly more supporters of the 'NSU' and shedding light on possible further criminal offenses." In February 2023, prosecutors announced they wouldn't charge Kapke. As of this writing, prosecutors were still considering charging three other suspects, including Susann Eminger.

together, all at once. Bailiffs began readying a courtroom in Munich, the city where two of the murders had taken place. Prosecutors, lawyers, and judges prepared for a trial that would force Germany to grapple with what drove an ordinary German woman and her ordinary German friends to carry out an extraordinary serial killing of innocent people—people targeted for the country from which they came, the accent in their voice, the color of their skin.

Chapter 17

The Chancellor's Last Chance

One night Gamze and her mother, Elif, were at home in Dortmund watching TV when they heard a loud crash—so loud that Elif thought a bomb had gone off. Someone had thrown a stone through the Kubaşıks' window. They called the police, who couldn't figure out who had done it. *Was it just children playing—or was it Nazis?* Gamze wondered.

The Kubaşıks never found out, but they had good reason to suspect the latter. A few years after Mehmet's murder—2009, in Gamze's recollection—neo-Nazis had marched through their Dortmund neighborhood, passing in front of their home. Some carried Germany's Nazi-era flag and shouted hateful slogans: *"Deutschland den Deutschen. Ausländer raus!"*—"Germany for Germans. Foreigners out!"

Gamze was incensed. They even had the nerve to march past the former kiosk where Mehmet was killed. Police had prevented the Kubaşıks from marching there themselves. *Why,* asked Gamze, *do these Nazis want to march on the street where my father was killed?*

Gamze spent the first year after the murder sequestered inside her house. When she finally returned to her studies, she struggled to focus. She managed to complete her technical degree in economics and administration and was offered an apprenticeship at a perfume chain in the city of Münster. But while she was taking the train there from Dortmund on her first day of work, her hands began to shake and she started to sweat. When she emerged from the station in Münster, she was startled to see so many

bikes. She thought of what a passerby had told police after her father's murder: that they'd seen two men riding away on bikes. Now, everywhere Gamze looked she saw men and women cycling. What if one of them was her father's killer? On her second day of work, she broke out in tears.

There's no point in going, Elif told Gamze. Reluctantly, Gamze agreed and canceled her traineeship. Whenever she ventured out of the house, she felt like people were pointing at her, whispering. *That's the daughter of that drug dealer! That's the daughter of that mafia member!* She stopped meeting friends, and for an entire year she tried not to leave the safety of her room. Once, when she ventured into the waiting room of a doctor's office, Gamze spotted a magazine with a photo of her father on the cover. She mustered the courage to open it. The article described how her father had been running drug money between Germany and some Turkish bank. Gamze knew it wasn't true. But there it was, printed in a magazine for all the world to read. *Everybody in Germany believes this story, and there's nothing I can do,* she thought. She stuffed the magazine into her purse and took it home, less out of a desire to read it than to ensure that no one else would.

Gamze eventually found another job and became her family's sole breadwinner. Whenever her income ran out before the next paycheck arrived, she and Elif skipped meals, hoping Gamze's siblings wouldn't notice. Officer Köppen, the policewoman who had treated them kindly, showed them how to apply for unemployment benefits. A couple of Gamze's father's friends chipped in to pay the rent—debts that Elif would eventually repay. After her husband's death, Elif wore only dark-colored clothes—nothing bright, nothing happy. Once, Gamze tried to get her to put on a white blouse, but Elif wouldn't even look at it.

On the first anniversary of Mehmet's killing, hundreds of people turned out for a ceremony to remember him, which then became a tradition: Each year on April 4, family and friends would gather at Mehmet's small memorial stone and mingle with strangers who showed up to pay their respects. Often, Gamze would struggle to sleep the night before, but afterward she'd feel uplifted by a sense of community. "That day is always very painful, but it also makes me very proud that I live in Dortmund and that many are with us—*we are not alone.*"

Once, on a visit back to her father's village in Turkey, Gamze met

a man. They married, and Gamze gave birth to a boy and, later, two girls. They named the boy Mehmet, in honor of his grandfather. When Mehmet was five he began asking questions about what had happened to his grandpa. *Grandpa used to run a shop*, Gamze would tell him, *but then he became "Melek"*—an angel. Gamze's husband suggested they show him where it happened and tell him the truth. Gamze couldn't bring herself to do it, but when Mehmet turned six, her husband took him to examine the commemorative stone that had been placed there to honor his life. Afterward, Gamze overheard her son boast to another kid that his grandfather had become an angel, and that there was a special stone just to prove it.

One breezy afternoon in November 2011, Gamze was out for a walk when her phone rang. "Gamze, there is a report about you. Something happened," a friend told her excitedly. "The murderers have been found!"

Gamze rushed home and turned on the TV. On every channel, presenters were reporting that two dead bank robbers had murdered nine men. Gamze called her mother, who was in Turkey, and by the time Elif flew back to Germany, scores of journalists were camped outside her home. Finally, thought Gamze, the police, the journalists, her neighbors, the public would believe her: Her father was no drug dealer, no mafioso. He'd been murdered by native-born Germans.

Still, Gamze didn't understand *why* the terrorists had chosen *her* father. "I grew up here. Germany is my home," she reminded herself. And yet white Germans had killed Mehmet precisely to send the message that immigrants like him didn't belong. As for Elif, it brought her no peace to know the identities of her husband's killers. It only made her afraid. *If they could kill my husband, maybe they could come for my children, too*, she thought. A few months later, as Elif took a train out of town to a *Kur*—a German wellness retreat often prescribed by doctors—the sight of two skinheads startled her so much that she considered abandoning the retreat and returning home.

Sometimes the press could aggravate the families as much as skinheads did. At a remembrance ceremony for Enver Şimşek in Nuremberg, Semiya held up a newspaper with front-page portraits of the perpetrators—Beate and the Uwes—and below them the headline "Killer Trio Also Responsible

for the Nine Döner Killings." Even after the truth came out, journalists were still using a racially charged slur to refer to the families.

Semiya and Gamze continued speaking to the press, agitating for answers as to why their fathers were killed. They wanted answers from the legislature, the courts—and from Germany's chancellor, Angela Merkel, who decades before had helped create youth clubs like the Winzerclub in Jena that wound up harboring young extremists. On February 23, 2012, three months after the NSU came to light, Merkel invited the families of the victims to Berlin for a nationally televised ceremony. Merkel set out to reassure her country and the world that, seventy-five years after the Holocaust, Germany was no longer a graveyard for minorities, but a peaceful place where people of all backgrounds, religions, and colors could coexist. But could Merkel's words mend a nation? What if Germany wasn't that place?

Before the ceremony, Merkel met with the families in private to assure them that justice would be done. She had read about Mehmet, and she spoke about him as if she'd known him herself. Merkel looked Gamze straight in the eye.

"Take a deep breath," the chancellor told her. "You'll be fine and there will be an explanation." At the time, Merkel's words reassured her. "I really thought something would happen now. I believed in it. I had such an indescribable hope."

The televised part of the service took place in a concert hall in Berlin. Gamze and Semiya sat next to each other in the front row, and behind them sat an audience of twelve hundred. A group of students placed twelve candles onstage: ten for each of the murder victims, an eleventh to represent the unknown victims of right-wing extremist violence, and a twelfth to symbolize "hope." Merkel spoke about Süleyman Taşköprü and the three-year-old daughter he left behind in Hamburg. About Mehmet Turgut, who at just twenty-five years old was still new to Germany when he was killed in Rostock. About İsmail Yaşar, whose Nuremberg snack shop would crowd with schoolchildren eager for ice cream. The chancellor kept her words factual and plain. When it came to Gamze's father, Mehmet Kubaşık, the chancellor said, "He had come to Germany with his wife,

opened a kiosk with her in Dortmund, and built a livelihood for his daughter and his two younger sons. He was thirty-nine years old."

After addressing the families and sympathizing with their losses, she turned to the topic of the killers, calling them "terrorists." Merkel described watching the Pink Panther manifesto. "In this video its creators brag about the murders and mock the victims. I have never seen anything more inhumane."

Germany must not ignore the threat posed by far-right extremists, she urged. "Indifference—it has a creeping but devastating effect...it leaves behind victims without names, without faces. That is why we are setting an example here, with an eleventh candle on the pedestal. We have lit it for all known and unknown victims of right-wing extremist violence. This memorial service is also dedicated to them."

Still, Merkel empathized with discontented youth in Germany's former East, in places like Jena.

"We have to admit that sometimes in places where unemployment is high and migration is strong...the enemies of our democracy know how to take advantage of this." Young minds, she seemed to say, can be easily misled.*

Merkel then addressed how police had treated the victims.

"Few in this country thought it was possible that right-wing extremist terrorists could be behind the murders," Merkel continued. "Some relatives were themselves under suspicion for years." For this "never-ending nightmare...I ask them for forgiveness. How bad it must be to be subjected to false suspicions for years instead of being able to mourn."

With a nod toward the future, Merkel announced the creation of a federal inquiry into right-wing terrorism. She also demanded better

* Merkel wasn't wrong, but her answer seemed to overlook an important fact: Unemployment isn't what drove the trio to become white supremacist terrorists. Though eastern Germans experienced enormous economic and political upheaval after the socialist state collapsed, the two Uwes didn't grow up in poverty. They had access to jobs, and their parents did, too. And although Beate's mother sometimes struggled to find work, Beate had jobs and apprenticeships. They didn't become terrorists for lack of other options. Terrorists were what they wanted to be.

cooperation between the intelligence agencies and police. She ended her speech with a promise.

"As chancellor of the Federal Republic of Germany I promise you: We will do everything in our power to solve the murders and to uncover the accomplices and to bring all perpetrators to justice."

After the chancellor, Semiya stood up to speak. She told the story of sitting with her father, Enver, in their family's garden in Turkey on a warm summer's night, eating cherries and listening to sheep bells ringing in the hills.

"I can find no words for how immensely sad we were" when, one year later, her father was brutally killed, Semiya said. But even worse was that, "we could not say goodbye and mourn in peace. For eleven years we were not allowed to be victims with a clear conscience. *Can you imagine what it was like for my mother to suddenly be the target of the investigation herself? And can you guess how it felt for me as a child to see both my dead father, and my mother, a suspect?* All these accusations were made up out of thin air."

"I was born and raised here and firmly rooted in this country," Semiya continued. But "am I at home in Germany? How can I still be sure of that when there are people who do not want me here?"

"Let us not close our eyes," Semiya concluded. "We must prevent this from happening again."

After Semiya, Gamze said a few words.

"The Turkish poet Nâzım Hikmet wrote a poem. It expresses how we all feel"—the desire "to live free and single like a tree, but in brotherhood like a forest." Like him, "We *too* want to live here," said Gamze—to be a part of that forest.

Next came Ismail Yozgat, the father of Halit, who was slain in their cybercafé in Kassel. When Ismail rose to address the nation, he rejected the monetary compensation Germany's federal government offered the families—5,000 or 10,000 euros to each bombing victim and to each relative of the deceased.

"I would like to express my sincere thanks, but I would like to say that we do not want to accept it. Our wish is that the murderers are caught, and that the accomplices are uncovered. This is our greatest wish and we have faith: Our trust in the German justice system is great."

But Ismail's wife, Ayşe, couldn't help fixating on something Merkel had told her before the ceremony:

"Let go of your son now, take care of your daughter."

Letting go is impossible for a mother, thought Ayşe. *A piece of my heart is missing*. To Ayşe, the compensation Germany offered for their son's death "feels like blood money." Had Germany protected immigrants like Halit, "that would have been worth more than all the money in the world. I will never forgive anyone for the death of my son."

Ayşe longed for politicians to be held accountable. She resented that the CDU and the Green Party in Hesse had voted against creating a state committee to investigate the NSU, like the committee Katharina sat on in Thuringia. When politicians from the SPD and Katharina's Die Linke party outvoted them, Ayşe hoped the committee would shed light on the involvement of intelligence agents and the informants they employed. *Perhaps*, thought Ayşe, the committee "could find out why people are increasingly taking the same path as Hitler once did."

When the speeches ended at noon, Germany observed an official moment of silence. After the ceremony, a politician from Die Linke approached Salime, Ismail Yaşar's mother, in the parliamentary library. Salime was in a wheelchair, so the politician got down on her knees and told her how terrible it was what happened in Rostock, and how regrettable it was that the city still hadn't commissioned a memorial stone for her slain son. There was just one problem: Salime's son wasn't slain in Rostock. He was slain at his kebab stand in Nuremberg. The politician had confused Ismail with Mehmet Turgut, mistaking one immigrant mother for another. The politician's mistake was the perfect metaphor for a government that felt guilty about what it let happen—but didn't know how to fix.

To the left of Götzl and his associate judges sat three federal prosecutors led by Herbert Diemer. Their fight to get Beate the maximum sentence wouldn't be easy. They would need to convince the justices that Beate wasn't just a terrorist and a murderers' *accomplice*, but a murderer, too, despite that she wasn't present at the killings. Prosecutors would have to persuade the judges that by providing cover for the two men at home and helping them maintain their undercover identities, she was a co-conspirator. Across from the prosecutors sat the five defendants and some of their fourteen defense attorneys. None had more at stake than Beate. She was hoping not to be locked up for what might be the rest of her life. Her defense rested on her attorneys' ability to persuade the court that she was a helpless victim of two dominating men.

Behind Beate and the other defendants sat a small army of lawyers representing the interests of the victims' families—sixty in all. But as the trial progressed, it became clear that the type of justice many family members wanted couldn't be measured in months or years behind bars. The families wanted to know why their loved ones were targeted, why German authorities failed to stop the bombings and murders—and who else had lent a hand. Like many in the German public, they refused to believe that the NSU's reign of terror could have been carried out by just seven people, two of whom were now dead.

"I want to know who—especially in Dortmund—aided and abetted the murder," Gamze told a German newspaper. "What did the secret service and the informants know, and why was the murder not stopped?" Gamze and her mother, Elif, flew in from Dortmund for the start of the trial. The night before, Gamze barely slept. In court she sat nervously next to her lawyer, Sebastian Scharmer. Elif sat in the row behind her. Mother and daughter were dressed in black. To Elif's side sat her attorney, Antonia von der Behrens, who told the press that her client wanted "criminal charges pressed against the people who are responsible for covering up and for not passing on relevant information or who did not act on this information"—that is, against German authorities themselves. She wanted the court to "acknowledge that the investigation into the murder...was one-sided and racist."

On the right side of the balcony sat bloggers and journalists from some

of Germany's biggest newspapers—German TV stations as well as most of the Turkish press quickly lost interest. Audio and video recordings aren't permitted in German courtrooms, nor is there any official transcript, so dozens of journalists attended day after day to write down every word. For all the people present—when full, the courtroom held 230, including 50 journalists and 50 members of the public—it was hard not to notice who *wasn't* on trial: the authorities. Not a single police officer who lied to victims' families, not a single intelligence agent who funneled taxpayer money to far-right informants or shredded intelligence files would be charged for negligence, misconduct, or racial prejudice for failing to stop the NSU.

* * *

To attend the NSU trial was to sit among Nazis. Sometimes a short, sleepy-looking man with a mouselike face and small eyes sat in the front row of the balcony. Karl-Heinz Statzberger was no stranger to justice. He'd spent four years and three months in prison for plotting to bomb a Munich synagogue in 2003 on the anniversary of Kristallnacht. Police got wind of the plot and discovered two hand grenades, four pounds of TNT, thirty-one pounds of additional explosives, a hit list of prominent politicians, and a list of Munich mosques. One of his co-conspirators, Martin Wiese, had organized the demonstrations against the traveling photography exhibition condemning German army atrocities during World War II—demos that the Uwes and Beate attended. Now this would-be white terrorist was one of dozens of curious onlookers at Germany's most captivating trial of the twenty-first century. He sometimes sat near a large man who had fallen for Beate, writing her love poems and posting them on the internet. Day after day he would stare down at her from the balcony, hoping she'd return his gaze. Once, Beate's lawyer asked the judges to remove him, but because the trial was open to the public, the admirer remained.

On the eighth day of the trial, Carsten Schultze made a statement that led to a bombshell of a revelation: that unbeknown to prosecutors and police, the NSU may have committed not two bombings, but three. On the morning of Wednesday, June 23, 1999, more than a year before the NSU killed Enver Şimşek in Nuremberg, an eighteen-year-old German born to Turkish parents named Mehmet O. was cleaning his Nuremberg

bar, Sonnenschein (Sunshine), after celebrating its grand opening the previous night. In the bathroom he noticed what looked like a flashlight behind the trash bin. Curious, he pressed the button. The ensuing explosion blew Mehmet's body from one side of the bar to the other. He suffered severe burns to his hands and face. Splinters pierced his skin. He was rushed to the hospital and spent the next eight weeks wrapped in bandages, unable to feed himself because his hands and face were so badly burned. He was lucky to survive.

The Uwes, Schultze told the court, had once boasted to him that they'd "left a flashlight in a store" in Nuremberg, but at the time he claimed not to know what they'd meant. Because the flashlight bomb occurred *before* he passed the Uwes the Česká in the spring of 2000, Schultze might have surmised that the Uwes could use the gun to terrorize immigrants, because they'd already done just that. But Schultze stayed mum about the bombing until after the trial had begun, and prosecutors never charged him or anyone else for the bombing of Mehmet O., the NSU's very first victim.*

To Katharina, confessions like Schultze's were too little too late. Even worse were the NSU's helpers who never recanted at all. When Katharina first attended the trial, she was struck by Ralf Wohlleben's aggressive gaze. Years ago, a night spent photographing Wohlleben and his cronies in Jena had ended in a fistfight. Now Katharina couldn't help noticing that Wohlleben and the other defendants sat at the front of the courtroom, while relatives of the victims were pushed to the back. *It's like you don't see them*, thought Katharina. *Don't focus on them, focus on the fascists*, the courtroom's architecture seemed to say.

On weekends, Wohlleben's fascist friends organized far-right concerts to raise funds for his defense. They wore T-shirts that read *"Freiheit für Wolle"*—"Freedom for Wool"—with a drawing of a sheep. It was a play on Wohlleben's name that seemed to say he was meek and innocent—a dark joke, since everyone knew Wohlleben was anything but. Sometimes Wohlleben's supporters would sit in the balcony. Each day after taking his seat, Wohlleben would glance up, and when he saw friends who had come

* As of this writing, Bavaria's parliament was looking into the bombing, and in 2023 it offered Mehmet O. 5,000 euros compensation.

to support him, his face would relax into a satisfied smile. If he instead saw a stranger looking down at him, he would lock eyes and stare them down.

When the court paused for lunch, Katharina would go outside to smoke a cigarette—and so too would the defendant André Eminger, who, unlike Beate and Wohlleben, wasn't held in jail during the trial. *It's so strange*, thought Katharina. *Someone who supported the NSU's killings stands five meters away and smokes. And the families pass right by.*

On day fourteen of the trial, without warning, Judge Götzl decided to screen the Pink Panther video. Everyone sat in silence as they watched the cartoon panther murder and bomb, saw the photos of the dead men, saw Süleyman Taşköprü soaked in his own blood. After it ended, people sat frozen in their seats.

Two weeks later, on a July afternoon, Habil Kılıç's widow, Pinar Kılıç, fifty-one, was the first witness to be called. When Judge Götzl—going through what had become his usual routine—asked Pinar to list her address, she hesitated. It hurt her to say it aloud, to name the place where her husband had been killed, in the ground-floor grocery store beneath their apartment. And in front of the people accused of helping kill him, no less. She handed over her ID so Judge Götzl could read it instead. When she finally spoke, she mustered her courage and turned to face Beate.

"What this woman did . . . ," she began, then corrected herself, using the word "they." And by *they* Pinar seemed to implicate everyone. *They* were the killers who murdered her husband. *They* were the police officers who sprinkled black fingerprint dust across the apartment and store and didn't even clean up the blood. *They* were the investigators who interrogated her neighbors and friends and planted unfounded suspicions. Throughout it all, "I had to clench my teeth and not lose hope," Pinar said later. "After everything that happened to the Jews in Germany, I hope that this process opens people's eyes to the fact that the danger from the right is not over."

* * *

On November 5, 2013, Gamze took the stand. By this time, she'd begun to doubt whether Germany was committed to reckoning with what authorities had done wrong. In her televised ceremony, Merkel had stopped short of acknowledging that institutional racism had played a role in the

murders—that Germany's *institutions* had failed Gamze's father, left her mother a widow, and left her without a dad. For a time, she pinned her hopes on Germany's legislature, the Bundestag. While the trial progressed in Munich, legislators sifted through some twelve thousand files, questioned more than a hundred witnesses, and published thousands of pages of documents about the NSU's terrorist spree. But the resulting thirteen-hundred-page report didn't mention that racism was to blame for authorities' failure.

The families of the victims pressured legislators to start again. The new report, some sixteen hundred pages, admitted there was a failure in communication between law enforcement agencies, but that's as far as it went. To Gamze, to the families, and to much of the public and the press, this just wouldn't do. Revelations about police racism toward the families, negligence by intelligence agencies, and the "confetti cover-up" were making headlines. Under pressure, legislators returned to the drawing board for a third time, churning out a whopping 1,864-page report. Each new report shed additional light on the NSU and their associates, but legislators still didn't write the words that the families wanted to read. For that, Gamze pinned her last hopes on the court.

While Beate toyed with her laptop, Gamze described the Kubaşık family's life in Dortmund and recounted the day her father was killed. She described the aftermath: her anxiety attacks, the endless interrogations by police, their insistence that her father was a criminal. Then it was her mother Elif's turn to speak.

"We had a completely normal, lovely life," Elif told the court. "With his murder, all our dreams were shattered. What I suffered, only Allah can understand."

"Do not think that because you wiped out nine lives, we will leave this country," Elif wanted to tell her husband's killers, as if speaking on behalf of other naturalized Germans like her. "I live in this country, and I *belong* in this country."

A few weeks later, on November 26, 2013, day sixty began with a shuffling of seats. One of Beate's lawyers complained that a witness—a professor of psychology—was seated too close to her client and might overhear what they whispered, which would violate attorney-client privilege. At this, Judge Götzl let loose a rare laugh.

"I've never overheard anything, and [the witnesses] are sitting no further away than me." To anyone who'd been following the proceedings, the motion seemed absurd: It would be hard to overhear Beate, because Beate never spoke. Day after day she sat in silence, chewing candies. In the early days she seemed attentive, but with time she appeared to lose interest. Her demeanor became that of a spectator, as if it were somebody *else*'s trial. Even when her lawyers and Götzl bickered over her, as they did now, she appeared detached. When the professor slid one seat farther away, Beate's lawyer still wasn't satisfied, protesting that it wasn't enough. Götzl ignored her and turned instead to Beate:

"Ms. Zschäpe, how are you, otherwise?"

Beate's lips remained closed. Her attorney replied that her client was tired and in poor health and therefore needed frequent breaks, which Götzl would go on to grant.

The following day, Beate's mother, Annerose Zschäpe, was invited to testify. At sixty-one, she arrived in a long, bronze-colored puffy winter coat and a black knit hat. When she walked into the courtroom, Beate closed her laptop, sat back in her chair, and glanced up at her, though only briefly. Annerose didn't look back. From her cell in pretrial detention, Beate had written letters to her mother and grandmother, and both replied with letters of their own, though what they contained was anyone's guess. Many in the media wondered what Annerose thought of her long-estranged daughter, but no one would ever know: Annerose's lawyer informed the judges that her client wished to exercise her right under German law not to testify against a family member. When Judge Götzl asked Annerose's permission for the court to consider the written transcript of her interrogation by police the week after Beate turned herself in, Annerose refused. Then, without greeting her daughter, she walked out of the courtroom.

Another mother, Brigitte Böhnhardt, couldn't refuse to testify the way Annerose had. Her son wasn't on trial—he was dead—so the same privilege didn't apply. When her turn came, she reminded the court that she'd lost not one son, but two: Her firstborn, Peter, had either fallen or been pushed to his death at age seventeen—police never worked out which.

"You never forget them," Brigitte told the court. "Perhaps my complicated relationship with the police stems from this time."

Götzl asked Brigitte about the money she and her husband sent to the terrorists while they were on the run.

"We didn't support a criminal group," Brigitte snapped, "we supported *our son!*"

Perhaps the most telling testimony came when Götzl asked if her son was "right-handed—or left-handed."

Brigitte nodded to indicate *left*, unable to say it out loud. Surely she understood the significance of the question. Medical examiners had concluded that several of the murdered men had been shot by someone left-handed. As a child, Mundlos's teachers had "corrected" his left-handedness, meaning only Böhnhardt could have pulled the trigger those times.

Later, Brigitte would say that, in one sense, the victims' families had it easy. *Their* dead loved ones were innocent, so they were allowed to publicly grieve. If Brigitte wished to mourn the loss of *her* son, she'd be chastised— *How dare she grieve, given what Uwe Böhnhardt had done?* Despite all the evidence before the court, Brigitte couldn't bring herself to admit that her son was a cold-blooded killer.

"The prosecution is looking for any evidence that all three of them committed these acts," Brigitte told the court. "And I, as a mother, am looking for any hint that it can't have been that way."

The week before Christmas, more than six months into the trial, Siegfried Mundlos was called to the stand. He arrived carrying a briefcase, from which he retrieved a bottle of water, a cup, and an apple, which he placed on the table in front of him. As he spoke, it became clear that he was in denial, pointing a finger at everyone but his own son. Siegfried blamed Böhnhardt and Beate, Tino Brandt, and Thuringia's intelligence agency, which Siegfried insinuated had somehow radicalized his son into an extremist. As to the accusation that his son was the ideological force behind the NSU, Siegfried said "the German people will never buy that story." He insisted to Judge Götzl that the bombmaking workshop in the garage never existed. Perhaps, he suggested, police had planted the TNT and the pipes. Later, when Siegfried insinuated that authorities had intentionally let the trio escape Jena that day, Götzl ignored him. But other times the two men argued over Siegfried's conspiracies. Once, when Götzl made the mistake of addressing him as "Mr." Siegfried Mundlos instead

of "Dr." or "Professor," Siegfried grew enraged. "How dare you address me like that!" An argument ensued, and the two men bickered for some time. Mundlos called Götzl an "arrogant know-it-all."

"I warn you, I will not take this from you!" Götzl replied.

It's *"Professor* Mundlos," Siegfried instructed the judge. Götzl retorted that he would use "Dr. Mundlos" instead. At one point in the heat of an argument, Siegfried reached out for the apple he'd brought and took a loud bite.

If Siegfried was a proud man and a vain one, he was also a man who had lost his son. Like Brigitte, he reminded the court that there were not ten people dead, but twelve—his son, and Brigitte's son, too. Like Brigitte, Siegfried and his wife, Ilona, found out about their son's death from Beate. Later that day, they went to a Jena police station to make a statement about Beate's call, and Siegfried offered to go to Eisenach to help identify the bank robbers' bodies.

"I asked to take a look at my son" for the very last time, "so I would know who I am burying." Listening to the radio on his way back to Jena, Siegfried heard the head of Germany's federal police announce what forensic specialists believed transpired in the camper van: that *Siegfried's* Uwe—Mundlos—had shot *Brigitte's* Uwe, set the van on fire, and then shot himself. This, Siegfried told the court, was a lie—but Götzl cut him off, saying the courtroom was no place for conspiracies. When Siegfried insisted on saying something briefly to the families of the victims, Götzl agreed. Siegfried told them that he, just like they, would not live in peace until he found out exactly "what was behind the mess"—as if his son wasn't the perpetrator, but the victim of some big conspiracy. He told them that he felt their pain.

* * *

As the trial progressed, lawyers for the victims' families made motions to introduce evidence or elicit testimony that might implicate the state. Police officers, intelligence agents, informants: anyone who might reveal what German authorities knew about the NSU or why they didn't act. In response, the three prosecutors objected that such lines of inquiry were beyond the court's purview, and the judges would usually agree. Judge

Götzl seemed to view such motions as a distraction from his task: ascertaining the guilt or innocence of the five defendants before him, and the five of them alone.

But one day something unusual happened. Despite Götzl's efforts not to let the court fixate on the failures of the German *state*, an intelligence agent took the stand—an agent who may have witnessed a murder.

Chapter 19

The Spy in the Cybercafé

As twenty-one-year-old Halit Yozgat was shot to death at the front desk of his internet café, a thirty-eight-year-old white man was sitting at a computer in the back. His name was Andreas Temme. He worked for the state of Hesse's intelligence agency, handling far-right extremists. And he was a far-right extremist himself.

After the murder, Temme didn't inform the police or his superiors that he'd been at the café that day, much less that he'd witnessed a murder. Even when authorities tracked him down, searched his house, and brought him in for questioning, he didn't tell the truth. Now Temme's testimony would captivate a courtroom: *What was an intelligence agent doing there while a murder took place? Why did he pretend that he wasn't? What might he reveal?*

The court convened at 9:47 a.m. and Götzl began by calling Halit's fifty-eight-year-old father, Ismail Yozgat, to the stand. Ismail spoke in Turkish with great emotion, but the court interpreter spoke blandly, and the contrast was disconcerting. Beate looked at her laptop while Ismail called his son and the other slain men "martyrs." Carsten Schultze stared at Ismail wide-eyed, but the other defendants appeared unmoved. Their disinterest angered Ismail. He recalled how police had questioned him and his wife, Ayşe, after their son's murder. They'd cooperated completely. Now the people who might know the answers sat in front of him, refusing to say anything at all.

"This is not justice," Ismail would later lament. In the years after his

son's murder, he had traveled to Hamburg, Nuremberg, Munich, to try to do what authorities had not—to find some clue that might lead to his son's killers. "I knew who my son's murderers were. I told the police officers that my son's murderers were xenophobes or enemies of Turkey. But they did not believe us."

But Judge Götzl wasn't interested in such proclamations. He asked Ismail to describe the position of Halit's body the day of the murder. Ismail decided to demonstrate instead, lying down on his stomach on the courtroom floor in front of Beate, who looked away. Ismail showed how he'd pushed away the desk and pulled his son's body into his arms. Then he screamed in Turkish:

"They shot my son!"

When Ismail got up from the floor, a lawyer asked him if he'd seen any money on the desk. He replied that there might have been a 50-cent coin— a clue that would become important later. But seven years had passed, and he could no longer be sure. At one point, he turned to Beate.

"Why did you kill my son?" he demanded. Beate didn't reply.

"I had five children. Only four are left," Ismail said, overcome with emotion. "My son will not come back."

The court paused for lunch. After hearing from one more witness, it was Temme's turn to talk.

* * *

At six feet two inches, Temme was tall, heavy, balding—and unfaithful. At the time of the murder, the intelligence officer was handling at least five Islamic informants and at least two far-right ones. The reason he was in the cybercafé that day, he claimed, was that he needed to communicate with them. But when police sifted through the browsing history of the café's computers, they discovered that between 4:50 and 5:01 p.m., the customer at PC-2 had been browsing ilove.de, which advertised its services at "dating, flirting, and friend finding."

"Your next date will be fantastic!" the website proclaimed.

A married man, Temme had been browsing the website at the café while his wife was at home pregnant with their first child.

"I'm not proud of it!" Temme proclaimed to the judges.

Temme shut down his ilove account six days after the murder, but officers managed to find the phone number associated with it, then paid a visit to his home. Temme told them that he only found out about the murder three days afterward, in the Sunday papers. Police searched his apartment as well as his room at his parents' place where he sometimes still stayed, discovering a copy of Hitler's *Mein Kampf* and other Nazi literature, including copies of an SS handbook that Temme had typed up by hand. His neighbors told police they called him "Little Adolf," on account of his far-right views. In his home and car they found a Smith & Wesson revolver, a Beretta, and a pistol from Heckler & Koch, the manufacturer of the service weapons the Uwes stole from the police officers in Heilbronn. The guns were legal, but some of the ammunition was not.

Temme spent the night in police custody and was interrogated throughout the following day. By then his story had changed. He admitted he'd been in the cybercafé, but maintained that he hadn't heard the gunshots, hadn't seen Halit's body on the floor, hadn't seen the blood on the counter—he claimed he left before the crime occurred. Perhaps the only consistent aspect of Temme's story was the lengths he went to avoid disclosing his work for the intelligence agency. He never told the police he was a handler: It was only when officers searched his post office box that they discovered documents revealing Temme was an intelligence agent, at which point police decided to do some intelligence gathering of their own. They bugged Temme's phone and listened in on a call in which Temme's superior coached him on what to say and what not to say to *them*—to the officers investigating the murder. They even caught Hesse's interior minister, Volker Bouffier, instructing Temme not to cooperate. But nothing caught the attention of the German press more than what one of Temme's superiors, Gerald-Hasso Hess, told Temme on a recorded call a month after the murder:

"If you know something is happening, please don't pass by."

It sounded as if Hess was suggesting that if Temme knew about the murder in advance, he ought to have avoided the café. Hess later claimed his comment was meant as a joke. But in Courtroom A 101, nobody was laughing. At one point, Götzl showed the court a video in which Temme

returned to the cybercafé with state investigators to reenact his movements that day. In the ninety-second clip, Temme demonstrated how he supposedly walked calmly to the front of the café and, unable to find Halit, deposited 50 cents on the desk, then walked out the door.

Unfortunately for Temme, it was around this time that a team of British forensic experts called Forensic Architecture was on the hunt for a case to put their innovative methods of data and spatial reconstruction to the test. In Berlin, they constructed a precise replica of the cybercafé and meticulously reenacted the shooting, monitoring the volume of simulated gunshots to test Temme's claim that he hadn't noticed the murder. When they shot a Česká 83 pistol with a silencer—which the Uwes probably used—the sound where Temme would have been sitting was louder than a chainsaw or thunder from a nearby lightning strike—about the same noise level as the deck of an aircraft carrier. True, the noise lasted just a fraction of a second. But some of the other witnesses in the café had heard it—the woman in the back who had been on a phone call with relatives in Turkey, one of the teenagers playing video games with headphones on, and the man who thought he glimpsed the killer from behind the glass.

Temme's claim that he hadn't heard anything now seemed impossible. Not only must he have heard the gunshots, the forensic architects concluded, but he might even have smelled the gunpowder in the air. The simulation also demonstrated that Temme could not possibly have left his 50-cent coin on the desk without noticing Halit's body on the floor. One British journalist who reported on the reenactment summed up its findings: "He either saw the killer—or he *was* the killer."

But the judges refused to admit the Forensic Architecture reenactment as evidence at trial, ruling that the question of Temme's presence was immaterial to the guilt of Beate and her co-accused. To the families of the victims, this showed how far Germany's government institutions were willing to go to protect their own. The judges let Temme's patently false testimony—possibly perjury—stand, even as his story continued to change before their eyes. The reason he didn't contact the police after he read about the murder in the papers, Temme now told the court, was that he had been confused about which day of the week he'd been at the café. The murder

happened on a Wednesday, but Temme thought he had been there on Thursday. Or perhaps it was the other way around? The intelligence agent could hardly have come off as less intelligent.

"The facts caught up with me." Temme shrugged. At one point he referred to himself as "stupid," and Götzl didn't disagree.

When asked about one witness's testimony that he had been carrying a heavy object in a bag that day, Temme told the judges it was true, but said he couldn't reveal what it was without compromising state security. He claimed the object related to his work monitoring Islamic extremists. Many in the courtroom and in the press suspected that the object was a gun. Their suspicions grew when they learned that at 5:19 p.m., within minutes of the murder, Temme had placed a phone call to a "source." But Temme told the court he was bound by secrecy not to disclose who it was.

At one point during Temme's testimony, Ismail Yozgat became distressed and yelled out *"Vermiyor,"* Turkish for "he does not give" an answer.

"I don't believe a word you say," Ismail yelled. Judge Götzl repeatedly told Ismail to quiet down, but he couldn't help himself.

"Either Mr. Temme himself killed my son, or he noticed whoever it was that killed him," Ismail told the press after the emotional trial day came to an end. "One day, Allah will enlighten everything."

* * *

If Germany's courts were content with allowing an intelligence officer to lie about his presence at a murder, Katharina König determined to hold Thuringia's legislature to a higher standard. As the trial progressed in Munich, she set out to expose the truth about how Thuringia's intelligence agency failed to stop the trio before their terror spree began.

By this time, her high-profile antifascist activism was drawing the ire of far-right extremists not just in Thuringia, but all across Germany—and even other parts of Europe.

"You will die cruelly," taunted the lyrics of one far-right Swiss band in 2016, which described Katharina being tortured and murdered. Katharina wasn't rattled by the threats. Although her committee didn't have the power to indict anyone or press charges, they could still summon people to testify. Katharina and the committee's other members used this power to

peel back the layers of what German authorities ignored about the NSU. As to the question of who should be held responsible, Katharina looked to the very top—Thuringia's intelligence chief, Helmut Roewer. When Katharina's committee summoned Roewer, incredibly, the former spy chief couldn't keep a secret. Asked how he was hired for the job, in Katharina's recollection he replied:

How I became president of the Office for the Protection of the Constitution? It was 11 p.m. and a person I didn't know handed me a certificate of appointment in a yellow envelope. It was dark, I couldn't see her. I was also drunk. In any case, I found the envelope in my jacket in the morning. And so it was that a drunk man became Thuringia's top spy.

He was in good company.

"Behind [our] employees' friendly façade, there is not always competence," said Roewer of his agents. "Once I had to take disciplinary action because one of my employees had crashed a company car while drunk."

For the families of the victims, Roewer's and his agents' incompetence was no laughing matter. History would remember Roewer as the embodiment of a government that failed to stop the terrorists-to-be. As to whether his agency overused or misused far-right informants, Roewer admitted outright that relying on them had gone horribly wrong.

"Recruiting skinheads was an absolute disaster. They get drunk, then say they couldn't remember anything," said the intelligence chief who sometimes did the same. And yet knowing this hadn't stopped Roewer from recruiting them.*

On day 143 of the trial, in September 2014, one of Roewer's far-right informants took the stand. He was large and pudgy-faced, with glasses, and he wore a black hoodie with the hood pulled tightly around his face. His hands were bound in cuffs: The man was now a prisoner, and his name was Tino Brandt.

More than twenty years had passed since Brandt earned fame in

* Roewer resigned in 1998 while under investigation for allegedly funneling state money into his private accounts. He became an outspoken conspiracy theorist, asserting that the NSU murders were in fact the work of a liberal "deep state" for which far-right extremists were framed in order to make Germany look bad. The Uwes hadn't committed suicide, Roewer contended—they were assassinated as part of some nefarious government scheme.

Thuringia's far-right scene for secretly organizing the Rudolf Hess rally that caught the attention of Roewer's agency. Brandt worked as an informant until 2001, when a Thuringian intelligence officer leaked his identity to the press. When the far-right men and women he'd spent years befriending learned he was a snitch, they abandoned him, and the THS neo-Nazi network that Brandt had so carefully built disowned him—or so Brandt claimed. He also lost his job at New Europa, the far-right publishing house.

But it wasn't Brandt's unconstitutional activities, or the violence he allegedly directed THS members to commit, or even his support for Beate and the Uwes that landed him in prison. It was sex trafficking of children that did him in. At least sixty-six times between 2011 and 2014, Brandt trafficked children to adults for the purposes of sex or sexually abused young boys himself. In 2014, Brandt pleaded guilty and was sentenced to a mere five and a half years in prison, which to those unfamiliar with Germany's lenient sentencing seemed incommensurate to the lifelong trauma his sex crimes against children likely induced.

To those familiar with the protection Brandt had received as an informant, what was even worse was the thought that Brandt might never have felt emboldened to act upon his pedophiliac impulses if Thuringian authorities hadn't thwarted Mario Melzer's case against him back in the 1990s. Instead, if there was one lesson Roewer's intelligence agency taught Brandt about the benefit of being an informant, it was that he could get away with *anything*.

When it was Brandt's turn to testify, he didn't speak of his sex crimes. But nor did he divulge much about his role helping to radicalize, train, and fund the trio that would become the NSU. When Götzl asked Brandt how much Roewer's intelligence agency had paid him, Brandt replied that he "didn't keep a receipt book," but he estimated it could have been 200,000 deutsche marks—around $115,000 at the time.* Brandt made it clear that he was proud of the German taxpayer money he pocketed. When asked what he did with the money, Brandt admitted he'd invested it back into

* The journalist Annette Ramelsberger, who wrote a book about the trial, estimated it might have been as much as 300,000 deutsche marks—about $172,000.

the very far-right scene that the intelligence agency was employing him to watch. For all the agency's claims about how indispensable he was as an informant, Brandt claimed he never compromised a single comrade—"I never put anybody in jail."

Brandt shocked the court again when he divulged sending some of this money to the fugitives themselves. German taxpayers hadn't just funded far-right extremists—they'd funded *terrorists*. Brandt insisted that he didn't know the trio was plotting to bomb and to murder. Of his relationship with Beate and the Uwes during the 1990s, "we were definitely friends," Brandt said. But by all accounts they were more than that: One former THS member testified that Brandt "was like a god" to the trio.

Outside the courtroom, Katharina set out to expose how Brandt's cozy relationship with intelligence agents protected both him and his protégés. As a lawmaker, Katharina had clearance to read his criminal records. She discovered that police once had a chance to catch Brandt red-handed, but that Roewer's intelligence agency thwarted it. Officers had obtained a warrant to search Brandt's home and computer for evidence that might indict him for hate speech, disturbing the peace, and resisting law enforcement officers. Early one morning, officers drove to his home.

"The police say it was 6 a.m., and Tino Brandt was awake. And if you know Tino, you know it's unusual for him to be awake at this time," Katharina recounted. When officers rang his doorbell, they were surprised to find Brandt not only awake but fully dressed, as if he'd been expecting them.

"Good morning," he bid the officers. "I know you need my computer, and I've prepared it."

When officers examined the computer, they realized something was missing: the hard drive. Brandt was "grinning from ear to ear," an officer who'd been there recounted. Later, when Katharina's investigative committee compelled one of Brandt's handlers to testify about the incident, he claimed he hadn't tipped Brandt off. But when pressed he admitted he had paid Brandt a visit the day before, pointing to Brandt's various electronic devices saying, "*this, this,* and *this*—I don't want to see it tomorrow." Not only had intelligence agencies thwarted police officers' attempts to build a case against their mole. They'd directly—likely illegally—interfered with a criminal investigation by directing Brandt to destroy or conceal evidence.

"In the end there were thirty-five criminal cases against Tino Brandt but not one conviction" for his far-right crimes, said Katharina. Because the statute of limitations to prosecute Brandt for supporting the fugitives had long since passed, he would never face any repercussions for radicalizing, financing, or otherwise supporting the NSU.

Thuringia's intelligence agency "stopped all their cases against Tino Brandt in order to save their spy," said Katharina. "Without the protection of the secret service, without the money of the secret service, the Nazi structure would never have been that big, that organized," Katharina concluded. "The NSU wouldn't exist."

*　*　*

One February day, some neo-Nazis filed into the spectators' seats in the balcony to support Wohlleben on his thirty-ninth birthday. When he looked up at them, he smiled.

These people must be truly sick, thought Kerem, whose father, Ismail Yaşar, had been slain at his Nuremberg döner stand. Kerem attended the trial rarely, but when he did, it always appeared as if his father's killers were at ease. It frustrated Kerem that German sentencing laws were so lenient that convicted killers can sometimes walk free after just fifteen years behind bars, then live a quiet life, as if they hadn't done anything wrong. But there was another would-be immigrant killer living a quiet life, too, one who attended the trial not as a defendant, but as a witness. In October 2014, attorneys for the victims' families made a motion to summon Carsten Szczepanski to the stand.

Twenty years had passed since the KKK fanatic and publisher of the far-right magazine *Feurkreuz* tried to murder the Nigerian schoolteacher Steve Erenhi—twelve years since Brandenburg's intelligence agency finally decommissioned their mole after discovering he'd been planning to attack leftists with pipe bombs. Fearing his neo-Nazi comrades might kill him for being a snitch, he entered witness protection and was given a new identity. To call him to testify, Brandenburg's intelligence agency argued to the court, might put him in danger.

Gamze's attorney, Sebastian Scharmer, was outraged. Even in the unlikely event that someone might reveal Szczepanski's new identity, why

was Szczepanski's life more important than Mehmet Kubaşık's? After some debate, the judges agreed, and on December 3, 2014, more than a year and a half into the trial, a man with a scarf over his face and what appeared to be a wig entered the courtroom. Judge Götzl began by asking Szczepanski about the famous American novel that inspired him and other right-wing radicals, including the NSU.

"What's it called? *The Turner Diaries*?" Did the book serve as inspiration for the far-right scene?

"That was *the* book to read at the time," Szczepanski replied. He also spoke about how he and other neo-Nazis obtained weapons to prepare for Day X, just like the lead character had. One of the attorneys for the victims of the Keupstrasse bombing, Alexander Hoffmann, questioned Szczepanski about his anti-immigrant beliefs and about the type of racist rhetoric and calls to violence he published in *Feuerkreuz*.

"Were the cross burnings"—like the one Szczepanski did with Mahon that got televised across the nation—"intended to spread fear among non-Germans?"

"You can assume that, yes."

"Should non-Germans be expelled?"

"I was of that opinion at the time, yes," said the far-right extremist who once tried to kill an immigrant.

Another lawyer asked if he had any regrets.

"Yes, I do," he replied, without saying what they were.

When Judge Götzl interrogated Szczepanski about his role as an informant, he recounted how, on as many as ten occasions, Meyer-Plath's intelligence agency took him out of prison to work at the neo-Nazi store in the Ore Mountains owned by the Saxon skinheads Antje Probst and Jan Werner. When Probst told him she planned to give her passport to Beate to help her escape to South Africa, Szczepanski told his handlers that, too. And yet they didn't share this intelligence with police. Prosecutors never charged Probst or Werner with supporting the NSU. Götzl asked Szczepanski the significance of the infamous text message Werner had allegedly sent him about "the bangs."

"Of course, you could associate *bangs* with weapons," Szczepanski conceded. The text should have been a clue to law enforcement that the fugitives

were arming themselves. But Szczepanski now claimed he couldn't recall who sent it. Each evening when he returned to prison, he was required to hand over his cell phone to his minders. Szczepanski seemed to be implying that if the judges wanted to know how the NSU got away with it, they ought to ask intelligence agents themselves.

Another year and a half of the trial would elapse before they finally did.

* * *

On day 199 of the trial, in April 2015, Szczepanski's handler Gordian Meyer-Plath took the stand. By then he'd risen through the ranks to become head of Saxony's intelligence agency. How much had he and Brandenburg's agency known about the NSU and their plans?

Meyer-Plath confirmed that in the autumn of 1998, Szczepanski told him about some "Saxon skinheads" who had fled into hiding and intended to acquire weapons.

"Only with the help of Szczepanski did we learn that they were looking for weapons, planning bank robberies, and wanted to go abroad," Meyer-Plath had told federal legislators for one of their reports on the NSU. "It makes me sad and will weigh on me for the rest of my life that it was not enough to catch the group two years before the first murder." Meyer-Plath's agency paid Szczepanski 50,000 to 80,000 deutsche marks—about $29,000 to $46,000—for his work as an informant. But Meyer-Plath claimed Szczepanski never provided any more intelligence about the trio than that.

Later, a legislator would call Meyer-Plath and his agency's failure to pass along crucial information about the NSU "illegal." Meyer-Plath admitted that the way he had recruited and worked Szczepanski in the 1990s would never fly today. After the NSU, some of Germany's intelligence agencies passed new "best practices" directives governing how agents should go about choosing and recruiting informants. But Meyer-Plath fiercely defended his and his agency's actions at the time. Germany *needed* informants in the rank and file of far-right groups. Tino Brandt, in Meyer-Plath's view, was too high up: Brandt had *created* this far-right world. How could agents possibly count on him to bring it down? They needed

people "in the second, third or fourth echelon of structure"—someone like Szczepanski.

"He gave the police the chance to get them just a month after they went underground," Meyer-Plath said of the trio, deflecting the blame. He objected to the notion that his agency ought to have gotten more out of Szczepanski with regard to the NSU.

"What is an informant *really*? He is not someone controlled by the state. He is not a robot," but a rational actor who, when offered the right incentives, can reveal only as much as he knows. "The perfect terrorist—the perfect political extremist and hate crime committer—we won't catch him. We will only catch the ones that make mistakes."

To Meyer-Plath, the fact that authorities failed to stop the NSU didn't negate the value of far-right informants—it merely showed that the NSU's terror was too "perfect" to prevent.

"For me it's proof that those three and the couple of people who helped them didn't really talk about it. Obviously these three didn't share their plans and their whereabouts with anyone else. Otherwise, informants would have gotten that information," Meyer-Plath maintained.

But to many, Meyer-Plath's defense of the informant system didn't add up. He seemed to insist that Germany's long tradition of relying on informants to stop terrorism was undeniably indispensable—despite that for thirteen years, it failed to stop the NSU.

Chapter 20

A Terrorist Speaks

After her father's death, Semiya struggled to live. The terrible things the police had said about her father, things the newspapers had printed about him, were almost too much for her to bear. For her mother, Adile, they *were* too much. Afflicted with anxiety, in 2011, just months after the NSU came to light, Adile left Germany—the country she and her husband had emigrated to decades earlier for a better life—and returned to Turkey. It was there that Adile watched on TV as Chancellor Merkel apologized at the memorial ceremony in Berlin. Adile watched her brave, determined daughter speak.

"Can you imagine what it was like for my mother?" Semiya told the nation. "I was born, raised, and firmly rooted in this country. Am I at home in Germany? How can I still be sure of that, when there are people who do not want me here?"

For his part, Semiya's brother, Abdulkerim, was determined to send a message by *staying*. "This is my land. I was born here, grew up here, and I will not leave it. It doesn't matter how many people they kill. This is my land, and I will stay." After Enver's death, Abdulkerim tried to make his father proud. He'd completed high school, then university, earning a degree in medical technology. When he married in 2013, he told his wife that he hoped to one day be able to tell their children the truth: *who* helped murder their grandfather, and why *he* had been chosen. Merkel's words had felt like an important step in the right direction—recognition of a grave injustice—but they brought him no closer to that dream.

When Abdulkerim attended the trial, he liked Judge Götzl's attitude and his strict, no-nonsense demeanor. The verdict, Abdulkerim expected, would be just. But to him, the defendants weren't only guilty of terrorism and murder. They were also guilty of not coming clean—of not telling the world the truth. It made him physically ill to see the people who helped murder his father sit there, refusing to speak. If *he* were the judge, he'd even give Beate a few years off her sentence if she'd be willing to break her silence. Which is why Abdulkerim was surprised when he heard the news from Munich in November 2015: Two and a half years into the trial, on day 243, Götzl announced that he'd received notice from Beate's attorneys that, at long last, Beate wished to speak.

* * *

"What would it mean to you," a journalist asked Gamze, "if Beate expressed remorse?"

Gamze had followed the trial in the news, and every night before she attended a proceeding, she struggled to sleep. When far-right witnesses were called, she found it unbearable to listen to "lying Nazis drag out the trial with their statements." Gamze replied to the journalist. "After more than two years of trial, and four years since the whole thing came to light, it feels very late for her to speak up."

Nearly a month passed before a date was set for Beate's statement—December 9, 2015. Gamze and Elif traveled in from Dortmund. Like Abdulkerim, Gamze was angry that Beate had refused to repent. She longed for Beate to apologize, ask forgiveness, and tell the world why they did it. But if Beate wanted to talk, it wasn't for the sake of the families—of this, Gamze was certain.

"She only wants to save her own skin."

The TV crews set up their cameras early that morning, their vans lining the street outside the courthouse. By eight o'clock more than a hundred spectators stood in line. Soon every seat in the courtroom was taken. The Yozgats were there, as was Yvonne Boulgarides, widow of the Greek immigrant Theodoros who was slain in his locksmith shop just a short distance from the courthouse. So too were the Şimşeks, as well as a victim injured in the Keupstrasse bombing in Cologne. At 9:42 a.m., Beate entered through

a side door wearing a black pantsuit and a faint smile. She didn't shy away from the photographers the way she had at the start of the trial. The audience sat on the edge of their seats. Rather than speak herself, Beate had her lawyer read a long prepared statement.

"I was born on January 2nd, 1975, as Beate Apel in Jena," it began. She described how she grew up in Winzerla and later met Uwe Mundlos at a playground with a concrete block shaped like a snail.

> On my 19th birthday I met Uwe Böhnhardt, who was introduced to me by a friend at my birthday party. I fell in love with him but was still with Uwe Mundlos at the time. Even when I found out… that he had already committed multiple crimes and was already in prison, my love for him didn't change.

Although she had hung out with her fellow members of Comradeship Jena, "I only became active after Tino Brandt joined our group, which drastically changed how we lived and worked together. Tino Brandt was the person who provided the money and thus made our activities possible." Beate said she detested Brandt and was never very close with him, but that he had his fingers in everything. "His money was used to put up posters, make stickers, distribute right-wing propaganda material," and pay for trips to far-right rallies, Beate asserted. "Without Tino Brandt all these undertakings would not have been possible."

"I wish that Tino Brandt had been busted earlier," Beate claimed— "that we had been arrested before we went into hiding and that the crimes had never happened." She seemed to eschew all culpability, redirecting it at Brandt and others, just as Gamze had expected.

Beate did admit to helping create the dummy—the effigy of Jewish leader Ignatz Bubis—that Böhnhardt hung from the bridge outside Jena. But she denied building the real bombs the trio had planted across the city. Beate wanted the court to believe that she found out about the stadium bomb, the cemetery bomb, and the theater bomb only after they'd been placed. Despite that she'd rented the garage in which they were built, she claimed she didn't know the garage was packed with TNT. As for the threatening letters, she said their intent was to "increase public awareness

of the seriousness of our actions, without there being any actual danger to life and limb." But the statute of limitations had long since passed for the trio's crimes in Jena, so admitting to them now posed no risk.

The day police raided their garages, when officers let Böhnhardt leave, he phoned Beate and told her to "torch the place"—meaning the garage in the sewage district, Beate informed the court. She filled a bottle with some gasoline and set off, but she had to turn back when she saw that police officers and firefighters were already there. After they fled Jena, Tino Brandt helped the Uwes make plans to flee to South Africa, Beate said. Beate did admit to being in on the bank robberies. As fugitives, they couldn't work normal jobs, she reasoned. The robberies were, in her mind, a necessary evil to pay their bills. She knew the Uwes were planning to use a gun to rob the Edeka grocery store, but said she thought the gun wouldn't be loaded. When she learned they had fired it, Beate said the Uwes told her it had only been a warning shot.

When it came to the very first murder, Beate claimed she merely suspected the Uwes were planning another robbery. "Although I had often seen a mobile home parked in front of the house, I never specifically asked what they planned to do with it." Beate wanted the court to believe that she'd never seen the Česká pistol, nor the Browning. That she didn't know the Uwes kept so many weapons in the apartment—that they each had their own room and respected one another's privacy.

When the Uwes told her about having killed Enver Şimşek, Beate claimed she threatened to report them to the police. They replied that they'd kill themselves if she dared. But Beate didn't dare. She said she found out about each murder only after it had taken place, and that she tried to tell the boys to stop. When they told her about the back-to-back murders in June 2001—Abdurrahim Özüdoğru in Nuremberg and Süleyman Taşköprü in Hamburg—"I was just speechless, stunned and unable to respond. I didn't ask for details. I didn't want to hear it. I felt numb." When they set off to murder Habil Kılıç in Munich, Beate claimed they told her they were going to rob a bank. Beate would never forget the day they fessed up to that one. It was just after the 9/11 attacks. The Uwes had cheered as they watched footage of the planes hitting the Twin Towers. They seemed to find solidarity in the act—two far-right terrorists celebrating the destruction wrought by Islamist ones.

As for the first bombing in Cologne, Beate said Böhnhardt built the bomb in his room, placed it in the Christmas stollen box, and left it in the Iranian-owned grocery store while Mundlos waited outside. She claimed she found out about it only afterward, in the press. After four murders and that bombing, the terrorists took a nearly three-year hiatus. Then, in February 2004, Mundlos turned to Beate out of the blue: "It happened again."

They'd "shot a Turk in Rostock"—Mehmet Turgut, the Kurdish immigrant from Turkey. As to the bombing that followed, the one on Keupstrasse that injured twenty-two people, "I was not involved in either the preparatory acts or the execution of the crime," Beate said. The reason the Uwes attacked the two police officers in Heilbronn, Beate said, was to get their guns: The ones they had too often jammed.

Together, the three friends made a plan in case anything went wrong. If ever "both [Uwes] were shot or if they shot themselves to avoid being arrested," Beate explained, "I was to put the DVDs prepared by Uwe Mundlos in the mailbox—insert and send. I was supposed to set the apartment on fire, and I was supposed to notify Uwe Mundlos's and Uwe Böhnhardt's parents." When the day finally came, "there was an incredible emptiness inside me. The day had come that I had always feared— *Uwe Böhnhardt and Uwe Mundlos will not be coming back*." Beate admitted to pouring gasoline over the apartment in Zwickau and setting it aflame with a cigarette lighter. She claimed she did it not to protect herself from prosecution, but rather to fulfill the Uwes' dying wish. "I myself had no intention of destroying evidence that could criminally incriminate me," she insisted. Nor did she intend to put anyone in danger—she'd tried to save Ms. Erber, the elderly neighbor who looked after Lilly and Heidi, from the flames.

As to who else had supported the three fugitives while they were underground, Beate named seven people, among them André Eminger, Matthias Dienelt, and Mandy Struck. Prosecutors already knew these names: Beate didn't implicate a single person whose support for the NSU hadn't already been revealed.

To many, Beate's obliviousness to the plot seemed too perfect, her script too smooth, her alibis too good to be true. At every step of the way, it wasn't her fault, she had no idea, there was nothing she could do. No

matter that she managed the trio's money and had every opportunity to leave them or to go to the police. No, Beate wanted the court to believe *she* was a victim—a helpless housewife caught in a terrorists' trap.

"Uwe Mundlos and Uwe Böhnhardt became my surrogate family... my only emotional caregivers," she said. Mundlos was always more than a friend: She loved him like a brother. Böhnhardt had been her boyfriend throughout. Her only regret was that she was unable to stop them.

"I sincerely apologize to all victims... of the crimes committed by Uwe Mundlos and Uwe Böhnhardt. On the one hand they were extremely brutal. They killed people with unimaginable coldness." And yet Beate also went on to defend them. "On the other hand, they could also be loving and courteous, both towards me and the cats."

Elif's arm went numb when she heard that. It struck her as particularly perverse. "Ms. Zschäpe valued her cats' lives more than humans," Elif later remarked.

Gamze's prediction that Beate's statement would be designed to save her own skin proved correct. "Ms. Zschäpe could have answered many things. [Instead] she simply tried to downplay her role," Gamze said. "Ms. Zschäpe is trying to avoid responsibility. I don't believe a word."

Another victim's relative told *The Guardian* it was a "slap in the face." Another said it "appears completely contrived."

"My clients wanted to find out why their fathers, husbands, and brothers had to die," Mehmet Daimagüler, who represented the family of Ismail Yaşar, told Deutsche Welle. "Ms. Beate didn't say anything about that."

Ismail Yozgat spoke to journalists outside the courthouse. "How can you sleep, Ms. Zschäpe? With my own hands I have laid my son into the grave."

* * *

Two and a half more years and 188 trial days later, Beate, now forty-three, surprised the court by opening her own lips at last. She reached into her pocket for a piece of paper, then began to read its contents quickly, unemotionally. She complained of the stress and the scrutiny brought on by the media frenzy surrounding the trial. As to the families' questions about why the NSU chose to kill the men they did, she claimed she didn't know and

that she hadn't helped them choose. Beate reiterated that she *too* was a victim—a victim of the Uwes. She ended with a few words addressed to those she viewed as the *other* victims in the room.

"I'm a compassionate person," she said. "I'm sorry for the misery that I've caused."

"I just want one more thing," she continued—"to find closure and at some point lead a life without fear. Please don't convict me in the place of others for something that I never wanted to do nor ever did."

Beate continued in the manner of a student forced by a teacher to apologize to the class. "Today, I don't judge people based on their origins or political views, but based on their behavior."

"I no longer have any sympathy for nationalist ideas..."

"I believe that violence should never be used to achieve political ends..."

"For me it was the killing of a *person* that was frightening and not the fact whether it was a foreigner or a German..."

"The fear of being invaded by foreigners has become increasingly unimportant to me."

If this last statement were true for Beate, the same could not be said for millions of her countrymen: As the trial dragged on in Munich, across the nation, a shift was underway. Something was causing xenophobic Germans to fixate on foreigners—and to target them—once again.

* * *

The first train arrived in September 2015, a few months before Beate made her first statement. Hundreds of refugees were riding the rails. Many had fled Syria, where the autocrat Bashar al-Assad was slaughtering civilians during the country's civil war, helped by Russia and Iran. Others came from Afghanistan, where fifteen years after the 9/11 terrorist attacks America was still waging war, with civilians caught in the crossfire. Millions of refugees from these countries and others began making the perilous journey across the Aegean Sea to Turkey, or the Mediterranean to Greece. Those who didn't drown carried their belongings and trudged onward to Hungary, where some boarded trains bound for Berlin.

Katharina heard rumors that some of these trains would roll on to Thuringia. But she didn't know when or to where. *Jena? Gera? Erfurt?* She

called Thuringia's prime minister, but even he didn't know. Then, one Friday in early September, Katharina got the call: The first train would arrive the following morning in Saalfeld—a far-right stronghold not far from Tino Brandt's home.

"It was like, *Oh shit, call the people, organize! We have to be prepared!*" Katharina recalled. She and hundreds of other volunteers descended upon the Saalfeld train station carrying food and water, toothpaste and children's toys. Katharina wanted to show them *this* was the real Germany—a nation welcoming toward immigrants. At least, that was what she *wanted* Germany to be.

The so-called global refugee crisis was in full swing. That year, 2015, more than 1.3 million refugees arrived in Europe, twice as many as the year before and three times as many as the year before that. As millions of people fled the aftermath of America's wars and other conflicts in the Middle East, Germany, unlike the United States, would not turn them away, Katharina determined. It would stand up to the moment. It would embrace these refugees.

At the station, volunteers carried signs and shirts declaring "Refugees Welcome." Farsi- and Arabic-speaking immigrants who'd come to Germany years before volunteered as interpreters. When the train pulled in, the minister of Thuringia opened one of the doors and welcomed them with a loudspeaker:

"We're happy you are here."

When somebody translated his message into Arabic, some of the immigrants smiled. The crowd started clapping, cheering, chanting:

"Say it loud and clear—refugees are welcome here!"

Just outside the station, some twenty neo-Nazis assembled with a chant of their own: *Deutschland den Deutschen. Ausländer raus!*—"Germany for the Germans. Foreigners out!" But the refugees couldn't hear them—the throngs of immigrant supporters drowned them out. The refugees—569 of them, including 21 infants—boarded buses that took them to schools where they'd sleep.

Three days later, another train arrived. Soon, one or two trains carrying hundreds of refugees were pulling into Thuringia each week, while others rolled on to Saxony. There, in the town of Heidenau, between six

hundred and a thousand Germans—including members of the neo-Nazi party, the NPD—tried to block buses from carrying refugees to their new homes.

"They hate us, I don't know why," said a refugee from Iraq.

When Katharina heard about the commotion, she raced over from Thuringia and was shocked at what she saw. The neo-Nazis "started to fight the police—tried to get close to the camp to attack it, throw Molotov cocktails." Katharina called for reinforcements, and soon some 400 pro-immigrant demonstrators descended on the town to defend the refugees, 250 of whom were redirected to tents, for lack of anywhere else to go.

Similar scenes played out across the nation. Germany's chancellor tried to hold her country together, but many viewed Merkel as responsible for the divide: At the end of August 2015, Merkel had given a press conference the world would not forget.

"A few days ago in Austria, over 70 people were found dead in a truck by unscrupulous traffickers. These are atrocities that you can't believe. These are pictures that exceed our imagination," Merkel said. Her advisors predicted that some eight hundred thousand asylum seekers would arrive in Germany by the year's end. International law, Merkel reminded her countrymen—to which Germany was bound—required nations to harbor people fleeing for their lives. The universal right to asylum shouldn't just be respected, but celebrated, Merkel insisted, before uttering three words that would be heard around the world:

"*Wir schaffen das*"—We can do it. We'll manage this. *We'll survive.*

But not everyone was convinced. By November 2015, 44 percent of Germans believed these asylum seekers shouldn't be allowed to settle in Germany or that those who had should be deported. Half of Germans surveyed the following year said the number of refugees arriving to Germany made them afraid.

These sentiments reverberated in the rhetoric of Germany's newest political party, the Alternative für Deutschland, or AfD, founded in 2013 in opposition to the euro and critical of the EU. The party's leaders embraced this anti-immigrant sentiment and the voters who espoused it. They rode that wave into the statehouse, winning seats in state parliaments

across Germany and even the Bundestag in Berlin.* Just a few months after Merkel's reminder that Germany was obligated to shelter the persecuted people who arrived at its door, the tide began to turn. As they watched the trains of refugees roll in, a small cadre of white supremacist Germans believed *this* was the moment they'd been warned about—the moment when they, the white race, were being replaced.

And so, just like after the Berlin Wall fell, Germany's white terrorists once again emerged from the shadows to hunt the foreigners down.

* * *

One of the attacks occurred Halloween night in 2015. It took place in the Saxon town of Freital, an hour-and-a-half drive northeast of the NSU's former hideout in Zwickau. Abu Hamid walked into his kitchen to grab a snack when he noticed sparks outside the window. Sensing danger, the asylum seeker from Syria ran out of the kitchen just as a booming explosion shook his apartment. It shattered the windows and sent shards of glass flying into the face of one of his housemates, a fellow refugee.

"The explosion, it shocked me," Hamid said in the aftermath. "We came from the war to Germany to find safety. *To think*—that this would happen *here*."

The terrorists behind the attack, the Freital Group, had formed in early 2015 after rumors surfaced that two Moroccan immigrants had harassed schoolchildren on a public bus. Shortly thereafter, white vigilantes began riding the buses on "patrols." By September they'd gone on the offensive, shooting fireworks into the windows of a house where Eritrean refugees lived. When the national press got wind of it, newspapers began referring to the attacks as "the new NSU." Freital became a test: Had police learned anything from their failure to stop anti-immigrant terrorists?

The answer seemed to be "no." The Saxony police—one of the departments that failed to find the NSU—didn't see any connection between the assault and the recent far-right protests against immigrants. The day after

* In September 2021, voters in Thuringia and Saxony, where the NSU grew up and hid, would favor the AfD over all other parties.

the attack on the Eritreans, police tapped the phones of some of the Freital Group members, intercepting chatter that hinted the men were plotting another attack. Had police arrested them then, they could have prevented the assault on Abu Hamid and his housemates. Instead, in December, rumors surfaced that a Saxony police officer had *colluded* with the terrorists, warning them about different police deployments around town—an act of deliberate sabotage. Two more officers were suspected of doing the same, but the cases against all three would later be dropped. It wasn't until newspapers as far away as Berlin began pressuring authorities that Germany's federal prosecutor took up the case. In a dramatic SWAT-style raid, federal and state police arrested five suspects, and later arrested three more. The NSU trial in Munich was still ongoing when eight white Germans were charged, tried, and convicted of forming a terrorist group.*

But the Freital attacks were just a few among thousands. Far-right attacks against immigrants surged from nearly a thousand in 2014 to more than thirty-five hundred in 2016—nearly ten attacks against immigrants each *day*. Five hundred and sixty people were injured in those attacks, forty-three of them children.

"The problem is not that the immigrants are threatening the Germans," a journalist for the left-leaning Berlin newspaper *Taz* said, "but that Germans are threatening immigrants. Right-wing violence has exploded."[†]

* Earlier that year, in response to the NSU, German legislators had amended the nation's criminal code to require judges to consider racist, xenophobic, or other discriminatory motives as grounds for stricter sentences. A judge used this new legislation to sentence the Freital Group members to between four and ten years in prison.

† To those Germans who associated terrorism with foreigners, the events of 2016 gave some credence to their fears. That December, a Muslim immigrant from Tunisia hijacked a truck and drove it through a crowded Christmas market in Berlin, killing twelve and injuring fifty-five people. But far-right extremists had committed at least three terrorist attacks, too, including one that killed and injured nearly as many people as the Christmas market attacker did. David Sonboly, an eighteen-year-old German of Iranian heritage, considered himself "Aryan," demonized Turkish immigrants, admired the AfD, and reportedly boasted about sharing the same birthdate as Hitler. Dates were important to Sonboly: On the fifth anniversary of Anders Breivik's white terrorist killing spree in Norway—July 22—he entered a McDonald's in Munich, his hometown, and opened fire

It wasn't just a few far-right extremists who were angry about nonwhites moving to Germany. Millions of Germans' attitudes toward refugees were beginning to shift. A comprehensive study would soon find that one in three respondents agreed that German identity was being compromised by immigration. Three-quarters of a century after the Holocaust, three in ten Germans agreed to varying degrees that Jews were too influential, and a similar number said that Germans were "superior" to other peoples. One in four thought Germany needed a dictator to remedy these problems. Despite all that Germany had done to reckon with its toxic past, millions of twenty-first-century Germans held some of the same racist, fascist beliefs as their forefathers did under Hitler and the Nazis. What's more, researchers discovered a clear correlation between far-right rhetoric and violence. The regions of eastern Germany where the AfD won the most votes also saw a greater number of attacks against immigrants.* As more than a million refugees fleeing war and persecution sought safety in Germany, millions of Germans set out to keep Germany white.

* * *

Gordian Meyer-Plath tried to make sense of this schism one June morning in 2016 at Dresden's city hall.

"As a German, I'm pretty proud that most asylum seekers come to Germany. Germany must obviously be a very attractive place, and a safe place," Meyer-Plath said of the more than one million people who were

with a Glock 17 9mm semiautomatic pistol, killing nine and injuring thirty-six before killing himself. Bavarian authorities initially claimed Sonboly's motive was revenge for bullying by his peers. Only later did Germany's Department of Justice acknowledge that his suicide attack was motivated by his far-right extremist beliefs.

* When researchers at the University of Göttingen examined the motives behind these anti-immigrant attacks, they discovered that "right-wing extremist thinking" in Saxon and Thuringian towns like Freital was rooted in "the devaluation of ethnic and sexual minorities" and "an excessive need for harmony, purity, order." Survey respondents were oblivious to Germany's history of violence against immigrants. One local politician insisted—incorrectly—that fascists hadn't existed during GDR times, and others downplayed the fact that their fellow Saxons still harbored National Socialist ideas.

requesting asylum in Germany at the time. "They don't flee to Russia. They come to *us*."

But from his new vantage point as head of Saxony's intelligence agency, Meyer-Plath began to notice more radical, anti-immigrant chatter among the far-right groups his agency monitored. He knew what came next: Just like the research showed, when racist speech against immigrants proliferates, violence usually isn't far behind. In 2016, Brandenburg, where Meyer-Plath began his career, saw more violence against immigrants than any other state. The following year, anti-immigrant crime in Saxony surged on Meyer-Plath's watch, and Saxony eclipsed Brandenburg's record as the most dangerous state in Germany in which to be a refugee. That year, Saxony recorded more than two dozen violent attacks against immigrants *each month*.

White people began attacking refugees, setting fire to their homes. The perpetrators were not the usual skinhead suspects, with their far-right clothing and tattoos. They were normal, working-class Germans—"everyday racists from the middle of society," Meyer-Plath observed. People like the two fathers who were barbecuing one weekend when, on a whim, they decided to drive to a refugee hostel and barbecue it instead, setting it on fire.

What struck Meyer-Plath wasn't just the bellicosity of the perpetrators of these attacks, but the number of people who stood by and watched. Somehow, a nation of people who'd claimed to be ashamed that their parents or grandparents had stood by silently during the Holocaust were themselves standing around silently—some enthusiastically—while their countrymen attacked minorities. Germany's xenophobes found strength in numbers. In February 2016, some seventy protestors in the Saxon town of Clausnitz blocked a bus carrying fifteen asylum seekers from Syria, Lebanon, Iran, and Afghanistan.

"They were shouting and yelling and insulting us. The children were crying," said a twenty-four-year-old Iranian refugee. "We were wondering what will happen to us. *Will we be allowed to stay?*"

The frightened refugees pleaded to the driver to turn around. But Germany's asylum distribution system mandated they be resettled there, so police ushered the frightened refugees through the mob to their new home.

By 2016, Germany's immigrants had suffered the grim milestone of surpassing Jews, leftists, and liberal public figures as the foremost victims of far-right attacks. As the NSU trial dragged on in Munich, immigrants across Germany faced a startling reality. The NSU's terror may have ended, but their ideology only grew: Once again, committing violence against foreigners and their descendants had become a quintessentially *German* thing to do.

Chapter 21

Judgment Day

Three years into her trial, Beate seemed bored. One day she opened a magazine called *Frau im Spiegel* (Woman in the Mirror), turned to the section marked *rätsels*—puzzles—and set to work on a crossword, utterly unconcerned with the proceedings that would decide whether she'd live captive or free. The crossword was a competition: If Beate mailed the magazine the correct answers in time, she could win a coveted prize such as four pairs of "Fashionable Sandals," tickets to a theme park, or four nights at a hotel in Tirolo, Italy.

Beate wouldn't be leaving prison to travel to Italy anytime soon, but on another occasion she was rushed from the courthouse to a hospital—with what ailment wasn't clear. A week later her lawyer announced she was too sick to stand trial. Later, when prosecutors showed photos of the burning house in Zwickau, Beate took care not to look at them. She whispered to her lawyer that she felt unwell, and Judge Götzl ordered the court to take a break. Each day Beate felt ill was another day of justice delayed—another day that the court, the families, the nation went without closure.

Beate wasn't the only reason the trial progressed at a glacial pace. The court convened just three days each week, and the judges would adjourn whenever witnesses failed to appear or when documents needed to be copied and distributed. When someone accused the court of improper procedure, the court would sometimes recess for days or weeks to give parties time to make their case. Each August, the proceedings stopped so everyone but Beate and Wohlleben could enjoy a summer vacation.

At last, in July 2017, four years after the trial began, Judge Götzl invited prosecutors to prepare their closing remarks. Two more months would pass before lead prosecutor Herbert Diemer announced the sentences he hoped the judges would impose. For Beate, life in prison. For Wohlleben, twelve years for aiding and abetting nine murders, for his role in helping furnish the gun. Three years for Carsten Schultze for accessory to murder, back when he was twenty. Five years for Holger Gerlach for supporting a terrorist organization, including the three times he rented the trio RVs. None of these recommendations were surprising. But people bolted upright when Diemer announced that Eminger should be given twelve years for being an accessory to attempted murder, armed robbery, and supporting a terrorist organization—a potential sentence as severe as Wohlleben's, who had helped the NSU procure the gun. Not only that, but Diemer asked the judges to order Eminger arrested on the spot, out of fear he might try to flee. Eminger had remained free throughout the trial—Katharina had run into him smoking cigarettes during breaks. Now he would be in custody until it was through.

But it wasn't until July 3, 2018, five years after the trial began, that Götzl gave the defendants the opportunity to make their final pleas. Gerlach, who had admitted to assisting the trio but denied knowing about the attacks, said:

"I would like to use my last words again to apologize to the bereaved."

Then came Schultze, who had cooperated with the prosecution. He thanked the Boulgarides family, who had agreed to meet with him, after which Yvonne Boulgarides and her daughter petitioned the court to give Gerlach a more lenient sentence.

"I wasn't myself at the time," Schultze claimed. "I went in the wrong direction. I then pulled myself out. But I made a mistake that caught up with me. I have to learn to live with this mistake. The guilt I've shouldered won't be taken away."

Wohlleben said nothing, and when Götzl asked Eminger if he wanted to speak, he said, "No." When Beate's turn came, her lawyer read a statement on her behalf. If Beate knew why the nine men had been selected to die, she didn't reveal it now. Instead, she told the court how *she* had been maligned by the proceedings.

"The accusations made in the trial and in media reports unsettle me to this day. I have the feeling that every word, no matter how seriously and honestly I mean it, is being misinterpreted," she complained. "Looking back, November 8th, 2011," the day she turned herself in,

> was a kind of liberation for me. I wanted and still want to take responsibility for the things that are my own fault, and I apologize for all the suffering I have caused. I am sorry that the families of the murder victims lost a loved one. You have my sincere condolences. Every word of my apology read out on December 9th, 2015 was and is meant absolutely seriously. Unfortunately, there is nothing more I can give than these words of sincere regret. I cannot give the bereaved their loved ones back.

* * *

One week later, hundreds of people traveled to Munich for the verdict. It was July 11, 2018.

The previous afternoon, dozens of journalists had descended on a press conference where Gamze was to speak. She sat next to her lawyer, Sebastian Scharmer. On her other side sat Abdulkerim Şimşek. His sister Semiya, with whom Gamze had marched in Kassel and lit candles at the ceremony in Berlin, was in Turkey.

Gamze faced the cameras—sixteen of them affixed to large tripods in the back of a conference room packed with press. Six years had passed since the day Merkel looked Gamze in the eye and promised there would be answers.

"She lied," Gamze now believed. The memory of that ceremony disappointed her. Had she known then what she knew now, she'd never have attended at all. Merkel had promised the families there would be clarity, closure.

"But she never kept her promise. And if I were in her shoes, I would be ashamed."

Disappointed with the chancellor and by the Bundestag's refusal to admit that institutional racism was to blame, Gamze had pinned what little hope she had left on Germany's courts.

"Throughout the entire trial I was always hopeful that clarity would

come and questions would be answered," said Gamze. Even when she learned intelligence agencies were shredding classified files, even when they refused to release others, Gamze never lost hope. Now she glanced around the room of journalists, took a deep breath, and looked down at the speech she'd prepared.

"I want to know why my father was selected as a victim. I want to know why, until today, there has been no real investigation into who helped them. I want the intelligence agencies to at last say what they knew." Gamze's eyes were wide and tearful, darting between her paper and the press, but never directly at the cameras. "Why did they cover this up? All of their cards must be put on the table."

"The NSU murdered my father," Gamze said, "but the *investigators* have ruined his honor—they murdered him a second time."

* * *

That night, the streets of Munich were empty. But by daybreak, the plaza in front of the courthouse had filled with people lining up for the fifty seats reserved for the public to witness the verdict.

Four hours after sunrise, police began ushering the spectators through security. As the 9:30 a.m. start time neared, police announced that just three seats remained. That's when a woman with full-length arm tattoos and a black jacket—the sort of dress favored by neo-Nazis—cut to the front of the line to snag the final seat. The others protested, but the police officers just shrugged. They hadn't been paying attention. Two large men with buzz cuts—friends of the woman—lied to the officers, insisting she hadn't skipped the line.

"Shit Nazis," someone muttered. After a brief deliberation, the police decided to believe the white woman and her two skinhead friends at the expense of two darker-skinned men standing in line behind them—a relative and a friend of Süleyman Taşköprü, the man the NSU had murdered in Hamburg. The officers' incompetence or bias seemed like a fitting end to a twenty-year saga in which the indifference and prejudice of their colleagues across the country were a matter of life or death.

Inside, the courtroom was packed with police. Beate wore her usual black blazer, with a purple-and-white scarf. Wohlleben wore a black dress

shirt that made him look like a wedding DJ. The corners of his mouth
dripped downward as if trying to suppress a grin. Next to Eminger sat his
wife, Susann, whom prosecutors never charged. When Eminger saw some
far-right friends in the balcony, he waved at them and laughed.

When the judges walked in for the very last time, nobody rose—
everyone was already on their feet. Götzl wasted no time in delivering the
verdict.

"Beate Zschäpe, born on January 2, 1975, is guilty of ten counts of mur-
der in conjunction with attempted murder," and for being part of a terrorist
group while committing these acts. Götzl announced Beate's sentence.

"The accused Zschäpe is sentenced to life imprisonment. The particular
severity of guilt is determined."

Guilty of Murder. Life imprisonment. Severity of guilt. It was the con-
viction prosecutors wanted. Beate wasn't just an accomplice, the judges
determined: Citing her racist motives, they decided *she* was a terrorist and
murderer, too. Not only that, but they gave her the maximum sentence.*

Beate remained calm, lips pressed tight. The sentence didn't seem to
surprise her. Her cheeks sagged, eyes slightly dazed. It was as if she wasn't
really listening, unable to take it all in.

As for Wohlleben, the judges found him guilty of nine counts of aid-
ing and abetting murder—the victims of immigrant descent. When Götzl
announced Wohlleben's sentence, neo-Nazi spectators in the balcony burst
into applause, and a court officer went down to the waiting room to spread
the news.

"Have you heard? Zschäpe got life. Wohlleben, ten years."

Sitting there in silence were the two large skinheads who had helped
their tattooed friend skip to the front of the line. They'd come to support
Wohlleben, and they didn't take the news well. One, Jens Bauer, stared
ahead in silence, leaning forward, eyes wide. "*Ohne Beweise,*" he whispered.
Without evidence.

* Beate could begin applying for parole as early as November 2026, fifteen years from the
time of her arrest. But because the court sentenced her to life with a "particular gravity of
guilt," it would be unusual for a parole board to release her at that time. Instead she would
continue serving indefinitely until her parole was approved.

"I'm shocked," Bauer said. "You bought the weapon. You gave the weapon. Ten years? Is every man with a gun a murderer's accomplice?"

It didn't seem to occur to him that Wohlleben's arms trafficking to terrorists was precisely what distinguished him from any other man with a gun. Bauer also didn't yet realize that his friend would soon walk free: Arrested in 2011, Wohlleben had already served nearly seven years, more than two-thirds of his sentence. He was already eligible for early release, to serve the rest out on parole. The very next week, Wohlleben would move in with Bauer, who would give Wohlleben a job at his car window repair shop, fixing broken glass.*

The lives that Wohlleben helped shatter would not be so easily repaired.

These people have destroyed our souls, and now they just sit there—grinning, silent, thought Mustafa Turgut, whose brother Mehmet was slain at the döner stand in Rostock. Mustafa had longed for them to be punished but struggled to imagine what a just punishment might be. Life, "it's like a glass. If it falls on the floor and shatters, you can glue the pieces together, but it will never be the same."

It took hours for Judge Götzl to read the entire verdict. As he recited the names of all twenty-two victims of the Cologne bombing, a blond-haired woman in the balcony began to cry. Her lawyer, who sat beside her, tried to comfort her. But the courtroom was not a comforting place. When Götzl adjourned for a brief recess, five men dressed like neo-Nazis shuffled into the row beside the woman. One asked the other spectators to slide down to make space.

"Not for you," replied the blond-haired woman curtly. One of the neo-Nazis gave her a long, cold stare.

The judges found Schultze guilty for the same crimes as Wohlleben—nine counts of aiding and abetting murder. But because he was twenty at the time he handed the Uwes the Česká, he was considered a juvenile and sentenced to just three years in prison. Gerlach received the same, for supporting a terrorist organization. Because both men had been free during

* In 2020 a judge would order Wohlleben back to prison to serve out the remainder of his sentence, ruling he remained a danger to the public on account of his ongoing involvement in potentially violent far-right scenes.

the trial, they'd begin serving their sentences right away. When Götzl announced André Eminger's sentence, everyone was surprised. The court convicted him only for supporting a terrorist organization—not for aiding or abetting the bombings or murders. The judges gave him just two and a half years. Like Wohlleben, he too would be walking free.

The five neo-Nazis erupted in applause.

"Have respect for the family," someone yelled at them. "We have so many Nazis here!" a woman called down to the judge. Below the balcony, a man cried out in exasperation, interrupting Götzl. It was Ismail Yozgat, the father of Halit.

"We do not accept this ruling," he later told reporters. Instead of getting to the truth, Germany's judiciary "covered up the guilt of intelligence officers like Andreas Temme," and agencies had "destroyed evidence. They have done nothing to relieve our pain."

Götzl scolded Yozgat, then continued reading, notably faster, in a race to get to the end. When he finally finished, he announced, "The case is closed." At that, he looked up, a slight smile on his face. He and the other justices stood up and left the room. Beate fiddled with her purse, shook her attorneys' hands, and bid them goodbye. The side door opened, and wardens led her back to prison.

Outside the courthouse, a few thousand demonstrators were facing off with about a hundred police officers. Some made rousing speeches demanding accountability for German authorities, calling for heads to roll. Gamze spoke with reporters. She was glad Beate received a life sentence. But "what I find so disappointing and so sad is the news about Eminger and Wohlleben," she said. "The court gave them such a low sentence. For me, they are as guilty as the two murderers who are now dead."

Later, when a journalist asked what she missed most about her father, Gamze paused.

"His voice." She could no longer remember the sound.

* * *

By the time the trial ended, the NSU was a household name in Germany. For many it was a black spot on the nation's reputation, for others a tale of intrigue. For more than a few, it was an incredible achievement: In the

years since the NSU came to light, they had earned far-right fans across Germany and the world. From one prison cell to another, Anders Breivik, the Norway terrorist, wrote a fan letter to Beate, praising the NSU's terror and calling her a "Martyr."

The NSU case found its way into literature, art, entertainment, and popular culture. In 2018 a German playwright named Michael Ruf created the *NSU Monologues*, in which actors recount the stories of Adile Şimşek, Elif Kubaşık, and Ismail Yozgat in their own words. The play is a living memory of the carnage wrought by the NSU. It was also a warning of what unchecked white nationalism can do to a nation.

Calling the NSU's terror an "extraordinary defeat of the German security agencies," the head of Germany's federal intelligence agency, Heinz Fromm, resigned, as did the leaders of three state intelligence services, including Saxony's; Gordian Meyer-Plath was promoted to fill that vacancy. But that's where the official fallout from the NSU stopped. Lothar Lingen, the code-named intelligence official who ordered far-right files to be shredded in the so-called "confetti cover-up," was moved to a different department but never prosecuted. Not one police officer, intelligence agent, or informant was charged for negligence for failing to stop, or for enabling, the NSU.

Critics of the intelligence agencies such as Katharina argued they ought to be abolished altogether. Thuringia announced its agency would no longer use informants except in terrorism cases. But the Bundestag passed no such federal legislation, and today in Germany these agencies still have discretion over when or whether to inform police about their informants' crimes.

A few months after the verdict, in October 2018, Katharina followed some seven hundred white supremacists to the town of Apolda, Thuringia, for a neo-Nazi music show. As she identified them and photographed the event, she could see in the distance the smokestack of the Buchenwald concentration camp, the one the two Uwes once visited wearing Nazi uniforms. It enraged her to watch these new Nazis pick up right where the three friends from Jena left off.*

* The concert devolved after only an hour, when the neo-Nazis began throwing bottles at police.

In its final report, Katharina's committee concluded that Thuringia's authorities had acted with "sheer indifference to finding the three fugitives" and that the actions of Roewer's agency may have amounted to "deliberate sabotage and deliberate thwarting of the search for the fugitives." It was a damning report of institutional failure. But all Thuringia's legislature could do was compensate the NSU's victims the way the federal government had done—not level charges or indictments.

"This monetary compensation cannot be regarded as an adequate redress," Katharina said, "but we would like to demonstrate that we are aware of our responsibility."

For those whose loved ones had been murdered, the money did little to ease the pain. Ever since burying her husband in Turkey, Elif felt torn between two worlds.

"Part of me is in Turkey, part of me in Germany," Elif explained. "Germany is my home," but "Germany is also the country where my husband was murdered." Just like Adile Şimşek, Elif eventually left Germany, returning to the country from which she'd emigrated decades before.

Others, like Tülin Özüdoğru, wife of Abdurrahim who was slain in his tailor shop in Nuremberg, determined to stay, as did the Yozgats. The city of Kassel didn't rename the street where Halit was killed, as his parents had asked, but it did dedicate a small plaza Halitplatz in his honor. Nuremberg did the same in memory of Enver Şimşek, placing a large stone engraved with the names of the murdered men in the city's center, one of several memorials erected by cities across Germany to commemorate the NSU's victims. But in the weeks after the verdict, some memorials were vandalized with graffiti, presumably by the NSU's neo-Nazi admirers.

Ayşen Taşköprü, whose brother Süleyman had been slain in their Hamburg grocery store, reflected on those admirers—on Germany's white supremacists today.

"Instead of asking us victim families about our feelings, the journalists should rather ask the [native-born] Germans: *Why do you have such a hard time with people of different nationalities or skin colors? Why don't you have the tolerance to change yourselves so that people can integrate here?*"

One day when Ayşen visited Hamburg's city hall to do some paperwork,

a clerk informed her young son that he was not *German*. Ayşen laughed.
She watched with amusement as her son insisted earnestly that he *was*. He
even had a German passport to prove it. At the time Ayşen thought little of
the encounter—a mistake, nothing more. But later, it made her feel unwel-
come in her own country, conjuring memories of the disregard authorities
had shown to her family. A few months before the NSU came to light, in
the summer of 2011, Hamburg police officers had rung Ayşen's doorbell to
return her brother's belongings that they'd confiscated a decade earlier as
evidence.

"Why did it take so long?" Ayşen asked the officers.

"We forgot," came the reply.

More than twenty years after Süleyman's death, Hamburg's legislature
still hadn't opened an investigative committee into his murder.

To Mustafa Turgut, whose brother Mehmet was slain in Rostock, the
Germans "were all monsters"—or so he felt in the aftermath of the mur-
der. But in 2013, Mustafa followed in his brother's footsteps and emigrated
from Turkey to Hamburg, settling not far from where Mehmet had lived.
He began to learn German and was reminded that for his brother, Ger-
many had been a place of opportunities and hope. Perhaps Germany could
be that for *him*. Mustafa applied for a work permit and received it. He soon
found a job in a snack bar—just like his brother had done. Sometimes he'd
sit at a fish restaurant by a lake, where the people, he noticed, seemed kind.
Then he'd feel a pang of guilt and remind himself, "This is the country
where your brother was murdered."

Pinar Kılıç, whose husband was slain in their Munich grocery store,
tried to move on.

"Sometimes I dream of opening a coffee house. I like being with peo-
ple. A coffee house, yes, that would be nice. But who's to say that one day
there won't be men with guns in front of the counter again? Then I get
scared…and I feel so broken."

Masha, the Iranian immigrant who as a teen had been badly injured
by the bomb in her parents' grocery store in Cologne, now tends to other
people's wounds as a doctor. Asked what she would tell the people who
tried to kill her, she said, "I ask myself with what right these people, of all

people, have appointed themselves protectors of the German nation. I ask: What have you done for your German nation, what have you achieved for this country that allows you to take the lives of other people?"

Unsatisfied with the trial, the families of the victims convened a sort of people's court of their own—an "NSU tribunal" in which they held a mock trial in absentia of eighty people they believe had ties to the NSU or were complicit in failing to stop them. Among those named was Gordian Meyer-Plath.

"We accuse the incumbent president of the LfV Sachsen, Gordian Meyer-Plath, of supporting informants like Piatto, who were able to spread terrorist propaganda," their verdict read, using Szczepanski's code name. "The NSU is not a single phenomenon, it is part of a history of racism in Germany. The story continues today with burning refugee shelters, with daily attacks. But who is telling this story?"

Semiya Şimşek published a memoir, *Painful Homeland*, which recounts her family's immigration to Germany, her childhood in the small town of Flieden, and their harrowing experience with German white supremacist terror. Two months before the NSU came to light, Semiya had married a journalist named Fatih. She had met him back in her parents' home village, Salur. Soon she gave birth to a son. The couple needed a safe place to raise a child of Turkish heritage. Clearly, Germany wasn't that place. To Semiya, Germany was no longer the country she'd grown up in, frolicking in the field in Flieden with families from all over the world. It was a place where native-born Germans had murdered her father, and where the authorities had blamed the victims instead. And so, like her mother, Semiya returned to Turkey—to Salur, where Enver is buried.

"When I sit by the grave today, I see the mountains in the distance, into which the shepherds move in spring. The cemetery is not far from my father's house. You can see the tomb from the balcony on which we were sitting when we heard the sheep bells ring."

Epilogue

Germany's Reckoning

L ate one night in August 2018, a month after the verdict, Seda Başay-Yıldız, the Şimşeks' family attorney, was in Tunisia for work when she received an anonymous fax at her hotel.

"Turkish Swine," it read. "We will slaughter your daughter in revenge." The fax was signed "NSU 2.0." Başay-Yıldız was born in Germany, the daughter of Turkish guest workers. Whoever sent the threat included the address where she and her young daughter lived. Başay-Yıldız called the police.

When officers in her hometown of Frankfurt investigated, they discovered that her personal information had been leaked from a computer within their own department, then shared with far-right trolls. Four officers were temporarily suspended—including Johannes Sprenger, who was investigated for sedition, but never charged—but the threats didn't stop. By August 2020, twenty-eight lawyers, politicians, and journalists across Germany had received more than 140 threatening emails and faxes signed "NSU 2.0."* Police refused to offer Başay-Yıldız a security detail, instead advising her to buy a handgun to protect herself.

That message—*protect yourself*—doesn't inspire confidence that Germany

* In wasn't until 2022 that police discovered that the man behind the threats was an unemployed IT technician and far-right extremist named Alexander Mensch. A court sentenced him to nearly six years in prison for threats of violence, incitement to hatred, attempting to disturb public peace, and use of anticonstitutional symbols, but no police officer was ever charged. Others continued Mensch's menacing campaign: By August 2023 at least thirty

is prepared to defend immigrants and minorities today. The same month Başay-Yıldız received the letter, an anti-immigrant protest organized by the AfD in Chemnitz devolved into white Germans attacking immigrants in the streets while police scrambled to maintain control. A few weeks later, eight white men attacked immigrants with baseball bats in a park, formed a terrorist group they called "Revolution Chemnitz," and—as prosecutors alleged—plotted to incite a far-right coup.*

To many Germans, the Chemnitz riots were reminiscent of those in Rostock, twenty-six years before. At the time, Angela Merkel had been overseeing the creation of safe havens like Winzerclub on the belief that social workers could reason with far-right radicals—bring them back from the edge of extremism and into the mainstream. Three decades later, it was clear that this plan hadn't worked. On the thirtieth anniversary of the Rostock riots, 180 far-right Germans would commemorate the event by trying to repeat it, demonstrating outside an asylum housing complex in Leipzig, which some attempted to set on fire. When it came to meeting Germany's obligations under international law to protect asylum seekers, Merkel had assured her fellow Germans that they would *schaffen das*—would manage, would survive.

But would the refugees *schaffen das*, too? Bilal M. almost didn't. In July 2019, the twenty-six-year-old former refugee from Eritrea was sitting in his car in the town of Wächtersbach near Frankfurt when a fifty-five-year-old white man named Roland Koch spotted him and shot him in the stomach. The attack took place in broad daylight just minutes after Koch boasted at a local bar that he wanted to shoot nonwhite people. After the shooting, he returned to the bar and bragged about what he had done. Nobody bothered to call the police. Koch eventually called the police himself, threatened to carry out more attacks, then drove to the outskirts of town and killed himself. Bilal survived.

Three months later, on Yom Kippur in 2019, a white German terrorist

such letters had been sent to mosques across the country. "What we did to the Jews, we will do to you too," one of the letters read.

* In 2020, all eight were convicted of membership in a terrorist group and sentenced to between two and six years in prison.

named Stephan Balliet attempted to storm a synagogue in Halle much like the American white terrorist Robert Bowers, who had massacred worshippers at the Tree of Life synagogue in Pittsburgh a year before.* When Balliet couldn't get through the door, he shot and killed a forty-year-old woman who happened to be walking by. He then approached a kebab shop where he shot and killed a twenty-year-old man whom he apparently mistook for an immigrant.†

Then came Germany's deadliest anti-immigrant terrorist attack of all. One night in February 2020, a white man named Tobias Rathjen entered two hookah bars in his hometown of Hanau in a suicide attack. He fired fifty-two shots with an automatic handgun, killing nine immigrants and Germans of immigrant heritage—Turkish, Syrian, Sinti, Kurdish, Afghan, Bosnian, Bulgarian, Romanian—as they smoked and sipped their evening tea. He also injured five others of Turkish, Cameroonian, and Afghan descent. In a twenty-four-page manifesto, Rathjen wrote that many "races and cultures" of the world were destructive, "especially Islam." The populations of twenty countries ranging from Morocco to Israel, he wrote, should be exterminated. When the AfD tweeted a link to Rathjen's manifesto, some accused the party of spreading his white terrorist ideology to the world.

Rathjen's terror took place in Hesse, the same state where fourteen years earlier the NSU murdered Halit Yozgat, the last of their nine victims of immigrant descent. Rathjen killed the same number in a single night. In the aftermath, the head of Germany's federal domestic intelligence agency acknowledged that far-right extremism poses the "biggest danger to German democracy today."

What's more, "The 'typical' Nazi no longer wears a bald head, a bomber jacket and combat boots," warned one German political scientist, "but is conspicuously inconspicuous." These *new* neo-Nazis feel emboldened by the rhetoric of a political party that believes Germany has become too fixated with remembering the terror of its past. An AfD leader named Björn

* Bowers's terror was inspired by his hatred for immigrants, as well as Jews. Hours before his rampage he accused Jews of bringing "hostile invaders to dwell among us" in a nod to the popular far-right "replacement theory" conspiracy. "It's the filthy evil jews Bringing the Filthy evil Muslims into the Country!!"

† Balliet shot and seriously wounded two more people before being captured by police. In 2020 he was sentenced to "life" in prison for murder.

Höcke has referred to Berlin's iconic Memorial to the Murdered Jews of Europe as a "monument of shame." Germany's "laughable policy of coming to terms with the past," he told a crowd of supporters, "is crippling us."

It isn't just politicians and members of the public who think this way. Oftentimes it's the police. Between 2014 and 2020, *Der Spiegel* counted 340 suspected cases of racist or far-right extremist activity by the very officers who are paid to *protect* people from such threats. In 2018 at a McDonald's in the Bavarian town of Augsburg, an off-duty police officer yelled "Black man go home!" at an asylum seeker from Senegal, then assaulted him. That same year an officer and apparent admirer of the NSU chose the code name "Uwe Böhnhardt" during an assignment to protect Turkey's authoritarian president Recep Tayyip Erdoğan on an official visit. It was a dark joke, a nod to the fact that eight of the NSU's victims were of Turkish descent.

Other times, police *are* the terrorists. The following year, white officers at the Baden-Württemberg police department formed a terrorist cell and began plotting to assassinate Muslims and immigrants with the aim of sparking a race war.*

"Germany likes to present itself as a country that has shown the world how to deal with the past—that it can acknowledge past atrocities and, supposedly, learn from them," said Antonia von der Behrens, Elif Kubaşık's attorney. "For a country like that not to be able to acknowledge that we have racist murders...If the police can't even admit they did something wrong, how are they supposed to learn?"

Germany's military too is rife with far-right extremists. Nearly a quarter century after Mundlos was caught singing Nazi songs in his barracks, German soldiers stationed in Lithuania were let go after they were caught doing the same in celebration of Hitler's birthday. German soldiers, police officers, and intelligence agents were suspected of taking part in fourteen hundred extremist acts between March 2017 and March 2020, everything from violating Germany's sedition laws to violently attacking immigrants—a frightening prospect in a nation whose armed forces waged two world wars.

* After an informant within the group alerted authorities, police arrested twelve men across six federal states. Prosecutors charged four of them with forming a terrorist organization and eight with supporting it. As of this writing, their trial was still underway.

Some want to start a third—Day X, a global race war. In 2017, police at Vienna's airport discovered a loaded handgun hidden inside a bathroom wall. The white man who came to retrieve it, thirty-three-year-old Franco Albrecht, was a first lieutenant in the German military. Strangely, his fingerprints matched those of a Syrian refugee seeking asylum in Germany. But the refugee didn't exist. Albrecht had been posing as one in order to carry out some sort of terrorist attack and pin it on immigrants to spark Day X. He'd already pilfered four guns, more than a thousand rounds of ammunition, and fifty-one explosive devices from different military bases where he'd been stationed. In July 2022, a judge sentenced him to five years in prison for plotting to commit terrorism.

One of the most sensational far-right plots of all came to light that December, when some three thousand police and special forces officers raided 150 properties across the country and arrested twenty-five far-right extremists who had been plotting to overthrow Germany in a coup. They planned to storm the Bundestag, assassinate Germany's chancellor, and install a military regime. These were no average citizens or small-time soldiers. One had served in the Bundestag, as a legislator for the AfD and was a standing judge at the time of her arrest. Another served in the same paramilitary police unit as Albrecht. Another, a conspiracy theorist named Heinrich Reuss, was a Thuringian aristocrat who prosecutors say planned to install himself as Germany's new leader. As *Der Spiegel* described, when police arrested Reuss at his home on the river Saale, an hour south of Jena, "he wore a large plaid tan tweed jacket, rust brown corduroy pants, a shirt and neckerchief, his white hair slicked back—not exactly the appearance one might expect of a terrorist."

But the journalists got it wrong. In Germany, as in America, as in nearly every predominantly white nation on earth, Reuss is *precisely* what a typical terrorist looks like. Although the majority of convicted terrorists in the West are less educated and less wealthy than Reuss, most are male, right-wing, and white.

* * *

Across the Atlantic, on January 6, 2021, supporters of President Donald Trump stormed the U.S. Capitol to prevent Congress from certifying the

2020 presidential election after Trump refused to accept his defeat. Some of the rioters were members of militant white supremacist groups like the Proud Boys, the Three Percenters, No White Guilt, the National Socialist Club (NSC-131), and the Oath Keepers. Their attempted coup conjured up scenes from a similar one in *The Turner Diaries*, published more than forty years before.

The Capitol coup was the moment many Americans recognized the extent of the danger that white nationalists pose to their nation. The siege was shocking—but not surprising to anyone who had been paying attention. America has known for decades what its far-right extremists are capable of. The wreckage of the Twin Towers had barely stopped smoldering when the FBI reminded Americans that *right-wing* terror was America's greatest threat.

"In the 1990s, right-wing extremism overtook left-wing terrorism as the most dangerous domestic terrorist threat to the country," the FBI told the Senate Intelligence Committee in 2002. "Two of the seven planned acts of terrorism prevented in 1999 were potentially large-scale, high-casualty attacks being planned by organized right-wing extremist groups."

Since 9/11, more people have been killed on American soil by far-right extremists than by Islamist ones. They also committed nearly three times as many violent attacks. And it's getting worse: Between 2013 and 2021, domestic terror attacks more than tripled. And yet it's a threat America's leaders and law enforcement seem reluctant to address. In 2019, the FBI told Congress that 80 percent of its counterterrorism agents were assigned to international terrorism cases, just 20 percent to domestic ones. This despite data showing that since 9/11, the actual threat was precisely flipped: 80 percent of terrorist plots were planned by U.S. citizens and permanent residents.

Immigrants are likely to face the brunt of America's failure to fixate on far-right extremists.

"Anti-immigrant hate groups are the most extreme of the hundreds of nativist and vigilante groups that have proliferated since the late 1990s," warned the Southern Poverty Law Center in 2022. Despite that immigrants make up less than 14 percent of the U.S. population, white supremacist Americans claim they are being "replaced." And as global conflict,

poverty, and disasters compel more and more people to seek safety in Western nations, nativist violence against them may continue to rise. Germany's NSU begs the question: *Could that same sort of terror happen here?* The answer is that it already does. But you wouldn't know it from the hyperbole of the news media, which in the United States give nearly five times as much coverage to terrorist attacks perpetrated by Muslims than attacks by anyone else.

Like Uwe Mundlos in Germany, America's white extremists are disproportionately military men. The white terrorist in Wisconsin who massacred seven and injured three at a Sikh temple in 2012 radicalized while serving in the U.S. Army. So did America's most infamous terrorist of all, the 1995 Oklahoma City bomber Timothy McVeigh, who as a young soldier read and sold copies of *The Turner Diaries*. In the book, a truck bomb is detonated at a federal building. McVeigh brought along a copy of that page the day he drove a truck bomb to the Alfred P. Murrah Federal Building, wounding 680 people and killing 168. It was the second-deadliest white terrorist attack in U.S. history.*

Many of the more than eleven hundred people charged for crimes at the Capitol had served in the U.S. military or police. But unlike Germany, the United States has done little to expel far-right extremists from its ranks. In 2018 the U.S. Department of Defense informed Congress that of the 1.3 million Americans serving in the military, a mere eighteen had been disciplined for far-right activities in the preceding five years.

America's leaders are aware of the danger: As early as 2009, the U.S. Department of Homeland Security issued a report warning that far-right extremist groups were actively recruiting men and women in uniform. But the political and media backlash against the idea that U.S. soldiers and veterans might radicalize into violent extremists—despite being true—was so fierce that the Obama administration retracted the report and apologized. After that, "we got rid of the domestic terrorism focus and they reassigned those in my former unit to look at al-Qaida," said Daryl Johnson, the DHS official who authored the report.

* In 1921, just a hundred miles northeast of Oklahoma City, white supremacists killed some three hundred Black residents in the Tulsa Race Massacre.

If Obama shied away from exposing some of America's far-right extremists, Trump endorsed them with pride. He attempted to suppress an internal DHS memo warning that domestic, far-right terrorism is "the most persistent and lethal threat in the homeland." He also canceled the DHS program Obama had created to enable different law enforcement agencies to collaborate to monitor far-right extremist threats. In June 2021, President Joe Biden reinstated it:

"Too often over the past several years, American communities have felt the wrenching pain of domestic terrorism. Black church members slaughtered during their Bible study in Charleston. A synagogue in Pittsburgh targeted for supporting immigrants. A gunman spraying bullets at an El Paso Walmart to target Latinos. It goes against everything our country strives to stand for in the world," Biden said. "We cannot ignore this threat or wish it away."

And yet that's precisely what America's legislators are doing. Year after year, the U.S. Senate has refused to pass versions of the Domestic Terrorism Prevention Act, which law enforcement agencies say would help authorities monitor, investigate, and prosecute far-right hate crimes and other types of hate speech that might escalate into violence.

If America's elected leaders are failing to give law enforcement agencies new ways to stop white terror, those agencies and the Department of Justice are failing to use some of the antiterrorism tools they already have. Federal law prohibits material support for terrorist acts. Between September 11, 2001, and 2019, prosecutors charged four hundred people for supporting *international* terrorists. They charged just one person for supporting domestic ones. Since 9/11, the Justice Department used antiterrorism laws against international terrorists more than five hundred times, but against far-right extremists on just thirty-four occasions. None of the white men who massacred Latinos in El Paso, Black shoppers in Buffalo, or Black worshippers in Charleston were charged with terrorism. The latter—Dylann Roof—even laid out his terrorist objectives in a manifesto. But prosecutors still didn't charge Roof with terrorism.

To stop white terror, we must learn to recognize it and to call it by its name. White terror will not end overnight, but there are reasons to think we could contain it. Americans are beginning to pay attention. An Associated

Press survey seven months after the Capitol siege found that Americans were significantly—and rightly—more concerned about domestic extremists than foreign ones. Democrats were nearly four times as likely to fear homegrown extremists than foreign ones, and Republicans were equally concerned about each. This bipartisan support is revealing: We know that *we* are our own biggest threat.

Every time a white man massacres Asian American women in Georgia, Indian Americans in Indiana, Mexican Americans in Texas, it is a chilling reminder that anti-immigrant terror is alive and well on our shores. To stop white terror, we must demand that our leaders take action. The United States will not be spared Germany's crisis, or its carnage, if we continue to look away.

Acknowledgments

I am deeply grateful to Gamze Kubaşık for finding the courage to speak with me about her family's life, from the most joyful moments to the nearly unspeakable. I owe the same to Yvonne and Mandy Boulgarides, for sharing with me their memories of that difficult time. My understanding of the NSU would have been incomplete without the relentless research of Katharina König and her dedication to sharing it with me by day and by night, from near and far.

Thank you to my agent, Elias Altman, for believing in this book, for enriching it, and for expanding the possibilities of what it could be. I'm also grateful to my editor, Colin Dickerman, for his patience and for steadily shaping it into what it has become.

This book would have been impossible without the inexorable research and fastidious fact-checking of Garry Zettersten, to whom I'll be forever grateful. I cannot begin to express my thanks to James Reed for meticulously transforming my prose into something that's worthy to read. I also owe a debt of gratitude to John Palattella, Sandra Zhao, and Rebecca Gilsdorf, for editing my complete manuscript, which they did with ruthless attention to detail and incredible care. This book might nonetheless have been a burden to read were it not for the plethora of people who scrutinized substantial parts, including Andrew Curry, Tim Williams, Jessica Camille-Aguirre, Daniel Ammann, Caitlin Chandler, Nick Pierson, Evanna Hu, Sean Williams, and David Klingenberger.

I owe an enormous thanks to Tim Müller for expanding the scope of my research over Mensa meals and espressos; challenging my assumptions; and for so patiently introducing me to empirical evidence on politics, prejudice, and more.

I am deeply indebted to the German Fulbright Commission, especially Kerstin Klopp-Koch and Jamie Moore, for sparking and taking interest in my research and for giving me the chance to pursue it in Berlin. Thanks also to the American Council on Germany for making my early reporting possible, to Columbia Global Reports and Annette Ekin at Al Jazeera for publishing it, and to the Heinrich Böll Foundation for inviting me back. Thanks to Bill Wheeler and Thalia Beaty for bringing the NSU to my attention, and to the many Berliners whose feedback I couldn't have done without: Qian Sun, Felix Franz, Parker Bennett, Andrew Quarmby, Gayatri Parameswaran, Felix Gaedtke, Ben Mauk, Madeleine Schwartz, Luisa Beck, Christina Wolson, Sam Wolson, and Joshua Hammer.

Ein grosses Danke to the Max Planck Institute for Comparative Public Law and International Law in Heidelberg for inviting me to pursue my research to new depths and for their feedback, especially Anne Peters, Armin von Bogdandy, Alexandra Kemmerer, Wartan Hofsepjan, Richard Dören, Lea Berger, Richard Georgi, Robert Stendel, Philipp Sauter, Marie Lohrum, and Rubén García Higuera. A special thanks to Ina, Ben, Kim, and Frédérick for giving me such a wonderful home.

Ein herzliches Danke to the Max Planck Institute for the Study of Crime, Security and Law in Freiburg, for engaging me in such fascinating conversations and showing such curiosity in my work, especially Tatjana Hörnle, Jean-Louis Van Gelder, Ralf Poscher, Carolin Hillemanns, Johanna Rinceanu, Anna Schaich, Hans-Jörg Albrecht, Claudia Wittl, Anna Pingen, Gunda Wössner, Manuel Cordes, Céline Feldmann, Dietrich Oberwittler, Marc Engelhart, Florian Kaiser, Natalie Popov, Sebastian Kübel, Linus Ensel, Aniek Siezenga, Lisa Natter, Carina Hasitzka, Annika Hampel, Jakob Hohnerlein, Svenja Schwartz, Mehmet Arslan, Marie Manikis, and Miki Kadota. *Ein besonderer Dank* to Jörg Arnold for encouraging me and for taking the time to share his insights into the case. Special thanks to Barbara and Klaus for sharing their house; to Koray and Sevil Doğan for making it home; and to Annabelle, Clemens, and their children for making Günsterstal such an exciting place to be.

A big thank-you to the Logan Nonfiction Program, especially Carly Willsie and Josh Friedman, for allowing me to kick-start this book

alongside ambitious journalists from across the globe. Special thanks to Samuel G. Freedman who advised this project when its feasibility was still unclear.

Words cannot express how grateful I am to the educators who inspired me and challenged my notion of what journalism can be: Michael Halloran, Jack Mitchell, Pat Hastings, James Baughman, Katy Culver, Scott Straus, Alexander Stille, Nicholas Lemann, and many more. Thanks also to my students, whose interest in the world and unbridled enthusiasm to explore it gives me hope that the world they'll write about will be better than today's. I could not have written this without the skills imparted upon me by my editors and mentors, especially Andy Hall, Dee Hall, Jonathan Katz, Paul Reyes, Annika Konrad, and Patrick Jarenwattananon. I am forever indebted to Alicia Wittmeyer and Cameron Abadi for so beautifully editing the *Foreign Policy* magazine piece that led to this book and to Sasha Polakow-Suransky for being the first to encourage me to pursue it. Thanks to Trevor Aaronson for so graciously supporting my journalism in every conceivable way.

Thanks to the many people who provided early insights and feedback, including Gemma Sieff, Rafil Kroll-Zaidi, Anne Diebel, Yudhijit Bhattacharjee, Michael Scott Moore, Rupert Russell, Samanth Subramanian, and M. R. O'Connor. Thanks also to those who advised and encouraged this undertaking, including Alexis Sobel Fitts, Daniel Bush, Valerie Hopkins, Isaac DiGinnaro, April Zhu, Rebecca Sweeney, James Carlton, Caitlin McMurtry, Elizabeth Pierson, Alice Weinert, Molly Donnellan, Danny Weisberg, Maria Fahr, Stephanie Ott, Marvin Anderson, Rachel Banay, and Charles Petty.

I'm deeply grateful to Antonia von der Behrens for her assistance examining the case, as well as to Sebastian Scharmer, Alexander Hoffmann, Seda Başay-Yıldız, and Miriam Benker for engaging with me during and after the trial. Thanks also to Heike Kleffner, Steffi Unsleber, Konrad Litschko, Christian Jakob, Stephan Kramer, Markus Ulbig, Gordian Meyer-Plath, and Michael Ruf for speaking with me about the case.

Vielen Dank to Svenja Mank, who spent many hours assisting me in the early years of my research and without whom this project would never have come about. Thanks also to Ralf Mank for sharing his home and to Sylvia Modrow for sharing her story.

To my brother, Michael, for his quick humor and big heart, and to my parents, Blanche and Pat, whose love knows no limit and whose admiration gives me a reason to write: Words cannot begin to express my gratitude. You mean the world to me.

Last but not least, thank you, KC, for your passionate critiques, your incredible kindness, and for putting up with me along the way.

Notes

Prologue

1 would claim that she waited: "Dokumentation. Die Aussage der Beate Zschäpe," *Die Welt*, December 9, 2015.

2 carrying two pistols: Clemens Binninger et al., *Beschlussempfehlung und Bericht des 3. Untersuchungsausschuss gemäß Artikel 44 des Grundgesetzes*, Deutscher Bundestag, June 23, 2017, pp. 128–45, 185, 713.

2 a vampire mask: Kai Mudra, "NSU Prozess: Der Raubüberfall von Arnstadt," *Thüringer Allgemeine*, March 24, 2015.

2 a gorilla mask: "Protokoll 113. Verhandlungstag—20. Mai 2014," NSU Watch, May 25, 2014; Mudra, "Der Raubüberfall."

2 in a bag: "Protokoll 116. Verhandlungstag—28. Mai 2014," NSU Watch, June 17, 2014.

5 More often, it's homegrown: Bundesministerium des Innern, für Bau und Heimat, *Verfassungsschutzbericht 2020: Fakten und Tendenzen—Kurzzusammenfassung*, 2021.

5 murdered by far-right extremists: U.S. Government Accountability Office, *Countering Violent Extremism: Actions Needed to Define Strategy and Assess Progress of Federal Efforts*, April 2017; U.S. Government Accountability Office, *Domestic Terrorism: Further Actions Needed to Strengthen FBI and DHS Collaboration to Counter Threats*, February 2023.

5 praised Trump: Anti-Defamation League, "White Supremacist Terrorist Attack at Mosques in New Zealand," March 15, 2019.

7 "There are those": Heike Kleffner (German journalist and political researcher) in conversation with the author, May 2016.

Chapter 1. Rebirth of a Nation

11 a video camera: NSU-Archiv, "Beate Zschäpe im Winzerclub 1991," YouTube, September 29, 2018, www.youtube.com/watch?v=RS3sJdTUAvM.

11 run the club once it opens: "Uwe Mundlos: Radikalisierung eines NSU-Terroristen," Belltower.News, November 26, 2014.

13 came into this world by surprise: Arne Lichtenberg, "Die Mutter der Terrorzelle," Deutsche Welle, April 11, 2013.

13 Thousands of young East Germans: Mitteldeutscher Rundfunk, "Studium in der DDR," January 11, 2022; Rayk Einax, "Im Dienste außenpolitischer Interessen:

Ausländische Studierende in der DDR am Beispiel Jenas," *Die Hochschule* 1 (2008): 167–69.

13 **Beate's birth father:** Julia Jüttner, "Unser Vertrauen war weg," *Der Spiegel*, November 16, 2012.

13 **Anneliese Apel raised Beate:** Maik Baumgärtner and Marcus Böttcher, *Das Zwickauer Terror-Trio: Ereignisse, Szene, Hintergründe* (Berlin: Das Neue Berlin, 2012), 24; "Zu Hause bei Familie Zschäpe," *Die Zeit*, May 24, 2021.

13 **"Beate tries hard":** Wolf Schmidt, "Die Unfassbare," *Taz*, April 13, 2013.

14 **divorced, returned to Jena:** Julia Jüttner, "Die Frau mit den zehn Namen," *Der Spiegel*, May 4, 2013.

14 **Founded in 1846:** Zeiss, "The Company's History of ZEISS—At a Glance."

14 **six-story building:** *Chronik der Wohnungsgenossenschaft "Carl Zeiss" eG: 60 Jahre Gemainsam, 1954–2014*, November 22, 2016.

14 **more than 2.7 million East Germans:** Berlin Mayor's Office, "The Construction of the Berlin Wall."

14 **"It takes effect":** Melissa Eddy, "Günter Schabowski, Whose Gaffe Helped Burst the Berlin Wall, Dies at 86," *New York Times*, November 1, 2015.

15 **announcement was poorly worded:** Timothy Garton Ash, "Yearning to Breathe Free," *New York Review of Books*, May 11, 2023.

15 **In reality, the agency:** Sumi Somaskanda, "Germany's Thatcherite Turn: How Privatisation Became a Flashpoint in East Germany," *New Statesman*, November 2, 2019.

15 **Thirty percent of the East German workforce:** Rüdiger Dornbusch and Holger Wolf, "Economic Transition in East Germany," *Brookings Papers on Economic Activity* 1 (1992): 235–72.

15 **would endure for decades:** Pew Research, "East Germany Has Narrowed Economic Gap with West Germany Since Fall of Communism, but Still Lags," November 6, 2019.

15 **one in three eastern Germans:** Federal Ministry for Economic Affairs and Climate Action, *Annual Report of the Federal Government on the Status of German Unity 2019*.

15 **purchased the hemorrhaging Carl Zeiss company:** "Carl Zeiss baut in Jena nochmals 650 Stellen ab," *Süddeutsche Zeitung*, February 18, 1995, LexisNexis Academic.

15 **"a journey into the unknown":** Stephan Paetrow, *Birds of a Feather: 20 Years of Reunification at Carl Zeiss*, published by the Carl Zeiss Archive (Hamburg: Verlag Hanseatischer Merkur GmbH, 2011).

16 **Annerose was laid off:** Christian Fuchs, "Beate, die braune Witwe," *Die Zeit*, May 31, 2012.

16 **Beate began shoplifting:** Andreas Förster, "Vom unbeschwerten Teenager zur Terroristin," *Stuttgarter Zeitung*, May 5, 2013.

16 **professional apprenticeships:** Deutscher Bundestag, *Beschlussempfehlung und Bericht des 2. Untersuchungsausschusses nach Artikel 44 des Grundgesetzes*, August 22, 2013, pp. 75–76.

16 **literally watching paint dry:** Schmidt, "Die Unfassbare," *Taz*.

16 **Merkel and her colleagues:** Robert Lüdecke, "Glatzenpflege auf Staatskosten," Amadeu Antonio Stiftung, September 25, 2013.

16 rebelled against their new, capitalist world: Thüringer Landtag, *Bericht des Untersuchungsausschusses 5/1 "Rechtsterrorismus und Behördenhandeln"* (Committee report, Erfurt, 2014), 163.

17 "Beate, her cousin": Thomas Grund, *Die Stasi, der NSU & ich: Mein Leben in Thüringen* (Hamburg: Tredition, 2020), chap. 6.

17 treated his brother with kindness: Baumgärtner and Böttcher, *Das Zwickauer Terror-Trio*, 23.

17 good grades in school: "Protokoll 69. Verhandlungstag—18. Dezember 2013," NSU Watch, December 27, 2013.

17 would one day interest police: "Protokoll 70. Verhandlungstag—19. Dezember 2013," NSU Watch, December 27, 2013.

17 capitalist contraband: Staatsanwaltschaft Zwickau, *Sachakte: Ermittlungsverfahren gegen Beate Zschäpe*, 400–402.

17 a military jacket: "Uwe Mundlos als Teenager von der RAF fasziniert," *Welt*, March 12, 2015.

18 publicly display Nazi symbols: Strafgesetzbuch (StGB) § 86a Aussetzung des Strafrestes bei lebenslanger Freiheitsstrafe, Bundesrepublik Deutschland, Bundesamt für Justiz.

18 more than 50 billion euros: Bundesministerium der Finanzen, *Wiedergutmachung: Regelungen zur Entschädigung von NS Unrecht*, May 3, 2018, www.bundesfinanzministerium .de/Content/DE/Downloads/Broschueren_Bestellservice/2018-03-05-entschaedigung -ns-unrecht.pdf.

18 Courts eventually convicted: Theodor Meron, "Reflections on the Prosecution of War Crimes by International Tribunals," *American Journal of International Law* 100, no. 3 (2006): 551–79; Toi Staff, "Historian Exposes Germany's Minute Number of Convictions for Nazi War Crimes," *Times of Israel*, November 10, 2018.

18 Some served as judges: Deutscher Bundestag, *Drucksache 17/8134*, December 14, 2011, https://dserver.bundestag.de/btd/17/081/1708134.pdf.

19 Deutsche Welle: Heike Mund and Suzanne Cords, "How Germany Deals with 'Mein Kampf,'" Deutsche Welle, August 25, 2015.

19 field trip to the Buchenwald: "Protokoll 192. Verhandlungstag—12. März 2015," NSU Watch, March 12, 2015.

19 Nazi nostalgia: "Beate Zschäpe im Porträt auf den Spuren in Winzerla," *Weser Kurier*, December 9, 2015.

19 "there was no wall": Grund, *Die Stasi, der NSU & ich*, chap. 6.

20 began an apprenticeship: "Protokoll 69. Verhandlungstag—18. Dezember 2013," NSU Watch, December 27, 2013.

21 he was careful to feign tolerance: "Protokoll 61. Verhandlungstag—27. November 2013," NSU Watch, December 3, 2013.

21 "Looking at our scene today": Matthias Quent, *Rassismus, Radikalisierung, Rechtsterrorismus* (Weinheim: Beltz Juventa, 2019): 239–45.

Chapter 2. The New Nazis

23 On Beate's nineteenth birthday: "Dokumentation: Die Aussage der Beate Zschäpe," *Welt*, December 9, 2015.

23 "their favorite toy": "Protokoll 57. Verhandlungstag—19. November 2013," NSU Watch, November 22, 2013.

23 Böhnhardt was only eleven: "Protokoll 125. Verhandlungstag—9. Juli 2014," NSU Watch, July 21, 2014.

24 trivial transgressions: Gerhard Schäfer et al., *Gutachten zum Verhalten der Thüringer Behörden und Staatsanwaltschaften bei der Verfolgung des "Zwickauer Trios,"* Freistaat Thüringen, 26–27, 29–31.

24 "Böhnhardt was like a bomb": Wolf Schmidt, "Die Unfassbare," *Taz*, April 13, 2013.

24 a "loose cannon": "Protokoll 275. Verhandlungstag—13. April 2016," NSU Watch, April 13, 2016.

24 A police officer described him: Mario Melzer (former police officer) in conversation with the author, September 2022.

24 victim spent five days: Deutscher Bundestag, *Beschlussempfehlung und Bericht des 2. Untersuchungsausschusses nach Artikel 44 des Grundgesetzes*, 77.

24 The two men allegedly tortured: Deutscher Bundestag, *Beschlussempfehlung und Bericht des 2. Untersuchungsausschusses nach Artikel 44 des Grundgesetzes*, August 22, 2013, p. 77.

25 to get his driver's license: Thüringer Landtag, *Bericht des Untersuchungsausschusses 5/1 "Rechtsterrorismus und Behördenhandeln"* (Committee report, Erfurt, 2014), 795, 914–15.

25 Katharina König was walking: Katharina König (politician, Die Linke) in conversation with the author, 2016–23.

26 930 far-right extremists: "Thüringen: Der Verfassungsschutz subventionierte die Neonaziszene," *Berliner Zeitung*, November 14, 2011.

27 Germany's antifascist movement: Loren Balhorn, "The Lost History of Antifa," *Jacobin*, May 8, 2017.

27 "blind in the right eye": Barbara Abrell, "Terrorism Research: Gaining a Better Understanding of How Terrorist Organizations Learn from Their Mistakes and Successes," Max-Planck-Gesellschaft, January 29, 2016.

28 One song was so explicit: Christoph Hentschel, "Slime: Warum wurde "Bullenschweine" erst im Mai 2011 indiziert? Eine Spurensuche," *Rolling Stone* (Germany), July 5, 2011.

28 an all-female antifa division: Valerie Schönian, "Angst frisst alles auf," *Die Zeit*, April 30, 2019.

28 *"Bratwurst statt Döner"*: "Wohllebens Vollstrecker," *Der Spiegel*, January 27, 2012.

29 attacked döner restaurants: Opferperspektive, "Rassistische Anschläge gegen Imbisse 2000–2004," February 5, 2005, www.opferperspektive.de/aktuelles/rassistische -anschlaege-gegen-imbisse-2000-2004.

31 referred to immigrants as: Thies Marsen, "Braune Bands und Bomben," *PULS*, April 6, 2016; Uli Jentsch et al., *Rechte Musik und Symbolik* (Berlin: Schule ohne Rassismus—Schule mit Courage, 2005).

31 They lamented what their singers believed: Steve Silver, "Das Netz wird gesponnen: Blood and Honour 1987–1992," in *White Noise: Rechts-Rock, Skinhead-Musik, Blood and Honour. Einblicke in die internationale Neonazi-Musik-Szene* (Münster: Unrast, 2004), 31.

31 "Turks are shit, Africans are shit": "Protokoll 61. Verhandlungstag—27. November 2013," NSU Watch, December 3, 2013.

32 "Foreigners are taking away our jobs": "Protokoll 57. Verhandlungstag—19. November 2013," NSU Watch, November 22, 2013.

32 Böhnhardt brought home a gas pistol: "Protokoll 58. Verhandlungstag—20. November 2013," NSU Watch, November 27, 2013.

32 "gun fanatic": "Protokoll 257. Verhandlungstag—21. Januar 2016," NSU Watch, January 21, 2016.

32 He also owned a crossbow: "Protokoll 125. Verhandlungstag—9. Juli 2014," NSU Watch, July 21, 2014.

32 stepping in to save Böhnhardt: "Protokoll 69. Verhandlungstag—18. Dezember 2013," NSU Watch, December 27, 2013.

33 for some six hundred years: Minderheitensekretariat, "The German Sinti and Roma," https://t.ly/cOAlZ.

33 always used violence: Bradden Weaver, "Violence as Memory and Desire: Neo-Nazism in Contemporary Germany," in The Legitimization of Violence, ed. D. E. Apter (London: Palgrave Macmillan, 1997), 128–58.

Chapter 3. Rostock Riots

34 bombed the place: Norddeutscher Rundfunk, "Als Rostocks Innenstadt vom Bombenhagel zerstört wurde," April 23, 2022, www.ndr.de/geschichte/chronologie/Als-Rostocks-Innenstadt-vom-Bombenhagel-zerstoert-wurde,bombenaufrostock101.html.

34 One out of every five Germans: U.S. Library of Congress, "Historical Background: Germany," https://countrystudies.us/germany/84.htm.

34 "guest workers": Christof van Mol and Helga de Valk, "Migration and Immigrants in Europe: A Historical and Demographic Perspective," in Integration Processes and Policies in Europe, ed. B. Garcés-Mascareñas and R. Penninx (Heidelberg: Springer Cham, 2016), 31–55.

34 never meant to be integrated: Philip L. Martin, "Germany's Guestworkers," Challenge (July/August 1981): 34–42.

34 female workers: Dokumentationszentrum und Museum über die Migration in Deutschland, "Migrationsgeschichte in Bildern: 1967–1989," 2023, https://domid.org/en/news/contractwork-in-the-gdr.

34 "friends" and "brothers": Ann-Judith Rabenschlag, "Arbeiten im Bruderland," Bundeszentrale für politische Bildung, September 15, 2016, www.bpb.de/themen/deutschlandarchiv/233678/arbeiten-im-bruderland.

34 made racism a crime: Marcia C. Schenck, Remembering African Labor Migration to the Second World (Basingstoke: Palgrave Macmillan, 2022), 185.

34 thirty-nine documented attacks: Thomas Klug, "Das verdrängte Pogrom in Erfurt 1975," Deutschlandfunk Kultur, August 10, 2020, www.deutschlandfunkkultur.de/rassismus-in-der-ddr-das-verdraengte-pogrom-in-erfurt-100.html.

35 unemployment jumped from near zero: Panikos Panayi, "Racial Violence in the New Germany 1990–93," Contemporary European History 3, no. 3 (November 1994): 271, 282.

35 lost their homes: Karin Weiss, "Zwischen Rückkehr in die Heimatländer und Existenzsicherung vor Ort," Bundeszentrale für politische Bildung, March 5, 2021,

www.bpb.de/themen/deutsche-einheit/migrantische-perspektiven/325194
/zwischen-rueckkehr-in-die-heimatlaender-und-existenzsicherung-vor-ort.

35 **return to their home countries:** Patrice Poutrus, "Ausländische Arbeitsmigrant*innen
'Arbeiter-und-Bauern-Staat': Die sogenannten Vertragsarbeiter in der DDR," Hans
Böckler Stiftung, April 2021, www.boeckler.de/fpdf/HBS-008078/p_ek_ap_24
_2021.pdf, pp. 7–15.

36 **thirty years would pass:** Barbara Spitzer, "Yeboah-Prozess: Zeuge aus rechtsex-
tremem Milieu vernommen," SR, August 11, 2023.

36 **"first city free of foreigners":** Mitteldeutscher Rundfunk, "Hoyerswerda 1991:
Die erste 'ausländerfreie' Stadt Deutschlands," September 13, 2022, www.mdr.de
/geschichte/hoyerswerda-rassistische-ausschreitungen-100.html.

37 **seventeen murders:** Bundesamt für Verfassungsschutz, "Verfassungsschutzbericht
1992," 1993, https://verfassungsschutzberichte.de/bund/1992.

37 **"Forty-six years after Adolf Hitler":** Stephen Kinzer, "A Wave of Attacks on For-
eigners Stirs Shock in Germany," *New York Times*, October 1, 1991.

37 **On the afternoon of August 22:** Sylvia Modrow (Rostock resident) in conversation
with the author, May 28, 2016.

38 **"Sunflower House":** Landtag Mecklenburg-Vorpommern, *Drucksache 1/3277* (Com-
mittee report, Schwerin, 1993), www.landtag-mv.de/fileadmin/media/Dokumente
/Parlamentsdokumente/Drucksachen/1_Wahlperiode/D01-3000/Drs01-3277.pdf.

38 **just 1.2 percent:** Holly Cartner, "'Foreigners Out': Xenophobia and Right-Wing
Violence in Germany," Human Rights Watch.

38 **half of 1 percent:** Statistisches Bundesamt (Destatis), "12521-0020: Foreigners: Län-
der, Reference Date, Sex/Age Years/Marital Status," 2023, www-genesis.destatis
.de/genesis/online?sequenz=statistikTabellen&selectionname=12521&language
=en.

38 **"Everything was in flux":** Dorit Kesselring (newspaper editor) in conversation with
the author, May 27, 2016.

38 **"serious assaults and even killings":** Bettina Markmeyer: "Alle wußten bescheid,
doch nichts passierte," *Taz*, September 5, 1992.

39 **"Mecklenburger Allee 19":** Cartner, "'Foreigners Out.'"

39 **"at least 1,000 neo-Nazis":** Panayi, "Racial Violence in the New Germany."

40 **"riot tourism":** Steve Vogel, "Germany's Rightist Violence Sparks Concerns," *Wash-
ington Post*, September 5, 1992.

40 **deployed helicopters:** JAKOTADesignGroup, "The Truth Lies in Rostock," You-
Tube, August 3, 2012, www.youtube.com/watch?v=5P21AfG6SPE.

40 **half a million people sought asylum:** Jan Schneider and Marcus Engel, "Asylum
Law, Refugee Policy and Humanitarian Migration in the Federal Republic of Ger-
many," Bundeszentral für politische Bildung, June 2, 2015, www.bpb.de/gesellschaft
/migration/kurzdossiers/207671/asylum-law-refugee-policy-humanitarian-migration.

40 **"began a campaign":** Stefan Zeppenfeld, "Der 'Asylkompromiss.' Historische Verortung
eines aktuellen Schlichtungsversuchs," Geschichte der Gegenwart, May 24, 2023,
https://geschichtedergegenwart.ch/der-asylkompromiss-historische-verortung
-eines-aktuellen-schlichtungsversuchs/print/.

41 "Onslaught of the Poor": "Ansturm der Armen," *Der Spiegel*, September 8, 1991.

41 in favor of restricting asylum: "Talfahrt der SPD zu Ende?," *Der Spiegel*, February 16, 1992.

41 "Politics sometimes listens to the loudest": Katharina König (politician, Die Linke) in conversation with the author, 2016–23.

41 The law passed: Bundeszentrale für politische Bildung, "Vor zwanzig Jahren: Einschränkung des Asylrechts 1993," May 24, 2013, www.bpb.de/kurz-knapp /hintergrund-aktuell/160780/vor-zwanzig-jahren-einschraenkung-des-asylrechts -1993/.

41 "they could do whatever they wanted to": Jacob Kushner, "Revisiting Germany's Xenophobic Rostock Riots of 1992," Al Jazeera, June 15, 2017.

41 neo-Nazis firebombed the home: Ministerium für Justiz und Gesundheit Schleswig-Holstein, "30 Jahre Anschlag Mölln," November 17, 2022, www.landtag.ltsh.de /export/sites/ltsh/beauftragte/fb/Dokumente/2022-11-17_Landtag_BeauftrFLU _Broschuere_Moelln_20221116_BF_K.pdf.

42 Two white men: Rich Atkinson, "2 Neo-Nazis in Germany Get Maximum Sentences," *Washington Post*, December 9, 1993.

42 self-identified as right-wing: Thomas Ohlemacher, "Fremdenfeindlichkeit und Rechtsextremismus: Mediale Berichterstattung, Bevölkerungsmeinung und deren Wechselwrikung mit fremdenfeindlichen Gewalttaten, 1991–1997," *Forschungsberichte*, no. 72 (1998): 17.

42 fifteen hundred far-right arson attacks: Daniel Koehler, *Right-Wing Terror in the 21st Century: The National Socialist Underground* (London: Routledge, 2016), 85.

42 burned to death in the flames: Bundeszentrale für politische Bildung, "29. Mai 1993: Brandanschlag in Solingen," May 26, 2023, www.bpb.de/kurz-knapp/hintergrund -aktuell/161980/25-jahre-brandanschlag-in-solingen/.

42 immigrants in Lübeck: William Drozdiak, "Fire Kills 10 at Refugee Hostel in Germany," *Washington Post*, January 19, 1996.

Chapter 4. Fiery Cross

43 the Baltic island of Usedom: "Protokoll 25. Verhandlungtag—18. Juli 2013," NSU Watch, July 20, 2013.

43 neo-Nazis at the beach: Ulrike Putz, "German Neo-Nazis in Paradise," *Der Spiegel*, October 6, 2010.

43 Markus Horsch: Clemens Binninger et al., *Beschlussempfehlung und Bericht des 3. Untersuchungsausschuss gem. Artikel 44 des Grundgesetzes, Deutscher Bundestag*, June 23, 2017, p. 93.

43 Toitenwinkel: Ann Christin von Allwörden, *Beschlussempfehlung und Zwischenbericht des 2. Parlamentarischen Untersuchungsausschusses zur Aufklärung der NSU-Aktivitäten in Mecklenburg-Vorpommern*, Landtag Mecklenburg-Vorpommern, 2021, p. 610.

44 broke a bottle: "Protokoll 61. Verhandlungtag—27. November 2013," NSU Watch, December 3, 2013.

44 Katharina's friend Maria: Maik Baumgärtner and Marcus Böttcher, *Das Zwickauer Terror-Trio: Ereignisse, Szene, Hintergründe* (Berlin: Das Neue Berlin, 2012), 34.

44 a "normal" girl: Katharina König (politician, Die Linke) in conversation with the
 author, 2016–23.

44 in one telling: "Protokoll 107. Verhandlungstag—16. April 2014," NSU Watch,
 April 28, 2014.

45 investigating Uwe Mundlos: Deutscher Bundestag, *Beschlussempfehlung und Bericht
 des 2. Untersuchungsausschusses,* August 22, 2013, pp. 76–80.

45 the Bundeswehr had documented: Nils Werner, "Wie rechts ist die Bundeswehr?,"
 MDR, July 1, 2020, www.mdr.de/geschichte/zeitgeschichte-gegenwart/politik-gesells
 chaft/bundeswehr-rechte-tendenzen-100.html.

45 hung military flags: Deutsche Friedensgesellschaft Darmstadt, "Ist die Bundeswehr
 der Bundesrepublik Deutschland von Nazis und Neonazis durchsetzt?," 2023, www
 .documentcloud.org/documents/23977586-deutsche-friedensgesellschaft-darm
 stadt-2023?responsive=1&title=1.

45 soldiers stationed in Münster: "Ist die Bundeswehr der Bundesrepublik Deutsch-
 land," 10.

46 "played down the arson attack: Matthias Gehbauer, "Wie die Bundeswehr den Neo-
 nazi gewähren ließ," *Der Spiegel,* October 1, 2010.

46 with pictures of Hitler: Gerhard Schäfer et al., *Gutachten zum Verhalten der Thüringer
 Behörden und Staatsanwaltschaften bei der Verfolgung des "Zwickauer Trios,"* Freistaat
 Thüringen, 4, 34, 39, 50.

46 seven days' disciplinary arrest: Deutscher Bundestag, *Beschlussempfehlung und Bericht
 des 2. Untersuchungsausschusses,* 77, 82.

46 The NPD believed: Jens Mecklenburg, *Handbuch deutscher Rechtsextremismus* (Ber-
 lin: Elefanten Press, 1996), 282–84.

46 was sentenced to prison: Verfassungsschutz Baden-Württemberg, "'Kämpfer für
 Deutschland'? Der 'Trauermarsch' für Günter Deckert am 16. April 2022 in Wein-
 heim," June 26, 2022.

47 banks of the river Danube: Mike Szymanski, "Einem Täter auf der Spur," *Süddeutsche
 Zeitung,* August 22, 2012.

47 far-right infractions: Thüringer Landtag, *Bericht des Untersuchungsausschusses 5/1
 "Rechtsterrorismus und Behördenhandeln"* (Committee report, Erfurt, 2014), pp. 86,
 502–3.

48 proposed to Beate: Wolf Schmidt, "Die Unfassbare," *Taz,* April 13, 2013.

48 Brigitte was impressed: "Protokoll 57. Verhandlungstag—19. November 2013,"
 NSU Watch, November 22, 2013.

49 black combat boots: "Zu Hause bei Familie Zschäpe," *Die Zeit,* May 24, 2017.

50 "red pigs": Thomas Grund, *Die Stasi, der NSU & ich: Mein Leben in Thüringen* (Ham-
 burg: Tradition, 2020), chap. 4.

50 dressed head to toe: Frank Döbert: "Erinnerung an 90er Jahre," *Ostthüringische Zei-
 tung,* December 17, 2011.

50 One summer night: Heike Kleffner and Anna Spangenberg, *Generation Hoyer-
 swerda: Das Netzwerk militanter Neonazis in Brandenburg* (Berlin: be.bra, 2016),
 113.

51 Neukölln district of Berlin: "Ein Phantom im Landtag," *Märkische Allgemeine Zei-
 tung,* June 11, 2018.

51 "great victory for Germany": Garry Zettersten, "'White Man Fight Back!' Der Ku Klux Klan in der Bundesrepublik Deutschland, 1980–2000," in *Rassismus: Von der frühen Bundesrepublik bis zur Gegenwart*, ed. Vojin Vukadinović (Oldenbourg: De Gruyter, 2023), 358.

51 KKK-themed magazine: *Feuerkreuz* no. 1 (January 1991).

51 "Virtually every week": David Binder, "Violence by Bands of Racist Skinheads Stalks East Germany," *New York Times*, August 21, 1990.

52 a quarter of Germans agreed: Holly Cartner, "'Foreigners Out': Xenophobia and Right-Wing Violence in Germany," Human Rights Watch.

52 *The Turner Diaries*: Andrew MacDonald [William Luther Pierce], *The Turner Diaries* (Washington, DC: National Alliance, 1978).

53 on one of their computers: Christoph Arnowski, "Die Turner-Tagebücher und der NSU," Bayerischer Rundfunk, February 4, 2016.

53 the one behind the camera: Deutscher Bundestag, *Beschlussempfehlung und Bericht des 2. Untersuchungsausschusses*, 79, 183–84.

53 Highway 88: Kriminalpolizei Saalfeld, *Beschuldigten-Vernehmung*, 1.

53 Heinrich Heine Park: Interrogation transcript Zschäpe (Az. 1680-00-95/2, Rudolstadt, 10.09.1995, 13:30, p. 1).

53 "Wherever they burn books": "Bebelplatz: Wo die Nazis Bücher verbrannten," Berlin.de, September 7, 2015.

53 *Den Opfern*: Z. Thomas, "Platz der Opfer des Faschismus in Rudolstadt," Wikimedia, September 6, 2013.

53 "Germans learn": "Protokoll 84. Verhandlungtstag—5. Februar 2014," NSU Watch, February 19, 2014.

54 "Enough with the Holocaust": Schäfer et al., *Gutachten zum Verhalten der Thüringer Behörden*, 45.

54 detained them: Thüringer Landtag, *Bericht des Untersuchungsausschusses 5/1 "Rechtsterrorismus und Behördenhandeln"* (Committee report, Erfurt, 2014), 635–37.

54 Tino Brandt: Thüringer Landtag, *Bericht des Untersuchungsausschusses 6/1 "Rechtsterrorismus und Behördenhandeln"* (2019), 919.

54 found a dagger: Schäfer et al., *Gutachten zum Verhalten der Thüringer Behörden*.

55 a small storage garage: Thüringer Landtag, *Bericht des Untersuchungsausschusses 5/1*, 619.

55 "We hated the state, foreigners": "Protokoll 61. Verhandlungtstag—27. November 2013," NSU Watch, December 3, 2013.

Chapter 5. Moles and Minders

57 During the Roman Empire: Steven H. Rutledge, *Imperial Inquisitions: Prosecutors and Informants from Tiberius to Domitian* (London: Routledge, 2001), xiii.

57 the thirty-year-old Austrian: Reinhard Opitz, *Faschismus und Neofaschismus* (Berlin: De Gruyter, 1984).

57 hundred thousand soldiers: Sebastian Felz, "Verräter verfallen der Staatsnothilfe," *Legal Tribune Online*, June 25, 2023.

58 the Gestapo recruited: Claire Hall, "An Army of Spies? The Gestapo Spy Network 1933–45," *Journal of Contemporary History* 44, no. 2 (April 2009): 247–65.

58 **one officer for every ten thousand Germans:** Robert Gellately, "The Gestapo and German Society: Political Denunciation in the Gestapo Case Files," *Journal of Modern History* 60, no. 4 (December 1988): 662.

59 **federal and state intelligence agencies:** Jonas Grutzpalk and Tanja Zischke, "Nachrichtendienste in Deutschland," Bundeszentrale für politische Bildung, June 14, 2012.

59 **encouraged children to inform:** Angela Marquardt, "Verführung zu Feindbildern: Jugendliche im Dienst des MfS," Bundeszentrale für politische Bildung, October 16, 2016.

59 **an army of spies:** Alison Lewis, *A State of Secrecy: STASI Informers and the Culture of Surveillance* (Dulles, VA: Potomac Books, 2021), 342.

60 **tasked with defending:** Marc Engelhart and Mehmet Arslan, *Security Architecture in Germany* (Freiburg im Breisgau: Max-Planck-Institut für ausländisches und internationales Strafrecht, 2020), 35–36.

60 **"on the edge of legality":** Constantin Goschler and Michael Wala, *"Keine neue Gestapo": Das Bundesamt für Verfassungsschutz und die NS-Vergangenheit* (Hamburg: Rowohlt, 2015).

61 **Amadeu Antonio:** Amadeu Antonio Stiftung, "Amadeu Antonio: His History Is Our Mission," 2023.

61 **didn't even have the internet:** Gordian Meyer-Plath (former OPC handler and politician) in conversation with the author, June 2016.

61 **a handwritten letter:** Holger Ruprecht, *Beschlussempfehlung und Bericht des Untersuchungsausschusses zur "Organisierten rechtsextremen Gewalt und Behördenhandeln, vor allem zum Komplex Nationalsozialistischer Untergrund (NSU)"* (Committee report, Potsdam, 2019), 296–97.

62 **attempted to light him on fire:** Garry Zettersten, "'White Man Fight Back!' Der Ku Klux Klan in der Bundesrepublik Deutschland, 1980–2000," in *Rassismus: Von der frühen Bundesrepublik bis zur Gegenwart*, ed. Vojin Vukadinović (Oldenbourg: De Gruyter, 2023), 359.

62 **"was regarded in the scene":** Deutscher Bundestag, *Stenografisches Protokoll der 64. Sitzung des 2. Untersuchungsausschusses*, June 21, 2013, p. 30.

63 ***Der Weisse Wolf:*** Stefan Aust and Helmar Büchel, "NSU-Morde; Der V-Mann mit 'Bums,'" *Welt*, June 27, 2019.

63 **"Adolf Hitler fighting force":** Ruprecht, *Beschlussempfehlung und Bericht des Untersuchungsausschusses*, 139–40, 938–42.

64 **Brandt was one of the neo-Nazis:** Thüringer Landtag, *Bericht des Untersuchungsausschusses 6/1"Rechtsterrorismus und Behördenhandeln"* (2019), 990, 1058–60, 1398.

65 **"Martyr for Germany":** Thüringer Landtag, *Bericht des Untersuchungsausschusses 5/1"Rechtsterrorismus und Behördenhandeln"* (Committee report, Erfurt, 2014), 1795.

65 **Thuringia Homeland Protection:** Bundeszentrale für politische Bildung, "Thüringer Heimatschutz."

66 **Brandt organized legal trainings:** Gerhard Schäfer et al., *Gutachten zum Verhalten der Thüringer Behörden und Staatsanwaltschaften bei der Verfolgung des "Zwickauer Trios,"* Freistaat Thüringen, 42–44.

66 From his boots to his bomber jacket: "Protokoll 128. Verhandlungstag—16. Juli 2014," NSU Watch, July 25, 2014.

67 Brandt continued organizing: Maik Baumgärtner and Marcus Böttcher, *Das Zwickauer Terror-Trio: Ereignisse, Szene, Hintergründe* (Berlin: Das Neue Berlin, 2012), 33.

69 Pretty Good Privacy: Clemens Heinrich, "Pretty Good Privacy (PGP)," in *Encyclopedia of Cryptography and Security*, ed. Henk Tilborg (Boston: Springer, 2006), 466–70.

70 to free neo-Nazis from punishment: Gisela Friedrichsen, "Stramme Kameraden," *Der Spiegel*, July 15, 2014.

70 Mario Melzer: Mario Melzer (police officer) in conversation with the author, September 2021.

70 enlisted fascist skinheads: Jörg Arnold (researcher at the Max-Planck-Institut für ausländisches öffentliches Recht) in conversation with the author, June 2022.

71 blood gushing from his head: Jana Simon, "Es geschah an einem Montag," *Die Zeit*, June 13, 2013.

72 "Our grandfathers were not criminals": "Protokoll 357. Verhandlungstag—6. April 2017," NSU Watch, April 6, 2017.

73 "unlikable": Staatsanwaltschaft Gera, *Sachakte Band I: Verfahren 114 Js 20864/96* (Prosecution files, Gera, 1996), 8.

Chapter 6. Bombs over Jena

74 a Jena department store: Kai Mudra, "Rohrbomben, Sprengstoff, gefährliche Briefe," *Thüringer Allgemeine*, June 10, 2013.

74 the chest of a mannequin: Thüringer Landtag, *Bericht des Untersuchungsausschusses 5/1 "Rechtsterrorismus und Behördenhandeln"* (Committee report, Erfurt, 2014), 1857.

74 hung from a highway overpass: Thüringer Landtag, *Bericht des Untersuchungsausschusses 5/1*, 595, 1405–6.

75 Prosecutors eventually charged Böhnhardt: Gerhard Schäfer et al., *Gutachten zum Verhalten der Thüringer Behörden und Staatsanwaltschaften bei der Verfolgung des "Zwickauer Trios,"* Freistaat Thüringen, 32–33, 47, 50–53, 64–70, 73.

76 at the Ernst-Abbe sport field: Thüringer Landtag, *Bericht des Untersuchungsausschusses 6/1 "Rechtsterrorismus und Behördenhandeln"* (2019), 764–65.

76 twenty liters of granite chippings: Clemens Binninger et al., *Beschlussempfehlung und Bericht des 3. Untersuchungsausschuss gemäß Artikel 44 des Grundgesetzes*, Deutscher Bundestag, June 23, 2017, pp. 655, 817.

76 "On Day X, it's your turn": Mario Melzer in conversation with the author, September 2021.

77 couldn't control his temper: "Protokoll 128. Verhandlungstag—16. Juli 2014," NSU Watch, July 25, 2014.

78 Beate admitted it was her: "Protokoll 249. Verhandlungtsag—9. Dezember 2015," NSU Watch, December 9, 2015.

78 Böhnhardt was charged: Deutscher Bundestag, *Beschlussempfehlung und Bericht des 2. Untersuchungsausschusses nach Artikel 44 des Grundgesetzes*, August 22, 2013, pp. 80, 115–17.

79 August 17, 1996: Wolf Schmidt, "Die Unfassbare," *Taz*, April 13, 2013.

79 a gap year to volunteer: Thüringer Landtag, "Katharina König-Preuss," 2023.

79 Beit Horim S. Moses: Katharina König (politician, Die Linke) in conversation with the author, 2016–23.

79 a voluntary pilgrimage: Emily Schultheis, "Teaching the Holocaust in Germany as a Resurgent Far Right Questions It," *The Atlantic*, April 10, 2019.

83 Her son's name was printed as a suspect: "Protokoll 58. Verhandlungstag—20. November 2013," NSU Watch, November 27, 2013.

84 police finally made their move: Thüringer Landtag, *Bericht des Untersuchungsausschusses 5/1*, 800.

85 Some of the TNT: Annette Ramelsberger and Tanjev Schultz, "Spruchreif," *Die Zeit*, April 25, 2016.

86 climbed into Ralf Wohlleben's car: Thüringer Landtag, *Bericht des Untersuchungsausschusses 5/1*, 1793.

86 "Dirty Pig Ali We Hate You": "Protokoll 375. Verhandlungstag—25. Juli 2017," NSU Watch, July 25, 2017.

Chapter 7. Refugees Welcome

91 One day in primary school: Gamze Kubaşık in conversation with the author, 2021.

92 through the cotton fields: Michael Ruf, *Die NSU-Monologe*, performed May 20, 2018, at the Heimathafen Neukölln, Berlin.

93 more immigrants than ever before: Vera Hanewinkel and Jochen Oltmer, "Historical and Current Development of Migration to and from Germany," Bundeszentrale für politische Bildung, November, 1, 2018.

93 play volleyball together: "Der NSU-Prozess und die Opfer—Das lange Leiden der Angehörigen—Bayerischer Rundfunk," YouTube, 2018. A webpage (in German) about the documentary is available at br.de/br-fernsehen/programmkalender/sendung-2060776.html.

94 Germans had nearly ended their lives: Katharina König (politician, Die Linke) in conversation with the author, 2016–23.

97 rang Mandy Struck's doorbell: Gerhard Schäfer et al., *Gutachten zum Verhalten der Thüringer Behörden und Staatsanwaltschaften bei der Verfolgung des "Zwickauer Trios,"* Freistaat Thüringen, 116.

97 "White Power Mandy": "Protokoll 105. Verhandlungstag—10. April 2014," NSU Watch, April 19, 2014.

98 "Skinsons": "Das Nazi-Netzwerk hinter dem Terror-Trio," *Panorama*, Das Erste, April 19, 2012.

98 to see a gynecologist: "Protokoll 89. Verhandlungstag—26. Februar 2014," NSU Watch, March 11, 2014.

98 like an "earthquake": "Protokoll 127. Verhandlungstag—15. Juli 2014," NSU Watch, July 23, 2014.

98 donated their own earnings: Bayerischer Rundfunk, "Benefizkonzerte für das untergetauchte Trio," July 16, 2023.

98 "Pogromly": Heike Kleffner, "(K)Eine gespaltene Wahrnehmung: Antisemitismus und der NSU," NSU Watch, September 18, 2018.

99 **agents did offer Brandt a reward:** Schäfer et al., *Gutachten zum Verhalten der Thüringer Behörden*, 182.

100 **he and seventeen fellow THS members:** Petra Pau et al., "Südafrika-Reise von 17 deutschen Neonazis und eines V-Mannes aus dem Umfeld des NSU im Oktober 1999," Deutscher Bundestag, September 18, 2014.

100 **Intelligence agents squandered:** Thüringer Landtag, *Bericht des Untersuchungsausschusses 5/1 "Rechtsterrorismus und Behördenhandeln"* (Committee report, Erfurt, 2014), 227–28, 528, 533, 1030, 1793.

101 **Six p.m. was closing time:** Deutscher Bundestag, *Beschlussempfehlung und Bericht des 2. Untersuchungsausschusses nach Artikel 44 des Grundgesetzes*, August 22, 2013, pp. 72, 715.

101 **A sixteen-year-old boy:** Thomas Moser, "Die Raubüberfälle des NSU," Telepolis, November 2, 2016.

101 **Several months later:** "Protokoll 265. Verhandlungstag—25. Februar 2016," NSU Watch, February 25, 2016.

102 **a three-inch strand of hair:** Thomas Moser, "NSU-Prozess: Die vergessenen Opfer der Banküberfälle," Deutschlandfunk, August 3, 2015.

Chapter 8. "The Bangs"

103 **thirty-seven intelligence-gathering attempts:** Gerhard Schäfer et al., *Gutachten zum Verhalten der Thüringer Behörden und Staatsanwaltschaften bei der Verfolgung des "Zwickauer Trios,"* Freistaat Thüringen, 91, 102–3, 113–14, 217.

105 **Officers sensed an opportunity:** "Protokoll 69. Verhandlungstag—18. Dezember 2013," NSU Watch, December 27, 2013.

105 **Walther had been talking:** "Protokoll 98. Verhandlungstag—26. März 2014," NSU Watch, April 8, 2014.

106 **The last time Siegfried:** Tom Sundermann, "Als Siegfried Mundlos seinen Sohn verlor," *Zeit Online*, December 19, 2013.

107 **Brigitte was relieved:** "Protokoll 57. Verhandlungstag—19. November 2013," NSU Watch, November 22, 2013.

108 **"On February 8, 1998":** Stefan Aust and Helmar Büchel, "NSU-Morde; Der V-Mann mit 'Bums,'" *Welt*, June 27, 2019.

108 **"what about the bangs?":** Clemens Binninger et al., *Beschlussempfehlung und Bericht des 3. Untersuchungsausschuss gemäß Artikel 44 des Grundgesetzes*, Deutscher Bundestag, June 23, 2017, p. 1169.

108 **Werner and his girlfriend, Antje Probst:** Thüringer Landtag, *Bericht des Untersuchungsausschusses 5/1 "Rechtsterrorismus und Behördenhandeln"* (Committee report, Erfurt, 2014), 1161–64.

109 **Years later, many would wonder:** Binninger et al., *Beschlussempfehlung und Bericht*, 305.

109 **Meyer-Plath would claim:** Gordian Meyer-Plath (former OPC handler and politician) in conversation with the author, June 2016.

109 **Meyer-Plath would claim not to remember:** "Protokoll 199. Verhandlungstag—22. April 2015," NSU Watch, April 22, 2015.

110 **finally decommissioned their mole:** "V-Mann Porträt: Carsten Szczepanksi," NSU Watch, February 23, 2015.

110 Born in New Delhi: Özlem Topçu, "Der Fehler des Carsten S.," *Zeit Online*, April 11, 2013.

110 breaking into Beate's apartment: Deutscher Bundestag, *Beschlussempfehlung und Bericht des 2. Untersuchungsausschusses nach Artikel 44 des Grundgesetzes*, August 22, 2013, p. 346.

110 Wohlleben told him: "Protokoll 5. Verhandlungstag—4. Juni 2013," NSU Watch, June 5, 2013.

110 Schultze followed his instructions: "Protokoll 8. Verhandlungstag—11. Juni 2013," NSU Watch, June 12, 2013.

110 an apartment rented: Maik Baumgärtner and Julia Jüttner, "Wir brauchen viel Geld und einen Videorecorder," *Spiegel Panorama*, December 21, 2012.

110 "all cops are bastards": "Protokoll 13. Verhandlungstag—20. Juni 2013," NSU Watch, June 21, 2013.

110 an abandoned building: "Protokoll 6. Verhandlungstag—5. Juni 2013," NSU Watch, June 7, 2013; "Protokoll 8. Verhandlungstag—11. Juni 2013," NSU Watch, June 12, 2013.

110 serial number 034678: Baumgärtner and Jüttner, "Wir brauchen viel Geld und einen Videorecorder."

111 off the highway into Chemnitz: "Protokoll 78. Verhandlungstag—23. Januar 2014," NSU Watch, January 30, 2014.

Chapter 9. Flowers for the Dead

112 Semiya Şimşek heard a voice: Semiya Şimşek, *Schmerzliche Heimat* (Berlin: Rowohlt, 2013).

112 "I felt how happy he was": *Deutscher Bundestag, Beschlussempfehlung und Bericht des 2. Untersuchungsausschusses nach Artikel 44 des Grundgesetzes*, August 22, 2013, pp. 62–63.

113 she married Enver: Birgit Mair, *Die Opfer des NSU und die Aufarbeitung der Verbrechen—Begleitband zur Wanderausstellung*, Institut für sozialwissenschaftliche Forschung, Bildung and Beratung e.V. (ISFBB), 2021.

113 Adile brought Enver back to Germany: Barbara John, *Unsere Wunden kann die Zeit nicht heilen: Was der NSU-Terror für die Opfer und Angehörigen bedeutet* (Freiburg im Breisgau: Herder, 2014), 31–39.

113 Enver worked: Niklas Prenzel, "Am Anschlag," *Fluter*, June 29, 2020, www.fluter.de /nsu-opfer-werden-zu-taetern-gemacht.

113 started a business of his own: Stefan Wirner, "Interview: Peter Schwarz zu NSU Morden," Bundeszentrale für politische Bildung, April 19, 2013, www.bpb.de/gesellschaft /medien-und-sport/lokaljournalismus/158404/interview-peter-schwarz-zu-nsu-morden.

114 a Mercedes van: Deutscher Bundestag, *Beschlussempfehlung und Bericht des 2. Untersuchungsausschusses nach Artikel 44 des Grundgesetzes*, August 22, 2013, p. 491.

115 destroyed by bullets: Ina Krauß, "Der Schmerz von Abdulkerim Simsek," Deutschlandfunk, January 13, 2018.

116 "Over the years": Semiya Şimşek *Schmerzliche Heimat* (Berlin: Rowohlt, 2013).

117 "in case I was next": Michael Ruf, *Die NSU-Monologe*, performed May 20, 2018, at the Heimathafen Neukölln, Berlin.

117 racial profiling: Vanessa Eileen Thompson, "'Racial Profiling,' institutioneller Rassismus und Interventionsmöglichkeiten," Bundeszentrale für politische Bildung, April 27, 2020.

117 "the focus was definitely on organized crime": Deutscher Bundestag, *Beschlussempfehlung und Bericht des 2. Untersuchungsausschusses*, 496.

118 police found her there: Semiya Şimşek, *Schmerzliche Heimat*.

119 "grew up from one day to the next": John, *Unsere Wunden kann die Zeit nicht heilen*.

119 Officers wiretapped: Elke Graßer-Reitzner, "Sohn von NSU-Opfer Simsek: 'Kein Vertrauen mehr in diesen Staat,'" *Nordbayern*, September 5, 2020.

119 For *ten months*: Krauß, "Der Schmerz von Abdulkerim Simsek."

Chapter 10. Dead of Summer

120 an Iranian-owned grocery store: Barbara John, *Unsere Wunden kann die Zeit nicht heilen: Was der NSU-Terror für die Opfer und Angehörigen bedeutet* (Freiburg im Breisgau: Herder, 2014), 37.

120 a festive red tin: Clemens Binninger et al., *Beschlussempfehlung und Bericht des 3. Untersuchungsausschuss gemäß Artikel 44 des Grundgesetzes*, Deutscher Bundestag, June 23, 2017, pp. 747–48.

121 a tattoo artist: Wolf Schmidt, "Die Unfassbare," *Taz*, April 13, 2013.

121 Beate would cook: Bayerischer Rundfunk, "60. Verhandlungtag, 26.11.2013."

121 two children overheard: Peter Gärtner, "Auf den Spuren in Winzerla," *Weser Kurier*, December 9, 2015.

121 André Eminger: Andreas Förster, "André E.: Das Hakenkreuz ist eintätowiert," *Stuttgarter Zeitung*, May 5, 2013.

122 Mundlos usually kept watch: Gisela Friedrichsen, *Der Prozess: Der Staat gegen Beate Zschäpe* (Munich: Penguin Verlag, 2019), 214–15.

122 November 30, 2000: Oberlandesgericht München, *Aktenzeichen 6 St 3/12: In Namen des Volkes*, April 21, 2020, https://media.frag-den-staat.de/files/docs/08/c0/70/08c0 7057298e4f90a50504b68253ae8d/nsu-urteil.pdf.

122 an even more sinister purpose: Christian Fuchs and Daniel Müller, "Die weißen Brüder," *Zeit Online*, April 11, 2013.

122 a city of immigrants: Stadt Köln, *Konzept zur Stärkung der integrativen Stadtgesellschaft Zukunft gestalten*, 29.

122 the force of the explosion: Binninger et al., *Beschlussempfehlung und Bericht des 3. Untersuchungsausschuss*, 748–53.

123 prosecutors closed the case, unsolved: Thüringer Landtag, *Bericht des Untersuchungsausschusses 6/1 "Rechtsterrorismus und Behördenhandeln"* (2019), 1214.

123 Abdurrahim Özüdoğru: John, *Unsere Wunden kann die Zeit nicht heilen*, 45.

123 a tailor shop: Allianz Gegen Rechtsextremismus, "Im Gedenken an Adburahim Özüdoğru," August 22, 2021, www.allianz-gegen-rechtsextremismus.de/aktuelles /aktionen/der-jahre/gedenken-an.

123 daughter named Tülin: Deutscher Bundestag, *Beschlussempfehlung und Bericht des 2. Untersuchungsausschusses nach Artikel 44 des Grundgesetzes*, August 22, 2013, pp. 491–92, 729–30.

124 shot twice in the head: "Protokoll 28. Verhandlungtag—25. Juli 2013," NSU Watch, July 27, 2013.

124 searched Abdurrahim's apartment: Amadeu Antonio Stiftung, "Abdurrahim Özüdoğru," June 13, 2001.

125 Born in Istanbul: Benjamin Laufer, "Die Ermittlungen waren rassistisch," *Hinz &*
 Kunzt, June 18, 2021.
125 His friends called him Sülo: John, *Unsere Wunden kann die Zeit nicht heilen*, 54–56.
126 "Son, did you spill something here?": "Protokoll 37. Verhandlungstag—23. Sept
 2013," NSU Watch, September 24, 2013.
128 used Ayşen as an interpreter: Deutscher Bundestag, *Beschlussempfehlung und Bericht*
 des 2. Untersuchungsausschusses, 492, 499, 733, 939.
128 Police even posed as journalists: Jana Simon, "Das zweite Trauma," *Zeit Online*,
 November 22, 2012.
129 she married him: "Unvergessen: Die zehn NSU-Opfer," Merkur.de, July 12,
 2018.
129 fired two shots: "Protokoll 30. Verhandlungstag—31. Juli 2013," NSU Watch,
 August 2, 2013.
130 professional hit men: "Protokoll 22. Verhandlungstag—11. Juli 2013," NSU Watch,
 July 13, 2013.

Chapter 11. Twenty-First-Century Terror

132 "stupid immigrant": Gamze Kubaşık in conversation with the author, 2021.
132 "he had a very close relationship": Antonia von der Behrens (Hrsg.), *Kein Schluss-*
 wort: Nazi-Terror, Sicherheitsbehörden, Unterstützernetzwerk; Plädoyers im NSU-
 Prozess (Hamburg: VSA, 2019).
133 "Your father is so great": Clemens Binninger et al., *Beschlussempfehlung und Bericht*
 des 3. Untersuchungsausschuss gemäß Artikel 44 des Grundgesetzes, Deutscher Bund-
 estag, June 23, 2017, p. 1210.
133 "Everyone, whether small or big": "Zusammenfassung des 389. Verhandlungstag—
 21. November 2017," NSU Watch, November 21, 2017.
133 suffered a stroke: "Protokoll 51. Verhandlungstag—5. November 2013," NSU
 Watch, November 8, 2013.
133 dual citizenship law: European Union CORDIS, "Dual Citizenship Recognition
 and Equal Rights in Germany," 2016.
134 too many immigrants living in Germany: Oya S. Abalı, "German Public Opinion
 on Immigration and Integration," Transatlantic Council on Migration, May 2009.
134 economists worried there were too *few*: W. W. Rostow, "The Economics of a Stag-
 nant Population," in *Frontiers of Development Economics: The Future in Perspective*,
 ed. Gerald M. Meier and Joseph E Stiglitz (Washington, DC: World Bank/Oxford
 University Press, 2000), 122.
134 Europe's largest economy: World Bank, Data, "GDP (current US$)—European
 Union," accessed September 7, 2023.
134 Germany's birthrate: Veysel Oezcan, "Germany: Immigration in Transition,"
 Migration Policy Institute, July 1, 2004.
134 planes had crashed in New York City: Katharina König (politician, Die Linke) in
 conversation with the author, 2016–23.
134 bad-mouthing Muslims: Semiya Şimşek, *Schmerzliche Heimat* (Berlin: Rowohlt,
 2013), 160.

135 "an aging society": "La campagne anti-immigration de la CDU ne plaît guère à Angela Merkel," *La Croix*, April 5, 2000.

135 made it easier to deport foreigners: Dominik Bender, "'Verpolizeilichung' des Ausländerrechts?—Die ausländerrechtlichen Maßnahmen des Gesetzgebers nach dem 11. September 2001," *Kritische Justiz* 36, no. 2 (2003): 130–45.

136 a 2002 survey: Harald Welzer, *Grandpa Wasn't a Nazi: The Holocaust in German Family Remembrance*, American Jewish Committee, 2005.

136 he was beaten badly: Broschüregruppe (Hrsg.), ... *Nicht vom Himmel gefallen: Rechtsextremismus in Jena*, 2001.

136 In January 2001: Thüringer Landtag, "Kleine Anfrage des Abgeordneten Dittes (PDS) und Antwort des Thüringer Innenministeriums Rechtsextremismus und Sprengstofffunde," February 26, 2001.

137 because the FBI and the CIA: Center for Public Integrity, "Agencies Failed to Share Intelligence on 9/11 Terrorists," December 10, 2008.

137 9/11 was a wake-up call: Gordian Meyer-Plath (former OPC handler and politician) in conversation with the author, June 2016.

138 Meyer-Plath returned from Bonn to Brandenburg: Binninger et al., *Beschlussempfehlung und Bericht*, 40–43.

138 would nearly double: Bernadette Droste, *Handbuch des Verfassungsschutzrechts* (Stuttgart: Boorberg, 2007), 735–37.

138 ban the NPD: Marc Engelhart, "The National Socialist Underground (NSU) Case: Structural Reform of Intelligence Agencies' Involvement in Criminal Investigations?," in *Privacy and Power: A Transatlantic Dialogue in the Shadow of the NSA-Affair*, ed. R. Miller (Cambridge: Cambridge University Press, 2017), 382–83.

138 rejected the ban: "Warum das NPD-Verbotsverfahren scheiterte," *Süddeutsche Zeitung*, January 24, 2005.

138 "The secret service believed": Volker Eick, political scientist studying far-right extremism, in conversation with the author, May 23, 2016.

139 a video manifesto: "Plädoyer der Bundesanwaltschaft 3. Tag: vollständige Mitschrift," Nebenklage NSU Prozess, July 17, 2017, www.nsu-nebenklage.de/blog/2017/07/27/27-07-2017-protokoll/.

139 National Socialist Underground: "Protokoll 249. Verhandlungstag—9. Dezember 2015," NSU Watch, December 9, 2015.

139 "victory or death": Thomas Heise et al., "In der Parallelwelt," *Der Spiegel*, August 2012.

139 thanked the NSU: "'Vielen Dank an den NSU': Was wusste der 'Weisse Wolf'?," NSU Watch, March 28, 2012.

139 the NSU operated with the help of: Heike Kleffner, "Keine gespaltene Wahrnehmung: Antisemitismus und der NSU," NSU Watch, September 18, 2018; Binninger et al., *Beschlussempfehlung und Bericht des 3. Untersuchungsausschuss*, 1166.

139 All the money they'd stolen: Maik Baumgärtner and Jörg Diehl, "Die verschwundene Beute des NSU," *Spiegel Panorama*, April 24, 2014.

140 10,000 deutsche marks: "Protokoll 7. Verhandlungstag—6. Juni 2013," NSU Watch, June 7, 2013.

140 in Gerlach's presence: "Protokoll 23. Verhandlungstag—16. Juli 2013." NSU Watch, July 18, 2013.

140 decided to rob a bank: Deutscher Bundestag, *Beschlussempfehlung und Bericht des 2. Untersuchungsausschusses nach Artikel 44 des Grundgesetzes*, August 22, 2013, pp. 72, 394–95, 670, 689.

140 statute of limitations: Matthias Quent, *Rassismus, Radikalisierung, Rechtsterrorismus*, 3rd ed. (Weinheim: Beltz Juventa, 2022).

140 the only crime: Author's correspondence with the Office of the Federal Prosecutor in Karlsruhe, 2022.

141 In September 2003: Frank Jansen, "Letzte Revision gegen NSU-Urteil: Neonazi André E. muss um seine Freiheit bangen," *Tagesspiegel*, December 2, 2021.

Chapter 12. The Bomb on the Bike

142 under Holger Gerlach's name: Oberlandesgericht München, "Der 6. Strafsenat—Staatsschutzsenat—des Oberlandesgerichts München erlässt in dem Strafverfahren gegen" (Urteil), April 21, 2020, 140–42.

142 Mr. Kebab Grill: Tanjev Schultz, "Waffen-Narr als Zeuge," *Süddeutsche Zeitung*, August 1, 2013.

142 "You're not even German": Links Fraktion, "Die Dimension des NSU in Mecklenburg-Vorpommern," 2018.

142 Mehmet Turgut: Barbara John, *Unsere Wunden kann die Zeit nicht heilen: Was der NSU-Terror für die Opfer und Angehörigen bedeutet* (Freiburg im Breisgau: Herder, 2014), 72–75.

143 the Turguts had fled: Clemens Binninger et al., *Beschlussempfehlung und Bericht des 3. Untersuchungsausschuss gemäß Artikel 44 des Grundgesetzes*, Deutscher Bundestag, June 23, 2017, pp. 492, 594, 809, 845, 1308.

143 Hearing no response: "Protokoll 49. Verhandlungstag—23. Oktober 2013," NSU Watch, October 27, 2013.

143 a torrent of blood: "Protokoll 32. Verhandlungstag—6. Aug. 2013," NSU Watch, August 9, 2013.

144 "We're flying on vacation": Gamze Kubaşık in conversation with the author, 2021.

145 "But I can't just sit around": Michael Ruf, *Die NSU-Monologe*, performed May 20, 2018, at the Heimathafen Neukölln, Berlin.

145 In June 2004: Sven Wolf, *Schlussbericht des Parlamentarischen Untersuchungsausschusses III* (Committee report, Düsseldorf, 2017), 427.

146 Turkish and Kurdish storefronts: Annette Ramelsberger, Tanjev Schultz, and Rainer Stadler, "'Bitte schön, was sollen die Mätzchen!,'" *Süddeutsche Zeitung Magazin*, January 11, 2016.

146 249 euros: Deutscher Bundestag, *Beschlussempfehlung und Bericht des 2. Untersuchungsausschusses nach Artikel 44 des Grundgesetzes*, August 22, 2013, pp. 670, 672–73, 689.

146 seven hundred carpenter's nails: "Protokoll 173. Verhandlungstag—12. Januar 2015," NSU Watch, January 12, 2015.

147 locked eyes with a barber: Martin Block, *Der Kuaför aus der Keupstraße: Hintergrundmaterial für die Schule und die außerschulische Bildungsarbeit* (2016), 7.

148 Sandro D'Alauro: Karin Truscheit, "Damit das alles einen Sinn ergibt," *Frankfurter Allgemeine Zeitung*, March 15, 2015.

148 He didn't hear a sound: Ramelsberger, Schultz, and Stadler, "'Bitte schön, was sollen die Mätzchen!'"

148 Another victim felt: "Protokoll 175. Verhandlungstag—20. Januar 2015," NSU Watch, January 20, 2015.

149 Köhler had been a far-right extremist: Annette Ramelsberger, "Bundesanwaltschaft stellt Ermittlungen zum Oktoberfestattentat ein," *Süddeutsche Zeitung*, July 7, 2020.

149 "In certain circles": Deutscher Bundestag, *Beschlussempfehlung und Bericht des 2. Untersuchungsausschusses*, 892–991.

150 20,000-euro reward: Esther Dischereit, "NSU-Opfer unter Verdacht," Deutschlandfunk Kultur, April 18, 2013.

151 the camera caught a glimpse: Thorsten Moeck and Axel Spilcker, "Vierzig Minuten vor dem Anschlag gefilmt," *Kölner Stadt-Anzeiger*, June 2004.

Chapter 13. "Turkish Mafia Strikes Again"

152 a Cologne newspaper: Philipp J. Meckert, "Ein Jahr danach," *Cologne Express*, June 8, 2005.

152 two cyclists dressed in black: Deutscher Bundestag, *Beschlussempfehlung und Bericht des 2. Untersuchungsausschusses nach Artikel 44 des Grundgesetzes*, August 22, 2013, p. 493.

152 Ismail Yaşar: Lena Kempf and Michael Streck, "Frau Yaşar im Land der Mörder," *Stern*, September 12, 2013, 74–85.

152 a kebab stand: "Protokoll 132. Verhandlungstag—30. Juli 2014," NSU Watch, August 5, 2014.

152 give the children free ice cream: "Protokoll 48. Verhandlungstag—22. Oktober 2013," NSU Watch, October 25, 2013.

153 His flight to Turkey: Barbara John, *Unsere Wunden kann die Zeit nicht heilen: Was der NSU-Terror für die Opfer und Angehörigen bedeutet* (Freiburg im Breisgau: Herder, 2014).

154 265 euros: "Protokoll 50. Verhandlungstag—24. Oktober 2013," NSU Watch, October 29, 2013.

155 "highly taboo": "Protokoll 32. Verhandlungstag—6. Aug. 2013," NSU Watch, August 9, 2013.

155 "Kebab Killings": Niklas Prenzel, "Am Anschlag," *Fluter*, June 29, 2020, www.fluter .de/nsu-opfer-werden-zu-taetern-gemacht.

155 "It was careless:" Semiya Şimşek, *Schmerzliche Heimat* (Berlin: Rowohlt, 2013).

155 A 1996 poll: R. Alba and M. Johnson, "Zur Messung aktueller Einstellungsmuster gegenüber Ausländern in Deutschland," in *Blickpunkt Gesellschaft, Bd.5. Deutsche und Ausländer: Freunde, Fremde oder Feinde? Empirische Befunde und theoretische Erklärungen*, ed. R. Alba, P. Schmidt, and M. Wasmer (Wiesbaden: Springer Fachmedien, 2000), 229–53.

156 just 22 percent: Bundesrepublik Deutschland, *Polizeiliche Kriminalstatistik 1996*, 76, 114.

156 Theodoros Boulgarides: John, *Unsere Wunden kann die Zeit nicht heilen*.

156 **vibrant Greek immigrant community:** "Protokoll 38. Verhandlungstag—24. Sept 2013," NSU Watch, September 25, 2013.

157 **The officers lied repeatedly:** Yvonne and Mandy Boulgarides in conversation with the author, June 7, 2016.

157 **officially terminated:** "Protokoll 46. Verhandlungstag—15. Oktober 2013," NSU Watch, October 21, 2013.

158 **"Turkish Mafia Strikes Again":** Armin Lehman, "Die Familien der NSU-Mordopfer: Vom langen Weg zurück in die Gesellschaft," *Tagesspiegel*, February 19, 2012.

158 **102,000 euros in rent:** Maik Baumgärtner and Jörg, "Die verschwundene Beute des NSU," *Der Spiegel*, April 24, 2014.

159 **white supremacist concerts:** Stefan Eilts, Carsten Janz, and Eike Lüthje, "NSU: Schleswig-Holstein als Rückzugsort?," Norddeutscher Rundfunk, April 16, 2013.

159 **Risk and *The Settlers of Catan*:** "Protokoll 313. Verhandlungstag—29. September 2016," NSU Watch, September 29, 2016.

159 **a neighbor named Heike:** Wolf Schmidt, "Die Unfassbare," *Taz*, April 13, 2013.

159 **they'd play Legos:** Christian Fuchs and Daniel Müller, "Die weißen Brüder," *Zeit Online*, April 11, 2013.

159 **Susann knew about the robberies:** "Protokoll 313. Verhandlungstag—29. September 2016," NSU Watch, September 29, 2016.

160 **André fell off a roof:** "'Ich trank den Alkohol heimlich,'" *Der Spiegel*, January 21, 2016.

160 **Heaven and Hell:** Stefan Aust, Helmar Büchel, and Dirk Laabs, "Protokolle? Unter Verschluss. Ergebnisse? Geheim," *Welt*, April 17, 2016.

Chapter 14. A Death in Dortmund, a Killing in Kassel

161 **task force Bosporus:** "Protokoll 46. Verhandlungstag—15. Oktober 2013," NSU Watch, October 21, 2013.

161 **"Have you ever seen":** "Protokoll 22. Verhandlungstag—11. Juli 2013," NSU Watch, July 13, 2013.

161 **vehemently oppose immigrants:** Thomas F. Pettigrew et al, "Recent Advances in Intergroup Contact Theory, *International Journal of Intercultural Relations* 35, issue 3 (2011): 271–80; Thomas F. Pettigrew, "In Pursuit of Three Theories: Authoritarianism, Relative Deprivation, and Intergroup Contact," *Annual Review of Psychology* 67 (2016).

161 **the multicultural west:** Bildungsbericht, *Migration*, 2006, www.bildungsbericht.de /de/bildungsberichte-seit-2006/bildungsbericht-2006/pdf-bildungsbericht-2006 /h-web.pdf, p. 140.

162 **Dortmund's unemployment:** City of Dortmund, "URBAN II Evaluation, Case Study: Dortmund 2005–2008," 2008.

162 **"National Liberated Zone":** Bundeszentrale für politische Bildung, "National befreite Zone," October 4, 2022.

162 **Gamze awoke:** Gamze Kubaşık in conversation with the author, 2021.

162 **The first bullet missed:** Clemens Binninger et al., *Beschlussempfehlung und Bericht des 3. Untersuchungsausschuss gemäß Artikel 44 des Grundgesetzes*, Deutscher Bundestag, June 23, 2017, pp. 830, 845–46, 1210.

164 *Did your father take drugs?*: Deutscher Bundestag, *Beschlussempfehlung und Bericht des 2. Untersuchungsausschusses nach Artikel 44 des Grundgesetzes*, August 22, 2013, p. 63.

164 with the PKK: Andrea Grunau, "A Daughter Demands Justice," Deutsche Welle, April 4, 2013.

166 "Isn't that the daughter": Ali Şirin, "'Ich möchte dass man meinen Vater niemals vergisst,'" *Lotta Magazin*, February 9, 2021.

166 Twice they searched the kiosk: "Protokoll 57. Verhandlungstag—19. November 2013," NSU Watch, November 22, 2013.

166 the family's honor: Antonia von der Behrens (Hrsg.), *Kein Schlusswort: Nazi-Terror, Sicherheitsbehörden, Unterstützernetzwerk; Plädoyers im NSU-Prozess* (Hamburg: VSA, 2019).

166 police hadn't bothered: Michael Ruf, *Die NSU-Monologe*, performed May 20, 2018, at the Heimathafen Neukölln, Berlin.

166 Elif struggled to sleep: Von der Behrens, *Kein Schlusswort*.

167 Halit Yozgat: "Protokoll 41. Verhandlungstag—1. Oktober 2013," NSU Watch, October 14, 2013.

167 "so tiny and small": Barbara John, *Unsere Wunden kann die Zeit nicht heilen: Was der NSU-Terror für die Opfer und Angehörigen bedeutet* (Freiburg im Breisgau: Herder, 2014).

167 until he turned eighteen: Informations- und Dokumentationszentrum für Antirassismusarbeit, "Die NSU-Mordserie," October 20, 2022, www.idaev.de/fachstellen-projekte/projekt-dimensionen/die-nsu-mordserie.

168 an internet café: Deutscher Bundestag, *Beschlussempfehlung und Bericht des 2. Untersuchungsausschusses*, August 22, 2013, 495–96, 533.

168 didn't want his presence to be known: Forensic Architecture, "77sqm_9:26min," Goldsmiths University of London, July 18, 2017, pp. 11–17.

169 They swabbed him: Özlem Topçu, "Er starb in meinen Armen,'" *Zeit Online*, October 11, 2012.

169 Newspapers in both Germany and Turkey: Topçu, "Er starb in meinen Armen.'"

170 Would the Kubaşıks come, too?: Şirin, "Ich möchte dass man meinen Vater miemals vergisst."

170 "How can it be": Ruf, *Die NSU-Monologe*.

170 "No 10th Victim": Semiya Şimşek, *Schmerzliche Heimat* (Berlin: Rowohlt, 2013).

171 "hindsight bias": Dr. Tatjana Hörnle, director of the Max Planck Institute for the Study of Crime, Security and Law in Freiburg, in conversation with the author, June 2022.

174 Gülay Köppen: Alexandra Gehrhardt, "NSU-Ausschuss lädt Staatsschützerin und Waffenexperten," *Ruhrbarone*, March 18, 2016.

174 "Silent Vigil, Loud Reminder": Miriam Bunjes, "Stille Trauer, laute Mahnung," *Taz*, June 13, 2006.

Chapter 15. Dead Men and Homeless Cats

175 Would she shoot herself: "Protokoll 271. Verhandlungstag—16. März 2015," NSU Watch, March 16, 2016.

175 "Are you crazy?" "Protokoll 261. Verhandlungstag—17. Februar 2016," NSU Watch, February 17, 2016.

176 a classified memo: U.S. Department of Justice, Federal Bureau of Investigation, Memo to the Munich Police Department, Bavaria, Germany, June 15, 2007. Obtained by the author.

177 Michèle Kiesewetter: Deutscher Bundestag, *Beschlussempfehlung und Bericht des 2. Untersuchungsausschusses nach Artikel 44 des Grundgesetzes*, August 22, 2013, pp. 639–48.

177 town of Oberweissbach: Exif Recherche & Analyse, "Hammerskins im NSU-Komplex," July 2021.

177 become a police officer: Barbara John, *Unsere Wunden kann die Zeit nicht heilen: Was der NSU-Terror für die Opfer und Angehörigen bedeutet* (Freiburg im Breisgau: Herder, 2014).

178 Heckler & Koch pistols: Sebastian Leber, "Unzureichende Aufklärung der NSU-Morde: Das Desaster der offenen DNA-Spuren," *Correctiv*, June 28, 2021.

179 one Roma suspect: "Institutional Racism as Exemplified by the Case of the Terror Group 'National Socialist Underground' (NSU)," Parallel Report on the 19th–22nd Report Submitted by the Federal Republic of Germany to the UN Committee on the Elimination of Racial Discrimination, April 7, 2015.

179 "too many foreigners": Oya S. Abalı, "German Public Opinion on Immigration and Integration," Transatlantic Council on Migration, May 2009.

179 xenophobic beliefs: Andreas Zick and Beate Küpper, "Die geforderte Mitte. Rechtsextreme und demokratiegefährdende Einstellungen in Deutschland," Friedrich-Ebert-Stiftung, 2021.

179 black eyes and leaving deep gashes: Danylow Hawaleshka, "Germany's Summer of Hate," *Maclean's*, October 15, 2007.

179 a mob of Germans chanted: "Ausländer in Wismar angegriffen," *Der Spiegel*, September 23, 2007.

179 attacked four immigrants: "Betrunkener bedroht Nigerianerin," *Der Spiegel*, December 4, 2007.

180 Frühlingsstrasse 26: Bundeskriminalamt, "Ermittlungsverfahren des Generalbundesanwaltes beim Bundesgerichtshof: Aktenzeichen 2 BJs 162/11-2" (Police report, Meckenheim, 2012), 8.

180 Footage showed: Zeitpunktplus, "NSU: So lebten Zschäpe, Böhnhardt und Mundlos nach 10 Morden ungestört in Zwickau," YouTube, November 26, 2014.

180 retrieve their bicycles: Tim Aßmann, Holger Schmidt, Eckhart Querner, and Gunnar Breske, "60. Verhandlungstag, 26.11.2013," Bayerischer Rundfunk, April 28, 2014.

180 drink more heavily: "Protokoll 249. Verhandlungstag—9. Dezember 2015," NSU Watch, December 9, 2015.

181 Anders Breivik: Åsne Seierstad, *One of Us: The Story of Anders Breivik and the Massacre in Norway* (London: Virago, 2015).

181 "civil war due to Muslim immigration": Mark Townsend and Ian Traynor, "Norway Attacks: How Far Right Views Created Anders Behring Breivik," *The Guardian*, July 30, 2011.

182 setting up for the summer: Wolf Schmidt, "Die Unfassbare," *Taz*, April 13, 2013.

182 They introduced themselves: "Protokoll 60. Verhandlungstag—26. November 2013," NSU Watch, November 29, 2013.

182 windsurfing: Frank Jansenm, "Wie die Neonazi-Mörder ahnungslose Camper täuschten," *Tagesspiegel*, November 26, 2013.

183 workout video: Stefan Eilts, Carsten Janz, and Eike Lüthje, "NSU: Schleswig-Holstein als Rückzugsort?," Norddeutscher Rundfunk, April 16, 2013.

183 never came back: Eva-Maria Meste, "Prozess um Tod zweier Kinder beginnt," *Hamburger Abendblatt*, January 17, 2012.

183 "system checks": "Protokoll 7. Verhandlungstag—6. Juni 2013," NSU Watch, June 7, 2013.

184 Stralsund: "NSU-Prozess: Zschäpe will umfassend aussagen," *Der Standard*, November 9, 2015.

184 Arnstadt: Clemens Binninger et al., *Beschlussempfehlung und Bericht des 3. Untersuchungsausschuss gemäß Artikel 44 des Grundgesetzes*, Deutscher Bundestag, June 23, 2017, pp. 128, 134, 136, 139–45, 164, 185, 207–8, 231–59, 713, 1032.

185 the movie *Scream*: "Protokoll 113. Verhandlungstag—20. Mai 2014," NSU Watch, May 25, 2014.

185 grabbed an older woman: Maik Baumgärtner and Marcus Böttcher, *Das Zwickauer Terror-Trio: Ereignisse, Szene, Hintergründe* (Berlin: Das Neue Berlin, 2012), 19.

186 Beate was buzzed: "'Ich trank den Alkohol heimlich,'" *Der Spiegel*, January 21, 2016.

187 the music had stopped: Julia Jüttner, "Zschäpe, die Brandstifterin," *Der Spiegel*, June 7, 2018.

187 set off down the street: Gisela Friedrichsen, *Der Prozess: Der Staat gegen Beate Zschäpe* (Munich: Penguin Verlag, 2019), 80.

Chapter 16. The Confetti Cover-up

191 a telephone interrupted: Gisela Friedrichsen, *Der Prozess: Der Staat gegen Beate Zschäpe* (Munich: Penguin Verlag, 2019), 105, 117–18.

191 "This is Beate": "Protokoll 58. Verhandlungstag—20. November 2013," NSU Watch, November 27, 2013.

192 "Susann Dienelt": Clemens Binninger et al., *Beschlussempfehlung und Bericht des 3. Untersuchungsausschuss gemäß Artikel 44 des Grundgesetzes*, Deutscher Bundestag, June 23, 2017, pp. 185–89, 214–22, 259.

192 a nationwide alert: Wolf Schmidt, "Die Unfassbare," *Taz*, April 13, 2013.

192 vaccination records: Exif Recherche & Analyse, "Hammerskins im NSU-Komplex," July 2021.

193 radio frequencies: Maximilian Bülau et al., "The Yozgat Case: The Long Search for Answers," HNA, 2020, available at www.documentcloud.org/documents/24120194 -the-yozgat-case_-the-long-search-for-answers?responsive=1&title=1.

193 a copy of *The Turner Diaries*: Deutscher Bundestag, "Schriftliche Fragen, 16. Wahlperiode, Drucksache 16/4329, Abgeordnete Petra Pau (Die Linke)," February 16, 2007, www.petrapau.de/16_bundestag/dok/down/1604329_rechte-medien_07_02 _12.pdf.

193 Winchester pump-action shotgun: Maik Baumgärtner and Marcus Böttcher, *Das Zwickauer Terror-Trio: Ereignisse, Szene, Hintergründe* (Berlin: Das Neue Berlin, 2012).

193 twenty firearms: Deutscher Bundestag, *Beschlussempfehlung und Bericht des 2. Untersuchungsausschusses nach Artikel 44 des Grundgesetzes*, August 22, 2013, p. 919.

193 Česká 83 pistol: "Einstieg NSU: nsuleaks Česká83W04," FDIK, available at www .documentcloud.org/documents/24120197-key-nsu-leaks-ceska-83-and -documents-on-zschaepe-ceska83w04?responsive=1&title=1.

194 the cartoon Mundlos liked: "Uwe Mundlos als Teenager von der RAF fasziniert," *Die Welt*, March 12, 2015.

194 "protection of the fatherland: "Transkript Bekennervideo NSU," NSU Watch.

194 phoned André Eminger: "Protokoll 257. Verhandlungstag—21. Januar 2016," NSU Watch, January 21, 2016.

195 "Good day": Friedrichsen, *Der Prozess*, 151.

195 law office: "Protokoll 173. Verhandlungstag—12. Januar 2015," NSU Watch, January 12, 2015.

195 *This is what we always expected*: Katharina König (politician, Die Linke) in conversation with the author, 2016–23.

195 began studying Judaism: Die Linke Fraktion im Thüringer Landtag, "Katharina König-Preuss: Sprecherin für Migrationspolitik, Antifaschismus und Antirassismus," www.die-linke-thl.de/fraktion/abgeordnete/katharina-koenig/.

195 "Katharina, we need women!": Jan Jirát, "Die Antifa ist unverzichtbar," *WOZ Die Wochenzeitung*, April 20, 2017.

197 "walking antifa Wikipedia": Valerie Schönian, "Angst frisst alles auf," *Zeit Online*, April 30, 2019.

197 One week after the fire: "NSU exklusiv," *Der Spiegel*, January 15, 2012.

197 documents into a shredder: Wolf Schmidt, "Verfassungsschutz feiert Karneval," *Taz*, November 11, 2011.

197 code name Lothar Lingen: Toralf Staud, "Verfassungsschutz muss über Aktenschredderer Auskunft geben," *Zeit Online*, October 13, 2020.

197 operation to recruit far-right informants: "Intelligence Agency Under Fire for Shredding Files," *Der Spiegel*, June 29, 2012.

198 destroyed even more potential evidence: Julia Jüttner, "Sachsens rätselhafte Geheimakten," *Der Spiegel*, July, 11, 2012.

198 Officials swore: Matthias Gebauer, "Innenministerium ordnete Vernichtung weiterer Akten an," *Der Spiegel*, July 19, 2012.

198 an internal investigation: Frag Den Staat, "NSU-Akten gratis! Wir veröffentlichen, was der Verfassungsschutz 120 Jahre geheim halten wollte."

198 Officers arrested Gerlach: Binninger et al., *Beschlussempfehlung und Bericht*, 200–203, 242.

198 aiding a terrorist organization: Deutscher Bundestag, *Beschlussempfehlung und Bericht des 2. Untersuchungsausschusses*, 10–11.

199 When police interrogated André Eminger: Christian Fuchs and Daniel Müller, "Die weißen Brüder," *Zeit Online*, April 11, 2013.

199 video production company: Martin Lejeune, "NSU Trial Defendants," Deutsche Welle, May 5, 2013.

199 "Never forgotten": Friedrichsen, *Der Prozess*, 266.

199 "Well, you terrorist": Exif Recherche & Analyse, "Hammerskins im NSU-Komplex," July 2021.

200 Ten counts of murder: Oberlandesgericht München, "Der 6. Strafsenat—Staatsschutzsenat—des Oberlandesgerichts München erlässt in dem Strafverfahren gegen" (Urteil), April 21, 2020, p. 25.

200 "life sentence": Strafgesetzbuch (StGB) § 57a Aussetzung des Strafrestes bei lebenslanger Freiheitsstrafe, Bundesrepublik Deutschland, Bundesamt für Justiz.

Chapter 17. The Chancellor's Last Chance

202 *Was it just children playing*: Gamze Kubaşık in conversation with the author, 2021.

203 Elif would eventually repay: Ali Şirin, "Ich möchte dass man meinen Vater niemals vergisst," *Lotta Magazin*, February 9, 2021.

204 to a *Kur*: "Protokoll 51. Verhandlungstag—5. November 2013," NSU Watch, November 8, 2013.

204 "Killer Trio Also Responsible": Birgit Mair, *Die Opfer des NSU und die Aufarbeitung der Verbrechen—Begleitband zur Wanderausstellung*, Institut für sozialwissenschaftliche Forschung, Bildung and Beratung e.V. (ISFBB), 2021, p. 103.

205 for a nationally televised ceremony: Clemens Binninger et al., *Beschlussempfehlung und Bericht des 3. Untersuchungsausschuss gemäß Artikel 44 des Grundgesetzes*, Deutscher Bundestag, June 23, 2017.

205 an audience of twelve hundred: Andrea Grunau, "A Daughter Demands Justice," Deutsche Welle, April 4, 2013.

207 "The Turkish poet": Deutscher Bundestag, *Beschlussempfehlung und Bericht des 2. Untersuchungsausschusses nach Artikel 44 des Grundgesetzes*, August 22, 2013, p. 63.

207 the monetary compensation: "973.542,67 Euro für NSU-Opfer," *Taz*, April 9, 2013.

208 *Letting go is impossible*: Barbara John, *Unsere Wunden kann die Zeit nicht heilen: Was der NSU-Terror für die Opfer und Angehörigen bedeutet* (Freiburg im Breisgau: Herder, 2014).

208 a politician from Die Linke: Lena Kempf and Michael Streck, "Frau Yaşar im Land der Mörder," *Stern*, September 12, 2013, 74–85.

Chapter 18. Courtoom 101

209 excluding journalists from Turkey: Frank Jansen, "Akkreditierung für den NSU-Prozess: Eine Sache von Minuten," *Tagesspiegel*, April 9, 2013.

209 Nicole Schneiders: Lena Kampf, "Die Akte Nicole Schneiders," *Stern*, June 1, 2013.

210 Gisela Friedrichsen: Gisela Friedrichsen, *Der Prozess: Der Staat gegen Beate Zschäpe* (Munich: Penguin Verlag, 2019).

210 by professional judges: Felix Hansen and Sebastian Schneider, "Der NSU-Prozess in Zahlen—eine Auswertung," NSU Watch, July 9, 2018.

211 To the left: Bayerischer Rundfunk, "Sitzverteilung im Schwurgerichtssaal A 101," September 18, 2013.

212 Karl-Heinz Statzberger: Martin Bernstein, "Strafbefehl für Neonazi wegen verbotener Demonstration," *Süddeutsche Zeitung*, July 19, 2022.

212 **He sometimes sat:** "Protokoll 287. Verhandlungstag—7. Juni 2016," NSU Watch, June 7, 2016.

212 **not two bombings, but three:** Patrycja Kowalska, "Der vergessene Anschlag des NSU," NSU Watch, June 23, 2019.

212 **Mehmet O.:** "Folge #27 Vor Ort—gegen Rassismus, Antisemitismus und rechte Gewalt. Die Podcastserie von NSU Watch und VBRG e.V.," Verband der Beratungsstellen für Betroffene rechter, rassistischer und antisemitischer Gewalt (VBRG).

213 **Schultze told the court:** "Protokoll 8. Verhandlungstag—11. Juni 2013." NSU Watch, June 12, 2013.

213 **ended in a fistfight:** Katharina König (politician, Die Linke) in conversation with the author, 2016–23.

214 **Pinar Kılıç:** "Protokoll 22. Verhandlungstag—11. Juli 2013," NSU Watch, July 13, 2013.

214 **"What this woman did":** Barbara John, *Unsere Wunden kann die Zeit nicht heilen: Was der NSU-Terror für die Opfer und Angehörigen bedeutet* (Freiburg im Breisgau: Herder, 2014).

215 **Beate toyed with her laptop:** "Protokoll 51. Verhandlungstag—5. November 2013," NSU Watch, November 8, 2013.

215 **"Do not think":** "Die zwei Leben der Familie Kubaşık," *Zeit Online*, November 21, 2017.

215 **was seated too close:** "Protokoll 60. Verhandlungstag—26. November 2013," NSU Watch, November 27, 2013.

216 **Beate's mother:** "Protokoll 61. Verhandlungstag—27. November 2013," NSU Watch, December 3, 2013.

216 **Beate closed her laptop:** Tom Sundermann, "Als sich Böhnhardt und Mundlos in der Kaufhalle kennenlernten," *Zeit Online*, November 27, 2013.

216 **couldn't refuse to testify:** § 48 Strafprozessordnung, § 52 Strafprozessordnung, Bundesrepublik Deutschland, Bundesamt für Justiz.

216 **lost not one son, but two:** "Protokoll 57. Verhandlungstag—19. November 2013," NSU Watch, November 22, 2013.

216 **"We didn't support":** Friedrichsen, *Der Prozess*, 112–19, 134–41.

217 **Siegfried Mundlos:** "Protokoll 69. Verhandlungstag—18. Dezember 2013," NSU Watch, December 27, 2013.

Chapter 19. The Spy in the Cybercafé

220 **Andreas Temme:** "Protokoll 41. Verhandlungstag—1. Oktober 2013," NSU Watch, October 14, 2013.

220 **Ismail spoke in Turkish:** Gisela Friedrichsen, *Der Prozess: Der Staat gegen Beate Zschäpe* (Munich: Penguin Verlag, 2019), 89–101.

221 **the customer at PC-2:** Forensic Architecture, "77sqm_9:26min," Goldsmiths University of London, July 18, 2017, pp. 11–17.

221 **"Your next date will be fantastic!":** ilove.de, December 3, 2004.

222 **shut down his ilove account:** Hessischer Lantag, report, https://starweb.hessen.de /cache/DRS/19/1/06611.pdf, pp. 354–57.

222 other Nazi literature: Die Linke Fraktion im hessischen Landtag, "Abschlussbericht NSU_Untersuchungsausschuss," July 17, 2018, https://starweb.hessen.de/cache /DRS/19/1/06611.pdf, p. 38.

222 "Little Adolf": Katrin Bennhold, "Day X, Part 3: Blind Spot 2.0," New York Times, June 10, 2021.

222 Heckler & Koch: Deutscher Bundestag, "Ermittlungsverfahren wegen Verdachts des Mordes z.N. von acht türkischen und einem griechischen Staatsangehörigen."

222 bugged Temme's phone: Sarah Müller, "'Wir Wissen Alle, Dass Dieser Mann Lügt,'" Der Rechte Rand, September/October 2016.

223 the ninety-second clip: "Andreas Temme bei der Tatortbegehung in Kassel," Welt, February 27, 2015; "Protokoll 91. Verhandlungtstag—11. März 2014," NSU Watch, March 17, 2014.

223 Forensic Architecture: Forensic Architecture, "77sqm_9:26min."

223 louder than a chainsaw: "Noise Comparisons: Noise Sources and Their Effects," Purdue Chemsafety, www.chem.purdue.edu/chemsafety/Training/PPETrain/dblevels .htm, accessed September 8, 2023.

224 "I don't believe a word": Tanjev Schulz, NSU: Der Terror von rechts und das Versagen des Staates (Munich: Droemer, 2018), 20–21, 62.

224 "You will die cruelly": "Band ruft zum Mord an Linken-Politikerin auf," Der Spiegel, October 29, 2016.

225 How I became president: Katharina König, "Top-Aussagen im Untersuchungsausschuss," Haskala, July 9, 2012.

225 one of Roewer's far-right informants: "Protokoll 143. Verhandlungtstag—24. September 2014," NSU Watch, Oktober 5, 2014.

226 leaked his identity: Thüringer Landtag, Bericht des Untersuchungsausschusses 5/1 "Rechtsterrorismus und Behördenhandeln" (Committee report, Erfurt, 2014), 521–22, 548.

226 sex trafficking of children: "Tino Brandt zu fünfeinhalb Jahren Haft verurteilt," Der Spiegel, December 18, 2014.

226 200,000 deutsche marks: Annette Ramelsberger, "Drei Jahre NSU-Verfahren: über Täter, Helfer und Hinterbliebene," Bundeszentrale für politische Bildung, April 6, 2016.

227 catch Brandt red-handed: Katharina König (politician, Die Linke) in conversation with the author, 2016–23.

228 Wohlleben on his thirty-ninth birthday: "Protokoll 90. Verhandlungtstag—27. Februar 2014," NSU Watch, March 13, 2014.

228 These people must be truly sick: Barbara John, Unsere Wunden kann die Zeit nicht heilen: Was der NSU-Terror für die Opfer und Angehörigen bedeutet (Freiburg im Breisgau: Herder, 2014).

228 attack leftists with pipe bombs: Heike Kleffner, "V-Mann Piatto im NSU-Komplex: Die wissende Quelle," NSU Watch, October 29, 2014.

229 scarf over his face: "Protokoll 167. Verhandlungtstag—3 Dezember 2014," NSU Watch, December 3, 2014.

229 Alexander Hoffmann: "Protokoll 174. Verhandlungtstag—13. Januar 2014," NSU Watch, January 13, 2015.

230 **Gordian Meyer-Plath:** "Protokoll 199. Verhandlungstag—22. April 2015," NSU Watch, April 22, 2015.

230 **"It makes me sad":** "Protokoll 199," 7–10.

230 **"illegal":** Stefan Aust and Helmar Büchel, "NSU-Morde; Der V-Mann mit 'Bums,'" *Welt*, June 27, 2019.

230 **was too high up:** Gordian Meyer-Plath (former OPC handler and politician) in conversation with the author, June 2016.

Chapter 20. A Terrorist Speaks

232 **Semiya struggled:** Semiya Şimşek, *Schmerzliche Heimat* (Berlin: Rowohlt, 2013).

232 **"Can you imagine":** Deutscher Bundestag, *Beschlussempfehlung und Bericht des 2. Untersuchungsausschusses nach Artikel 44 des Grundgesetzes*, August 22, 2013, p. 62.

232 **degree in medical technology:** Ina Krauß, "Der Schmerz von Abdulkerim Simsek," Deutschlandfunk, January 13, 2018.

232 **Merkel's words:** Barbara John, *Unsere Wunden kann die Zeit nicht heilen: Was der NSU-Terror für die Opfer und Angehörigen bedeutet* (Freiburg im Breisgau: Herder, 2014), 31–39.

233 **Beate wished to speak:** "Protokoll 243. Verhandlungstag—10. November 2015," NSU Watch, November 10, 2015.

233 **"What would it mean to you":** Frank Jansen, "Interview mit Tochter eines NSU-Opfers: 'Allzu große Hoffnungen habe ich nicht,'" *Tagesspiegel*, November 10, 2015.

233 **Gamze and Elif traveled:** Gamze Kubaşık in conversation with the author, 2021.

233 **a hundred spectators:** "Protokoll 249. Verhandlungstag—9. Dezember 2015," NSU Watch, December 9, 2015.

233 **The Yozgats were there:** Gisela Friedrichsen, *Der Prozess: Der Staat gegen Beate Zschäpe* (Munich: Penguin Verlag, 2019).

234 **"I wish that Tino Brandt":** Tanjev Schulz, *NSU: Der Terror von rechts und das Versagen des Staates* (Munich: Droemer, 2018), 60–61.

237 **"Ms. Zschäpe valued her cats' lives":** "Das Eidelstedter Kulturhaus präsentiert die 'NSU Monologe,'" *Eimsbütteler Nachrichten*, March 12, 2019.

237 **surprised the court:** "Protokoll 437. Verhandlungstag—03. Juli 2018," NSU Watch, July 3, 2018.

238 **Katharina heard rumors:** Katharina König (politician, Die Linke) in conversation with the author, 2016–23.

239 **1.3 million refugees:** European Council, "Asylum Applications in the EU," June 21, 2023.

239 **unlike the United States:** Oxfam, *Syria Crisis Fair Share Analysis 2016*, February 1, 2016.

239 **569 of them:** "Sonderzug mit Flüchtlingen aus Ungarn in Saalfeld eingetroffen," *Süddeutsche Zeitung*, September 5, 2015.

239 **were pulling into Thuringia:** "Migration Zug Mit 600 Flüchtlingen legt in Saafeld Pause ein," *Welt*, November 20, 2015.

240 **tried to block buses:** "Protest Dispersed Near Dresden Refugee Center," Deutsche Welle, August 22, 2015.

240 **eight hundred thousand asylum seekers:** IOM Global Migration Data Center, "Migration, Asylum and Refugees in Germany: Understanding the Data," January 1, 2016.

240 ***"Wir schaffen das"*:** Angela Merkel, August 31, 2015.

240 **should be deported:** Infratest Dimap, "Eine Umfrage zur politischen Stimmung im Auftrag der ARD-Tagesthemen und der Tageszeitung DIE WELT," November 2015.

241 **sparks outside the window:** Jacob Kushner, "Escaping Aleppo Only to Encounter Violence in Germany," Al Jazeera, July 13, 2017, from author's conversations in Freital.

241 **Freital Group:** "Lange Haftstrafen im Prozess gegen Gruppe Freital," *Zeit Online*, March 7, 2018.

242 **Germany's federal prosecutor:** Timothy Jones, "German Far-Right Terror Suspects Arrested," Deutsche Welle, April 19, 2016.

242 **arrested three more:** "'Freital Group' Found Guilty of Terror Crimes," Deutsche Welle, March 7, 2018.

242 **charged, tried, and convicted:** Strafgesetzbuch (StGB) § 46, Grundsätze der Strafzumessung, Bundesrepublik Deutschland, Bundesamt für Justiz.

242 **a few among thousands:** D. Benček and H. Strasheim, "Refugees Welcome? A Dataset on Anti-refugee Violence in Germany," *Research & Politics* 3, no 4. (2016).

242 **attacks against immigrants surged:** Zentrum für Betroffene rechter Angriffe e.V. (ZEBRA), "Presse Spiegel," July 2016, www.zebraev.de/wp-content/uploads/2017/07/ZEBRA-Artikel.pdf.

242 **thirty-five hundred in 2016:** "Jeden Tag gibt es fast zehn Gewalttaten gegen Flüchtlinge," *Die Welt*, February 26, 2017.

242 **"The problem is not":** Christian Jakob, *Taz*, in conversation with the author, April 14, 2016.

243 **German identity was being compromised:** Heinrich Böll Stiftung, "Leipziger Autoritarismus-Studie 2018: Methode, Ergebnisse und Langzeitverlauf," 2018.

243 **far-right rhetoric and violence:** U. Liebe and N. Schwitter, "Explaining Ethnic Violence," *European Sociological Review* (2021): 429–48; S. Jäckle and P. D. König, "Threatening Events and Anti-refugee Violence: An Empirical Analysis in the Wake of the Refugee Crisis During the Years 2015 and 2016 in Germany," *European Sociological Review* (2018): 728–43.

243 **AfD won the most votes:** K. Müller and C. Schwarz, "Fanning the Flames of Hate: Social Media and Hate Crime," *Journal of the European Economic Association* (2021); W. Krause and M. Matsunaga, "Does Right-Wing Violence Affect Public Support for Radical Right Parties? Evidence from Germany," *Comparative Political Studies* 56, issue 14 (2023).

243 **Dresden's city hall:** Gordian Meyer-Plath (former OPC handler and politician) in conversation with the author, June 2016.

244 **than any other state:** "Over 600 Attacks on Refugees in Germany This Year," Deutsche Welle, September 5, 2019.

244 **Saxony recorded:** Ayhan Simsek, "Right-Wing Violence on Rise in Eastern Germany: Report," Anadolu Agency, February 4, 2019.

244 two fathers: "Two Refugee Home 'Attacks' in as Many Days," *The Local*, June 29, 2015.

244 "They were shouting": Zeina, a twenty-four-year-old Iranian woman in Clausnitz, in conversation with the author, June 4, 2016; Jacob Kushner, "Clausnitz: When a Mob Awaited Refugees in a German Town," Al Jazeera, July 6, 2017.

245 the grim milestone: Daniel Koehler, *Right-Wing Terror in the 21st Century: The National Socialist Underground* (London: Routledge, 2016), 177.

Chapter 21. Judgment Day

246 Woman in the Mirror: Gisela Friedrichsen, *Der Prozess: Der Staat gegen Beate Zschäpe* (Munich: Penguin Verlag, 2019), 105, 267, 296.

246 a coveted prize: *Frau im Spiegel* no. 35 (2022).

247 "I would like to use": "Protokoll 437. Verhandlungstag—03. Juli 2018," NSU Watch, July 3, 2018.

248 a press conference: Author's notes and recordings, Munich, July 10, 2018.

248 "Throughout the entire trial": Gamze Kubaşık in conversation with the author, 2021.

249 "I want to know why": "Total enttäuscht," *Nürnberger Nachrichten*, July 11, 2018.

249 just three seats remained: Author's notes, Munich, July 11, 2018.

250 nobody rose: Friedrichsen, *Der Prozess*.

250 delivering the verdict: Oberlandesgericht München, "Der 6. Strafsenat—Staatsschutzsenat—des Oberlandesgerichts München erlässt in dem Strafverfahren gegen" (Urteil), April 21, 2020.

251 Wohlleben would move in with Bauer: Ben Knight, "German Neo-Nazi Terrorist Helper Freed," Deutsche Welle, July 18, 2018.

251 *These people have destroyed*: Barbara John, *Unsere Wunden kann die Zeit nicht heilen: Was der NSU-Terror für die Opfer und Angehörigen bedeutet* (Freiburg im Breisgau: Herder, 2014).

252 "His voice": Gamze Kubaşık in conversation with the author, 2021.

253 "Martyr": "Breivik fordert Zschäpe zu Propaganda auf," *Der Spiegel*, July 18, 2018.

253 the *NSU Monologues*: Bühne für Menschenrechte, "NSU Monologues."

253 "extraordinary defeat": *Der Spiegel*, "Fromm vor U-Ausschuss: 'Schwere Niederlage' des Verfassungsschutzes," July 5, 2012, spiegel.de/video/verfassungsschutz-heinz -fromm-vor-nsu-untersuchungsausschuss-video-1207540.html.

253 the town of Apolda: Erika Solomon, "The Dangers of a Neo-Nazi Woodstock," *The Atlantic*, October 2018.

253 smokestack: Katharina König (politician, Die Linke) in conversation with the author, 2016–23.

254 "Part of me": John, *Unsere Wunden kann die Zeit nicht heilen*.

254 Hamburg's city hall: Deutscher Bundestag, *Beschlussempfehlung und Bericht des 2. Untersuchungsausschusses nach Artikel 44 des Grundgesetzes*, August 22, 2013, p. 985.

256 "NSU tribunal": *Wir Klagen An! Anklage des Tribunals "NSU-Komplex auflösen,"* May 2017, www.nsu-tribunal.de/wp-content/uploads/2017/10/NSU-Tribunal_Anklageschrift _DE_V3.pdf.

256 *Painful Homeland*: Semiya Şimşek, *Schmerzliche Heimat* (Berlin: Rowohlt, 2013).

256 **married a journalist:** Elke Graßer-Reitzner and Stanislaus Kossakowski, "Semiya Simsek: 'Ich kann keine Wurzeln mehr setzen!,'" *Nordbayern*, October 29, 2021.

Epilogue

257 **"Turkish Swine":** Annette Ramelsberger, "'Die Täter wollen mich einschüchtern, aber ich werde nicht aufgeben',", *Süddeutsche Zeitung*, January 14, 2019.

257 **more than 140 threatening emails:** "Fast 100 Drohschreiben vom NSU 2.0 eingegangen," *Zeit Online*, August 20, 2020.

257 **protect herself:** Matthias Meisner and Heike Kleffner, "Extreme Sicherheit: Rechtsradikale in Polizei, Verfassungsschutz, Bundeswehr und Justiz," Bundeszentrale für politische Bildung, August 2, 2021, p. 137; Annette Ramelsberger, "Rechte bedrohen erneut Frankfurter Anwältin," *Süddeutsche Zeitung*, January 14, 2019.

258 **AfD in Chemnitz:** "The Riots in Chemnitz and Their Aftermath," *Der Spiegel*, August 31, 2018.

258 **"Revolution Chemnitz":** Andreas Burger, "Germany Uncovers Terrorist Group Which Attacked Foreigners in Chemnitz," Reuters, October 1, 2018.

258 **On the thirtieth anniversary:** "Rechtsrockkonzert nach einer Stunde abgebrochen," *Die Zeit*, October 7, 2018.

258 **Bilal M.:** Jan Schiefenhövel, "'Viele rechte Anschläge,'" *Frankfurter Allgemeine*, July 23, 2020.

259 **Tree of Life synagogue:** Masha Gessen, "Why the Tree of Life Shooter Was Fixated on the Hebrew Immigrant Aid Society," *New Yorker*, October 27, 2018.

259 **Hanau:** Özlem Gezer and Timofey Neshitov, "Aftermath of a Deadly Racist Attack," *Der Spiegel*, February 18, 2021.

259 **The 'typical' Nazi":** Amadeu Antonio Stiftung, "Rechte Gewalt und staatliche Anerkennung," June 8, 2020.

260 **"monument of shame":** Madeline Chambers, "German AfD Rightist Triggers Fury with Holocaust Memorial Comments," Reuters, January 18, 2017.

260 **by the very officers:** Matthias Bartsch et al., "Exploring Right-Wing Extremism in Germany's Police and Military," *Der Spiegel*, August 13, 2020.

260 **code name "Uwe Böhnhardt":** "Sächsische Polizisten wählen NSU-Decknamen," *Tagesschau*, September 28, 2018.

260 **formed a terrorist cell:** "German Far-Right Accused of Plotting Attacks on Muslims," Deutsche Welle, April 13, 2021.

260 **"Germany likes to present itself":** Antonia von der Behrens in conversation with the author, June 7, 2016.

260 **Hitler's birthday:** "German Soldiers Dismissed over Hitler Birthday Song," Reuters, June 16, 2016.

260 **fourteen hundred extremist acts:** Christopher F. Schuetze and Katrin Bennhold, "Far-Right Extremism Taints German Security Services in Hundreds of Cases," *New York Times*, October 6, 2020.

261 **a loaded handgun:** Katrin Bennhold, "German Military Officer Known as Franco A. Found Guilty of Plotting Terrorism," *New York Times*, July 15, 2022.

261 **overthrow Germany in a coup:** Dirk Wilking, ed., *"Reichsbürger,"* Brandenburgisches Institut für Gemeinwesenberatung, Potsdam, 2017, www.gemeinwesen

beratung-demos.de/wp-content/uploads/2021/01/Reichsbuerger-Ein-Handbuch
-Auflage-3.3958246.pdf.

261 **"he wore a large":** Maik Baumgärtner et al., "The Motley Crew That Wanted to Topple the German Government," *Der Spiegel*, December 10, 2022.

262 **Their attempted coup:** Kathleen Belew, *Bring the War Home: The White Power Movement and Paramilitary America* (Cambridge, MA: Harvard University Press, 2018).

262 **"In the 1990s":** Dale L. Watson, executive assistant director, Counterterrorism/Counterintelligence Division, Federal Bureau of Investigation, testimony before the Senate Select Committee on Intelligence, February 6, 2022, https://archives.fbi.gov/archives/news/testimony/the-terrorist-threat-confronting-the-united-states.

262 **three times as many:** U.S. Government Accountability Office, *Countering Violent Extremism: Actions Needed to Define Strategy and Assess Progress of Federal Efforts*, April 2017; New America, "What Is the Threat to the United States Today?," September 3, 2023.

262 **domestic terror attacks more than tripled:** U.S. Government Accountability Office, *Domestic Terrorism: Further Actions Needed to Strengthen FBI and DHS Collaboration to Counter Threats*, February 2023.

262 **counterterrorism agents:** "Confronting the Rise of Domestic Terrorism in the Homeland," Hearing Before the House Committee on Homeland Security, U.S. Congress, May 8, 2019, www.congress.gov/116/chrg/CHRG-116hhrg37474/CHRG-116hhrg37474.pdf, p. 36.

262 **threat was precisely flipped:** "Who Are the Terrorists?," New America, September 15, 2023, www.newamerica.org/future-security/reports/terrorism-in-america/who-are-the-terrorists.

262 **"Anti-immigrant hate groups":** Southern Poverty Law Center, "Anti-immigrant," accessed September 8, 2023.

262 **less than 14 percent:** Abby Budiman, "Key Findings About U.S. immigrants," Pew Research Center, August 20, 2020.

263 **five times as much coverage:** Erin M. Kearns and Amarnath Amarasingam, "How News Media Talk About Terrorism: What the Evidence Shows," *Just Security*, April 5, 2019.

263 **terrorist in Wisconsin:** "Sikh Temple Killer Wade Michael Page Radicalized in Army," Southern Poverty Law Center, November 2012.

263 **Timothy McVeigh:** Allison Reese, "From Ruby Ridge to Oklahoma City: The Radicalization of Timothy McVeigh," senior thesis, University of South Carolina–Columbia, 2018.

263 **charged for crimes at the Capitol:** "Capitol Breach Cases," U.S. Attorney's Office, District of Columbia, accessed September 8, 2023.

263 **eighteen had been disciplined:** Dave Philipps, "White Supremacism in the U.S. Military, Explained," *New York Times*, February 27, 2019.

263 **recruiting men and women in uniform:** *Extremism in America*, Part 3: "Resurgence," PBS, May 3, 2022.

264 **"the most persistent and lethal threat":** Zolan Kanno-Youngs, "Delayed Homeland Security Report Warns of 'Lethal' White Supremacy," *New York Times*, October 6, 2020.

264 **canceled the DHS program:** Peter Beinart, "Trump Shut Programs to Counter Violent Extremism," *The Atlantic*, October 29, 2018.

264 **Biden reinstated it:** National Security Council, "National Strategy for Countering Domestic Terrorism," June 2021.

264 **Domestic Terrorism Prevention Act:** Congress.gov, "Domestic Terrorism," www .congress.gov/u/KHE4qZXz_U9iY5aW0EmeJ, accessed September 8, 2023.

264 **prohibits material support:** 18 U.S. Code § 2339A—Providing material support to terrorists, Cornell Law School, www.law.cornell.edu/uscode/text/18/2339A.

264 **supporting *international* terrorists:** Trevor Aaronson, "Homegrown Material Support: The Domestic Terrorism Law the Justice Department Forgot," *The Intercept*, March 23, 2019.

264 **just thirty-four occasions:** Trevor Aaronson, "Terrorism's Double Standard: Violent Far-Right Extremists Are Rarely Prosecuted as Terrorists," *The Intercept*, March 23, 2019.

264 **didn't charge Roof with terrorism:** James Verini, "The Domestic Terror Paradox," *New York Times Magazine*, February 8, 2008.

265 **more concerned about domestic extremists:** AP-NORC Center for Public Affairs Research, "Most Americans Say the Wars in Afghanistan and Iraq Were Not Worth Fighting," August 2021.

Index

About the Author

Jacob Kushner is a foreign correspondent who writes magazine and other longform articles from Africa, Germany, and the Caribbean. His writing has appeared in dozens of publications including the *New York Times*, *The Atlantic*, *The New Yorker*, *Harper's*, *The Economist*, *National Geographic*, *The Atavist*, *The Nation*, *Foreign Policy*, and *The Guardian*. He is the author of *China's Congo Plan*, which was favorably reviewed in the *New York Review of Books*. A Fulbright-Germany scholar and Logan Nonfiction Fellow, he was a finalist for the Livingston Award in International Reporting. He teaches and advises ambitious young journalists at the Pulitzer Center, the Overseas Press Club, and several universities.